# Looking on *Eileen*

## Images of femininity in the visual arts and media

Edited by Rosemary Betterton

**PANDORA**

London and New York

First published in 1987 by
Pandora Press
(Routledge & Kegan Paul Ltd)
11 New Fetter Lane, London EC4P 4EE

Published in the USA by
Pandora Press
(Routledge & Kegan Paul Inc.)
in association with Methuen Inc.
29 West 35th Street, New York, NY 10001

Set in Ehrhardt with Rockwell
by Columns of Reading
and printed in the British Isles
by the Guernsey Press Co Ltd
Guernsey, Channel Islands

Library of Congress Cataloging in Publication Data

Looking on.
Bibliography: p.
Includes index.
1. Feminism and art.   2. Feminine beauty
(Aesthetics)   3. Women in the mass media industry.
I. Betterton, Rosemary.
N72.F45L6   1987        701'.03        86–14602

British Library CIP Data also available

ISBN 0-86358-176-5 (c)
      0-86358-177-3 (pb)

# Contents

# Contents

vi

# Illustrations

# Acknowledgements

The idea for this collection goes back several years and during that time I have had support and helpful responses from many people, friends, colleagues and students at Sheffield City Polytechnic, especially from the MA in Women's Studies. My particular thanks and gratitude go to Charlotte Brunsdon, Sylvia Harvey and Angela Martin for their encouragement through various stages in preparing this book and for their invaluable critical comments on the draft introductions. I also want to thank Ahmed Gurnah, Monica Pendlebury and Angelo Bertucci for their support at difficult moments. My thanks go to the authors who have allowed me to reproduce their material and for all that I have gained in the course of reading their work. In particular I am grateful to Lubaina Himid, Pat Holland, Rosy Martin, Kathy Myers, Lynn Nead, Jo Spence and Janice Winship for providing me with original illustrative material to accompany their articles. Finally, my thanks go to the staff at the Faculty of Art and Design Library, Sheffield City Polytechnic, for their help in obtaining material, and especially to Elizabeth Holloway and Christine Watts for their work in preparation of the typescript.

I wish to thank the following for permission to reprint copyright material:

the author and Sage Publications Ltd for Janice Winship, 'Handling sex', *Media, Culture and Society*, vol. 3, no. 1, 1981. Used by permission of Sage Publications Ltd, London;

the author and SEFT for Griselda Pollock, 'What's wrong with images of women?' *Screen Education*, no. 24, Autumn 1977, copyright SEFT 1977;

the author and Marion Boyars Publishers Ltd for an extract from Judith Williamson, *Decoding Advertisements*, 1978;

the author and *m/f* for Rosalind Coward, ' "Sexual liberation" and the family', *m/f*, no. 1, 1978;

the author and SEFT for Kathy Myers, 'Fashion 'n' passion', *Screen*, vol. 23, nos 3-4, 1982, copyright SEFT 1982;

the author and Oxford University Press for Lynn Nead, 'The Magdalen in modern times', *The Oxford Art Journal*, vol. 7, no. 1, 1984. Reprinted by permission of Oxford University Press;

the author and *Ten.8* for Pratibha Parmar, 'Hateful contraries: media images of Asian women', *Ten.8*, no. 16, 1984;

the author and SEFT for Patricia Holland, 'The Page Three

girl speaks to women, too', *Screen*, vol. 24, no. 3, 1983, copyright SEFT 1983;

the author for Susan Butler, 'Revising femininity?' *Creative Camera*, September 1983;

the author and *Feminist Review* for Janice Winship, ' "A girl needs to get street-wise": magazines for the 1980s', *Feminist Review*, no. 21, Winter 1985;

the author and *City Limits* for Mandy Merck, 'Pornography', *City Limits*, November 13-19, 1981;

the author and *Feminist Review* for Elizabeth Wilson, 'Interview with Andrea Dworkin', *Feminist Review*, no. 11, June 1982;

the author and *Spare Rib* for Ruth Wallsgrove, 'Between the devil and the true blue Whitehouse', *Spare Rib*, no. 65, December 1977;

the authors and *Spare Rib* for Rosalind Coward and WAVAW, 'What is pornography?' *Spare Rib*, no. 119, June 1982;

Jill Pack, the estate of Mary Bos and *Camerawork* for Mary Bos and Jill Pack, 'Porn, law, politics', *Camerawork*, no. 18, 1980;

the author and *Camerawork* for Kathy Myers, 'Towards a feminist erotica', *Camerawork*, no. 24, March 1982;

the authors and the Whitechapel Art Gallery for an extract from Laura Mulvey and Peter Wollen, *Frida Kahlo and Tina Modotti*, Whitechapel Art Gallery, 1982;

the author and Routledge & Kegan Paul for Lisa Tickner, 'The body politic: female sexuality and women artists since 1970', *Art History*, vol. 1, no. 2, 1978, copyright RKP plc;

the author and *Spare Rib* for Rozsika Parker, 'Censored: feminist art that the Arts Council is trying to hide', *Spare Rib*, no. 54, January 1977;

the authors and *Feminist Review* for Rosy Martin and Jo Spence, 'New portraits for old: the use of the camera in therapy', *Feminist Review*, no. 19, Spring 1985.

# Introduction:
# feminism, femininity and representation

'Representation of the world, like the world itself, is the work of men; they describe it from their own point of view, which they confuse with the absolute truth.'[1]

Since its re-emergence in the late 1960s the women's movement in the west has had a continuous engagement with the politics of the visual image. The ways in which women are represented in advertising, the news media, fine art and pornography have become the subject of attack, debate and analysis. Given the omnipresence of the female image in modern capitalist culture, this is hardly surprising. Whenever we walk down the street, watch TV, open a magazine or enter an art gallery, we are faced with images of femininity. These make up a discourse on what it means to be feminine in our culture which affects us all, women and men, in various ways. For women in particular, the images are impossible to ignore. They tell us how to look, how to behave, and how we might expect to be seen and treated by others. The question of how visual images work to define femininity and whether they can be changed is therefore a central theme in this book.

The starting point for the book is the existence of a body of writing, discussion and debate which, over the last fifteen years, has developed a substantial critique of the representation of women in the visual media. The main focus of the articles collected here is on the still image and its diverse contexts of production and consumption in advertising, fine art, photography and pornography. I have not included any work on cinema and television since these areas are already well represented in other anthologies and by more specialist studies.[2] My aim in putting together this collection is to strengthen existing links between critical work in different areas of the visual arts and media, as well as to develop fresh connections. It will also, I hope, offer some sense of the recurring issues and developing debates in feminist writing on visual representation since the mid 1970s.

There are several reasons for bringing together critical work across the studies of the various media in one book. These stem in part from the cultural politics of the women's movement itself,

in part from practical demands for more easily available teaching and study material, and in part because increasingly similar theoretical issues are being addressed in the analysis of different media. While paintings, pin-ups, news photographs, fashion and pornographic images vary considerably in the ways in which they are produced and consumed, they overlap and intersect in their representations of femininity and female sexuality. It therefore makes sense to look at the ways in which the feminine image is constructed across a range of differing cultural practices.

In the struggle to change the place ascribed to women in culture and language, the women's movement has challenged traditional divisions between High Art and mass culture and the compartmentalisation of knowledge between disciplines. Arguing that cultural forms as diverse as the Page Three pin-up and the female nude in Renaissance painting articulate similar ideologies of female sexuality, feminist criticism undermines old cultural categories and makes a radical critique of all forms of representation. While, therefore, it is necessary to grasp the specific differences in the power and productiveness of images for women, it is equally important to see where different kinds of representation draw upon and restate the same relationships of sexual power and subordination between men and women.

Just as women's politics have cut across traditional divisions, between the public and domestic spheres, for example, so women's studies have challenged the division of knowledge into specialist areas of expertise. Rather than simply incorporating feminism as another 'perspective' within existing fields of knowledge, the interdisciplinary nature of women's studies questions the structure of those fields themselves. While often feminist critical work emerged as a series of interventions into established disciplines and practices, the development of work on women's studies in recent years has led to a need to explore common interests and approaches across different areas. In my own experience, teaching courses on women and representation means raiding a variety of materials and perspectives from several disciplines. This collection marks an attempt to rationalise that process, by putting together articles which are drawn from a range of disciplinary sources.

This process is made easier by the existence of theoretical frameworks which pull together work from disparate areas of study around common sets of issues and problems. Theories of culture and representation developed in the 1970s and 1980s have been extremely influential on the criticism and practice of visual media. Work on the visual image has paid new attention to the ways in which images produce meaning and circulate ideologies. This has been very fruitful for an understanding of how femininity is defined and reproduced. There are signs as well in recent years of a greater cross-fertilisation of interests and

approaches between the study of the cinema, mass media and art history, in which feminist writers and theorists have been particularly prominent. Thus, for example, questions about the spectatorship of images and the relationship between looking and sexuality, which were explored first in feminist film theory, have been taken up more recently in the analysis of art history. Conversely, the methodological concerns of media studies and art history with the institutional and historical contexts of the production and consumption of images are being recognised in feminist film analysis.[3] It seems an appropriate moment therefore to draw together and to attempt to represent some of the shared interests and methods in feminist analysis of the visual image.

## Feminism and critical practice

What does it mean to look at images from a feminist viewpoint? What kind of a practice is it and what issues does it address? It is not possible to define a single feminist critical perspective: a variety of different and sometimes conflicting approaches have emerged in feminist writing over the last fifteen years. However, there are shared assumptions which inform feminist criticism and which make it very different from traditional ways of seeing and thinking about the visual image. From its inception, the women's movement has given space to the cultural expression of women's experience in cinema and art, in writing and performance. The cultural is one important sphere where women have claimed the right to speak with a different voice and to contest the meanings of dominant traditions. The project of giving voice to experience and making visible oppression is a significant point of women's politics. But feminism also has recognised that women are already 'spoken' and made visible within mainstream culture: women are the ever-recurring subject of novels, films, poems, paintings and advertisements. One of the problems for feminist criticism then is how to reconcile a practice which takes apart the forms and meanings of existing culture with one which also seeks to represent women in new terms.

Women have an ambiguous relationship to the visual image. This is because they are represented so frequently within images and yet their role as makers and viewers of images is scarcely acknowledged. A *Self Portrait* by Laura Knight illustrates the problem of defining a woman's viewpoint (Figure 1). The artist shows herself in the act of painting a female nude, while her model stands on a dais to one side of the canvas. We thus see three images of women in the picture: the painted nude, the model and the artist herself. While the model is naked, the artist is clothed; she even wears a hat. The two figures appear to occupy different spaces, a separation which is reinforced by the strong vertical lines and the colour and tonal contrasts in the picture.

3

1 Laura Knight, *Self Portrait*, 1913,
National Portrait Gallery, London.

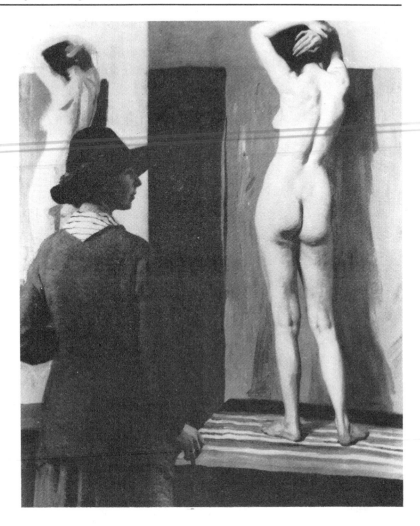

The first time I saw it, I completely misread the image. Failing to notice the brush in the artist's right hand, I thought I was seeing a woman looking through the window of a gallery or shop. This mistake seems to me to be revealing of certain cultural assumptions about femininity. While the woman's narcissistic glance in a mirror or a shop window is socially legitimated, her critical and investigative gaze is not. One of the most important aspects of feminist criticism is to explore this contradiction for women in producing or looking at representations in a culture which traditionally excludes their point of view. How, then, are we to understand the artist's position in this image?

It is not one of privileged access to sight, since she does not look *at* the model at all, but past her, as though her gaze were caught by something beyond the frame. The effect of this sideways glance is to contravene the normal expectations of the

nude, in which the relay of looks between the artist and model and the model and spectator confirms the viewer's privileged sight of the woman's body. The breakdown in the relationships of looking is reinforced by the fact that the model has her back to us, and that we see her not once, but twice. The illusion that she is posed solely for us, the viewers, is broken by this doubling of images and by the artist's gaze which cuts across our own. But while the picture does not produce the voyeurism usual in representations of the female nude, neither does it offer the viewer any other position from which to make complete sense. I would suggest that this is because the relationship between woman artist and woman model transgresses the normative roles of male and female, artist and model, clothed and naked: the one who looks and the one who is looked at. The effect of this transgression is not a reversal of meaning, but a problem over what the picture can mean at all. While recognition of women's position as makers and viewers of images can radically subvert traditional ways of seeing them, this does not lead automatically to the production of new meanings.

What is at stake is the power of images to produce and to define the feminine in specific ways. By investigating what controls the image and how its power operates, feminist criticism can begin to explore the ways in which women can produce and take possession of their own images. In practice, women are rarely in a position to direct the production, circulation and consumption of visual imagery either in the major institutions of the mass media or those of the art world. But through the independent production, publication and exhibition of films, art, books and graphics, women have begun to explore alternative cultural forms. Often small scale in distribution and limited in the audiences they can reach, nevertheless, these practices are significant in developing new kinds of viewing contexts, as well as meanings and pleasures for women.

The relationship between criticism, in its broadest sense, and practice has been an important feature of feminist cultural politics in breaking down the hierarchical divisions between critic and producer, and producer and her audience. Given the institutional divisions between criticism and art, this is a radical enterprise and one which is extremely important. Critical debate and discussion can produce new meanings and contexts for work, as well as a critique of those which already exist. This kind of radical practice seeks to shift and to transform the meaning of cultural artefacts, not merely to interpret them more accurately. Thus, for example, feminist graffiti on advertising directly intervenes in its meaning. When 'Better luck next time!' is added to 'To Volvo a Son' this neatly undermines the patriarchal assumptions of the slogan and turns the advertisement's 'joke' back on itself. The action resists the dominant meaning in a way which acknowledges, but

subverts, its message. It also changes the frame of reference of the advertisement to one in which women, not men, are implicitly addressed. Both these aspects, a refusal to accept meaning as given and the assertion of a different gender viewpoint, make feminist criticism, whether in the form of graffiti or the extended analysis of images, very different from other critical approaches.

In contrast to a dominant critical tradition which presents itself as an objective quest for truth, most feminist critical writing makes its gender 'bias' clear. In doing so, it questions the notion of an essential 'truth' which guarantees objectivity. By positioning women as viewing subjects, the assumption of neutrality implicit in mainstream criticism is thrown into question and different kinds of knowledge and understanding of the world can be opened up. Furthermore, in arguing that meaning is not fixed or innate, but subject to a continual process of struggle and redefinition, it suggests that a critical practice can actively intervene to change the meanings of cultural artefacts. This has been the case where, for example, a film like *Dressed To Kill* or the painting and sculpture of Allen Jones have been criticised by women for their violent and pornographic representations. Such debates produce quite different readings of the work from those generally offered by male critics and the film-maker and artist themselves, and place it within a new critical context. In a similar way, but with very different aims, critical debate and discussion can expand the framework for reading cultural texts produced by women.

By examining the conditions of creativity, and the cultural meanings ascribed to women's art of earlier periods, feminist criticism begins to reframe and reconstruct the past in new ways. What the work represents can be changed from a traditional frame of reference in which it signified marginal, secondary or unspoken values, to a new critical context in which those values can become central, productive and meaningful. Thus, for example, the republishing of 'forgotten' novels by women writers under feminist imprints can change the context and the expectations of their work and, therefore, the ways in which it will be read. This applies equally to current practices as to work of the past. As Mary Kelly suggests of her own work:

> I think the most interesting reading will be the one that follows it, rather than my own – that is, the reading the Women's Movement will be able to make of it in the future, in the sense of its representation of a particular historical moment within the Women's Movement, and also within the discourse of past art.[4]

In these various ways then, a feminist critical practice actively engages in the production and circulation of cultural meanings and values. By identifying with the woman who looks, it questions

what is 'natural' and 'normal' in representation. This depends crucially on an understanding of how definitions of femininity are produced and articulated in cultural forms. I want briefly to outline some of the ideas which I think are useful to this critical project, in particular those of representation and discourse and of pleasure and spectatorship which are most relevant to the writings in this collection.

## Constructing femininity

The term femininity implies a social process in which the female sex is attributed with specific qualities and characteristics. From the moment when, at birth, we are colour coded into pink or blue, we enter into a social world in which sexual difference is continually marked by cultural signs. The differences between 'being a woman' and 'being a man' are made visible in the clothes we wear, in the language we speak, in the work we do and in the pleasures we take. As anthropological studies have shown, what defines desirable female qualities may vary from culture to culture and through history.[5] They may also, as at the present time, be subject to struggles over definition by women themselves. But, 'being a woman' always means more than simple biological existence. It stands for a whole process in which individual and gendered identity are acquired. While it might be difficult to imagine a culture or society which does not mark feminine from masculine in some way, it is the particular forms which femininity takes, and the insistence on them, which many women object to.

Femininity, as defined in western culture, is bound up very closely with the way in which the female body is perceived and represented. There is a long history of imagery in religion, in literature and in art, which links feminine qualities and characteristics with what was supposed to be the frailty and capriciousness of women's bodies. Whereas men are more frequently judged by their social status, intellect or material success, women are commonly defined in terms of their appearance and relationship to men, as a glance through any current newspaper still shows. The visual is particularly important in the definition of femininity, both because of the significance attached to images in modern culture and because a woman's character and status are frequently judged by her appearance. To cite an extreme example, in rape trials, the clothes worn by the victim have been used as evidence of her complicity with the attack. Here, physical appearance is taken as a sign of moral worth and ultimately as a legal test of the guilt or 'innocence' of the attacker. On a more daily basis, all women are familiar with the way in which they are judged by appearance: virgin or whore, 'slag' or 'drag' are signified in codes of dress as well as of morality. Stereotypes of femininity then are constructed through

7

appearance, and are further closely linked to a sexual identity.

What kinds of implication has this for the study and analysis of visual images? It has been argued that visual images, along with other cultural texts and practices, help to organise the ways in which we understand gender relations. The concept of representation has become a crucial one for the analysis of sexual politics in the 1970s and 1980s. In its broadest sense the term is used to describe all those processes through which meaning is made and circulated in society. Thus novels, films, television, political speeches and news photographs all represent the world to us in ways which produce definite ideas about social reality. These, it has been argued, do not merely reflect existing realities but actually shape our perceptions of what that reality is. Images of femininity in advertising, fashion, fine art or pornography influence how we see the female body and what it means to us. Very often, as Rosalind Coward has pointed out, mass media images represent the body as the site on which feminine cultural ideals can be literally manufactured:

> We are set to work on an ever-increasing number of areas of the
> body, labouring to perfect and eroticise an ever-increasing number of
> erotogenic zones. Every minute region of the body is now exposed to
> this scrutiny by the ideal. . . . Moisturise, display, clean off, rejuvenate
> – we could well be at it all day, preparing the face to meet the faces
> that we meet.[6]

Current ideals reinforce a view that to be feminine is to possess certain bodily attributes, which makes it difficult to visualise femininity outside prevailing attitudes to and representations of the female body. In contemporary representation, then, definitions of femininity are elided with the way the body is depicted as a sexual entity. Feminist theorists have challenged the idea that gender and sexuality can be collapsed together in this way, arguing that socially prescribed ideals of femininity bear little relationship to the actual capabilities of the female sex. But, if femininity is not reducible to female sexuality, neither can it be separated entirely from it. The construction of feminine stereotypes and the construction of female sexuality are interconnected. This is not to say that femininity is determined by biological sex, but rather the reverse, that sexual identities are formed within prevailing codes of femininity. Visual codes are important in defining which forms of female sexuality are acceptable and which are unacceptable. As Lynda Nead argues in relation to nineteenth-century art:

> Images of women and paintings of the nude *must* be seen as part of
> this process of organisation of sexuality, of the shifting and negotiated
> construction of 'masculinity' and 'femininity'.[7]

Visual representations, whether in 'high' art or in popular culture,

help to shape social ideals of femininity, but they do so in specific ways. Paintings, advertisements, pornography, and fashion are all practices which produce particular ways of seeing the feminine body.

The idea of discourse has been seen as useful in explaining how various cultural and social practices intersect to define sexuality. Feminists have argued that sexuality should not be seen as an innate or natural instinct but rather as the product of various discourses in society. Here the ideas of Michel Foucault have been influential in developing a theoretical model through which to explain the social construction of sexuality. In *The History of Sexuality* Foucault argues that medical, legal, political and religious discourses all produce forms of knowledge about sexuality which seek to constitute it in particular ways.[8] Some sexual practices are defined as 'normal' (heterosexual intercourse, for example) while others are illegal (in Britain sexual relationships for men with girls under sixteen and with other men under twenty-one). These divisions between licit and illicit forms of sexuality do not reflect natural or biological divisions, but regulate which forms of sexual behaviour can be practised and are socially sanctioned. Definitions of femininity and female sexuality as we understand them are reproduced in cultural forms which help to define what are seen to be desirable roles and relationships for women in current society.

The idea that gender and sexual identities are constructed across different discursive practices helps to explain why femininity is represented, and often experienced, in contradictory ways. For, while there are prevailing ideas about ideal feminine qualities at any one time, there are also always differences in the way femininity is represented. So, while Page Three pin-ups and Barbara Cartland novels both define women solely in the context of heterosexual relationships, each represents female sexuality quite differently. These differences correspond to opposing ideologies about sex and marriage, but also to the differing markets and audiences for *The Sun* and for romantic fiction. There may therefore be competing definitions of femininity which can be found across various cultural discourses. Part of the work of critical analysis is to trace how and why one set of visual codes can be taken up and reworked in a different context.

An understanding of femininity as contradictory, shifting and subject to conflict is important if we want to change systems of representation as well as to explain them. For there can also be struggles around the meaning and definitions of femininity. For example, the popular press in Britain has used the image of the Greenham peace campaigners precisely to mark off their deviance from 'normal' women. But, for many women, their image has been powerful and inspiring, offering a sense of new possibilities for women's lives and action. These two different representations

suggest that what is at stake is a struggle to 'claim' femininity, each side using the image of the women to define the issues in particular ways. 'Greenham' does not offer a positive image in any simple way, but a site where the meanings ascribed to femininity are contested, as well as of course, a contest over the siting of nuclear weapons in Britain. It may be therefore that we need to look at those areas where struggles over representation are taking place, if only because by seeing what is denied or outlawed by dominant ideology, we can find the fragments to reconstruct femininity in new ways.

It is as important to look for what is hidden or suppressed in discourse, as well as for what is made visible. Femininity is not necessarily constructed in the same way for all women, nor are they addressed equally by systems of representation. Visual discourses also work to privilege certain social values and meanings, while excluding others. Thus, the construction of a feminine ideal which is white, heterosexual, young, able-bodied and usually middle class, denies and renders invisible women of different race, sexual preference, age, physical ability and class position. This is not only a matter of the *content* of representation, although that is important, but of the ways in which the viewer is addressed. An example given by Chinyelu Onwurah makes this clear.[9] She cites an advertisement for suntan products in a women's magazine which has the accompanying caption: 'Isn't it nice to be brown when everyone else is white?' The advertisement clearly is addressed to women, but the implicit assumption is that all its viewers are white, the point being that it is sexist *and* racist, but in rather different ways. The image makes use of a woman's body to sell its product, but the address specifically constructs an 'us' for whom there is value put on a suntan and excludes a 'them' for whom colour of skin in a racist society has very different connotations. Advertisements like this, and a majority of visual images in the mainstream media, help to define what forms of femininity are acceptable and desirable. In doing so they exclude and deny experiences which contradict or simply do not fit with prevailing values in society. Attention to the ways in which images address spectators, then, is one useful way of examining how visual discourses work to reinforce existing values and meanings. I want to look briefly at some of the thinking which has been done around the issue of spectatorship, mainly concerning questions of gender.

## Looking and pleasure

In the sense that feminist criticism is engaged with the politics of interpretation, it has emphasised the importance of cultural forms in shaping definitions of femininity. But, in doing so, it is often charged with failing to account for *why* we enjoy them. After all,

we do not look at pictures, photographs or films solely for their accuracy in representing social reality, we also use them as forms of entertainment and pleasure. How, then, has the issue of pleasure in looking been taken up? One central question which has been explored is whether men and women experience and enjoy looking in the same way. In asking: 'Whose pleasure?' critics have pointed out that many of the pleasures offered by dominant visual culture are connected to the ways in which it addresses a heterosexual *male* spectator. In many films, for example, the viewer's enjoyment comes through identification with a male hero and his capacity to generate actions which propel the narrative. Of course in practice women can and do enjoy such films too but, it is argued, only in so far as they are addressed as if they *were* male spectators. This prompts a number of questions. How is pleasure produced for the male spectator? Can 'ways of seeing' be re-formed to better represent what women want?

Whether it is a man looking at women on the street, the male artist's gaze at the model, or the male audience for a blue movie, women do not share in the culture of looking in the same way. Even when roles are reversed, as for example with the male pin-up, the relationships of power and control are not so easily reversible.[10] This gender difference in who has the power to look and at whom is embedded in cultural forms. As John Berger points out, in the visual tradition of the nude, men have always had privileged access to the sight of the female body:

> In the average European oil painting of the nude the principal protagonist is never painted. He is the spectator in front of the picture and he is presumed to be a man. Everything is addressed to him. Everything must appear to be the result of his being there. It is for him that the figures have assumed their nudity. But he, by definition, is a stranger – with his clothes still on.[11]

This description suggests that the male spectator's enjoyment is not solely erotic. It is also connected to a sense of power and control over the image. The woman's body is posed and framed for him, while his own body remains doubly hidden.

This kind of sexual pleasure in looking without being seen, or voyeurism, is also characteristic of other cultural forms such as cinema or pornography. Feminist critics using psychoanalytic theory have argued that the visual pleasures offered by these forms are closely connected with the ways in which the individual is formed in early infancy. In this view, as we acquire language and enter into the family we are formed as masculine and feminine subjects. In the process of acquiring a separate gender identity our psychic drives are structured in different ways which are linked to our sexuality. Cultural forms reproduce these psychic patterns and in doing so, structure pleasure along gender

lines. From this perspective it is impossible, or at least inadequate, to try and change the content of images without examining how visual texts position spectators as masculine or feminine. Psychoanalytic accounts of visual pleasure have been developed primarily in relation to the study of cinema and have, so far at least, been less central to the analysis of the still image.[12] Here spectatorship has been discussed more often in terms of the social context of the image and its audience. The precise relationship between psychic and social formations has been the subject of some theoretical debate in feminist writing, and is a question which is clearly important.[13] For, if looking is structured at a fundamental psychic level in patriarchal culture how can it be changed? This seems to present a problem for a movement such as feminism which is concerned with social as well as personal transformation. One possible way out might be to investigate how looking, and the psychic mechanisms which structure it, are themselves historically produced. The dominant modes of looking in capitalist and patriarchal culture have been linked to surveillance and control over those perceived as inferior: children, servants, workers and women.[14]. It is possible to point to historical connections between the development of the female nude as a new genre in art and the development of perspective, with its new capacity for ordering, regulating and controlling the visible world. A print by Albrecht Dürer, *Draughtsman Drawing a Nude*, Nuremberg, 1538, makes this connection visible (Figure 2). A partially draped female nude is shown lying on a table facing a man at the other end who is making a perspective drawing of her body through a screen divided into square sections. Svetlana Alpers makes the following point: 'The attitude toward women in this art – towards the central image of the nude in particular – is part and parcel of a commanding attitude taken toward the possession of the world.'[15] This kind of link made between forms

2 Albrecht Dürer, *Draughtsman Drawing a Nude, Underweysing der Messung*, Nuremberg, 1538.

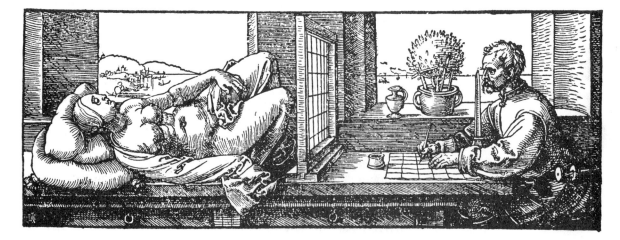

of representation and spectatorship needs further analysis in order to map out the historical shifts in modes of looking.

But if the voyeuristic gaze of the male spectator does not exhaust possible ways of seeing, what other ways might there be? In particular, what kind of power (or powerlessness) do women have in looking? One way in which these questions have been explored has been to look at cultural forms which are addressed to women. Soap operas, women's magazines, romance fiction and film melodrama have all been seen as areas where pleasure is constructed primarily for women. Often, however, these pleasures are contradictory, since they are bound up with the way in which femininity is defined. Thus, for example, while Romance is one way through which female sexual fantasy and imagination are articulated, the inevitable conclusion of the narrative in marriage might be seen as a way of closing off women's desires.

A similar kind of approach to visual images has yet to be developed, but could be very productive. There is no obvious equivalent category of women's pictures or photographs in the same way as there are 'women's films' or 'women's fiction'. Some genres of imagery such as nineteenth-century domestic pictures were produced by, and presumably *for*, women as well as men. But in general we know little about women as buyers and consumers of art, and still less about how women looked at images or what kinds of pleasure they had in them. While there is a vast repertoire of literature and criticism which documents male responses to the visual image, very little by women exists. However, there clearly *are* categories of image which are addressed to women, in particular in advertising, fashion and women's magazines. A useful study by Rachel Bowlby suggests that a new kind of consumer culture which developed with the rise of the department store in the 1890s began to address women specifically as consumers.[16] This new commerce invited women to buy its products by offering them sexually attractive images of themselves. The role of consumer brings out the contradictions for women in the kind of images offered in modern advertising and fashion. While on the one hand these open up the possibility of transforming identity and appearance, of literally putting on a different face and figure, at the same time they channel and limit potential identities by substituting a series of products for a truly different self-image. Women are sold their images in the form of commodities.

But, although such images work hard to include women in their address, they clearly do not close off the possibility of other identities, other pleasures, such as those offered by feminist art, theatre, film and performance. As with all cultural forms, meanings are not fixed, but produced in specific historical and social contexts by 'readers' whose own experiences and knowledge inflect meaning in particular ways. Rosalind Coward suggests in

*Female Desire* that the kinds of pleasure offered to women by a variety of cultural forms are so deeply implicated in the way in which femininity is structured that they cannot easily be given up. But, if the task of feminist criticism is to unpick the threads which bind women and men to certain representations of femininity, can it also enable them to reconstruct and redefine that femininity in different and more positive terms?

## The structure of the book

The articles which follow examine some of the ways in which femininity is represented in visual culture and the kinds of explanations which have been given for this. Together they explore what it means to look at images from a feminist point of view. Although there could be other ways of putting together a collection such as this, my choice of articles is governed by two different, but overlapping, concerns. The first is to try to represent the main theoretical questions and approaches which have informed feminist writing on representation. The second is to focus on the representation of femininity and female sexuality, which has been a central theme in that work. When I began to think about the choice of material, what initially seemed most important was to provide an overview of the kind of issues and debates which have taken place in feminist cultural theory since the early 1970s. From teaching in this area I saw a need to map out those debates and to make the ideas accessible to readers who are unfamiliar with the arguments. While I still think this is important, to some extent that initial impulse has been overtaken by events. New work and different politics have tended to shift some of the terms of the debates on to new ground which, while still indebted to earlier theoretical insights, has opened up fresh issues: about the context as well as 'text' of representations; about women as consumers of images as well as men; about differences in class and ethnicity amongst women which affect the ways in which they are represented. The focus of the book has therefore shifted slightly, and the majority of pieces included here have been written since 1980. To a certain extent then, I have chosen to summarise the developing debates about women and representation in the section introductions, while the pieces themselves represent more recent interests.

The other important criterion governing my selection was that of presenting a body of writing which develops and applies theoretical ideas in the concrete analysis of visual material. While its coherence stems from common ways of thinking about femininity as socially constructed, the actual material under discussion is diverse, ranging from nineteenth-century painting to photographic therapy. All the articles are concerned with the analysis of specific visual media. I hope that in this way, some of

the theoretical complexity and difficult terminology can be made more accessible to readers who are not familiar with the frameworks of marxist, structuralist and psychoanalytic theory from which many of the terms and concepts are derived. While acknowledging the real complexity of the ideas involved, my intention in introducing and selecting material has been to make difficult concepts more available. When in doubt, therefore, I have aimed for accessibility, rather than for theoretical sophistication.

Each of the four sections addresses a specific set of issues and deals with a different body of material. Section One is intended to highlight methods and approaches towards the analysis of visual images which have been developed by feminist critics in the last fifteen years. While it is possible to see continuing concerns in critical writing from the early 1970s to the mid 1980s, there has been a major shift in the theoretical perspectives adopted and the kinds of analysis undertaken and these are taken up in more detail in the Introduction to that section. Most of the actual material discussed in the articles is drawn from advertising. This is both because advertising has been a particular focus of criticism and attack because of the way in which it represents women, and because it has provided a point where the various concerns of film, media and art historical analysis have intersected.

Section Two represents recent concerns in feminist critical work with the historical and contextual analysis of representations of femininity and female sexuality. Each article considers a different area of practice – academic painting, Page Three pin-ups, news and fashion imagery and art photography – but all focus on stereotypes of the 'sexual woman'. The articles explore how feminine sexuality is differently constructed and represented according to prevailing ideologies, and to class and ethnic differences.

Sexuality has become a major and controversial political issue for the women's movement in the 1980s. This is nowhere more evident than in the angry debates about pornography in recent years. Section Three is intended to introduce those debates and to outline various perspectives on pornography within feminism in Britain. While the choice of articles does not represent all points of view, I hope that it is sufficiently wide to provide a sense of what the debates have been about, as well as indicating what is specific to a feminist analysis of pornography.

Section Four raises some of the issues and problems which relate to the representation of the female body and female sexuality by women. Any selection of the work of individual women artists is problematic and my choice of articles was governed by a desire to represent a range of work both in terms of different media practices and of different historical moments. I have therefore chosen pieces on three women artists from earlier

periods as well as on women working in painting, performance, photography and sculpture now. I have not included work which has been extensively discussed and documented elsewhere. Where this is the case, as with the work of Mary Kelly and Judy Chicago, I have referred to it in the Introduction to the section.

While this collection does not claim to be comprehensive, I hope it will begin to map out areas of feminist critical practice which have been developed in relation to the visual image in recent years. It will also, I hope, help to bridge a gap between more advanced theoretical work and the everyday practices of looking at, and making sense of, images of femininity.

## Notes

1 Simone de Beauvoir, *The Second Sex*, London, Penguin, 1972, p. 175.
2 See the Bibliography for further selected reading on women and cinema.
3 For example, the ideas outlined in Elizabeth Cowie's 'Woman as Sign', *m/f*, no. 1, 1978 in relation to film analysis, have been developed by Deborah Cherry and Griselda Pollock in 'Women as Sign in Pre-Raphaelite Literature: A Study of the Representation of Elizabeth Siddall', *Art History*, vol. 7, no. 2, June 1984 and by Desa Philippi in 'Desiring Renoir: Fantasy and Spectacle at the Hayward', *Oxford Art Journal*, vol. 8, no. 2, 1985, pp. 16-20. Annette Kuhn addresses the issue of contextual analysis in feminist film criticism in her book *The Power of the Image*, London, Routledge & Kegan Paul, 1985.
4 Terence Maloon, 'Interview with Mary Kelly', *Artscribe*, no. 13, 1979, p. 18.
5 Ann Oakley discusses anthropological research on the relationship between sex and gender in different cultures in her book *Sex, Gender and Society*, London, Temple Smith, 1972, especially ch. 2. Margaret Mead's work *Sex and Temperament in Three Primitive Societies*, William Morrow, 1935, makes a particularly interesting comparison between masculine and feminine roles in different societies.
6 Rosalind Coward, *Female Desire*, London, Paladin Books, 1984, pp. 80-81.
7 Lynda Nead, 'Representation, Sexuality and the Female Nude', *Art History*, vol. 6, no. 2, June 1983, p. 230.
8 Michel Foucault, *The History of Sexuality*, vol. I, *An Introduction*, London, Allen Lane, 1979.
9 Chinyelu Onwurah, 'Sexist, racist and above all, capitalist', *The Guardian*, 3 September 1985.
10 For a discussion of female spectatorship and the male pin-up see Richard Dyer, 'Don't Look Now: the Male Pin-up', *Screen*, vol. 23, nos 2-3, September-October 1982.
11 John Berger, *Ways of Seeing*, London, British Broadcasting Corporation and Penguin Books, 1972, p. 54.
12 Laura Mulvey, 'Visual Pleasure and Narrative Cinema', *Screen*, vol. 16, no. 3, 1975 was influential in developing an analysis of spectatorship and sexual difference in cinema, and she has addressed similar issues in relation to painting in 'You don't know what is happening do you, Mr Jones?', *Spare Rib*, no. 8, 1973, pp. 13-16, 30. The significance of psychoanalytic theory for feminist film criticism is discussed by Annette Kuhn in *Women's Pictures*, London, Routledge & Kegan Paul, 1982, ch. 3 and by E. Ann Kaplan in *Women and Film*, New York and London. Methuen, 1983, ch. 1.
13 See Michèle Barrett, *Women's Oppression Today*, London, Verso, 1980, pp. 84-99 and Rosalind Coward, 'Socialism, Feminism and Socialist

Feminism' in *Gay Left*, no. 10, 1980. Also the letter by both authors and the Editors' response in *m/f*, no. 7, 1982, pp. 87-91.

14 See Michel Foucault, *Discipline and Punish: The Birth of the Prison*, Harmondsworth, Penguin, 1977, especially pp. 170-77.

15 Svetlana Alpers, 'Art History and Its Exclusions' in Norma Broude and Mary D. Garrard (eds), *Feminism and Art History*, New York, Harper & Row, 1982, p. 187.

16 Rachel Bowlby, *Just Looking*, New York and London, Methuen, 1985.

# SECTION ONE

# Advertising femininity:
## theoretical perspectives

Witty. Confident. Devastatingly Feminine. Chanel No. 19. The Outspoken Chanel. (Chanel 1984)

Once she knows the facts of life, you should plan her marriage. (Cheltenham and Gloucester Building Society 1974)

Some day you'll settle down with a nice, sensible girl, a nice, sensible house and a nice, sensible family saloon. Some day. (MG Sports cars 1979)

If you'd like your wife to act more like a mistress, start treating her like one. (De Beers diamonds 1980)

Is looking younger only wishful thinking? (Oil of Ulay 1986)

In post-war capitalist culture advertising is a form of communication in which we all have a share, whether we choose to or not. Its imagery, slogans and narratives are exchanged like jokes, and have the same cultural invasiveness. As a system it is universally visible and yet is given little cultural value or significance. In spite, therefore, of its enormous economic and ideological importance, advertising is commonly dismissed as meaningless, or simply untrue. It is this assumption which feminists have contested, arguing that advertising, in the way that it deploys images of women, constructs and reaffirms stereotyped and limiting views of women's lives and capabilities. It has thus become a major target of criticism for women's campaigns. But, while all feminists might agree on their opposition to stereotyped, offensive and degrading representations of women, there is less agreement on exactly *how* such representations work, and therefore, on what to do about them. I want to review these differences briefly, not only because they form a debate which is taken up by a number of the writers included in this section, but also because they relate directly to questions of what kind of

strategy and action can be adopted to change representations.

The argument that women should be better represented in media imagery has been taken up in campaigns by groups and institutions in Britain as diverse as Women's Media Action, the Equal Opportunities Commission, the Trades Union Congress and the Greater London Council.[1] While these groups differ in their political perspectives and institutional power, they broadly share a common analysis of the problem. This is seen as one of changing advertising to reflect women's changed roles in modern society more accurately. The problem is defined as one of *mis*representation and the solution, to reform the content of advertising. The strength of this position is that it articulates very clearly what women object to about certain kinds of image and makes concrete demands for change. It is probably true to say that this view represented a widespread and 'commonsense' position in the women's movement from its beginning. The connections between sexist stereotyping and women's subordination seemed self-evident. Remove or change offending imagery in the media and, it was argued, women could be shown *as they really are*. In practice this meant demanding that women should be presented in more realistic and more positive roles than were offered by the usual dichotomy of housewife or whore. Popular media helped to disseminate and reinforce mythical views of woman as either supermum or sex-kitten, which underpinned sexist assumptions that women's place was really in the kitchen or in bed. Feminists challenged the media to recognise that women's experience was far more varied, complex and contradictory in real life. By showing how real women lived, it was argued, the conditions of women's oppression could be made visible. The assumption that underlies this argument is that if women are represented more realistically in the media, this will be better for women. But is this the case? If women are shown in more realistic ways does that necessarily mean a feminist transformation of imagery?

In fact in some respects advertisers have recognised women's changing roles over the last decade, although this has been prompted more by commercial interests in developing new and potentially profitable markets than by any feminist concerns. Thus, for example, if one glances through a current women's magazine, one may find adverts which show women actively involved in sport, using new technology or opening building society accounts. The problem is that although these images do show women in more varied *activities* than before, they rarely break with traditional *definitions* of femininity, nor do they alter fundamental inequalities in gender construction. Women may take on 'masculine' roles but they still have to be shown as attractive and desirable. And, when advertisers began to use the image of the 'liberated woman' in the late 1970s they did so in

forms which recuperated any radical implications which the notion might have. Often this was done through the way in which the viewer was addressed so that while the *content* of the image may have changed, the invitation was still to see women in traditional terms: 'Underneath they are all Loveable'. In this way adverts could both play with, and subvert, genuine notions of liberation.[2] So, while it is clear that the advertiser's view of women is still very limited, to demand more realistic representations of women *per se* begs a number of questions. How and why do images acquire meaning? How do they work? If images consistently *mis*represent what women are like, how can they be generally accepted as making 'sense'? As Judith Williamson has argued:

> Advertisements will always escape any criticism of them which bases its argument on their deceitfulness or even their harm in being 'capitalist', 'sexist' etc. Not that these criticisms are invalid: but they bypass the ideology of the *way* in which ads work.[3]

The articles selected for this section represent some of the kinds of investigation which have been made of the ways in which advertisements, and other images, work to construct particular views of femininity. Although they differ in particular respects, the writers share a common perspective which argues that simply to attack advertising imagery as misrepresentative and sexist does not adequately explain its power to shape our perceptions of social reality. They argue that the advertisers' view and the kind of criticisms made above are based on a similar conceptual model in which adverts are seen to reflect – or to distort – social reality. Against this, the authors propose that we need to understand what part advertising plays in actually defining femininity; why certain images should be taken to be more 'real' than others, and how we, as viewers, are caught up in the process of representation. This perspective could be summarised as one which pays greater attention to the ways in which images construct meaning, as well as an individual subject who is addressed by them. What is at issue is not only a different understanding of how representations work, but a different strategy for challenging them.

In the latter half of the 1970s cultural producers and critics working in diverse fields of film-making and theory, photography and media studies, fine art and art history, began to develop these new ideas with which to discuss the representation of women. They drew on theoretical frameworks which had largely been developed outside feminism, in Barthes' writings on the semiotics of the image, in Althusser's theory of ideology and in Freudian theories of the subject. The pieces by Griselda Pollock, Judith Williamson and Rosalind Coward show how crucial these ideas were in developing a new feminist perspective at this time.

Griselda Pollock argues that it is impossible to separate images from social reality. Rather than comparing unreal images with real women we should look at how such representations work to categorise and reproduce certain definitions of the feminine by, for example, comparing them with the way in which men are represented.

In a similar way, Janice Winship demonstrates that the representation of male and female hands in ads defines and differentiates the social power and place of men and women. The meaning does not derive from what men's and women's hands are actually like, but from the way these can be made to signify gender differences. Representations of women in ads therefore work to produce, or at least to reinforce, social meanings about appropriate gender roles. These already exist at the level of commonsense assumptions and knowledge but are articulated in specific ways by the image: men are world leaders; women are homemakers. Like Pollock and Winship, Rosalind Coward argues that we cannot separate the representation of women in cultural images from the social construction of gender and sexual difference. Advertisements, in the way that they fragment and sexualise parts of the female body, produce new definitions of female sexuality which have a reality and effectivity of their own. It is impossible, however much we might want to, to 'step outside' the world of representation.

From this point of view it is important to understand how and why representations come to have social currency and meaning, to appear to be 'real'. For example, advertising consistently represents the household which consumes everything from baked beans to package holidays in terms of the nuclear family: father, dependent wife, and child of either sex. Although we may 'know' that such families only represent 5 per cent of all households in Britain, nevertheless the image defines what many people think of as 'real' family life. It can do so, because such images draw upon and re-present already familiar values and attitudes which appear to be true. In a similar way, images of glamorous women or perfect mothers may not correspond to the experience of most women, but they do define femininity in ways which are perceived as actually existing. Femininity or family life as represented in advertisements, then, are not 'false' images but neither do they correspond to a pre-existing social reality. Judith Williamson explains this process by which advertisements construct meanings which then appear to be naturally 'given'. They do so, she suggests, by linking products to images, values and beliefs which already have social currency. Thus, in two different perfume ads the connections made between the particular brands and two famous actresses are totally arbitrary. But the ad naturalises the link by associating the two perfumes with different feminine styles. The two ads therefore differentiate the perfumes through

the way in which each is made to signify a different 'brand' of femininity. The explanation may be lengthy, but our reading of the image is instantaneous.

It is because these are familiar ideas that adverts can also address us as individual subjects. They speak to a 'you' who recognises what is being said, even though 'we' may consciously reject it. Furthermore, the 'you' is almost always gendered, we are addressed either as masculine *or* feminine, as the captions quoted above make clear. Advertising, then, does not simply create 'images of women', it constructs differences *between* men and women, and then addresses the viewer as though these *were* real. Some writers have taken this further to argue, as Coward does here, that cultural texts place or 'inscribe' their readers in particular ways. In other words, the structure of the advertisement determines how it will be read. But, while advertisements clearly try to construct a particular subject position for the spectator, this is not necessarily taken up in the way which is intended. Winship argues that we have to understand how meanings of ads are produced in specific social contexts by actual readers and viewers. So, for example, an advertising image which shows a man's hand on a woman's stockinged thigh depends upon social knowledge of class and sexual difference for its 'sense'. As social readers of different gender, class or race, we may, however, choose to reject or negotiate the implied meaning and see it quite differently – as sexual harassment, for instance. This ability to read across the intended meaning of an image suggests that, although the advertisement works to place us as ideal subjects, we may misunderstand or deliberately reject these 'subject positions'. According to this argument, meaning depends upon the kind of knowledge and expectations which the viewer brings *to* the image as well as on the context in which it is seen. And, because meaning is socially produced, it also changes historically. As Kathy Myers points out, the media is constantly creating new images and meanings which are difficult to 'fix' and to classify. Her analysis of the shifting visual codes of fashion, pornography, and erotic photography show how impossible it is to pin down the meaning of female sexuality in any single way. The image systems of fashion and pornography interact but construct different meanings and pleasures for their diverse audiences. These meanings are not arbitrary, but are determined by the specific demands of the market, of producers and of consumers. She argues that we need to look at *why* particular visual codes are adopted, at their economic and cultural rationales, as well as *how* they work to define femininity. Put another way, we need to develop a political economy of representation which would explain how images function to reproduce gender inequality in the social and economic spheres.

Any attempt to produce alternative imagery has to recognise

the way in which images are embedded in existing ideologies. But, this need not preclude any possibilities of challenging or changing meaning, simply that we have to be aware of the power of ideology to reframe and recuperate the potentially radical and oppositional in its own image. The purpose of the kind of critical work included here is to lay bare the processes through which representations define femininity and, by exposing such definitions as ideologically produced, to enable critical readings to be made. The importance of a theoretical understanding of how representation works to construct meaning is that it enables us to grasp, and to intervene, in the process by which femininity is defined. The question of how we intervene to change representation is a crucial, if problematic one and it is clearly important to make connections between theoretical analysis of how representation works and the political issue of challenging it. The problem for the 1980s is how an increasingly complex theory of representation can serve feminist demands for political, cultural and social change.

## Notes

1 See the Equal Opportunities Commission, *Adman and Eve*, Manchester, Equal Opportunities Commission, 1982, and the Trades Union Congress, *Images of Inequality*, London, Trades Union Congress, 1984. The Women's Media Action Group produces a regular bi-monthly bulletin and publishes the Women's Monitoring Network reports on specific issues each year. Both are available from A Woman's Place, Hungerford House, Victoria Embankment, London WC2. The Greater London Council Women's Committee campaigned to change London Transport's Conditions Governing Acceptance of Advertisements to ban sexist advertising in 1984.
2 For further discussion of the ways in which advertising has responded to women's liberation see Rosalind Coward, 'Underneath We're Angry', *Time Out*, no. 567, 12 Feb-1 March 1981, pp. 5-7. An analysis of the changing representation of women in film is made by Charlotte Brunsdon, 'A Subject for the Seventies', *Screen*, vol. 23, nos 3-4, Sept/Oct 1982, pp. 20-29.
3 Judith Williamson, *Decoding Advertisements*, London, Marion Boyars, 1978, p. 175.

Janice Winship

# Handling sex

Attention to women's and men's hands in ads may not seem *the* most burning issue to be tackled on the question of representations of femininity and masculinity in ads. Yet it is not just feminist nit-picking. As Erving Goffman has commented in his glossy book *Gender Advertisements*, gender is 'something that can be conveyed *fleetingly* in any social situation'.[1] If only a brief *time* suffices to communicate gender to us, similarly only a small part of our anatomy need be represented in that communication. A representation of a hand, or even only a part of one, will then do quite as well to signify cultural aspects of gender as a full-length portrayal. That this is so is sure evidence of the pervasiveness and depth to which gender construction penetrates.

However, there are other reasons why I have chosen the representation of hands to focus this discussion of gender difference and its construction in forms which, I argue, are oppressive to women. Firstly, there is a partly empirical consideration. In ads women are frequently represented in a 'fragmented' way, or as Trevor Millum describes, photographically 'cropped'.[2] Women are signified by their lips, legs, hair, eyes or hands, which stand, metonymically – the bit for the whole – for, in this case, the 'sexual' woman.[3] Men, on the other hand, are less often 'dismembered' and the only bit of them which is represented with any frequency seems to be the hand. Since women's hands also appear in ads this allows us to make a limited but fine analysis which begins to compare the representations of femininity with those of masculinity by beginning from a similar point. The *difference* of the meanings conveyed by a gendered hand, which the analysis then goes on to demonstrate, is only highlighted by this formally equivalent beginning. In the ad context we find that a woman's hand can never be substituted for a man's, nor a man's for a woman's: the gender difference the hand stands for is always crucial to the meaning of the ad.

This singular focus on hands also has a further pedagogic benefit in so far as it allows us to argue a particular theoretical position more clearly. Briefly, that position holds that ads as a discourse do have their own 'specificity' but that the order of that specificity must be pinned down. Simultaneously we must also conceptualize them in their 'external' relations, especially in their relation to the social reader and to other discourses. Behind this formulation is the political concern posed by the title, 'Handling sex'. *Who* is handling? The ad makers certainly, but we as readers

This is a shortened version of an article which appeared in *Media, Culture and Society*, vol. 3, no. 1, January 1981.

of the ad also 'handle' what we understand there. A feminist politics of representation with respect to ads has, then, to engage with the social reader, as well as the social text.

... To return now to the choice of hands, this focus allows us to illustrate that, clearly, one of the ideological fields these ads are working within is that of femininity and masculinity; that femininity and masculinity can be constructed by means quite specific to ads – the hand – but also alongside other means; that femininity and masculinity are constructed with particular ideological inflections, and nearly always have a class specificity; that the hand can be used as a visual mode of address which is also verbally repeated. In what follows it is these aspects which I examine in a selection of ads, paying particular attention to how ads mean differently for women and men reading them.

## 1 Naturally: 'men of the world' and 'women at home'

In most ads where we see a hand there is no doubt about it: it just *has* to be a woman's or a man's hand which we see there: the other sex would not do. It is not, however, the intrinsic qualities of each hand which makes that so. Rather it is the tightly organized production of the *whole* representation in the ad – of which the hand is only a part – which constructs a gender difference from which the hand accrues, as well as contributes, meaning. If we were merely to change the hands in the next two ads so that a woman's hand (signified by, say, painted nails and a gold bracelet) was offering that packet of cigarettes, and a man's hand (signified by, say, shirt cuff and jacket) was pouring that custard there would be a disruption of meanings. 'Hand' and text would rudely jar, signifying contradictorily: a woman's hand does not signify 'world leader'; a man's hand does not signify 'home-made'. But as it is, the appropriately gendered hand allows us to key into familiar ideologies of masculinity and femininity. Those ideologies seem 'naturally' masculine or feminine, and the represented hand is 'naturally' a man's *or* a woman's.

### Rothman's cigarettes (Figure 3)
At one level the background of deep blue, *royal* blue (royal confirmed by the royal insignia and 'By special appointment') only repeats the blue band across the packet. Yet at another it signifies, as we know from other texts outside the ad, the universe, the span of the sky, or the world's seas. That meaning is corroborated by the globe represented by (some of) the constituent flags (what imperialism is perpetrated here with Britain's union jack at the centre of the world, which the packet too occupies?); and by the assignation 'world leader'. This label is linked to 'Filter tipped' on the packet: both are against a red

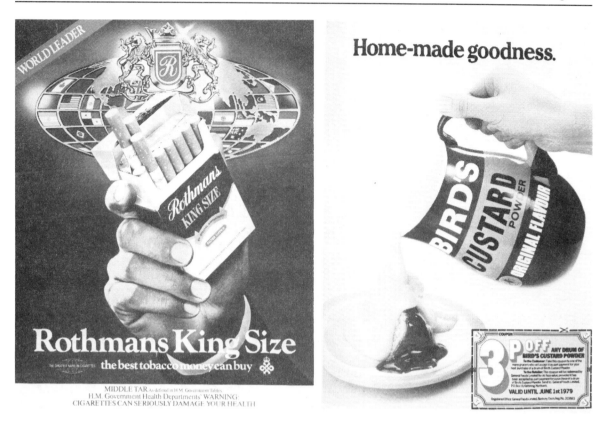

Rothmans King Size
the best tobacco money can buy

MIDDLE TAR As defined in H.M. Government Tables
H.M. Government Health Departments' WARNING:
CIGARETTES CAN SERIOUSLY DAMAGE YOUR HEALTH

Home-made goodness.

3 Rothman's cigarettes advertisement, *The Observer*, 28 September 1980.

4 Bird's custard advertisement, *Women's Weekly*, 24 March 1979.

background, both cut diagonally across the page. The cigarette is visually confirmed by this exchange of meaning, which we make, as the 'world leader', as 'King Size' in status as well as size. At the same time the male hand, marked as male by what seems the customary middle-class code in ads – the white shirt cuff, and accompanying jacket sleeve (here dark blue, with conveniently superimposed insignia), the well manicured and unblemished hand – partakes of that leadership. These are all the signs that *he* is a leader, the 'officered (naval?) gentleman'. Cigarettes and man add stature to each other.

But to whom is this packet of gourmet or snobbish fare proffered? The 'world', which includes 'you': 'the best tobacco money can buy'; the best tobacco *your* money can buy. But who is 'you'? Men. For the claims of a *masculine* leadership, over which hand and packet egg each other on in complicit and seemingly natural agreement, allows men a point of participation in the signification of the ad – via hand or packet. If that 'you' is a woman we can only submit to this dominating hand offering us a cigarette, and capitulate to the meaning of the ad *from which we are excluded*, even if we buy the cigarettes. How can we enter 'world leadership'?

Bird's custard (Figure 4)

If we were to replace the woman's hand here by a man's, we would no longer have 'Home-made goodness' as an appropriate caption. It might as a chef's hand signify a 'culinary delight', but then jam sponge would have been transformed from its 'homely' associations. This woman's hand (as woman herself) is synonymous with home; the meaning emerges 'naturally', something we recognize from what we know outside ads. But how do we know that *inside* the ad? Note what the hand looks like: *un*varnished nails, no indication of elegant long fingers which are the usual signs for that other non-homely femininity, the signification for 'beauty' or 'sex', and which definitively mark the hand as different from a man's. Here that difference is less visually established by the hand than by other visual and verbal cues in the ad. 'Home-made goodness' is conjured up not only by the 'plain' hand but by the unadorned plate, the old-fashioned, English pudding and custard itself. There is an implicit appeal to tradition, to the idealized value of femininity as 'home-making' which cuts across any class specificity: the absence of any background detail which would place the hand in class terms aids this signification. But see not only how easily and effortlessly that tradition is kept alive, but the *narrowness* of what it includes: *just* pour a jug of Bird's custard (as world leadership in the Rothman's ad *just* needed a packet of cigarettes). Modes of femininity and masculinity are achievable, then, through consumption.

If we delve a little deeper into the ad's rhetoric, as Alvarado puts it, to make an analysis which 'releases that frozen moment' of the representation, we might want to ask: who made the jam sponge and custard?[4] And who is going to eat this homely fare? Who is she serving? There are three sorts of answer here. One concerns who produced the *commodity*, Bird's custard. The second is concerned with who made the pudding, or the mock-up, for the purposes of the photograph. The third is the narrative the ad fictionally traps into this moment of representation, as if it were the 'natural' narrative, so 'natural' that we don't even have to think about it. The answers are sewn up. Obviously, she who owns the hand, a 'mum', a 'wife', has made the pudding and custard: Obviously 'he' or 'they' – children and/or husband – are going to eat it. Home-making is, unremittingly, for others. There she is preparing something which she is unlikely to eat herself: jam sponge at 250 calories a portion, uncompromisingly on all those diet lists of taboo foods. What woman dare eat that without feelings of self-damnation? This is truly men's and children's fare.

Reading this ad we are not verbally addressed as 'you'. Yet visually we are placed so that the hand which pours this custard could be ours: it is *our* body, if we are women, which completes the person off page. This is a frequent and useful artifice for ads,

a means of visually addressing us as powerful as the verbal exhortations to 'you'. We are inevitably caught up in this 'natural' association of the feminine hand and homemade goodness – for the family. To reject that on any grounds other than feminism, that is, to wrench apart some of this 'natural meaning', we are thrown into '*not* goodness'. What guilt to bear! Meanwhile, men enjoy the pudding, their masculinity unthreatened. Representationally their dominance is signified in their absence: they are being served.

## 2 Beauty and the boss

We have seen then, that these two hands, a man's and a woman's, signify seemingly natural and unquestionably the 'worldly' and the 'homely', masculinity and femininity.

However, there are other gendered qualities called into place by ads. John Berger's pithy statement on the subject of gender representations that 'Men act and women appear', has awesome applicability.

### (a) Men at work . . .

Scotcade shirts (Figure 5)
On the question of how masculinity is represented differently from femininity there is one simple point to make here. 'Man the (middle-class) worker' is signified both by what his hand is doing *and* by his appearance – the creaseless shirt and business tie. We can just about imagine that women's blouses might be advertised with this same caption which, by emptying our usual understanding of 'white, blue collar workers' to which the ad refers, and refilling with a 'commodity' meaning, trivializes that original understanding while *appearing* to extend it – 'cream collar workers' too. Workers are now differentiated by what they consume rather than by their place in the social division of labour. Judith Williamson considers this aspect of ads in some detail.[5] We can even imagine that a woman could be shown doing the same activities; they are not particularly masculine tasks. But what is extremely unlikely is this mutual support between 'doing' and 'appearance'. Either the whole stress would be on the woman's *looks* in the blouse (and the ad might show her face, or emphasize her sexuality by her bosom or even her hand) and/or there would be some dis-juncture between what she was doing and how, and for whom, she is looking. Men's sexuality is not in play in this ad; if the 'worker' were a woman it undoubtedly would be.

George Butler's cutlery (Figure 6)
Generally, unless it is domestic, the representation of women's activity with their hands is rather less purposeful than the

5 Scotcade shirts advertisement,
*The Observer*, 21 September 1980.

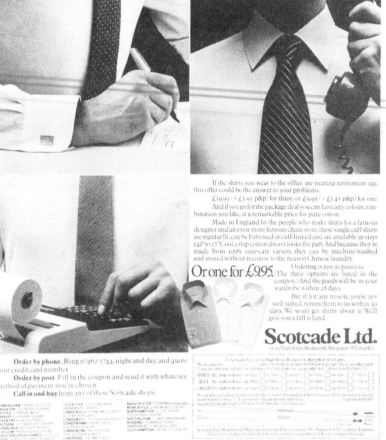

representation of men's activity above. As Goffman has noted,
'women more than men are pictured using their hands to trace
the outlines of an object or to cradle it or to caress its surface.'[6]
The woman's elegant long fingers, nails perfectly shaped and
varnished, gently holds this knife in precisely that way. There is a
complementarity between hand and knife at the level of
appearance: the softness of her hand, the sheen of her polished
nails, the hand as the embodiment of feminine beauty carries over
to the knife which also sparkles. We are to admire the cutlery as
we would admire her hand.

But *her* hand contrasts with the hand which is *not* visually there,
the absent hand which has painstakingly fashioned this knife, the
hand which wields the experience: the hand of the crafts*man*. She
achieves perfection in her manicure; he strives for 'Perfection in

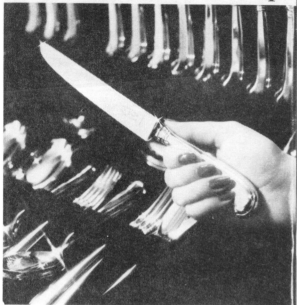

# It takes 300 years to make silver-plated cutlery as good as ours. And experience never comes cheap.

Perfection in cutlery, as in all things, is born from experience.

We've been making cutlery in Sheffield since 1681. Generations of craftsmen have enabled us to develop fine skills, which are wasted on anything but the best materials. With the result that our cutlery, although being outstanding in quality also carries a high price.

From the start our cutlery is destined to become costly, because we use genuine 18% nickel silver as our base metal. Which is far more expensive than the stainless steel, mild steel or alloys containing only a trace of nickel used on cheaper cutlery. That difference means ours can be marked EPNS, electro-plated nickel silver, like all the best silver plate.

We then take this valuable base metal and carefully fashion it into cutlery, using the skills and knowledge we've built up over the last three centuries. We carefully polish and buff and repolish each piece individually by hand, never mass producing anything.

We take an incredible amount of trouble over a knife blade too. We refuse to touch inferior mass produced blades, preferring to forge each one individually from a small bar of steel, which passes through over 50 different grinding, glazing and polishing operations.

You can see the difference that makes by the way each of our blades thins evenly down from the back to the cutting edge and tapers from the handle to the point.

Then we put a far heavier deposit of pure silver on each knife, fork and spoon. 20 microns compared with the 5 microns or less you'll find on cheaper cutlery. Which means that rather than getting scuffed and scratched, revealing the base metal underneath, Butler cutlery gradually mellows over the years to give the traditional bloom of fine silverware.

With Butler cutlery you're paying for craftsmanship, quality and 300 years' experience. Expensive ingredients which together make some of the best cutlery you ever could buy.

Send for details of our styles of top quality cutlery and the address of your nearest stockist.

**BUTLER CUTLERY**
*Craftsmen since 1681*

6 George Butler's cutlery advertisement, *The Observer*, 23 September 1979.

cutlery' which 'as in all things, is born from experience': 'We've been making cutlery in Sheffield since 1681.' 'She' is associated with consumption; 'he' is associated with production, albeit in an artisan (though of course it's a capitalist) mode, which adds the personal touch – like the touch of her hand which appreciates the knife.

At the verbal level, while the address is clearly to those with 'taste' and money – a middle-class appeal – it is non-gendered. Unlike the Bird's ad the hand is posed awkwardly so that it could not be ours: it is on display with the knife which it cradles, in a covert form of the way that women are most often displayed to men, but also the way women see themselves. Berger again:

> Men look at women. Women watch themselves being looked at. This determines not only most relations between men and women but also the relation of women to themselves. The surveyor of woman in herself is male: the surveyed female. Thus she turns herself into an object – and most particularly an object of vision: a sight.[7]

The sight is, then, for a male viewer even if it is women who pay most attention to the ad. I'll return to this 'double position' for women as it occurs in representation, in the Elbeo ad below.

**Who said slow motion replays were just for 'Match of the Day'?**

**JVC 3660 - the first colour home video recorder with slow motion and freeze frame.**

And you thought video recorders were just for copying TV programmes. Now there's one that can actually improve them. The new JVC 3660, from the company that invented the VHS system.

**Slow, slow...** With its unique remote control the JVC 3660 allows you more video freedom than ever before. The adjustable slow-motion playback provides action replays at the speed you want, any time you want. You don't have to wait for TV companies to say when.

**Quick, quick...** But there's more to the JVC 3660 than slow motion. If you're looking for where the action is you can run through your compatible VHS cassette at double speed and still hear what's going on. Just press the right button on the remote control unit.

**Stop.** You can freeze the action at any time with the 'pause'. (It even comes in handy during recording when you want to edit out the commercial breaks).

All you need now is a canvas chair with 'Director' on it.

Of course, we haven't forgotten the other features that make JVC the leading name in video. You can set the new JVC 3660 to record programmes up to 8 days ahead. There's even a serial timer that will switch itself on and off at the same time every day to catch your favourite daily programme.

Why not try armchair video for yourself at your JVC stockist. We're certain you'll give it a sitting ovation.

**JVC** ANOTHER STEP CLOSER TO REALITY

**VHS** PAL

The unique JVC 3660 remote control – for armchair video.

*SIMULATED PICTURE*

---

**(b) ... and men at play**

7 JVC video advertisement, *The Observer*, 4 November 1979.

JVC video (Figure 7)
As readers of the ad we are clearly put in the position of the viewer of the TV screen; moreover that position is occupied by a man whose hand we see controlling the screen. *If* we are men that could be our hand. The hand is marked as masculine both by its *lack* of feminine marks – no varnished nails – the caption – 'Who said slow motion replays were just for "Match of the Day"?' – and the TV image – the fanciful strip 'girls'. As if an appeal to the most popular TV programme for men were not enough, adding insult to injury, the ad relies on that other 'spectator sport', peculiarly masculine in style, that of 'bird' watching. I use this sexist term only because the 'Simulated picture' indicates too well the calculating construction of the ad: not just any old picture from the telly, but one showing women who are decoratively attired *like* extravagant birds. They are caught at some moment in

32

a striptease act posing with what Goffman has neatly described as 'the bashful knee bend'.[8] However his interpretation of this as representing 'a foregoing of full effort ... the position adds a moment to any effort', and his assertion that because women are seen supporting each other in this pose the question of gender relations does not arise, seems not to be quite the point. The gesture is surely one of submission in which the woman is pausing to gaze or to be gazed at – by men. And it is this representation of women which the male hand is seen to control; at the press of a button 'you' (he) can stop and start, obliterate or bring into gaze the strip act, like the director of a film. As the ad says, 'All you need now is a canvas chair with "Director" on it.' What is being advertised is the video and the control of the image which it provides, but what seems to be at stake is a control of women's sexuality: women as fare for men's play. Further, in a reversal which gives them no power or status at all, *women work* on the screen, while men play – with them.

### Sony stereo cassette player (Figure 8)

When a woman's hand appears in what is formally a similar mode – at the controls of a cassette player – its place and meaning bear no comparison with the controlling hand of masculinity. The limp-wristed way she holds her hand, finger delicately resting on a switch, hardly suggests she is actively working the equipment. As in the Butler cutlery ad, this elegantly attired, black-gloved hand, with ring and silver bracelets, complements and repeats the metallic tones of the cassette player. The hand and the hi-fi are interchangeable; not only through their colours, but also their size and, importantly, what they are meant to stand for. The cassette player is called 'Stowaway': it is tiny; so are women's hands (well, so the stereotypes say). But this gloved hand is also classy, daring, demonstrating style; so is the cassette player. If the hand signifies the ultimate in the 'lady of leisure', a female dilettante who has money and more to spend (or be spent on her), so too the cassette player is in a class of its own: 'Sony's little masterpiece'.

The ad primarily addresses men – hi-fi freaks – who may 'want to know about its performance in Hz, SPL, and watts per channel . . .'. They are urged, 'To see how small it is put your hand over the picture.' 'Your' (his) hand is then caught up in that of the dazzling lady; the electric touch only affirms the effect of Sony's technical achievement: 'to dazzle your ears'. Obviously it would not have been appropriate to encourage two male hands to touch: how could that signify 'dazzlement'?

Finally note the differences between Sony and their 'brilliant technical achievement' (*Who* are Sony? *Whose* achievement is it?), and the woman's hand; production and consumption; masculinity and femininity.

8 Sony stereo cassette player advertisement, *The Observer*, 22 June 1980.

The way Sony have drawn hi-fi stereo sound from their new pocket sized Stowaway is a brilliant technical achievement.

Even Sony think they've done quite well.

This is Sony's new Stowaway, actual size. To see how small it is put your hand over the picture.

Tiny, isn't it? Yet it plays standard music cassettes and rates as a serious piece of hi-fi equipment.

If you really want to know about its performance in Hz, SPL and watts per channel ask your Sony dealer or any of the staff at Sony's show-rooms, 134 Regent Street, London.

In layman's terms, though, Stowaway's sound is technicolour stereo to dazzle your ears.

Since it is the world's smallest cassette player it comes as no surprise to learn it is equipped with a set of the world's smallest, lightest hi-fi headphones.

They can pick up the tiniest tinkle of a triangle, or rasp the inside of your brain with the deepest bass of a synthesiser. You can plug in a second set of 'phones should you ever want to share your favourite music with a favourite friend.

Sony's little masterpiece runs off batteries, so you can tuck it in a pocket to play your own choice of music on the train, the plane or in a hotel room far from home. Or you can buy an adaptor to run it off the mains.

Listen to Stowaway for yourself. You won't believe it till you hear it, and even then you may find it difficult. **SONY.**

**The world's smallest stereo cassette player.**

Elbeo tights (Figure 9)

Here gender difference is organized explicitly around sexuality: blatantly a man's hand 'touches her up', but in a class mode which would refuse that idiom. Visually all is there for us to guess; verbally, like middle-class manners, double-talk is the key note. If a hand can be used in representation so that we are placed as the owner of it, off the page, it can also pose the riddle of what exactly is happening to the owner of the hand off the page. And when it is a man's hand resting on a woman's leg, the answer is clear: sex, however harmless. Yet the caption belies such a sexual appeal: 'Your appreciation of the finer things in life has always impressed me, Sir Giles.' With what are fast becoming tedious

Supersheer 15 Denier Nymphe by Elbeo fashion tights
that are more than a shade superior. **ELBEO**

9 Elbeo tights advertisement,
*Honey*, August/September 1980.

middle-class significations for masculinity – white shirt cuff, etc.
– *plus* large dress ring, which definitely ups the class position, this
'gentleman', Sir Giles, could not be concerned with anything so
brash as sex, but rather with 'the finer things in life'. What are
they? Outside the context of the ad we might guess: good wine,
antiques, tailor-made suits, caviar and truffles, those accoutre-
ments of a certain class position which his hand, the finely
upholstered sofa, are signs for in the ad. (Note how the
background here is important whereas it was purposely obliter-
ated in the Bird's ad.) The scene conforms to what Goffman
refers to as 'commercial realism' in relation to which 'the viewer
is to engage knowingly in a kind of make-believe, treating the
depicted world as if it were real-life but of course not actually
real'.[9] But for the ad the apotheosis of 'fineness' is, of course,
Elbeo tights which drain 'fineness' from the classy environment –
'. . . are more than a shade superior'.

If the man's hand signifies class, the bit of woman which is
represented primarily signifies sexuality, and would do so, *even* if
the man's hand were not there. A focus on legs, like a focus on
the lips, bottom, or breasts of a woman, always signifies sexuality.
Yet the gold chain round her ankle and mini (*c.* 1980), black,
broderie anglaise dress, support a sexual signification. There is
also something classy about her representation too: the stylishness
of black patent court shoes, gold chain and black dress. Indeed, a
'fine' sexuality which carries over to the 'Supersheer 15 Denier
"Nymphe" ' tights, which, in turn, themselves deliver that
fineness to whoever wears them. The sexual loading behind the
term 'fine' is not only carried in the name of the tights – Nymphe
– what kind of femininity does that suggest – but also in the
placing of his hand: literally it is his appreciation of the tights
which is being referred to. But really?

Since it is in a woman's magazine, and since it is an ad for
tights, it is women who read this ad. A woman appears to have
the speaking voice. But what she speaks of is only to be impressed
that *he* appreciates, what *she* appreciates; and the latter is only
what he has set up in the first place. She speaks to accept a male
possession – the hand on her knee: the 'man's eye view' of her
legs.

## Gender (dis)placement

The next two ads are similar in so far as they show a woman and
a man, respectively, in the 'wrong place'. In the Veuve du Vernay
ad a woman has invaded what is visually purported to be the male
terrain of a commuter train. In the Carling ad a man has been
and gone from what is verbally assumed to be a woman's place –
around the kitchen sink. These displacements serve, however, not
to be innovative, only to reinforce particular ideologies of

masculinity and femininity. Moreover the *form* of each ad – different in each case – heightens the separation between femininity and masculinity which is being constructed.

### Veuve du Vernay (Figure 10)

While the Elbeo ad corresponds to what Goffman describes as 'commercial realism', this ad uses a kind of montage technique: the incongruous chain of colour composed of the curiously emerging man's hand pouring the drink, and the woman's ridiculously placed arm and leg, seem to be superimposed against the background of drab grey and white businessmen. This achieves two effects: one of playing up a 'naughty' fantasy element, and perhaps of generating humour (funny for whom though?); the other of differentiating that brazen couple from the boring and repeated motif of the city gents.

Clearly the 'chain of colour' signifies excitement and sex. In the Elbeo ad a man's hand corroborated the sexual meaning of the woman's legs. Here the sexually explosive mixture constituted from the man's hand, the woman's hand and leg, still has the woman's leg as the core of sexual signification. Imagine the ad *without* that leg: neither so ridiculous nor so sexually 'ripe'. Yet the man's hand does have some sexual meaning – in its difference from the suited arm of the city gent clutching his *Times* and umbrella. The latter is middle aged, portly and formal; the former is probably young and certainly 'naked' – or shirtless – with bronzed arm, full of sexual potency. The potency is symbolized by her position, not quite supine, but certainly awkwardly below him who could be standing; she sexually submits as the drink is poured (coincidentally at crotch level?) into her glass: a metaphor for a 'sexual filling'.

10 Veuve du Vernay advertisement, *The Observer*, 13 July 1980.

'Travel 1st Class' exhorts the ad, and we can add, 'you will find sex and excitement'. But to whom is this addressed? Perhaps 'you' are a woman and the drink a woman's drink, for where is *his* glass? 'You' (she) reels with the effect, of him, or the drink, and see the same businessman many times over: woman out of control. She drinks it but *he* has bought it and offers it to her, a sign not of his service to her, but of her *dependence* on him. But we can also read the ad as perhaps the fantasy of that city gent. He imagines himself in the place of the one who pours the drink: their arms are almost in the same place. What he gets travelling first class is not the drink, but *her*. But then contrarily, we are put into the position of looking *up* to the line of men; as the crouching woman who extends her vulnerable limbs? If we are women what other position is offered us? While men revel in sweet fantasy.

## Carling (Figure 11)

A difference is marked here not by the contrast between colour and black and white, but between the background of the kitchen and the focal inset of the woman's hand pouring a can of lager. What the difference is about is not sexuality/asexuality or excitement/mundanity, contrasts which the woman primarily introduces into the Veuve du Vernay ad, but femininity and masculinity of another order: femininity as domestic and masculinity as definitely not.

The 'commercial realism' of the kitchen scene has all the signs of construction. Who can spot the visual clues which indicate, what we are told in text and caption, that a man (her husband – note the wedding ring we can usefully just see on her finger) has not only done the washing up, but that it is not taken for granted that he will do it: it is not his natural role? *He* needs reminding – 'Your turn xx'. Does she when it's her turn? The crockery needs putting away, the cloth hasn't been hung to dry; the bin hasn't been emptied, i.e. she still has work to do. Would *men* looking at this ad recognize those signs of masculine domesticity which are only *too* familiar to women? Yet here she is so thankful for this small lightening of her load, that she is rewarding him. What reward does she get each day? It is *such* an (extra)ordinary task for him to do that both a 'little feminine charm' is required to encourage its execution, and because the task is such a strain, so mammoth a chore – 'The things men do for . . .' – only Carling with its 'thirst shattering flavour' will suffice to quench the man-size thirst this task has generated. And there we see her pouring it for him; the inset of femininity restoring what is absent from that kitchen. Despite her absence from the kitchen then, she is confirmed in her domestic role; despite his presence he is affirmed as 'a man' – and non-domestic, naturally.

What we have seen in these ads are the ways in which the hand

11 Carling advertisement,
*Cosmopolitan*, June 1980.

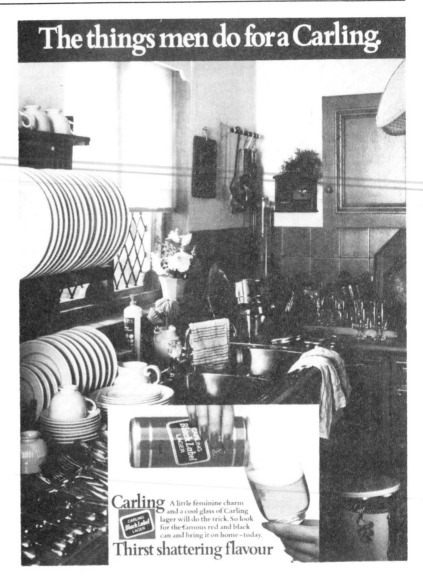

becomes a central mark of femininity or masculinity. If we were to look just at our friends' *hands* we might well *not* be able to tell whether the hand was a woman's or a man's. But of course, then, as in the ads, we *do* always know whose hand it is primarily from what the person as a whole looks like, if not from the hand itself. Usually, however, the hand is not the chief means by which we recognize femininity or masculinity, though this has not always been the case. Leonora Davidoff explains how the appearance of hands was a preoccupation of the middle classes in the nineteenth century; it was as much a concern about establishing class differentials as it was to separate women and men.[10] Even today

the difference between rough and calloused hands, and smooth white ones has both a class and gender reference, which we all recognize ideologically, but do not entirely rely on in our judgement of people as working class or middle class, women or men. What is specific to representation and ads is how they are able to 'elevate' this, in many cases, 'unmarked' part of our bodies and imbue it with gender, even when it is detached from any body: it becomes the focal sign of femininity or masculinity. Yet though as we look at the ads it appears that it does this *by itself*, that the gendered meaning is there 'naturally', in the hand, this is by no means so. The biological hand is parasitic on *cultural* markers for this 'natural meaning'. Thus either the hand itself is marked – the bracelet, or shirt cuff – or the text and visuals apart from the hand are marked – 'Home-made goodness' and sponge pudding in the Bird's custard ad, caption and the TV image in the JVC video ad – and these fill the hand with gendered and therefore cultural meaning. This process of representation occurs equally for masculinity and femininity. Inequality lies in the cultural meanings themselves to which representation only gives a heightened and particular expression.

## Notes

1 E. Goffman, *Gender Advertisements*, London, Macmillan, 1979, p. 7.
2 T. Millum, *Images of Women*, London, Chatto & Windus, 1975, pp. 83-4.
3 J. Winship, 'Sexuality for Sale' in S. Hall, D. Hobson, A. Lowe and P. Willis (eds), *Culture, Media, Language*, London, Centre for Contemporary Cultural Studies and Hutchinson, 1980.
4 M. Alvarado, 'Photographs and Narrativity', *Screen Education*, nos 32-33, Autumn-Winter 1979-80, p. 8.
5 J. Williamson, 'The History that Photographs Mislaid' in *Photography/Politics: One*, London, Photography Workshop, 1979, pp. 51-68.
6 Goffman, p. 29.
7 J. Berger, *Ways of Seeing*, London, British Broadcasting Corporation and Penguin, 1972, p. 47.
8 Goffman, p. 45.
9 Goffman, p. 6.
10 L. Davidoff, 'The Rationalization of Housework' in D. Barker and S. Allen (eds), *Dependence and Exploitation in Work and Marriage*, London, Longman, 1976, p. 127.

Griselda Pollock

# What's wrong with images of women?

I want to address myself within this article to what I consider to be an unbridged gap within the women's movement between an awareness of the role of ideology in visual representations of women in our oppression and the level of critical and theoretical analysis developed by a small number of largely professionally involved women. The political interest in images is evidenced by the frequency with which courses are set up under the misleading title 'Images of Women' in a variety of educational establishments and at women's studies conferences. The theoretical analysis is more specialised and therefore only appears in small distribution journals of small study groups. I have found myself working within both camps and I would like here to both examine the practical problems of bridging this gap without failing to incorporate the important theoretical issues and also to explore some of those issues without losing sight of their practical exercise in teaching. Many of the points I shall raise below were originally developed by the collective work of a group of women over a long period, collecting images and experimenting in different teaching situations. Limitations of space do not allow for a full elaboration of issues which are both complex and part of a much wider study of women and representations. For instance, I cannot acknowledge properly within this article the full implications of the differences of media and qualities of photographs to be used as illustrations to the argument. Instead I shall try to outline the main points of our analysis and show certain images which we have found useful in teaching in this area.

In 1972 a group of women involved in art and media practice, art history and feminist criticism formed the Women's Art History Collective in order to attempt some analysis of women's position in, and in relation to, the history of art and representations. Our starting point was firstly an identification with the direct relevance of the issue to ourselves and our work as part of a political movement and women and secondly a response to the still limited literature on the subject, for instance John Berger's *Ways of Seeing* and American publications which included the work of feminist academics like Baker and Hess's *Art and Sexual Politics* and Hess and Nochlin's *Woman as Sex Object* as well as documentary material in art magazines, notably *The Feminist Art Journal*. The literature highlighted many important problems but

From *Screen Education*, no. 24, Autumn 1977.

was not on the whole theoretically very rigorous or helpful. A third influence was the attempt made by certain feminist artists to provide what they termed an alternative and positive imagery of women which, though important in terms of the political solidarity it encouraged, in fact foregrounded the impossibility of challenging existing imagery without an adequate theory of ideology and representation.

Of all the areas to which the Women's Art History Collective addressed itself, that of 'Images of Women' has consistently proved itself the most difficult and resistant to satisfactory theory or practice. The problem can, I think, be analysed on four major fronts: the confusion and mystification of the issue created by the title 'Images of Women'; the problematic and as yet undefined relation between so-called High Culture and the Media or Popular Culture; the lack of theoretical definitions of what terms like sexist, patriarchal or bourgeois mean when applied to images; and finally what practice can be suggested in order to rupture dominant ideology and undertake a radical critique and transformation of visual imagery.

The first difficulty arises out of labelling the area of study as 'Images of Women'. The term implies a juxtaposition of two separable elements – women as a gender or social group versus representations of women, or a real entity, women, opposed to falsified, distorted or male views of women. It is a common misconception to see images as merely a reflection, good or bad, and compare 'bad' images of women (glossy magazine photographs, fashion advertisements, etc.) to 'good' images of women ('realist' photographs, of women working, housewives, older women, etc.). This conception, represented by the title 'Images of Women', needs to be challenged and replaced by the notion of woman as a signifier in an ideological discourse in which one can identify the meanings that are attached to woman in different images and how the meanings are constructed in relation to other signifiers in that discourse. Thus rather than compare different kinds of images of women one needs to study the meanings signified by woman in images with reference, for instance, to man in images. A useful device for initiating this kind of work is the use of male/female reversals.

In 1973 *Women's Report* (vol. 1, no. 6) published a reversal of the then current Bayer advertisement on the Seven Ages of Man (Figure 12) posing a young man in exactly the same position as the ad had placed an adolescent girl and changing the gender of the pronouns in the accompanying copy which then read:

Adolescence – a time of misgiving. Doubts about the site offered by parents to build a life on. Both head and heart subject to the tyranny of hormones. Youth under stress in search of an identity. B . . . . is there to help *him* through this period of self-seeking. With textile

12 Test-tube baby, *Women's Report*, vol. 1, no. 6, 1973.

VOLUME 1: ISSUE 6 SEPTEMBER – OCTOBER 1973

# Test-tube baby

Crome

Adolescence - a time of misgiving. Doubts about the site offered by parents to build a life on. Both head and heart subject to a tyranny of hormones. Youth under stress in search of an identity.

B    is there to help him through this period of self-seeking. With the textile fibres and dyestuffs for the fashionable clothes he needs to wear. (B    made the first breakthrough in modern dyestuffs with magenta: the fashion colour of the 1860s.) With raw ingredients for the cosmetics he uses to create his own personality. And with simple remedies too. Like aspirin (a B    discovery) for the pain he will experience.

And all of it out of a test-tube.

B    will be there to help in the future. For a large part of their huge research programme is devoted to finding new methods of feeding people through animal and crop protection, of clothing people with new textile fibres, of transporting and housing them

using new structural foam plastics. They also expend a great amount of time and money exploring new ways of fighting pollution in the air and in the water.

A young boy will be uncertain of many things. But in his commitment to a brave future, he will have a powerful ally.

B    KEY FACTS
B    employ nearly 137,
Make over 6,000 products.
on research each year. Sell
in the five continents

WOMEN IN ADVERTISI

fibres and dyestuffs for the fashionable clothes *he* needs to wear. . . With raw ingredients for the cosmetics *he* uses to create *his* own personality. And simple remedies too. Like Aspirin . . . for the pain *he* will experience. (my italics)

The advertisement was one of a series of seven, but it was both the only female image and the only nude. The reversal serves initially to make strange the original image in which femaleness and nudity are completely elided. The contrast between the actual photographs themselves also opens up space between the model

and the nudity in so far as the original is soft-focussed, with smudged edges thus binding the image into the material of the photograph while the reversal is shot in sharper focus and the hard edged lighting emphasises the nakedness of the male model. The notion of woman as body which is thus made explicit is supported in the advertisement by the accompanying copy. By changing the original 'she' to 'he' the meanings become less automatic, denaturalised and a space is created between the signifier and the signified, exposing the notion of the female as both subject to bodily processes and also the field of action for various products which will act on the body to complete the flowering of this bud-like creature.

The density of meanings signified by the female nude can be further shown by a comparison of two other advertisements taken at random from the thousands that assault us daily (Figures 13 and 14). What is remarkable in this juxtaposition is the relative complexity of the advertisement for Lee Jeans and the startling economy of Levi's. To make its meaning clear, the Lee advertisement has to resort to a location on the wild pampas and the additional attributes in order to specify that which the Lee jeans will make of a man. Grotesque as this image is, it shows the necessary lengths to which one has to go to make a clear image of the desirability of purchasing the jeans when using a male model. The Levi's advertisement is of a completely different order – it simply offers its product for sale, but that it can do so merely by attaching the label to a nude portion of the female body depends on the identification of the female body and sale. A common critique of such an image simply condemns the exploitation of the female body in selling commodities. However, the use of the female nude is not arbitrary or exploitative, for a study of the transformation of the female nude in the history of representations does show how the body has come to signify 'sale'. It is not possible to adduce here all the illustrative material necessary to elaborate that point, but at the risk of sounding too speculative I would contend that that which recuperates a bottle of sherry or a car in advertisements from being read as still life with its traditional associations and indicates their status as purchasable commodities, is the presence of woman by virtue of that which the woman introduces into an image.[1]

In suggesting this, I am laying stress on the active relationship between the visual vocabulary, or what art historians prefer to call the iconographic traditions of High Art and the Media which is the second point raised above. John Berger has already made some observations on the way in which contemporary advertisements 'borrow' their images from Old Master paintings by showing examples of advertisements that quote directly from an oil painting. The implications of this practice go beyond quotation as Berger states,

13 Lee Jeans advertisement, source unknown.

14 Levi Jeans advertisement, source unknown.

43

The continuity, however, between oil painting and publicity goes far deeper than the 'quoting' of specific paintings. Publicity relies to a very large extent on the language of oil painting. It speaks in the same voice about the same things. Sometimes the visual correspondences are so close that it is possible to play a game of 'Snap'. . . It is not however on the level of exact pictorial correspondence that the continuity is important: it is at the level of the sets of signs used.[2]

15 Male pin-up, *Viva* magazine, source unknown.

The main thrust of Berger's argument is to show up the ideological meanings usually disclaimed for pure High Art. However, his final statement can be taken further and his argument, in a sense, reversed. Returning once again to reversals, one can cite an example from the misconceived attempts by certain magazines to offer to women erotic images of men, for instance the photograph of a nude man running through the woods which appeared in the magazine *Viva* (Figure 15). The photograph bears comparison with the advertisement for Lee Jeans in so far as the male figure does not stand alone or in a slight setting but is similarly placed in an elaborate woody glade and is posed in conjunction with an animal, in this case the horse's head, whose position and shape is not only suggestively phallic but recalls the longstanding association of a horse and virility in earlier iconographic traditions. In attempting to construct an erotic image of man, this picture foregrounds the difficulties of reversing erotic imagery and furthermore reveals a significant reliance on the images in European art, for this photograph is a fine paraphrase of the Hellenistic statue, the *Apollo Belvedere*.

One can read this image a number of ways in which it cannot be an equivalent of photographs of women in magazines for men. The figure is active, self-contained, does not engage with the gaze of the spectator whose hypothetical position can only be as some wood nymph catching a fleeting glimpse of this sylvan god through the blurred bushes of the foreground. What is absolutely lacking is any conceivable position of ownership or possession offered to the spectator. But in addition, the image inscribes into itself the contradiction inherent in the use of the Apollonian prototype which occurs in the severe disjunction between head and body and the bizarre relation of the almost phallic horse's head with the man's genitals virtually barred off by the reins. That which can be signified by the male figure is therefore curtailed by the historical specificity of the sign 'man' within patriarchal ideology whose synchronicity on the level of pre-presentations is ensured by the expansion of the art publishing industry and the production of so called popular art books as well as television serials like the now famous *Civilisation*.

But a further and more dangerous aspect of this process appeared recently again in the pages of a sex magazine. The

appropriation of woman as body in all forms of representation has spawned within the women's movement a consistent attempt to decolonise the female body, a tendency which walks a tightrope between subversion and reappropriation, and often serves rather to consolidate the potency of the signification rather than actually to rupture it. Much of this attempt has focussed on a kind of body imagery and an affirmative exposure of female sexuality through a celebratory imagery of the female genitals. The threatening implications of this undertaking is witnessed by a recent episode when the work of Suzanne Santoro (Figure 60) who produced a small booklet of vaginal imagery was in fact censored by the Arts Council who, after some complaints, removed it from a travelling exhibition of Art Books on the grounds of indecency and obscenity. However, that the radical potential of this kind of feminist imagery can easily be reappropriated can be seen if one looks beyond the petit bourgeois ideology of the art establishment to the major conveyors of bourgeois patriarchal imagery in the big-selling sex magazines where a profoundly disturbing development has taken place. In the pages of a recent *Penthouse* (figure 16) vaginal imagery appears in all its force and decorative glamour, liberated from the traditional coyness of such magazines' sexual invitations by a directness that radically questions the psychoanalytically based analyses of images of women undertaken by Claire Johnston and Laura Mulvey and the notions of castration fears and the phallic woman. In some senses there is a similarity to the images of men illustrated above with the lack of engagement between model and spectator and the sense of self-sufficiency which in the pages of *Penthouse* are underlined by the fact that these women are frequently engaged in private masturbation. The relation between spectator-buyer of these images and the picture of woman created in these photographs, is that of forceful intrusion or indeed possessive voyeurism inviting rape. While I can only remark on the insufficiency of present theory in the analysis of this development, I want here to hypothesise on the direct relations between levels of representations from the High Art undertakings of feminists to the mass-market sex magazines. I would argue the absolute insufficiency of the notion current in the women's movement which suggests that women artists can create an alternative imagery outside existing ideological forms, for not only is vaginal imagery recuperable but in that process the more sinister implications of sexual difference in ideological representations are exposed. However, it must be acknowledged that certain feminist critics have been aware of these dangers, as for instance Lucy Lippard who comments in her essay on Body Art in her recently published book *From the Centre*: 'It is a subtle abyss that separates men's use of women for sexual titillation from women's use of women to expose that insult.' Even so, such a comment reveals a certain lack of focus

16 Photograph, *Penthouse*, vol. 12, no. 3, July 1977.

on that which determines this process (this not-so-subtle abyss) and serves to illustrate my third introductory point concerning the lack of clear definitions of the precise ideological system within which the signification of woman is created and maintained. Notions of patriarchal ideology engendered by a recourse to psychoanalysis are on their own inadequate and insufficiently historical and the issue must be located in terms of capitalism and bourgeois ideology for, as I have briefly indicated above, one of the dominant significations of woman is that of sale and commodity. The transformation apparent in the pages of *Penthouse* is the replacement of willing transaction by what amounts to theft.

By way of conclusion and summary I would like to offer one final set of reversals which have proved useful in the exposition of such points by the Women's Art History Collective. In her essay on 'Eroticism and Female Imagery in Nineteenth Century Art' in *Woman as Sex Object*, Linda Nochlin published a nineteenth-century soft porn print entitled *Achetez des Pommes* and juxtaposed it with a photograph of a man she had posed carrying instead a tray of bananas. The usual reaction to this comparison is laughter, an embarrassed reaction to the recognition of that which we take for granted in the nineteenth-century print. This does, of course, invite some comment on its 'sexist' nature but it is nonetheless so naturalised that it is hard to isolate the precise ideological implications of such an image. On an obvious level, as Nochlin points out, while there exists a long tradition of association between female breasts and genitals with fruit, which renders the sight of breasts nestling amongst a tray of apples and the implied salability of both unsurprising, no such precedents exist for a similar juxtaposition of a penis and its fruity analogue, the banana. However, what is more significant in this comparison is precisely the failure of the reversal.[3] It is clear that a bearded man with a silly expression, woolly socks and moccasins does not suggest the same things as the sickly smile of the booted and black-stockinged woman not simply because there is no comparable tradition of erotic imagery addressed to women but rather because of the particular signification of woman as body and as sexual. There is a basic asymmetry inscribed into the language of visual representation which such reversals serve to expose. The impossibility of effective reversal also exposes the mystification brought about by the attempt to isolate 'Images of Women' outside the total discourse whereby the meanings carried by male and female are predicted on difference and asymmetry.

Nochlin also adduces a painting contemporary with the print culled from the realms of High Art, namely Gauguin's *Tahitian Women with Mango Blossoms* of 1899, New York Metropolitan Museum of Art (Figure 17) in which a similar configuration of breasts and fruiting flowers is created within the idyllic setting of

17 Paul Gauguin, *Tahitian Women with Mango Blossoms*, 1899, New York, Metropolitan Museum of Art.

18 Paula Modersohn-Becker, *Self Portrait with Amber Necklace*, 1906, Private collection, Bremen.

non-industrialised, pre-capitalist Oceania where all is natural and free. The comparison not only indicates the interconnections in terms of ideology of High Art and popular prints but demands a reintegration in cultural studies which does not falsely privilege mass forms over what is often their source material in the more elite manifestations of dominant ideology in High Culture and finally necessitates the rescue of the discourse of art history from its recent practices that are untouched by a radical critique or theoretical analysis.

A final example related to these works can be used to address the fourth point made above which concerns the nature of the practice through which the ideological nature of the representations can be exposed and the ideology ruptured. Paula Modersohn-Becker's *Self Portrait* (Figure 18) painted under the influence of Gauguin's Tahitian paintings at the turn of the century and the combination of such a source with the attempt at self-portraiture foregrounds the contradictions under which women attempt to represent themselves. The tension lies between the naturalness of the image of woman as nude and the unnaturalness of the portrait of the artist as a young woman. Two separate traditions collide, resulting in an image which neither

47

works as a nude, for there is too much self-possession, nor as a statement of an artist, since the associations are those of nature not culture. The painting must be considered as a failure not simply because an alternative iconographic tradition did not yet exist (for that presumes the possibility of simply creating one) but rather, I would maintain, because of the inseparability of the signifier and the signified. It is that false separation which the notion 'Images of Women' precisely attempts to make, which renders the term so inescapably mystifying, and the study engendered by it, so difficult, and which cannot be maintained if we are to expose the roles of the signifier woman within ideological representations. Nor can a separation be maintained between various manifestations of these signifying practices for, in order to make any intervention in theory or practice, we require a soundly based historical analysis of the workings of ideology and codes of representation in their historical specificity and through the interrelated systems by which ideology is maintained and reproduced. It is precisely here that the gap I mentioned in the opening sentences of this article opens up between the direct relevance of this undertaking to women as we live out that ideology, seek to challenge it and the kind of analysis necessary to expose and rupture it.

## Notes

1 This notion has to be carefully argued from the precise historical developments of bourgeois art and most importantly by a careful study of the transformations of the representations themselves. Verbal or purely theoretical argument without numerous illustrations would be disturbing. However, since the point is important, I make it here and can only suggest that anyone interested refers to the book co-authored by myself and Roszika Parker, *Old Mistresses – Women, Art and Ideology*, London, Routledge & Kegan Paul, 1981.
2 J. Berger, *Ways of Seeing*, Harmondsworth, Penguin, 1972, pp. 135-8.
3 Nochlin does not acknowledge its failure nor did she attempt to produce comparable images in terms of the photographic methods used.

Judith Williamson    # Decoding advertisements

There is very little real difference between brands of product within any category, such as detergents, margarine, paper towels and so on. Therefore it is the first function of an advertisement to *create* a differentiation between one particular product and others in the same category. It does this by providing the product with an 'image'; this image succeeds in differentiating between products only in so far as *it* is part of a system of differences. The identity of anything depends more on what it is *not* than what it is, since boundaries are primarily distinctions: and there are no 'natural' distinctions between most products. This can be seen by the fact that a *group* of products will sometimes be marketed with the same 'image', in a set or 'range' – these usually have names like 'Maybelline' or 'Spring Bouquet', etc. The limits of identity are chosen arbitrarily, it is clear, because in other cases two identical products from the very same manufacturer will be given different names and different images. If two different bottles of cleansing milk can have the same name – 'Outdoor Girl' or suchlike – but a third, apparently similar, can appear with a different name and therefore with supposedly different properties it immediately becomes apparent that there are no logical boundaries between most products. Surf and Daz essentially contain the same chemicals. Obviously there *are* products with special qualities or particular uses, but these do not usually need extensive advertising campaigns: the bulk of advertising covers exactly the areas where goods are the same: cigarettes, cornflakes, beer, soap.

I am taking a group of perfume advertisements – two of which come from the same manufacturer. These provide a good example of the creation of 'images', since perfumes *can* have no particular significance. This is a type of ad which can give no real information about the product (what information can be given about a smell?) so that the function of differentiation rests totally on making a connection with an image drawn from outside the ad world (Figures 19 and 20).

Catherine Deneuve's face and the Chanel bottle are not linked by any narrative, simply by juxtaposition: but there is not supposed to be any *need* to link them directly, they are as it were in apposition in the grammar of the ad, placed together in terms of an *assumption* that they have the same meaning, although the

From Judith Williamson, *Decoding Advertisements*, London, Marion Boyars, 1978.

49

The Fabulous
Babe

Introducing Babe,
a fragrance so fresh, so natural,
Fabergé named it just for you.

19 Chanel No. 5 advertisement, source unknown.

20 Fabergé 'Babe' advertisement, source unknown.

connection is really a random one. For the face and the bottle are not inherently connected: there is no link between Catherine Deneuve *in herself* and Chanel No. 5: but the link is in terms of what Catherine Deneuve's face *means to us*, for this is what Chanel No. 5 is trying to mean to us, too. The advertisement presents this transference of meaning to us as a *fait accompli* as though it were simply presenting two objects with the same meaning, but in fact it is only *in* the advertisement that this transference takes place. Chanel No. 5 only has the 'meaning' or image that it shares with Catherine Deneuve by having become associated with Catherine Deneuve through this very advertisement. So what Catherine Deneuve's face means to us in the world of magazines and films, Chanel No. 5 seeks to mean and comes to mean in the world of consumer goods. The ad is using another already existing mythological language or sign system, and appropriating a relationship that exists in that system between signifier (Catherine Deneuve) and signified (glamour, beauty) to speak of its product in terms of the same relationship; so that the

perfume can be substituted for Catherine Deneuve's face and can also be made to signify glamour and beauty.

Using the structure of one system in order to give structure to another, or to translate the structure of another, is a process which must involve an intermediate structure, a system of systems or 'metasystem' at the point where the translation takes place: this is the advertisement. Advertisements are constantly translating between systems of meaning, and therefore constitute a vast meta-system where values from different areas of our lives are made interchangeable.

Thus, the work of the advertisement is not to invent a meaning for No. 5, but to translate meaning for it by means of a sign system we already know. It is only because Catherine Deneuve has an 'image', a significance in one sign system, that she can be used to create a new system of significance relating to perfumes. If she were not a film star and famous for her chic type of French beauty, if she did not *mean* something to us, the link made between her face and the perfume would be meaningless. So it is not her face as such, but its position in a system of signs, where it signifies flawless French beauty, which makes it useful as a piece of linguistic currency to sell Chanel.

The system of signs from which the product draws its image is a *referent system* in that the sign lifted out of it and placed in the ad (in this case, Catherine Deneuve's face) *refers back to it*. It is not enough simply to know who Catherine Deneuve is: this will not help you to understand the ad. Someone from another culture who knew that Catherine Deneuve was a model and film star would still not understand the significance of her image here, because they would not have access to the referent system as a whole. And it is only by referring back to this system as a system of *differences* that the sign can function: it is hollow of meaning in itself, its signified is only a distinction rather than a 'content'. Only the form and structure of the referent system are appropriated by the advertisement system; it is the relationship and distinction between parts, rather than the parts themselves, that make an already-structured external system so valuable to advertising. The links made between elements from a referent system and products arise from the *place* these elements have in the whole system rather than from their inherent qualities. Thus Catherine Deneuve has significance only in that she is not, for example, Margaux Hemingway.

The 'image' of this ad derives its impact from the existence of precisely such ads as Figure 19, as it is able to 'kick off' against the more sedate Catherine Deneuve image and others like it. This new perfume, 'Babe', has been launched in a campaign using the new 'discovery' Margaux Hemingway. The significance of her novelty, youth and 'Tomboy' style, usually connected with modelling, is carried over to the perfume: which is thus signified

as new and 'fresh', in relation to other established perfumes. There would be no significance at all in the fact that Margaux Hemingway is wearing a karate outfit and has her hair tied back to look almost like a man's, were it not that *other* perfume ads show women wearing pretty dresses and with elaborately styled hair. The meaning is not, however, generated *inside* the advertisement system: there is a meaning in terms of 'women's liberation' and 'breaking conventions' in a model's having a tough, 'liberated' image (in one TV ad for 'Babe' Margaux Hemingway mends the car while her boyfriend watches) rather than a passive, 'feminine' one. In the widest sphere of meaning which the ad draws on, even outside modelling and images, the meaning still depends on a contrast, since the very idea of women doing karate is only significant because most women do *not* and have not done anything of the sort.

So this advertisement uses the 'Margaux Hemingway' image, *which itself depends for its significance on not being Catherine Deneuve's image* to give 'Babe' a distinct place in the inventory of perfumes, emphasising its novelty (its *not being like* what has gone before) and its difference from all the others. It uses a contrast made in social terms, 'feminine' v. 'liberated', as signified by two models, to make a contrast between products.

In the mythological system of fashion and publicity Catherine Deneuve and Margaux Hemingway are mutually differentiated and can only have value as signs in relation to each other: as Saussure says:

> in all cases, then, we discover not *ideas* given in advance but *values* emanating from the system. When we say that these values correspond to concepts, it is understood that these concepts are purely differential, not positively defined by their relation with other terms of the system. Their most precise characteristic is that they are what the others are not.[1]

Thus with Catherine Deneuve and Margaux Hemingway it is the *difference* between their significance (taking them not as women but as signs, for this is what they are in this context) that makes them valuable in advertising. Advertisements appropriate the formal relations of pre-existing systems of differences. They use distinctions existing in social mythologies to create distinctions between products.

## Note

1 F. de Saussure, *Course in General Linguistics*, quoted in *Saussure* by J. Culler, Fontana, 1976, p. 26.

Rosalind Coward

# 'Sexual liberation' and the family

The argument is of importance for a consideration of representations of sexuality. What it shows us about the process of representation is that, although representations are produced within definite conditions, what they represent is never wholly reducible to those conditions. Thus a representation of sexuality does not usually mirror an idea of sexuality found elsewhere in society – in this case a pre-given idea of female sexuality. Rather, exactly what is represented is produced through the work of the discourse itself. It is this which can explain conflicting representations, and the struggle within representations for definitions. Such an assertion has almost certainly been implicitly recognised by many in the women's movement, since it has always given attention to struggles for definition within representations, and recognised that what is at stake in these struggles is which group has the power in determining the definitions.

If representation is to be understood in this way, certain procedures become necessary. Firstly, we have to understand what is being accomplished in any particular representation, how that representation is being produced, and what are its conditions of existence. It is in this context that I wish to examine representations of female sexuality not bound by the family, and the contradictions between various representations. Without such work, marxist feminism might remain within a form of economism and only prepared to consider sexuality when it appeared formalised in an institution. This lacuna would have political and strategic effects, for it would mean we would be unable to differentiate between progressive and reactionary representations of female sexuality. This is a real danger which is already to be seen in the embarrassing fact recognised by feminists that we can at times occupy the same political platform as the extreme right-wing, in particular the Mary Whitehouse anti-pornography platform. Such problems point to the need for reassessing how we understand what is at stake in representations of sexuality; they point to the need to develop an analysis more subtle than 'If the representation is produced within capitalism it must be condemned as bourgeois.' They also point to the need to reassess the equation state = family = oppression/repression and call for an analysis which can specify what exactly is at play in representations, how these relate to the social formation as a

This is an extract from the article ' "Sexual Liberation" and the family', *m/f*, no. 1, 1978.

53

whole and how we are to assess their political effects. This is the context in which the representation of sexuality in *Cosmopolitan* and in the film *Emmanuelle* will be examined.

*Cosmopolitan*'s format, according to its first editor, is '. . . one profile, one piece on health, one on sex, two on emotions . . . one on man/woman relationships, one on careers, one short story, and one part of a major work of fiction, as well as our regular columns' (quoted by Polly Toynbee, *The Guardian*, 20.7.77). The emphasis in the magazine is on career improvement, on successful glamorous women, on improving sexual and emotional relationships with particular emphasis on the possibilities of female pleasure, contraception, and the need for 'independence', both sexual and economic. In general, the form of sexuality addressed is aggressively heterosexual and 'liberated', meaning by this term that it neither refers exclusively to sexuality within the family, nor does it ever deal with sexuality defined in terms of the production of children. In opposition to other women's magazines of the more traditional kind (*Woman's Own*, *Good Housekeeping*, etc.) the reference to family roles – cooking, housework and childcare – is almost non-existent.

The absence of these areas at the level of content is confirmed by their absence at the level of advertisements; it is typical to find issues whose sole advertisement for food is one for frozen food. There is a quite staggering preponderance of advertisements concerned with clothing and appearance. In a typical issue we find a vast number of advertisements for perfumes, shampoos, hair conditioners, hair tonic, hair colouring, hair dryers and stylers, hair removing cream, hair removing devices, cream for night care, day care, foundation cream, cream for spots and blemishes, cream for covering spots and blemishes, several varieties of make-up, moisturiser, skin tonic, mascara, lipstick, lip salve, nail varnish, nail varnish-remover, breath fresheners, general deodorants, foot deodorants, bubble and foam baths, soaps, toothpastes, sanitary towels and tampons. The only advertisements not in these areas were for drinks, cigarettes, one for gas, one for hi-fi and one for a building society. To detail the advertisements found in one issue is not irrelevant. It is this obsession with the glamorisation of the body which draws the feminist critics of the magazine for its 'commercialisation' of sexuality by which women are trapped in retrogressive narcissistic representations.

What can be detected in the excess of such advertisements as in many contemporary women's magazines (see also *Honey*, *19*, *Over 21*, *Vogue*, etc.) is the manipulation of areas of the body accessible to marketability. This is not a simple process; the imagery of the advertisements makes it clear it is not just marketability that is at stake, it is also the consistent 'sexualisation' of areas previously not defined as sexual. It is the

sexualisation of eyes, lips, ears, wrists, legs, feet, hair, mouths, teeth, smells, skin, etc. It is not a matter of exploiting a pre-existent, naturally sensitive body, but the actual construction of parts of the body as sensitive and sexual, as capable of stimulation and excitation, and therefore demanding care and attention if women are to be sexual and sexually desirable to men. The images also reveal the sexualisation of situations previously tabooed: work and the street. Thus consumerism is not a process which works either to manipulate an original sexuality, or to impose needs on a sexually static 'normal' body. What is happening is that a new definition of women's sexuality altogether is being produced. It is a definition which produces new areas as sensual, and equates that sensuality with *work* – a work with appliances and accessories in order to fulfil the stimulatory potential of the area. Through this work, female sexuality is defined as primarily narcissistic and primarily divided into separate and distinct areas of pleasure.

While the advertisements work almost exclusively towards these ends, the articles by no means follow such a narrow definition of sexuality. Many of the articles are directed towards understanding the pressures of such representations on women. Each month there is at least one article concerned with challenging the kind of female behaviour which is based on what men find attractive. The most regular features are to do with equal opportunities in the areas of management or professional careers. Equality is not described as a right but as the necessary reward for your own value.

The principal concern of *Cosmopolitan* is, however, the question of 'female sexuality' itself. If the magazine has a coherent project and identity it is this: it assumes its readers share this voracious interest in all aspects of female sexuality. But there is a multiplicity of discourses on sexuality within this. There's fashion, medicine (breast cancer, etc.), health/fashion (slimming, contraception), social trends ('Why do we still marry?'), psychology ('Hung up on approval?' 'Does guilt inhibit you?'), and a popular form of sexology. Under sexology appear an incredible number of aspects of sexuality open to the average heterosexual woman at all stages of life. Thus we have articles on affairs with married men, the first affair after marriage, the first affair after divorce, sexual behaviour before and after marriage, the 'libido' after five years with the same man, sex-life before the menopause, sex-life after the menopause and so it goes on. To caricature in this way does not do justice to the articles which are often helpfully and intelligently written. The point is to stress that beyond positing the reader as endlessly curious and endlessly tolerant, the magazine doesn't posit a norm of sexual behaviour. Instead it places itself precisely in the area of competing definitions, that is in the area of the definition of sexuality itself. Its common project

is the female body and this appears not as an already defined object but as something subject to competing definitions, often the cornerstone for conflicting ideologies. In taking as its object the female body and sexuality, *Cosmopolitan* is open to conflicting representations; there are debates between medicine and sex studies (the medical effects of contraception versus the emotional advantages, etc.), between biology and sex studies (is sex chemistry or emotion?), etc.

It is this openness which places the magazine at times within conflicting representations: at one extreme, the representations which sexualise an increasing number of parts of the female body to create areas of marketability; at the other extreme, representations which coincide with the explicit politicisation of sexuality by the women's movement – a politicisation to effect transformations in the social position of women.

If *Cosmopolitan* inscribes a particular reader, it is the reader obsessed with all aspects of female sexuality who finds the emergence of female sexuality worthy of interest and study. This interest can be seen across society as a whole. The vast sales of books by Erica Jong, Lisa Alther, and Shere Hite are further witness to the prevalence of the problem of female sexuality across an extremely wide area. Their books have been received in England with some critical reservations but with equally large sales. They have been presented as the prophets of women's liberated 'libido'.

The female body, then, is a site of particular significance in a struggle of representations which guarantees particular ideologies. The popularity of such a film as *Emmanuelle* and its sequel suggests that the way the issue of female sexuality is presented is particularly satisfying to certain sectors at the moment. *Emmanuelle*, bored and boring young wife of a rich young businessman, is made to discover a form of sexuality outside the monogamous couple. Her discovery is made through the guidance of a patriarchal figure, Mario, who intuitively recognises Emmanuelle's potential sexuality. He hints at the 'discovery of self' of which Emmanuelle has no idea and she submits to his guidance. Her 'initiation' involves a group rape by natives, and ends up with the realisation – dictated by Mario – that real sensuality and pleasure can never be achieved within the confines of monogamy and its cloying emotions. The necessary detachment from the distraction of such emotions is achieved through indulging in forms of sexuality where she has a witness. In other words, the voyeurism of viewing women as body on the screen is literally installed in the relationship shown. There must be someone continually watching her in the act of sex in order that her own body is not forgotten but narcissistically remembered – a remembrance which must define her identity.

Thus a specifically filmic representation of women, through

forms of voyeurism, is reinforced by the explicit content of the film. It makes an argument for 'liberation' – a liberation which is achieved by the assimilation of Emmanuelle's 'libido' to the organisation of cinematic voyeurism. With amazing exactness, the film was promoted as 'The film that makes you feel good without feeling bad.' In opposition to *Cosmopolitan* which is the forum for competing definitions, *Emmanuelle* is a work of closure; it foregrounds cinematic voyeurism and guarantees it with a particular representation of female sexuality.

In looking at representations from the point of view of their differences and multiplicities, I have begun to argue for their analysis in terms of practices which work to produce definitions. In this way it becomes possible to assess exactly what is at stake in a variety of discourses, instead of attempting to reduce everything to one model of power over women, that is, repression or censorship which will be overthrown with liberation. This begins to move away from an analysis in terms of direct correspondence with an economic formation but it does not reduce the imperative of understanding the conditions of existence of these discourses. It does, however, demonstrate how there can be a struggle for power in representations – something which the women's movement has always implicitly recognised in taking the redefinition of sexuality as one of its political aims.

The importance of the foregoing arguments is that they indicate how the work to define sexuality is a complex mechanism which puts women in definite and specific relations to the social formation. The work produces women in the very place of discourses, through their sexuality. The consistent over-estimation of the 'sexual' operates to equate identity with sexuality; thus women appear to discover themselves through sexuality, and in fact are placed through the discourses.

Kathy Myers

# Fashion 'n' passion

One of the problems with the 'content analysis' of media images is its inability to take into account image construction as an evolving process. This 'freeze frame' approach, whether applied to the moving picture or the still photograph, is always faced with a fundamental dilemma. On the one hand it seeks to classify and identify the dominant regime of codes and conventions which govern image production; and on the other, it needs to struggle constantly to keep abreast of the mutations in precisely those codes. The ability of the media continually to create new meanings gives a certain instability to the image, which constantly threatens to escape the analytic categories or stereotypes within which we seek to contain it. Yet this restlessness of the image, the search for the new, is not to be confused with a democratising of the visual market place. On the contrary, the proliferation of images suggests, for example, that in the case of the representation of women, the sites of exploitation are themselves multiple and shifting. Take, for instance, the ways in which notions of the positive or career-orientated woman have been adopted by advertising to promote anything from a 'liberating' range of makeup to a building society account.

At any single moment, it is possible to compare the sexual and photographic conventions which determine, for example, how a woman will be represented in a pornographic image to the codes which structure how she will appear in a family snapshot or an advertisement for nappies. A few months later, one may find evidence of the incorporation of amateur family 'snapshotness' into an advertisement. Equally, notions of what constitutes the 'professional photograph' may affect the ways in which individuals will pose for or photograph their friends. This trade-off of conventions is not to be confused with a blurring of boundaries. The discourses of the professional and the amateur photograph are distinct. What we need to examine is the nature of the economic and ideological structures which encourage an advertisement to deploy stylistic devices familiar in the snapshot. The same questions apply to a comparison I want to offer between pornographic and fashion images, specifically those published in magazines.

While arguing that different image systems influence each other, I think it's important not to lose sight of the fact that the fashion image and the pornographic image are in the first instance produced within quite distinct sets of social and

From *Screen*, vol. 23, nos 3-4, 1982.

economic circumstances. Those differences affect the way in which the image is constructed as a commodity, as well as the pleasures it makes available.

A fashion advertisement in a magazine is, like any other, itself the sum of a system of commodity exchanges: printing costs, hiring of props, models' and copywriters' wages, etc. These transactions may affect the reader in terms of a higher price for the advertised product on the one hand; or a reduction in the price of the advertising medium (the magazine), on the other. However, this system of exchanges is concealed from the reader, since the advertisement never refers to the commodities involved in its own production.

One of the jobs of the advertising agency is to invent or enhance use values for the product. Within the space of the advertisement these use values will be translated into intelligible meanings. Through the creation of meaning, the advertisement works to create identities simultaneously for both the product and the reader, who will be addressed as a potential customer. In order to engage the reader's attention, both text and image must be capable of offering certain forms of interest and pleasure. Crucially, for the image to fulfil its advertising function, it must not offer satisfaction in its own right. The advertisement works to displace satisfaction, promising fulfilment upon purchase of the commodity, at which point the reader becomes a consumer. It then articulates meaning and pleasure through a complex relationship which it establishes between reader, advertising image and commodity. This relationship is orchestrated by the overall marketing considerations, which determine not only where the advertisement will appear, but also where the commodity advertised will be distributed, retailed, etc. These marketing considerations establish the necessary conditions for consumption to take place.

Clearly, the pornographic image does not fulfil the same functions as a fashion advertisement. It is not a promotional device to increase the sales of a commodity. Where part of the pleasure offered by the advertisement depends upon the future purchase of a commodity, the pleasure of pornography is effected in the present conjunction of image and reader made possible by a past purchase. Unlike the advertising image, the pornographic image does not demand that the reader buy a specified commodity as a guarantee of pleasure. The pornographic image is itself a commodity, and it addresses the reader as an already positioned consumer – a satisfied (and satisfiable) customer.

## The erotic photograph

Certain forms of pornography have historically been labelled 'aesthetic' or 'erotic'. These terms have been deployed to defend sexually provocative or arousing imagery circulated within

minority markets or interest groups. The current proliferation of 'erotic' photography (e.g. David Bailey's *Trouble and Strife*,[1] Helmut Newton's *Sleepless Nights*[2] and John Hedgecoe's *Possessions*[3]) has enabled explicit allusions to sexual violence which would not be tolerated within the legal and political constraints which surround mass-market 'soft' pornography.

In his acknowledgements for *Possessions*, Hedgecoe thanks: 'The owners and the occupants for the loan of their possessions', a reference to both the country house locations and the women who modelled in the photographic sessions. One of these images depicts a beautiful woman lying on the floor, her mouth gaping, like a beached goldfish, suffocating under the net of her captor. The only thing which escapes the net is fetishistic waves of golden hair. The image, like her life, is neatly truncated at the neck. The spectators are placed in a privileged sexual position above this woman. We survey her orgasmic death in the company of an anonymous man, whose shiny patent shoes peek menacingly into the top of the frame; an authoritative fetish which sexualises the dying woman's subordination. While explicit genital sexuality may be subject to censorship, explicit sexual violence, it appears, is not.

One of the reasons for the exemption of so-called 'Erotica' from legal censorship is its location at the intersection of a number of different visual discourses which continually compete for the interpretation of the image. These are the visual traditions established within fine art, commercial fashion photography and hard-core pornography. The inability easily to classify the erotic photograph lends it enough ambiguity to defy censorship under a current legal system which has established an effective exemption clause for that which is thought to be 'art'.

The photograph by Tim Brown appeared in the October 1981 issue of *Camera* entitled 'Erotic Masterpieces' (Figure 21). Like many 'erotic masterpieces', this image takes as its starting point the fine art tradition of the female nude established within oil painting. The woman's body is presented as aesthetic object to be surveyed and possessed, endowed with the capacity to sexually arouse. The body, as artistic prop, is also a licensed vehicle for individual artistic expression, a medium, as well as an object in its own right. What differentiates the fine art nude from the erotic photograph in Brown's eyes is the capacity of the photograph to disrupt the tradition of nude representation by making strange the image: 'I thought the towel over her head would be disturbing, and I was right.' While fine art has developed its own tradition of representing the female form, erotic photographers such as Brown and Hedgecoe have taken their erotic inspiration from the domain of marginalised and usually heavily censored hard pornography. In the work of Hedgecoe and Brown we can trace the making safe, or the making acceptable, of many of the

21 Tim Brown, photograph,
*Camera*, October 1981.

sensibilities of hard-core pornography. Here necrophilia, suffocation, decapitation, mutilation and sadism appear as condoned. The erotic photograph trades on a dubious tradition of sexual libertarianism which invests that which is censored with the power to disrupt and liberate. Hence the 'erotic' – whether it alludes to sadism, nihilism or whatever – is acclaimed as a sexually liberating force.

The conventions of photographic erotica, however, are not exclusively derived from fine art, nor from the development of soft-core or hard-core pornography. The erotic photograph owes many of its formal devices to innovations created within the domain of commercial photography, and in particular fashion photography. It is interesting to note, for example, that two of its most celebrated practitioners, Helmut Newton and David Bailey, made their names in fashion. Fashion work occupies the prestigious end of commercial photography. The industry's seasonal demands for 'new fashion looks' and new modes of representation require both technical and stylistic innovation. Unlike other forms of commercial photography, fashion photography is auteuristic: David Bailey confers authorial prestige upon the fashion garments he chooses to shoot. The nude has been appropriated as the showcase for the photographic auteurs' work. Whereas the soft-porn image is anonymous, the erotic image is authorised.

## Fashion erotica

While certain conventions drawn from the system of fashion photography have influenced the representation of the 'erotic

nude' as photographic art, it can be argued equally that the codes and conventions of 'erotica' have influenced the construction of certain fashion images. Rosetta Brooks has argued that photographers like Guy Bourdin and Helmut Newton have applied the conventions of the erotic photograph in order to 'make strange' or challenge some of the 'stereotypical' notions of femininity and female sexuality which inform the dominant conventions of fashion photography. 'This emphasis upon the alien and artificial qualities of the picture make a straightforward accusation of sexism problematic. . . . Newton manipulates existing stereotypes; their alienness is accentuated.'[4] In the same way as this style purports to disrupt the conventions of the art-nude, so it can be seen to make strange the fashion image. Brooks suggests that this stylistic subversion is facilitated by making the photographer's mediation of the image apparent. In so doing, she argues, the photograph distanciates spectator from image, rendering any simplistic notion of identification impossible. She continues:

> Many of his [Newton's] more successful photographs hold a distanciated engagement with the manipulative devices of fashion photography and with the process of mediation. Those alien features present in suppressed form in fashion photography and current images of women are exposed and foregrounded. The image is presented as alien: a threat rather than an invitation. Stereotypes are presented as a falsity.[5]

One of the central problems with Brooks' argument is the equation of distanciation with subversion. Yet an analysis of advertisements aimed at an 'upmarket' female readership can demonstrate that distanciation has been created as a new norm in fashion and beauty marketing. Not all forms of stereotype are dependent upon easy audience identification with the image, and not all distanciation subverts.

The advertisement for the Revlon cosmetic range 'Formula 2' was target marketed by the Grey agency at a 'sophisticated' female readership (Figure 22). The notion of sophistication is juxtaposed against that of 'accessibility'. In image terms 'accessible' images rely on a straightforward notion of audience identification, supposedly inducing reactions of 'I want to be like that'. The 'accessible' image will tend to use models who look like the friendly, smiling girl next door. By comparison, the sophisticated image works to secure audience recognition of image as construct – image as image – without any immediate reference to the 'real' or to personal identity. It uses the image of the woman as a vehicle to deploy other kinds of codes and conventions. Often the 'sophisticated' image foregrounds itself in a readily identifiable cultural system, for example that of fine art painting, or in the case of Helmut Newton, avant garde erotic photography. The image of woman is used as a complex signifier

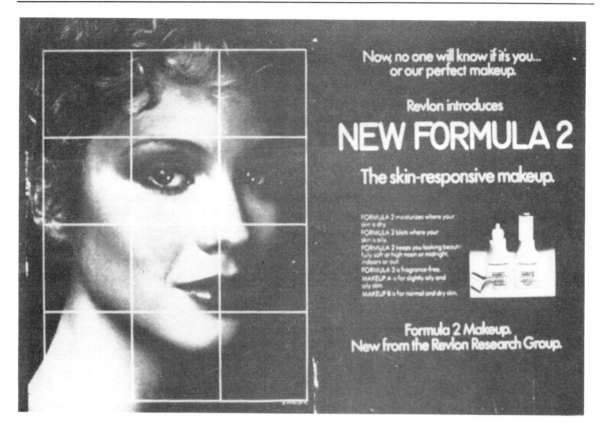

Now, no one will know if it's you...
or our perfect makeup.

Revlon introduces

# NEW FORMULA 2

The skin-responsive makeup.

FORMULA 2 moisturizes where your
skin is dry.
FORMULA 2 blots where your
skin is oily.
FORMULA 2 keeps you looking beauti-
fully soft at high noon or midnight,
indoors or out.
FORMULA 2 is fragrance-free.
MAKEUP A is for slightly oily and
oily skin.
MAKEUP B is for normal and dry skin.

Formula 2 Makeup.
New from the Revlon Research Group.

22 Revlon New Formula 2
advertisement, source unknown.

to associate the advertised product with other aspects of the
cultural and ideological system: art, status, wealth, etc.

The 'sophisticated' appeal of the Formula 2 advertisement is
constructed through a series of devices which mediate and
distanciate the spectator's relation to the image: the grid over the
face, the use of portrait framing and pose; the figure's serenity,
her acknowledgement of her to-be-looked-at-ness without
recourse to the familiarity of a direct smile at the spectator. The
image is constructed as a 'classic' beauty, derived as much from
oil painting (with all its economic and ideological implications of
rarity, cost, status, etc.) as commercial 'packshot' photography.

This sort of *haute couture* distanciation offers us an appropriate
site for the 'accentuated alienness' which Brooks notes in Newton
and Bourdin's work, including the now-common use of sado-
masochistic motifs. I would question her 'subversive' reading of
such representations (a harsher look has been fairly easily
incorporated into our notions of femininity via the influence of
recent styles like punk). But a marketing strategy founded on
reflexivity and deferred identification does problematise feminist
interpretations of these images as simply and directly encouraging
or condoning the activities represented.

63

# Soft-core pornography and the fashion image

I have suggested that notions of hard-core pornography as mediated through auteuristic eroticism affect the form and presentation of certain up-market fashion images. I want to argue that the soft-core image, familiar in magazines such as *Knave* or *Penthouse*, displays a different kind of relationship with the fashion image. What characterises the soft-core image is its amazing resistance to stylistic innovations in the fashion field. Soft-core magazines are very similar in design, format, layout and choice of model. In appearance these models tend to conform to a very particular version of what is thought to be sexually desirable: long curly hair, lightly tanned skins and a total lack of body hair – with the exception of neatly topiaried pubic growth. With their luxurious locks and toothy tanned looks, these models resemble nostalgic reappraisals of Farrah Fawcett-Majors: an image which the women's fashion market abandoned in the mid-1970s. But the pleasure which this pornography offers its reader depends on this sense of sameness, identity and repetition. The soft-core magazine is itself a fetish form, resistant to change and stylistic innovation, which demands an amazing conservatism not only in the choice of models, but also in the poses and locations deemed acceptable.

Such images are neither signed by name nor identifiable photographic style. While most readers of soft porn will realise that the image is posed and constructed 'for their pleasure', it works on a principle of disavowal: 'I know it's constructed, but nevertheless. . .' To facilitate this disavowal, soft-core images tend to be made-up, lit and tinted naturalistically. Readers are offered a version of the model's sexuality apparently unmediated by such devices as photographic innovation (flash light, blur, solarisation, etc.). Work on the image is denied rather than flaunted, as it might be in high fashion or erotic photography.

But the sexual codes which govern the representation of the soft-porn image may also appear in certain areas of the fashion market: for example, the advertisements which appeared in the mid-1970s for Janet Reger underwear deploy the soft-focus vulnerability of contemporary centrefolds (Figure 23). The position of Janet Reger at the more expensive end of the naughty nightie market is complicated by the fact that its merchandise is bought by women, and by men for their female lovers. This differentiates the lingerie market from other aspects of women's fashion, and perhaps can help to explain the persistence here of romanticised photographic imagery which has been outmoded or superseded in other aspects of the trade.

All this would suggest that different notions of the pornographic are at work in the construction of the female fashion image which can only be understood in relation to a detailed analysis of the construction of the respective markets for both. The ways in which female sexuality will be expressed are

23 Janet Reger underwear
advertisement, Janet Reger
catalogue.

dependent not only on the context in which the image appears,
but also on the intended target market for that image. While the
deployment of sexual codes is continually subject to change and
reorganisation, their alterations are far from arbitrary. An analysis
of the representations of female sexuality could usefully attend
not only to the range of codes and conventions through which
they are constructed, but also to the economic and cultural
rationales for their deployment.

# Notes

1 D. Bailey, *Trouble and Strife*, London, Thames & Hudson, 1980.
2 H. Newton, *Sleepless Nights*, London, Quartet Books, 1978.
3 J. Hedgecoe, *Possessions*, London, Mitchell Beazley, 1978.
4 R. Brooks, 'Fashion: Double Page Spread', *Camerawork*, January/February
  1980, no. 17, p. 2.
5 Ibid.

# SECTION TWO

# Changing stereotypes?
Women and sexuality

The new image for women in 1980s consumer culture embodies the contradictory qualities of 'masculine' strength and activity with a 'feminine' display of sexuality. Together with a sense of playing with style, of parody and artifice, it suggests a degree of self-consciousness about being feminine. The current craze for Madonna underlines the ambiguity of the image: ordinary girl *and* star; independent *and* desirable; she projects a sexual confidence which is as attractive to women as to men. But how are we to understand this new image of the sexual woman? Is it simply a reworking of old stereotypes, a blend of Marilyn Monroe's sexual innocent with Barbara Stanwyck's *femme fatale*? Or should we see it as a qualitatively different kind of image, one which draws upon an awareness of the possibility of a self-defined sexuality brought about by the women's movement? These questions open up broader issues of why and how changes in the representation of femininity take place. What produces such changes? And, how are we to make sense of them in the light of a feminist project to reconstruct representation?

The articles in this section explore various ways in which femininity and female sexuality have been constructed: the fallen woman in Victorian painting; the Page Three pin-up; the media image of Asian women; the erotic nude of art photography; the 'gender-bending' styles of current youth fashion. Each set of images differs in its cultural status, intended market and critical context. All, however, are images which are culturally dominant, either by virtue of their high status, like Royal Academy paintings and art photography, or through mass circulation like magazines and newspapers. They are thus important in the ways that they influence and shape commonly held ideas about femininity.

The articles show some of the ways in which we can begin to map out the connections between shifts in the representation of femininity and changing social formations, economic structures, and ideological contexts. They mark a new kind of attention to the relationship between sexual stereotypes and wider social and cultural discourses. Thus, while acknowledging that visual texts

structure femininity in specific ways, it is stressed that meaning is always produced in actual social contexts and in ways which cannot be predicted in advance. There are three aspects in particular on which I want to focus here. Firstly, the articles point to the importance of grasping the relationship between visual codes and conventions and the specific historical conditions in which images are produced and read. Secondly, they indicate a need to understand the ways in which femininity is differently constructed for women of different race and class. Thirdly, they question whether changing codes of the erotic offer the possibility of reconstructing femininity in new ways.

The notion of a stereotype is one common way of describing how groups of people are labelled with defining and often derogatory characteristics. Most frequently stereotypes pinpoint visible differences in gender, sexuality or race, which are then generalised and caricatured to apply to a whole social group. According to Teresa Perkins:

> The strength of a stereotype results from a combination of three factors: its 'simplicity'; its immediate recognisability . . . , and its implicit reference to an assumed consensus about some attributes or complex social relationship. Stereotypes are in this respect prototypes of 'shared cultural meanings'. They are nothing if not social.[1]

The usefulness of this definition is that it suggests that stereotypes draw upon and mobilise existing social and cultural knowledge in particular ways. Women are most frequently stereotyped in terms of sexual characteristics, for example, the 'dumb blonde' in Hollywood film. Here a combination of visual codes (blonde hair, red lips, tight clothes, high heels) generate meaning in their own right, but only in so far as they draw upon knowledge of other cultural texts and familiar assumptions about women's sexuality and intellect.

However, the idea of a stereotype suggests a fixed and simplified concept which is characterised by a rigidity and resistance to change. The articles in this section show how images of femininity are constantly being reworked in different ways. The example of the dumb blonde indicates how one particular stereotype of the sexual woman, while still being recognisable, has lost social currency and now appears mainly in residual forms. The question then is how to explain this double process by which sexual stereotyping persists and yet the defining characteristics of femininity change. As Kathy Myers argued in the previous section, there is a need to revise our analytic categories to take account of the power which the media has to constantly create new meanings.

By examining how sexuality has been defined in the past we can begin to understand what is at stake in the definition of femininity today, as well as the resistance of certain stereotypes to

change. Lynn Nead's work on nineteenth-century painting shows how its visual codes produced certain configurations of the erotic which helped to define and to 'police' the boundaries between respectable and unrespectable sexuality for women. By tracing the interaction between the production and reception of certain images of the 'fallen woman', she demonstrates their significance in the context of changing ideological debates and social policy in the latter half of the nineteenth century. The 'moral panic' over prostitution in the Victorian period has a clear resonance today, not only in relation to AIDS, but in the renewed debates about access to contraception and abortion, and over women's fertility. This suggests a need to investigate the mechanisms by which social, economic and political anxieties are displaced on to the sexual sphere. In nineteenth-century Britain the prostitute signified fears of social and public disorder which threatened to engulf the private world of the home. Her representation as the Magdalen, the repentant sinner, shows how an ancient and familiar religious image could be invoked in response to anxieties of the present. In the narrative of the fallen woman, the threat posed by unregulated female sexuality was finally resolved by her own death. In this way stereotypes in art function to contain or dispel social and psychic unease.

The reasons for the emergence of new representations of femininity are just as complex. The value of Janice Winship's analysis of young women's magazines in the 1980s is that it provides an analysis of a set of conditions in which a different kind of representation of sexuality could be produced. She specifies these conditions as the configuration of three very different elements: the social effects of mass unemployment on young women; a deliberate strategy on the part of magazine publishers to exploit a gap in the market; and the new cultural politics of the 1980s which were a result, at least in part, of the women's movement. Thus, the commercial interests of publishing lead to some accommodation with the changing cultural and social needs of a young female audience. The significance of this analysis is that it locates changing visual codes very precisely within a particular economic and ideological 'moment'.

Pratibha Parmar's discussion of media images of Asian women also places them within a specific context, that of changing ideologies of racism and imperialism in Britain. She argues that such images can only be understood in relation to a history of colonialism, of post-war immigration policies and of recent debates about race, each of which marks a shift in the way that Asian people are represented. But representations in the white press are not simply the effect of racist ideology or of state immigration policies, they help to form and to reproduce those ideological viewpoints. The way in which those media represent Asian women as victims of oppressive family structures reinforces

the racist view of the Asian way of life as a problem: Asian women are the visible sign of this difference in culture.

The second point to be made here is the way in which femininity is heterogeneously formed. Rather, perhaps we should speak of 'femininities', which are differently defined according to class and to race. Clearly, as Parmar shows, Asian women's sexuality is represented differently from that of white, western women. The contradictory stereotypes of the submissive, traditional wife and the sexually exotic Oriental lover articulate femininity in ways which are racially specific. It is the conjunction of discourses on race and class, as well as on gender and sexuality which determine the visibility of black women in representation. Images in the white media in Britain may be *about* black women but they almost always address a white majority audience, they do not speak to the women themselves.

Patricia Holland suggests that *The Sun*'s Page Three is a bit more ambivalent in its address, at least when it comes to gender. While obviously intended for men, the image of femininity which *The Sun* newspaper offers is one which invites women to enter as willing participants into the male-defined world of heterosexual pleasure. This, she suggests, is linked to *The Sun*'s attempt to claim and mobilise a working-class identity which, stripped of class politics, history and struggle, is redefined in terms of leisure and consumption. The Page Three 'girl' represents women as actively (hetero)sexual and invites them to join in with the boys, but always on the boys' terms. While many women object violently to *The Sun*'s exploitation of sexuality and of the female body, Holland points to the ways in which it attempts to define femininity *and* class, and to construct its readership on that basis.[2] It is precisely the moaners and spoilsports, such as feminists, to whom *The Sun* is *not* speaking.

Holland, like Winship, argues for a more complex account of the kinds of address which the mass media make to their audience. By paying attention to women as the readers and viewers of images, both offer a way out of the over-simplified dichotomy in some feminist writing between 'man the exploiter' and 'woman as victim'. While recognising that power relations are involved in the depiction of women's bodies by men, both analyses would suggest that such images can be read in contradictory ways and that *how* we read them depends on class and age, as well as on gender positions. The issue which this raises is quite a difficult one for feminism. For if, on the one hand, women have asserted objections to particular kinds of imagery on the basis of shared experience as a gender group, we also have to recognise that that experience is not necessarily formed or understood in the same way by all women. The implication is that 'sexism' is not something we can all identify immediately or unproblematically. Differences in class, in race

and in age produce different understandings of what oppression is and how it is manifested. Thus, Winship argues that for young women in the 1980s the soft-porn connotations of the 'Undercoats' image, simply do not mean the same as for an older generation of feminists of the 1970s. Times have changed, and with them the kind of readings which women make of images.

In her discussion of the changing codes of femininity of young women's magazines, Winship raises what seems to me to be ultimately a crucial question: whether new erotic codes can be created which do not in some way draw upon existing ones.

These essays show that this question can never be answered in the abstract. Lisa Lyon's image as a female bodybuilder points to the formation of a new feminine stereotype in the 1980s. Physically powerful and sexually confident, the image is linked to current obsessions with workouts, health and physical fitness in western culture. But, as Susan Butler points out, Robert Mapplethorpe's photographs of Lisa Lyon present a profoundly ambivalent image for women. On the one hand they demonstrate the potential for female strength and action, on the other, the traditional attributes of feminine beauty and the glamour of the *femme fatale*. Rather than radically subverting the visual codes of femininity, Mapplethorpe fashionably reworks them. This shifting of codes is less the result of 'unfixing' sexual difference, than a recuperation of potentially disrupting and disturbing images in the aesthetic forms of art photography.[3] Yet, the representation of feminine strength and power has potential for a radically different kind of imagery for women. As Winship suggests, current images which blend elements of masculine and feminine do offer at least the possibility of disrupting or redefining traditional gender roles. While heterosexual identity is still privileged, such images may open up a cultural space in which our definitions of gender can begin to become more fluid.

# Notes

1  Tessa E. Perkins, 'Rethinking Stereotypes' in Michèle Barrett, Philip Corrigan, Annette Kuhn and Janet Wolff (eds), *Ideology and Cultural Production*, London, Croom Helm, 1979, p. 141. See also Richard Dyer, 'Stereotyping' in Richard Dyer (ed.), *Gays and Film*, London, British Film Institute, 1977.

2  A bill was introduced in the British Parliament in Spring 1986 by the Labour MP Clare Short in which she sought to ban Page Three nudes from newspapers completely. Although the bill has not been passed, in the weeks that followed her speech Clare Short received between three and four hundred letters each day from women who overwhelmingly supported her views.

3  Elizabeth Wilson makes a similar point about the way in which current fashion plays with the distinctions between masculinity and femininity:

'Fashion permits us to flirt with transvestism, precisely to divest it of all its danger and power.' Elizabeth Wilson, *Adorned in Dreams*, London, Virago, 1985, p. 122.

Lynn Nead

# The Magdalen in modern times:
## the mythology of the fallen woman in Pre-Raphaelite painting

In a review of the recent wave of films and TV serials on the subject of the British Raj, Salman Rushdie commented:

> I am trying to say something which is not easily heard above the clamour of praise for the present spate of British-Indian fictions: that works of art, even works of entertainment, do not come into being in a social and political vacuum; and that the way they operate in a society cannot be separated from politics, from history.[1]

It is a simple point but a crucial one, and provides the framework for my discussion. In this paper[2] I want to establish the way in which paintings and other forms of cultural representation participated in the definition of sexual behaviour and 'respectability' during the nineteenth century.

The fallen woman has long been recognised as a popular theme for artists and writers during the nineteenth century. Indeed, this recognition has been built into the monolithic edifice of 'Victorian morality'. It is a well-established and familiar concept: those repressive and hypocritical Victorians, publicly advocating strict codes of chastity whilst privately endorsing a massive system of prostitution and pornography. Art historians have been content to notice the proliferation of the fallen woman in Victorian art and to confine themselves to narrow questions of artistic influence and iconographic development. They have struggled to identify the literary and pictorial sources of particular paintings and to establish the first artist in the nineteenth century to depict a modern fallen woman.[3] Whilst these questions have a limited local interest, the answers they provide have nothing to do with history. The works of art have been successfully kept in a social and political vacuum penetrated only by art or artists.

From *The Oxford Art Journal*, vol. 7, no. 1, 1984.

73

This paper seeks to relocate images of women in Victorian High Art within a specific history, that is, the history of sexuality; and to demonstrate that these paintings *actively* constructed meanings, values and morals. The discussion will not be confined to Pre-Raphaelite painting, but will examine a range of images produced during the middle decades of the nineteenth century.

It is a commonly held belief that sexuality is an overpowering natural force, that it is instinctive and innate. It is believed to be biologically determined and is regarded as the most basic and fundamental drive in the human animal. This understanding of sexuality is known as 'essentialism'. The concept of 'essentialism' has been fundamentally challenged by the theory that sexuality is historically constructed, that it has historical conditions of existence and is socio-culturally determined. Using this theory it is possible to identify the particular construction of sexuality in Victorian society and to understand the meaning and significance given to the sexual at this time. In *The History of Sexuality*, Michel Foucault rejected the notion that the history of sexuality in the nineteenth century could be seen in terms of 'repression' and suggested instead that sexual behaviour is organised through mechanisms of definition and regulation.[4] Thus in the nineteenth century sexuality is organised through the definition of a norm of social and sexual behaviour and of forms of deviancy – the categorisation of respectable and non-respectable practices and the differentiation between licit and illicit sex. Rather than seeing the Victorian age, therefore, as a period of silence and suppression regarding sex, we must begin to understand the nineteenth century in terms of a constant and persistent definition and re-definition of acceptable sexual behaviour.

The most central form of sexual categorisation is along lines of gender. Sexuality has been constructed for men and women in terms of difference. The male sexual urge is thought of as active, aggressive and spontaneous, whilst female sexuality is defined in relation to the male, and understood as weak, passive and responsive. The categories 'masculine' and 'feminine' have been defined on the basis of biological differences but are reinforced through medical, legal and other social practices. In the nineteenth century, with the establishment of the new medical profession, a whole field of inquiry into sexuality was opened up, a field which carried the status of a science. The new medical specialists asserted that women were entirely dominated by their reproductive systems.[5] There were many competing and conflicting ideas concerning the question of female sexual desire, but many experts agreed that the respectable woman did not experience sexual drives and that her pleasure and desire for sex (if at all) was for the pleasure of reproduction and satisfying her partner.[6] The man, on the other hand, was seen to have a natural and healthy desire for sex. It was a double standard of morality –

sexual desire was regarded in the man as normal and unavoidable, but was seen in the woman as deviant and pathological.

Female sexuality was thus defined in terms of a central opposition between the pure and the impure woman, the madonna and the magdalen, and it is this differentiation between the feminine ideal and the fallen woman which I will examine in this paper. The feminine ideal was the central term, the cultural norm, against which all other forms of female sexuality were defined as unnatural and deviant. It worked to regulate sexual behaviour and to define a class-specific notion of 'femininity'.

The feminine ideal was defined in terms of woman's roles within the nuclear family as mother, wife and daughter. As such, women were regarded primarily as domestic creatures and this definition of femininity must be understood in relation to the emergence of the industrial middle-classes at the end of the eighteenth century.[7] The formation of distinct gender roles and the ideologies of home and family were part of the creation of a middle-class moral and cultural identity. The domestic ideal was an expression of class confidence, signalling the moral superiority of bourgeoisie in comparison with the immorality and vice of the aristocracy and the working-classes. The values of domestic life were defined in terms of 'health' and 'respectability' – marking off those outside this category as deviant and dangerous.

The cult of domesticity developed with the separation of the home and the workplace during the late eighteenth century and early nineteenth century. As businessmen and tradesmen became more wealthy they desired a geographically and socially separated space for work and for the home. Rather than the home being above the business in the town centre, with the women of the family engaged in commercial *and* domestic activities, businessmen began to move out of the city, investing in new suburban homes and travelling daily into the city to the place of work. The separation of work and home had profound effects on the construction of gender roles. Increasingly, women were defined as domestic beings, 'naturally' suited to duties in the home and with children, whilst men were associated with the public sphere – the world of business and politics. The comfortable suburban home with dependent women was an index of material success and social position. As well as the notion of separate spheres of activity, the bourgeois home was also defined in terms of leisure and privacy in opposition to the sphere of work and public life.

The ideal of the stable family home was central to middle-class culture. Family and sexual order were metaphors for social order: breakdown in the family structure was understood in terms of a total social disintegration. The family home was identified as the nucleus of the state. As W. Lecky wrote in *The History of European Morals* in 1869:

[the home is] the central and archetype of the state, and the happiness and goodness of society are always in a very great degree dependent upon the purity of domestic life. (p. 299)

The family home was regarded as permanent, ordered and unchanging in contrast to the transience and chaos of modern city life. The huge, impersonal city was simply a 'place' and relationships in the city were isolated, lonely and anonymous. The crowds of homeless, hungry and displaced people could so easily turn into a 'mob', and the city was seen as the breeding-ground of revolution, disease and moral corruption. The meanings which were attached to the cult of the home must be understood in terms of the fears and anxieties which were felt concerning the city – the breakdown of traditional class relations and the rise of new class conflicts. The home was defined as the basis of moral and social order. It was the source of values and emotions which were nowhere else to be found, least of all in commerce and urban society. The image which was deployed most frequently in representations of the home was that of the haven or shelter. Insulated from the trials and temptations of the 'outside' world, it was the place of peace for the man who took the risks outside the sanctuary in the city. The construction of the feminine ideal was part of this ideology of home – woman presided over the haven and it was her duty or 'mission' to make the home comfortable and to keep out corruption and threat. The purity of the home was understood in terms of its difference to the immorality and danger of the streets. If the home was the site for the definition of normal, 'respectable' sexuality, then the streets were the site for the production of deviant forms. The public streets were the domain of the fallen, the promiscuous, the diseased and immoral.

In what ways, then, do paintings produced during this period for middle-class consumption take part in this process of definition and the formation of domestic ideology? Throughout the nineteenth century one of the most persistent debates around art practice concerned the necessity for a distinctly English school of painting, a national school of art which could surpass those of the rest of Europe. Critics argued about which type of art should constitute the English school. Although history painting was at the top of the hierarchy of subject-matter, some argued that it was in the smaller-scale and more familiar images of daily domestic life that the English painters excelled. It was a question of a national school of art devoted to representing the outstanding qualities of English moral life. The development and encourage-ment of domestic genre painting in the middle of the nineteenth century must be recognised as part of the formation of domestic ideology. Visual representations of the home were simply one element in a network of forms which produced for men and women of the middle classes a perception and understanding of

respectability, class and gender. Scenes of domestic ritual and activity gained steadily in popularity; in 1852 *The Spectator* added the category 'Domestic Pictures' to its review of the Royal Academy summer show in order to accommodate the increasing number of paintings on this subject. The values of English domesticity and English paintings of domestic life were conflated. In a review of the 1863 exhibition, published in the *Art Journal*, one writer proclaimed:

> England, happy in her homes, and joyous in her hearty cheer, and peaceful in her snug firesides, is equally fortunate in a School of Art sacred to the hallowed relations of domestic life. (p. 110)

George Elgar Hicks's triptych called *Woman's Mission* was exhibited at the Royal Academy of 1863 (no. 467). The title *Woman's Mission* was significant: the term was a heavily loaded and familiar concept, re-activating all the associations of duty and fulfilment, the respectability and moral purity of the feminine ideal. The picture was divided into three separate compartments each of which was devoted to one of the roles performed by the feminine ideal. The three scenes represent woman as mother, woman as wife, and woman as daughter. The three roles are constituted as separate and distinct but collectively they are seen to define respectable femininity. 'Woman' is offered as a unified and coherent category through the fulfilment of her domestic duties and mission.

The central picture of the series was called *Woman's Mission: Companion of Manhood* (Figure 24). The woman is shown comforting her grief-stricken husband who holds a black-edged letter in his hand. They are located in a comfortable, well-furnished middle-class parlour. The woman's respectability is signified by her appearance. Her hair is carefully arranged and she wears a neat, modest brown dress. The wife's fulfilment of her domestic duties is signified by the ornaments on the mantelpiece, the shining coffee-pot and the carefully arranged letters on the table. Although grieving, the husband stands upright and tries to hide his emotion by covering his face whilst his wife holds on to his forearm and shoulder and leans on him at an angle. The woman's posture signifies a mixture of support and dependency. She looks up at her husband with concern in a pose which emphasises the white curve of her neck (a heavily coded sign of femininity). Although the man is weakened there is no sign of a shift of dependency. He checks and controls his feelings; she offers her support but at the same time confirms her subordination to him. All the visual signs in the disposition of these two figures constitute the man as strong but temporarily weakened, and the woman as supportive, comforting and responsive. Norms of masculinity and femininity are constructed in this image. To use a much-repeated Victorian metaphor, he is

77

24 George Elgar Hicks, *Woman's Mission: Companion of Manhood*, 1863, London, Tate Gallery.

the oak and she is the ivy. Just as the ivy needs the support of the tree in order to grow, so a wife depends on her husband, and in the same way that the ivy may hold up the tree when it is weakened, so a wife is able to assist her husband when he is afflicted. Although it is possible for the woman to administer aid to the man, she is totally dependent on his strength and support to develop.

The two flanking compartments showed the woman as mother and daughter. (These are now known only through the preparatory oil sketches in the collection of Dunedin Public Art Gallery, Dunedin, New Zealand.) In the first image called *Woman's Mission: Guide to Childhood*, the young mother is shown leading her child along a thickly wooded path. The woman is defined as both physical and spiritual guide to childhood as she pushes aside the brambles in her son's path (with its Christian

connotations of the path of life) and bends over the child, her arms encircling him protectively.

The final compartment called *Woman's Mission: Comfort of Old Age* shows the same woman attending her sick father. The old man is seated in a high-backed armchair. His head rests on a pillow and he is covered with a blanket. The woman is shown in the process of giving her father a glass of water. She leans across from her seat, her right arm stretched across his frail body. Her left hand holds on to a book which she may have been reading aloud to the invalid. The old man looks up weakly at his daughter as she attends him.

The three images show the *same* woman with three different men – her son, her husband and her father. In other words, she is defined through her relationships to these men. Furthermore, whilst the woman is fixed in all three images at the same stage in her life – an optimum age when she can fulfil all three roles of young mother, dutiful wife and caring daughter – man is shown to mature and age. It is *his* life-cycle from childhood to old age which structures the narrative of the triptych and which defines woman's domestic role and duties.

Through *both* form *and* content *Woman's Mission* offered the Royal Academy viewer a realistic image of Victorian domestic life. In *Visible Fictions* (1982), John Ellis identifies realism as a question both of artistic construction and audience expectation, and outlines the general requirements of a 'realistic' representation. Hicks's triptych mobilises many features of classic realism. There are no unexplained gestures or details; costume, location and props are contemporaneous and accurate; actions are motivated through signs in the image; and the painting explains itself adequately to its audience. Through these conventions the picture constitutes a public response. *Woman's Mission* places its middle-class audience in a position of moral judgement – to perceive the 'truth' and 'rightness' of its representation of femininity, and to recognise female virtue. This construction of a public morality operates through a negotiation of commonsense ideas. The picture re-forms and re-works already familiar moral values and social relationships, and it is this recognition of the familiar which the spectator deems 'realistic' in the images.

One of the functions of the middle-class wife was to establish a household which would signify the status and respectability of her husband and demarcate their class position. This class identity was understood in terms of its difference to the classes above and below it. Sexual respectability expressed the interest of the middle class. The working class was perceived as the social other and the reports of the Parliamentary Commissions of the 1840s and 1850s show an obsessive concern with the immorality of the working-class. The moral state of the working-class was partly attributed to their physical conditions, and the economic and

political implications of slum housing and sanitation were displaced onto questions of morality in public health legislation of the period.

Attitudes to working-class women were highly contradictory. Whilst on the one hand they were believed to be unnatural and unfeminine as a result of work outside the domestic sphere, on the other hand there was an attempt to bring the masses into accord with bourgeois morality – a process of social colonisation which produced a particular working-class version of the feminine ideal.[8] After all, social stability had to be perceived at all levels of society and this necessitated a role model for the working-class wife. The working-class model was defined in terms of her piety, thrift and conscientiousness, but, above all, she could not display aspirations above her class in either her personal or domestic adornment. George Elgar Hicks's picture *The Sinews of Old England*, 1857 (Figure 25), defines the feminine ideal on a working-class scale. The man depicted in *The Sinews of Old England* is a navvy. However, the title and the setting belong to the conventions of the rural genre painting and re-activate the connotations of the health, peace and morality of the English countryside. The image depicts the manual labourer in terms of a timeless and natural rural idyll. The man, dressed in his working clothes, stands in the doorway of a cottage. He stands squarely and firmly and carries a pick-axe over his shoulder. He places his left arm around the waist of his young wife and stares straight ahead, his jaw firmly set, determined and strong. The wife stands next to her husband, the front of her skirt is tucked up and her sleeves are rolled up, indicating that she too will be working. She is pretty and strong, with muscular arms and a ruddy complexion. These signs are essential, they connote the *difference* between this woman and the *middle-class* ideal in *Woman's Mission*. They reassure us that this working-class woman is respectable but different from the middle-class woman. The *differences* are vital, for they provide the point of closure between the middle class and the class below it. The woman clasps her hands on her husband's shoulder and looks up at him devotedly. The different directions of the looks of the man and woman signal their different spheres of activity. The man gazes out and ahead with an almost religious intensity – his work is in the public sphere. The woman's gaze is directed at her husband – her activity is devoted to the domestic sphere and her dual roles as wife and mother. On the man's right is a small child who plays with a toy shovel (a reminder of father's pick-axe and work) whilst the other hand is clasped around the father's leg. There is an insistence on physical contact between the members of this nuclear family, a sequence of gestures which declares the strength and intimacy of the group.

The doorway is lined with climbing plants, including vines which wind themselves around the wooden door-frame. Inside

25 George Elgar Hicks, *The Sinews of Old England*, 1857, Private collection.

the cottage there are shelves of traditional blue and white plates and a table covered with a white cloth and set with a cup and saucer.

Domestic ideology is re-defined in this image in terms of a specific construction of class. The future of England is seen to lie in the reliable and dependable male worker and his devoted and competent wife. The definition of class and gender are central to this representation of England's foundation and future. Class conflict and difference are entirely eliminated. The picture offers an image of unity and shared interests around the concepts of home and country.

In such ways, female sexuality was organised in terms of a

separation between the pure and the fallen. The term 'prostitute' was an accommodating category, it could define any woman who deviated from the feminine ideal and lived outside the middle-class codes of morality.

The prostitute became the focus for social concern by the middle decades of the nineteenth century. Prostitution was perceived as a threat because of its visibility. It was a public vice and contemporary accounts consistently emphasised the vast numbers, the armies of women, who seemed to swarm the streets of the major British urban centres. The prostitute stood for many as a symbol of the fears and anxieties of the period – fears concerning economic efficiency, political stability and the development of the empire. During periods of social crisis, anxieties were deflected or displaced on to questions of morality. Prostitution frequently became the focus during these moments of moral panic; at the time of the Indian Mutinies, for example, the police organised a campaign to clear London streets of prostitution.[9] This process of the deflection of social fears on to the arena of moral standards indicates the way in which national stability was believed to depend upon public morality. In this context the prostitute was perceived as a *folk devil*. She was an agent of chaos bringing with her disruption and disorder. Prostitution was described as 'the great social evil' which clearly suggests this fear of prostitution in terms of its social implications. Above all, the prostitute was regarded as a conduit of disease, specifically venereal disease, spreading infection and contagion to respectable society. It was anxiety about the moral and physical health of the armed forces and their subsequent military efficiency which led to the passing of the Contagious Diseases Acts during the 1860s. It is this network of fears which informs the following statement which was quoted in the introduction to volume 4 of Henry Mayhew's *London Labour and the London Poor* of 1862. The vehemence of the passage is typical of the hatred and guilt which lay behind middle-class attitudes towards prostitution:

> Who can tell the pestiferous influence exercised on society by one single, fallen woman? . . . Woman waylaid, tempted, deceived becomes in turn the terrible avenger of her sex . . . qualified to act her part in the reorganisation of society. The *lex talionis* – the law of retaliation is hers. The weight of this influence is untold: view it in the dissolution of domestic ties, in the sacrifice of family peace, in the cold desolation of promising homes; but above all, in the growth of practical Atheism, and in the downward trend of all that is pure and holy in life. (p. xxxix)

The writer traces the influence of the fallen woman firstly in terms of the destruction of the home, and then develops the

argument to the effects of prostitution on a national scale. Prostitution was believed to be spreading and encroaching on the 'respectable' world. Encouraging atheism and threatening property, the prostitute was an object of fear and moral detestation to the middle-classes.

One way of negotiating these fears and disarming the threat and power of prostitution was by defining the fallen woman as victim rather than oppressor. It is a fairly simple mechanism – if you feel sympathy rather than fear towards a social group, its threat is displaced. Pity deflects the power of that group and redistributes it in terms of a conventional paternalist relationship organised around social conscience, compassion and philanthropy.

The image of the prostitute as a wretched outcast, ravaged by feelings of remorse and shame, was part of this attempt to deflect the power and threat of prostitution. By defining the prostitute in terms of *her guilt* the question of sexual and economic exploitation was erased. Prostitution was discussed in a *moral* language of temptation, fall and guilt. The fallen woman was understood in terms of lost innocence. Having succumbed to temptation, and deviated from the virtuous norm, the fallen woman could not return to respectable society but was forced into a life of prostitution. Tortured by memories of her lost childhood innocence, the prostitute turned to drink to ease her conscience and suicide was the final act of this poor social victim. Through death, the prostitute could find salvation with Christ, which again comfortably removed any responsibility or guilt from respectable society. I am not arguing that this was the actual experience of prostitutes at the time, but rather that this was *one way* in which prostitution was understood and negotiated; it was a dominant *representation* of the prostitute in the middle of the nineteenth century. The following passage, published in 1850 in *The Westminster Review*, exemplifies this way of seeing the prostitute:

> If the extremity of human wretchedness . . . is a passport to our compassion, every heart should bleed for the position of an English prostitute, as it never bled at any form of woe before . . . the agonies of grief and terror she must have endured before she reached her present degradation; the vain struggles to retrieve the first, false, fatal step; the feeling of her inevitable future pressing her down with all hopeless weight of destiny; the dreams of a happy past that haunt her in the night-watches and keep her ever trembling on the verge of madness . . . the career of these women is a brief one; their downward path a marked and inevitable one . . . they are almost never rescued; escape themselves they cannot. (pp. 451, 454)

The details of this image of the guilt-ridden prostitute, ravaged by remorse, privation and disease and ending in an early grave, were repeated insistently, again and again. This stereotype was

constructed in a wide range of publications on prostitution from medical and evangelical texts, to parliamentary reports, novels, poems, paintings and plays – all propagated this myth of the tragic life and early death of the prostitute.

In a series of prints published in 1847-8 and primarily intended as a tract against alcohol, George Cruikshank depicted the consequences of alcoholism on a respectable home and family. *The Bottle*, and its sequel *The Drunkard's Children*, trace as one theme the career of the daughter of the alcoholic. In the first plate of *The Bottle* the happy family home is shown on the first occasion that the bottle is introduced by the father. The daughter is securely located within the private sphere, engaged in domestic duties. Her virtue is also signalled in her dress and appearance which are neat, tidy and modest. The bottle brings about the collapse of the home, and the family is forced out of the security of the private sphere into the public streets to beg for money for drink. The household furniture is sold to finance the alcoholic habit and finally the husband murders his wife in a fit of rage. In the final plate (Figure 26) the bottle is seen to have done its work: the father is a lunatic and the daughter, we are told by the caption, has turned 'to Vice and to the Streets'. This fall from

26 George Cruikshank, Plate VIII, *The Bottle*, 1847.

virtue is signified in the appearance of the girl. Her boldly contrasting outfit, short skirt, kid boots and feathered bonnet, are stereotypical components of the dress of the prostitute; a stereotype which connoted the flaunting and meretricious life of the fallen. In a second series, *The Drunkard's Children*, Cruikshank unravels her downward progress through gin-shops and low dancing-rooms until in the final plate, he shows us the girl's end (Figure 27). The caption to the plate reads: '... the poor girl, homeless, friendless, deserted, destitute and gin mad, commits self murder.' Cruikshank represents the mythology of the life and death of the prostitute – the steady downward progress, the guilt and desperation, poverty and homelessness, and the inevitable final scene – the suicide itself – as she throws herself from a bridge into the water of the Thames. What is significant is the way in which representations such as these were received publicly as an accurate reflection of the life of the prostitute. In an article published in the *Quarterly Review* in the same year that *The Drunkard's Children* was issued, the question of reclamation and the fallen woman was considered. Referring to the mortality rate amongst London prostitutes the author declared:

> Every reader of the newspapers knows well what a multitude of suicides thin every year the ranks of these unhappiest of all human creatures. Month after month, and week after week, the terrible truth of Hood's verse (and we may now add, of George Cruikshank's tragic pencil) is realized.[10]

Thomas Hood's poem *The Bridge of Sighs* (published in *Hood's Magazine* May 1844) and Cruikshank's prints are called forth as

27 George Cruikshank, Plate VIII, *The Drunkard's Children*, 1848.

*evidence* of the high rate of suicide amongst prostitutes. Through this mechanism, a certain set of *beliefs* is received as a set of *facts*. The illustrations assume the status of truth, they are 'read' as a description of the actual fate of the prostitute and ensure the perpetuation of the myth.

The image of the suicide by drowning was a major component in visual representations of the prostitute. Abraham Solomon's painting of a dead prostitute called *Drowned! Drowned!* was shown at the Royal Academy exhibition of 1860 (Figure 28). The scene is located on a bridge, over a river, at night. The composition is divided in two. On the left, a group of masqueraders flirt and laugh together in their flamboyant costumes; on the right, a group of people (including two fishermen and a flowergirl) gather round the body of a young woman. The two groups are linked by the male masquerader in the centre who stares at the girl in fear and horror.

The critics easily recognised the language of this image and outlined the familiar narrative in their reviews. The dead girl was a prostitute who had committed suicide and had been washed up under Westminster Bridge. Her fall was explained by the male masquerader who was identified as a seducer recognising the girl

28 Abraham Solomon, *Drowned! Drowned!*, ex. R.A. 1860 no. 478, engraving by J. and G.P. Nicholls, *Art Journal*, March 1862.

as a former victim of his cruelty. The critics warmed to the contrast between the misery and human suffering represented by the girl on the right and the licentiousness and degradation of the revellers on the left. The painting was regarded as a pictorial sermon which taught a Christian lesson, warning and reminding viewers of the wages of sin.[11]

Solomon works the familiar signs of the mythology and the painting calls forth from a potentially diverse and guilty audience a unified moral response. The image constructs meaning at a number of levels. It connotes the mythology of the prostitute through the pietà-like image of the drowned girl and sets up a second narrative through the figures of the flower girl, the flirting women, and the dead prostitute. Through these figures the stages of country innocence, fall, prostitution and decline to death are signified. The Royal Academy painting works to negotiate and displace contradictions around class and sexual respectability, it offers the viewer a complete and seamless affirmation of middle-class moral values. The special pleasure of these narrative genre paintings can thus be understood as a recognition for the viewer of a universal domestic ideal, and his/her individual placing in this coherent and non-contradictory world.

It is in the light of this discussion of mythology and the construction of the prostitute in terms of guilt and memories of lost innocence that I want finally to refer to two Pre-Raphaelite pictures: Dante Gabriel Rossetti's picture *Found* and Holman Hunt's *The Awakening Conscience*. I would like to make it clear, however, that I am not trying to attribute a single meaning to these complex and highly discussed pictures, but rather want to set them into the history of the regulation of sexual behaviour during the nineteenth century and the definition of the prostitute as an object of pity rather than threat.

Rossetti's painting *Found* was begun in 1854 and left unfinished (Figure 29). It shows the meeting of a country drover with his former sweetheart who has become a city prostitute. The subject of the meeting of the prostitute with a figure from her past works to activate the mythic associations of lost innocence, shame and the inevitable downward progress to a premature death. But Rossetti's picture works these themes in a specific way: it mobilises middle-class values concerning the morality of work; the health of the countryside versus the corruption of the city; and the physical signs of sexual deviancy.

*Found* depicts the appearance of the prostitute in a highly specific way. In a letter of 1873, Rossetti declared: 'the woman should wear something with a pinkish tinge . . . pretty, showy, but seedyish.'[12] The way in which Rossetti constructed this 'showy, but seedyish' appearance can be seen by examining the preparatory sketches and the oil painting. Through a sequence of drawings Rossetti experimented with the style and position of the

29 Dante Gabriel Rossetti, *Found*, begun 1854, Wilmington, Delaware, Samuel and Mary R. Bancroft Memorial Collection, Delaware Art Museum.

30 Dante Gabriel Rossetti, Study for *Found*, 1853, Trustees of the British Museum.

hair and bonnet. In the study dated c. 1853-7, the straight hair is neatly tied back and the design of the bonnet is simple. However, in a later sketch the hair is wilder and curlier, the bonnet is more showy and tied with a large ribbon and the woman wears an earring. Rossetti developed this appearance further in the oil painting – the bonnet, fluted and pleated with a large ribbon and feather, is thrown back as the prostitute turns her head in shame. The changes which Rossetti made to the prostitute's clothes as he worked on *Found* indicate the elements which constituted the seedy stereotype of the prostitute. Comparing the finished drawing, dated 1853 (Figure 30) to the oil painting, it can be seen that the shawl was changed from plain black to a pale, patterned mantle with bedraggled silk fringing. The material of the dress was altered from white to the rose pattern with gathering at the sleeves and neck. Thus, through a shift from simplicity and plainness, to pattern and showy detail and texture, the faded finery and seedy gaiety of the prostitute is signified. The prostitute is on her decline to death – her clothes signal that she has seen better days, they are now soiled and too flimsy for walking the streets.

The faded, gaudy clothes of the prostitute were believed to represent the artificiality and corruption of modern city life and offered an obvious contrast to the simplicity and honesty of the *country* person. Prostitution was regarded as a city vice and was part of the discourse of the dirt and disease of the city versus the

health and spiritual soundness of the country. *Found* constructs this juxtaposition of city versus country through visual contrasts: the garish, vulgar appearance of the prostitute is juxtaposed with the simple rustic garb of the country drover. His pale coloured smock and gaiters connote rural tradition and unchanging ways of life in contrast to the artifice of the city prostitute. The honesty of the countryside is also indicated in terms of the morality of work. Work was seen to be man's way out of the darkness of doubt to light and clarity, and work belonged to the day.[13] In *Found* the drover has begun his work with the first light of day – he follows a Christian and a natural cycle. The prostitute sinks to the pavement in shame, she has been wandering the streets at night, she is deviant and unnatural and her end is suggested by the bridge in the background. Her guilt may drive her to suicide and through the act of suicide, the prostitute is drained of her power and threat and is constituted instead as an object of pity and compassion.

*The Awakening Conscience* received a mixed reception when it was exhibited at the Royal Academy in 1854. Those critics who praised the painting valued it for its didactic intention; like Solomon's picture *Drowned! Drowned!*, *The Awakening Conscience* was described as a lesson and a sermon in paint. The symbolic details in this image of a kept woman and her lover have been discussed at length elsewhere and need not be repeated here.[14] However, the picture demands far greater analysis in relation to its construction of gender, class and sexuality.

In those reviews which admitted to understand the narrative of the picture, the woman was generally discussed as a victim of seduction. The man had tempted her and she had fallen. It was assumed that she *had been* innocent prior to this relationship and was thus a victim of the man's cruelty. In an account of the picture published in 1860, F.G. Stephens identified the rank of this man very specifically. He described 'a man, a showy, handsome tiger of the human species, heartless and indifferent as death. One of his patrician arms surrounds the victim of his passions.'[15] The term 'patrician' is highly significant, it identifies the man specifically as a nobleman, an aristocrat. The picture is thus read as a critique of aristocratic morality and sexual behaviour and the woman is seen as a passive victim of this predatory licentiousness.

*The Awakening Conscience* is part of a formation of bourgeois morality. It defines sexual deviance in terms of its difference to the domestic norm of middle-class marriage and home. Critics emphasised the *absence* of signs of domesticity in the interior. It was new, flashy, vulgar and unused, it lacked the rich moral associations of the bourgeois domestic ideal. The immorality of the gentleman and his mistress has infected the inanimate objects which surround them. The critic for *The Athenaeum* described the

furnishings as 'unconsecrated to the domesticities by long use',[16] and in his explanatory letter to *The Times* describing the symbolic meaning of the picture, John Ruskin could identify 'nothing there that has the old thoughts of home upon it, or that is ever to become a part of home?'.[17] Home, it should be clear by now, is *not* an empty term but is laden with moral connotations – it signifies moral purity, private and public virtue and ultimately national stability.

The meaning of any given picture is not a fixed quality which is contained within the picture and which may be uncovered by scraping away at the surface of the canvas. Meaning is constructed through a circulation between the viewer, the picture and the social formation. Certain meanings are more 'apparent' and 'obvious' in relation to the current dominant ideology.[18] *The Awakening Conscience* offered the spectator an obvious meaning in relation to the dominant myth of the prostitute. The woman has risen from her lover's lap because a song has reminded her of her lost childhood innocence. This is a familiar concept and becomes the key element of the picture in a review published in *The Magdalen's Friend and Female Homes' Intelligencer* in 1862. The writer packs out the image with additional meanings and values, commenting:

> Poor child! Poor child! Your mother! you thought of her first, you know; and then the little cottage, and the shady lanes, and the still valley with the river, and the bit of garden, and the wide hayfields, and the cowslip glade and the foxglove banks![19]

The meaning of the picture is shifted into the dominant values of country versus city. The girl's innocence is located in the healthy, green fields of the countryside, her guilt and shame are part of the city's corruption and immorality.

And so what of the consequence of the girl's awakened conscience? Describing the significance of the details in the painting, Ruskin maintained:

> . . . the very hem of this girl's dress, which the painter has laboured so closely, thread by thread, has a story in it, if we think how soon its pure whiteness may be soiled with dust and rain, her outcast feet failing in the street.[20]

This is a significant comment. It reads the picture firmly in terms of the dominant myth: the downward progress, the appearance of the declining prostitute, and the final, tragic end. This does not mean that *The Awakening Conscience* is a pessimistic image. The frame, which was designed specifically for the picture, shows a frieze of alternating bells and marigolds, which symbolise warning and sorrow. But directly above the woman's head is a star – the symbol of Christ's redemption. Having recognised her guilt, the woman must follow her inexorable earthly fate: she cannot simply

return to respectable society, but through recognition of her sin she may find salvation with Christ. I am not claiming that this is the single and exclusive meaning of *The Awakening Conscience*; however, I want to suggest, in the light of my preceding discussion, that it is the reading which would have been most apparent for the spectator at the time of its exhibition in the middle of the nineteenth century.

In this paper I have tried to show the way in which paintings such as *The Awakening Conscience* must be understood as part of the much wider process of the categorisation of acceptable and unacceptable sexualities during the nineteenth century. To keep these images within the parameters of a history of Pre-Raphaelitism is to miss most of their social and historical significance. During the nineteenth century sexuality became a focus for social concern. National stability was believed to depend upon private and public morality. The middle-class family became the site of respectable sexuality and the feminine ideal of mother, wife and daughter was the norm for female behaviour. Women who lived outside this code of morality were defined as deviant and unnatural. The prostitute was a paradigm of the threat of disruption to modern industrial society, but these anxieties could be deflected by defining the prostitute as a victim and in terms of a mythology of her tragic life and death. The importance of this kind of history is not only to understand the way in which behaviour has been regulated in the *past*, but also to alert us to the way in which sexuality is defined today. To be aware of the ways in which contemporary visual representation, in the forms of film, television, advertising and high art, work to define normal and deviant social behaviour. We have to recognise the current definitions and functions of the family and the recent wave of moral panics around AIDS, herpes, video nasties and the contraceptive pill. Through examining the regulation of sexuality in the past it is possible to understand the ways in which economic, political, moral and cultural definitions map on to each other. This history will help us understand the specific configurations and the significance of the sexual today.

# Notes

1 Salman Rushdie, 'The Raj Revival', *The Observer*, Sunday, 1 April 1984, p. 19.
2 This paper was presented at the Tate Gallery, London, in April 1984.
3 These interests are most clearly demonstrated in Christopher Wood's chapter on 'The Fallen Woman' in *Victorian Panorama. Paintings of Victorian Life*, 1976. However, a more subtle and intelligent version of the approach can be seen in Linda Nochlin's article 'Lost and *Found*. Once More the Fallen Woman', *The Art Bulletin*, March 1978, pp. 139-53.
4 Michel Foucault, *The History of Sexuality*, Volume 1; *An Introduction*, 1979. For a clear account of theories of sexuality and the meaning given to

sexuality in Victorian society see Jeffrey Weeks, *Sex, Politics and Society. The Regulation of sexuality since 1800*, 1981.

5  See, for example, Samuel Ashwell, *A Practical Treatise On the Diseases Peculiar to Women*, 1844; R.B. Carter, *On the Pathology and Treatment of Hysteria*, 1853; Edward Tilt, *Elements of Health, and Principles of Female Hygiene*, 1852 and *The Change of Life in Health and Disease*, 2nd ed. 1857.

6  The best-known example of this argument is William Acton, *The Functions and Disorders of the Reproductive Organs*, 4th ed. 1865, pp. 112–13. And see also W.R. Greg, 'Prostitution', *The Westminster Review*, vol. 53, 1850, pp. 456-7, 459; W.W. Sanger, *The History of Prostitution*, 1859, p. 19; Bracebridge Hemyng, 'Prostitution in London', *London Labour and the London Poor*, vol. 4, 1862, p. 212.

7  The best discussion of gender and class formation is Catherine Hall, 'The Butcher, the Baker, the Candlestickmaker: the Shop and the Family in the Industrial Revolution', *The Changing Experience of Women*, E. Whitelegg and M. Arnot (eds), 1982, pp. 2-16. And on the ideology of 'separate spheres' see Catherine Hall, 'Gender Division and Class Formation in the Birmingham Middle-class, 1780-1850', *People's History and Socialist Theory*, Raphael Samuel (ed.), 1981, pp. 164-75.

8  On the attempted colonisation of the working class see J. Weeks, *op. cit.*, pp. 32-3.

9  For discussion of the mechanism of the 'moral panic' see Stan Cohen, *Folk Devils and Moral Panics*, 1972.

10 'Female Penitentiaries', *The Quarterly Review*, vol. 83, 1848, p. 376. This passage was cited by William Logan in his report on prostitution *The Great Social Evil*, 1871, p. 167. Clearly the poem and prints were important and durable factors in the circulation of the myth of the fallen woman.

11 For reviews of this kind see *The Literary Gazette*, 12 May 1860, p. 586; *The Magdalen's Friend and Female Homes' Intelligencer*, June 1860.

12 Dante Gabriel Rossetti letter to Treffry Dunn. Cited A.I. Grieve, *The Art of Dante Gabriel Rossetti. 1. Found 2. The Pre-Raphaelite Modern-Life Subject*, Norwich, 1976, p. 9.

13 The New Testament provided a paradigm for the association of daylight with work, honesty and virtue: 'Work while it is called Today; for the Night cometh, wherein no man can work' (2 Timothy, IV. 5). Thomas Carlyle quoted this passage in *Sartor Resartus*, 1834, and it was also cited by Lieutenant Blackmore, *The London by Moonlight Mission*, 1860. The night was seen as the domain of the vicious and evil, see J.B. Talbot, *The Miseries of Prostitution*, 1844, p. 3: 'Evil which lurks in, and loves darkness, dreads nothing so much as the broad and unclouded daylight of virtue and morality, and in the sunshine of religion hides its diminished head.' The prostitute was seen as the leading edge of the feared intrusion of the 'night side' of the city into respectable life.

14 For discussion of the symbolism of *The Awakening Conscience* see Judith Bronkhurst's catalogue entry on the picture in *The Pre-Raphaelites*, Tate Gallery, London, 7 March-28 May 1984, No. 58

15 F.G. Stephens, *William Holman Hunt and His Works; A Memoir of the Artist's Life, with Description of his Pictures*, 1860, p. 32.

16 *The Athenaeum*, 1 May 1854, p. 561.

17 John Ruskin, Letter to *The Times*, 25 May 1854.

18 For discussion on the construction of meaning in classic realist texts see Catherine Belsey, *Critical Practice*, 1982, pp. 68.

19 'The Awakened Conscience', *The Magdalen's Friend and Female Homes' Intelligencer*, vol. 2, 1862, p. 268.

20 John Ruskin, *op. cit.*

Pratibha Parmar

# Hateful contraries:
## media images of Asian women

A discussion of the imagery of Asian women in the media has to start from a recognition of the multiple nature of Asian women's oppression and exploitation in British society. Images of Asian women will be explored within a framework which distances itself from discourses on representations which grant images an autonomy and independence, by bracketing them as separate entities.

The baseline of this article is that images of Asian women are very much rooted in, and locked into, the political and social systems of domination and cannot be divorced from the processes of struggle that Asian women are involved in.

While we will argue that the visual construction of Asian women in the television and newspaper media is sited in a particular ideology of power and control related directly to our race, gender, and class positions, this has to be grounded in a more general discussion of the shifts in representations of Asian people as a whole.

Images of Asian women intersect with and against a background of a variety of 'taken-for-granted' images of Asian people formed well before the 1950s and 1960s, when Asian migration to Britain was in any way significant; they have their historical roots equally in the encounters of the British Raj during the heyday of the British empire as well as in pre- and post-war Britain. Images of Asians which were created within imperialist social relations were those of Asians as 'coolies', 'servants', 'ayahs' and 'incompetent natives' on the one hand, and rich but childlike maharajahs eager to part with their jewels and wealth to the British royalty on the other.[1]

The British encounter with India meant that more than just images of 'starving beggars' and servants and rich maharajahs were brought back; the British upper classes brought back Indian cooks and ayahs, while the Royalty indulged by adopting 'poor little Indian princesses and princes'. The circumstances in which East Indians were brought to England as domestics in the eighteenth century were very similar to those in which the majority of African blacks were imported from the Caribbean Islands.[2]

From *Ten.8*, no. 16, 1984.

93

The legal status of most Indian domestics corresponded exactly to that of the majority of Africans. They were completely at the disposal of their masters, and like Africans, they were bought and sold freely on the open market. Thus in *The Tatler* of 9-10 February 1709, the following advertisement appeared: 'A Black Indian Boy, 12 years of age, fit to wait on a Gentleman, to be disposed of at Denis's Coffeehouse in Finch Lane near the Royal Exchange.'[3]

The East Indian Company had provided wealth to many civil and military officials, who returned home to establish themselves in luxury and often brought over Indian servants with them. The reasons for this was often that the difficult and arduous journey by sea from India back to England was made less arduous by the ministrations of servants. Also, some of these officials had a desire to enjoy at home the same free labour that had been available abroad.

Many Indians were often abandoned once colonial families landed in Britain, and in 1786 the plight of the black poor escalated as many of them were forced to wander the streets and beg for food. There was public moral outrage at the existence of this 'black problem' on the doorstep and the predictable response of charity and pity was evident in the newspapers of the day. For instance, *The Morning Chronicle* of 26 December 1786, reported:

> considering them as foreigners, independent of any service they have
> rendered us by navigating our vessels, trading to the East Indies, I
> think they have a claim to our patronage and hospitality, in the
> condition in which they are at present permitted to roam about this
> opulent city, unnoticed and unrelieved, without a coat to shield them
> from the extremity of the weather, a shoe to preserve their feet from
> disaster, or even money to purchase sustenance sufficient to allay the
> griping pangs of hunger and thirst, with silent gesture and tears,
> signify the poignancy of their afflictions.[4]

This description is a familiar one and strongly resonates with the media's representation of Third-World people today, who are still mostly presented as picturesque exotica, as starving beggars, as natives fighting each other, or as perpetual victims of calamities, usually of their own making and incompetence. In the daily newspapers the Oxfam ads and photographs of people and events in the Third World incite a relationship to Third World people of charity and pity. The problem of documentary-style photographs is that they are treated as a kind of evidence or testimony, which like a 'window on the world' reveals the truth about the events or scenes depicted, and thereby reinforces the viewer's commonsense racist acceptance of poverty and under-development as expressions of a 'natural state of affairs' rather than as the outcome of centuries of imperialism and colonial domination. Photography is a powerful instrument for deperson-

alising our relationship to the world, so when Sunday colour supplements carry reports of war, poverty, hunger and over-crowding in Third-World Countries, it is not seen or consumed as anything to do with 'here and now' but 'out there' – therefore unreal and distant. So while photography can arouse emotions, it can also often end up neutralising emotions depending on the mode in which it is represented.

This is in sharp contrast to the role the media has historically played in relation to the development and orchestration of the public's response to the black presence in Britain. However, the media do not merely reflect the objective reality of social relations but actively construct accounts which are deeply ideological in character. One general feature of this ideology, for instance, is the way the media produce a form of news which is in fact based on the values of drama, entertainment, and the spectacle of news photography. Pat Holland has shown quite forcefully how this specific ideology of racism characterised Press coverage of the New Cross fire in which 13 black youths died; an ideology which relegated a major tragedy within the black community to the incidental status of an unfortunate and, worse still, an inevitable mishap.[5]

However, while the amount of blatant racist reporting is often confined to crisis situations such as 'The influx of Malawi Asians' and around dramatic events such as 'Black mobs on the rampage', a more subtle and indirect racism is ever-present; an insidious kind of racism which tends to disappear from view into the taken-for-granted, naturalised world of 'common sense'. It is this commonsense racism which informs not only the reporting of major events but also the daily, more run-of-the-mill reporting, which, when articulated through the popular media, provides fertile ground both for the legitimisation of repressive state measures directed at the black communities and fodder for the growth of racist ideologues.

The media produces and reproduces certain types of represen-tations and dominant frameworks of interpretation. In particular, reporting on Black people is impregnated with racist common sense. The processes by which such frameworks become naturalised and thereby institutionalised need to be challenged 'since (like gender) race appears to be given by nature, racism is one of the most profoundly naturalised of existing ideologies.'[6]

Racist ideologies in the post-war period carried over and reworked these images of Asians as colonised people who previously were seen to be in need of Britain's civilising missionary zeal and, having been given independence, needed to be protected as children emerging into adolescence. Between 1962 and 1981, the intense public debate on immigration produced a plethora of representations of Asians flooding the country in their millions and scrounging off the state. The year

1976, in particular, saw a concerted campaign by the politicians and the Press to pinpoint Asians as a problem group. For example, on 9 September of that year Alfred Sherman offered his views to readers of the *Daily Telegraph*. He saw 'mass immigration as a symptom of the national death wish' and argued that even while 'Britain was trying to cater for her own disadvantaged at a considerable cost, it simultaneously imports masses of poor, unskilled, uneducated, primitive and under-urbanised people into the stress areas of this country where they are bound to compete with the existing urban poor for scarce resources.'

His argument was that black people brought the problems with them and because of their cultures were not able to overcome these difficulties. The real problem was seen as the growth within English society of alien communities with alien cultures.

The timing of this particular campaign was not accidental – it coincided with new immigration legislation. This particular campaign started with the revelation that a homeless Asian family expelled from Malawi was being housed in a four-star hotel at a cost of £600 per week to the British taxpayer. Not surprisingly, the number of attacks on Asians began to rise around this time. A detailed comment on the connection between Press comment and racial hostility was documented[7] but suffice it to say that every time the Press has sensationalised reports about Asians coming to Britain, there has been a corresponding rise in racist attacks on Asians.

Of all the black communities settled in Britain, it is Asians who are viewed as the most alien. The problems that Asians present to the British way of life and culture, this threat to Britishness, is encapsulated in their difference: their unwillingness to adapt, to change, their tendency to cling to their curries, their languages, their way of dressing, and above all their particular and peculiar patterns of household organisation and sex-gender relations.

The traditional Asian household, organised through the extended family kinship system, is held to be responsible for a number of problems that Asians face in the context of a British society ravaged by social and economic decline. Overcrowding is seen as a direct result of their tendency to breed like rabbits and their partiality for wanting to live together. Racist housing policies are not seen or acknowledged in any way. Asians are further handicapped by the strength of their culture which is depicted as unchanging, homogeneous, static and inflexible. The linchpin of this pathology of the Asian culture and family is the notion that within the family network, the women and girls are ruled by excessively patriarchal menfolk who force their daughters into arranged marriages and their wives into seclusion. Asian women are shown as meek and passive victims – voiceless puppets of Asian men, afflicted by language problems, extreme shyness and modesty.

The rise of the New Racism in recent years[8] has shifted the grounds on which debates around race and racism are publicly conducted. Proponents and theoreticians of this new racism, while continuing to duplicate the racist view of Asians as aliens at the source of Britain's present economic and social problems, are openly talking about the only solution to these problems being repatriation. The connections between common sense and right-wing theories of race which are able to command popular support have been comprehensively explored elsewhere,[9] but it is important to note here that this new racist ideology shares and follows similar lines of argument to the racist ideologies of the organised Fascist parties who have always openly propagated repatriation as the only solution to the alien wedge in Britain.

Correspondingly, while in the 1960s the dominant image was that of Asian immigration into the country, the present-day image has changed to that of black people fighting to stay in Britain.

Numerous anti-deportation campaigns have been fought in the last five years or so and the majority have involved black women. The contrast in the Press coverage of Afia Begum's anti-deportation campaign and that of the Pereira family is worth examining, because it quite clearly illustrates how culture and identity are seen to be the key to 'assimilation and acceptance' – and therefore the answer to the race problem.

Afia Begum was a widowed young woman with a three-year-old British-born child. She lost her right of abode in Britain, which for many Asian women is dependent on their husband's status, when her husband died. A massive campaign was mounted on her behalf to fight for her right to stay. On the other hand, the Pereira family living in a Hampshire village were also threatened with deportation as a result of over-staying. In their case a totally different campaign was instigated by their white neighbours, including the village clergy. These two cases happened within weeks of each other, the result being that Afia was deported to Bangladesh, whereas the Pereira family were granted permission to live in Britain. Afia was part of the inner-city black population who mobilised support on her behalf, whereas the Pereira family lived in a white suburban village and it was their white neighbours who rallied round. This difference was undoubtedly instrumental in deciding the outcome of these campaigns.

The Afia Begum campaign challenged the racism of the British state and its immigration laws. The Pereira campaign argued that they be allowed to live in Britain on the grounds that they were totally assimilated into their English village and, apart from their colour, were totally English in their lifestyle – that is, they retained no alien cultural traits.

The Press coverage of the Pereira campaign concentrated on presenting their case as a sympathetic one, with the emphasis on their non-alien characteristics – their inability to speak any Indian

languages, and their British-born child. They were described as 'model citizens' by their friends and neighbours.

The *Daily Express* on 23 May 1984 highlighted their plight as that of the 'perfect immigrants' who 'are almost more English than the English'. They quoted one of the family's supporters, Rear Admiral Geoff Mitchell: 'He [Rodney Pereira] is a thoroughly reliable chap and is doing a first class job. Theirs is a very special case. The entire village and supporting neighbourhood was with them – the family themselves are thoroughly integrated.'

Representation of Asian women in the visual media of cinema, television and film, or in the written media of books, literature and newspapers continues to use particular categories of definition to paint images of us. Depending on the political motivation and climate, specific images of Asian women are mobilised for particular arguments. The commonsense ideas about Asian female sexuality and femininity are based within, and determined by, a racist patriarchal ideology. Women are defined differently according to their race. The ideology of femininity is contradictorily constructed for all women: they are both mothers who service husbands and children, and also desirable sexual objects for men.

These two aspects of the construction of femininity for Asian women are racially specific, so whereas white women are visible through the imagery provided through mass advertising and the popular media, Asian women either remain invisible or appear within particular modes of discussions which utilise assumed and unquestioned racialised gender roles.

Asian women's femininity is very often linked to notions of fertility, and they are hardly ever seen as independent from their children. Images of Asian women subjected to virginity tests, estranged mothers who are fighting to be reunited with their children – Anwar Ditta and M. Patel for example – or others facing deportation threats with their British-born children, are common. The threat of their fertility is ever-present and ultimately they are held responsible for the growth of the black communities in Britain. There is a definite relationship between the commonsense notion of Asian women's secretive and private breeding, qualified and linked to the popular understandings of the esoteric practices of the *Kama Sutra*.

The shifts in imagery are often dependent on shifts in state policies and debates on race. This was evident in the Press coverage of the virginity tests at Heathrow airport by immigration officials. The public outcry in the media over this is an instance of the racist and sexist assumption about Asian women who were represented as virtuous women whose sexuality is only confirmed through their marriage: 'It is not in their culture for women to engage in sexual activity before marriage'. This generalisation is

based on the stereotype of the submissive, meek, and tradition-bound Asian woman.

This contradictory imagery of Asian women – represented on the one hand as sexually erotic creatures, full of Eastern promise and on the other as completely dominated by their men, mute and oppressed wives and mothers – is explored through some examples which follow. They show how commonsense racism informs their representations as determined by racist gender constructions.

Asian women very frequently appear in the media as victims of arranged marriages. When the *Sunday Times Magazine* in June 1983 ran a 'pictorial anatomy of six vastly different weddings' one of them was a Sikh wedding, which added a touch of the quaint and obligatory multiculturalism. The text accompanying the image reads:

> At 19, Rashpul Kaur has come thousands of miles to marry a stranger, Gurdal Singh Sahota. The couple has seen photos of each other but had not met till six weeks ago. With no close relatives in Bradford, Rashpul has been living with his family. She will live there after they are married too though, as nine people must share four bedrooms, they would prefer a house of their own.

Within a few sentences, the photograph of a young, unwilling bride being assembled for a wedding she so fatefully seems to accept, is reinforced by the text which mobilises racist commonsense notions of Asians living like rabbits in overcrowded houses.

Anthropological photography has a long and established tradition in European societies, and the process through which anthropological and pseudo-scientific photographs constructed 'a particular genre of photography in which the image functions as empirical evidence of racial difference and identity' has been convincingly described elsewhere.[10] This tradition of using 'photography to examine other races and fix them in place as dominated cultures' continues to this day, and the thorny but pertinent issue of who photographs whom and how is often neglected within socialist discourses of representation.

Critical self-examination of what constitutes oppositional photographic practice is very rare. Jo Spence, in an honest reappraisal of her role as a photographer, says:

> As a socialist and a feminist it has become untenable for me to work any longer as a professional photographer in order to support myself. After 27 years I have rejected my 'right' to create and then sell the various fictions which I made about other people as I worked as an advertising, news and portrait photographer and later in so-called 'community' and 'alternative' projects. This is because the images I produced became part of an ideology which fixed and constructed

people into particular class, race, and gender positions which were not always in their own interests.[11]

Alternative photographic practice rarely takes up such issues – indeed, many photographers who consider themselves to be 'on the side of' (for instance) black people, continue to use their skills and power to represent 'multi-ethnic' Britain in the belief that they are doing so in the interests of black people. But their photographs are constructed through a series of choices based on their race, class and gender positions and often complement the hegemonic system which used photographs as a way of representing, classifying and evaluating black people in particular ideological ways.

The use of photographs to construct exotic oppression images which are then presented as revelations for the viewer to gaze at with abject fascination and/or horror is very much the tradition in which Mary Ellen Mark's photographs of prostitutes in Falkland Road, Bombay, have to be situated.[12] Her photographs raise pertinent political questions about representations of oppressed groups by those in positions of control and power.

In May 1981, *The Sunday Times Magazine* ran a sultry close-up of a Bombay cage girl on its front cover. Inside, it carried a report on the American photographer Mary Ellen Mark who had spent three months taking photographs of the prostitutes of Falkland Road, Bombay. After 10 years of being haunted by their faces she set out to capture them visually.

The images in her book are very clear examples of western voyeurism and the photographer herself has no qualms about this aspect of her 'mission': 'The night before I left I had a vivid dream; I was a voyeur hiding behind a bed in a brothel on Falkland Road watching three transvestite prostitutes making love; I awoke amused and somewhat reassured. Perhaps my dream was a good sign.'

The photograph reproduced on this page illustrates this

31 Mary Ellen Mark, photograph from *Falkland Road*, London, Thames & Hudson, 1981.

voyeurism in its starkest form (Figure 31). All the subjects in the photograph are totally unaware that they are being photographed, and even if they had been aware, it seems they had little power to do anything about it. As Mary Ellen says herself, the women's initial reaction to her was one of 'hostility and aggression. The women threw garbage and water and pinched me.' But like a pest she persisted because she was determined to enter a world no westerner had entered before – to be the first, in the true fashion of an explorer.

This photograph encapsulates the most intimate nature of the prostitute's trade, juxtaposed with an image of an old woman with her head in her arms, in a familiar gesture (to westerners) of helplessness portrayed in the charity posters. Here, the photographer's role is one of fly on the wall, a peeping tom, unobserved but observing. And, given the nature of what is being observed, it panders quite explicitly to sexual voyeuristic fantasies. The old woman in the next cubicle reminds us that this is India after all, and triggers the associated imagery of poverty, hunger, disease and death.

However, in spite of her liberal guilt ('At first when I visited them I was embarrassed and felt like an intruder. (sic)') and in spite of being rejected ('Whenever I climbed the stairs, the women would run out of the hallways into their rooms and hide behind the curtains, and a madam would start screaming at me.') the urge to be a modern-day anthropologist made her persist for acceptance. Her final betrayal of these women is as a woman whom some of them had accepted as a sister. 'One madam told me: "We are sisters".'

As a white person documenting Indian women's sexuality, her vision is informed by her commonsense racism, but as a woman photographing other women, one would expect her to be more sensitive and aware of the contradictions of her project. However, she seems to have incorporated the white male's sexist interpretations of Asian female sexuality without question of qualms. Her photographs reveal and perpetuate the contradictory imagery that exists about Asian women. While the stark images show these women as passive victims economically and sexually vulnerable, they also echo the racist imagery of 'uncivilised black animality'.

It is because these women are prostitutes and not air hostesses, for example, that the seamier side of the exotic, alluring Asian female, ever ready to please the western executive (see Air India and Air Malaysia ads) is exposed for the western male to leer at and for the western female to look on with disgust.

Apart from such infrequent glossy exposés, Asian women are mostly invisible from the daily newspapers.

Even when Asian women are taking militant actions, the Press is so entrenched in its view of them as helpless and mild that they substitute anger with pain. So for instance, in July 1983, when

Tamils living in Britain marched in a rally to protest against the violence in Sri Lanka, the front page of the *Observer* carried a report and a photograph of women leading the march, obviously angry and shouting, with the caption: 'Women *weep* as Tamils in Britain demonstrate against racial butchery.'

The lexicon of racism constrains and nuances many photographs that appear in the daily newspapers. There is a problem for those of us engaged in challenging such representations: there is the problem of how you represent the whole web of political relationships within which Asian people are enmeshed. How do you represent in images the resistance and strength of Asian women in their daily struggles to survive the onslaught of racism?

Asian women's political involvement in devising strategies for struggling against the objective reality of racism necessarily entails us in the process of creating our own imagery.

One illustration of producing self-images which reflect the experiences of Asian young women is the self-defence poster (Figure 32). This poster was produced together with a group of young Asian women and it is a clear instance of the text-image construction where the text doesn't attempt to explain but rather reinforces the representation of Asian young women taking control. The point that needs to be emphasised and cleared is that here we are not talking so much about creating 'strong' or 'positive' images which challenge racist stereotypes, but rather about the visceral understanding of the site of our oppression and thereby representing an aspect of the struggle against it.

Asian feminists, together with their African/Caribbean sisters in the black women's movement, are actively engaged in self-definition through our involvement in autonomous video and film collectives, publishing co-operatives and through writing which has begun the process of gaining control over our representation.

The year 1984 has seen a rise in the number of black groups either being set up, or consolidating previous projects in the area of film and video production. In April 1984, a group of black women organised a series of seminars and screenings on the theme of 'Black women and Representation'. The contributions through discussions and papers are currently being completed for publication in the near future.

One of the key problems for black women has been the lack of access to training and acquiring skills in film-making. Institutionalised racism of the mass media has prevented the black communities from gaining any significant access to the professional structures of the film industry. Several campaigns and pressure groups, such as the Black Media Workers Association, have campaigned for more black media professionals. However, such demands have to be linked to a critical assessment of the

32 Asian Women's Self Defence poster.

existing forms and content of films. While not denying that there is a legitimate struggle against the institutional racism of the mass media, many of us have felt that it is equally if not more important to concentrate on building our own alternatives.

In May 1984, there was a Black Women and the Media Conference, attended by more than 200 women from all over the country, where women gathered to learn and share media skills and discuss strategies for dealing with the distortion, racism and sexism of the mass media.

Another area where we have concentrated our energies is in

organising and participating in courses on film-making. A positive outcome of one such course has been the formation of a film and video collective consisting of Asian and African/Caribbean women called the Late Start Film and Video Collective. This group is at present editing a video made about Audre Lorde, black feminist and lesbian poet from America. The latest development in the independent black film sector is the formation of the Black Film and Video Association.

As Asian women we have to place ourselves in the role of subjects creatively engaged in constructing our own images based both in our material and social conditions and in our visions and imaginations. The task of reconstituting the prevailing images of Asian women entails us in a struggle on several fronts. We have to begin by rescuing ourselves and our history from the colonial interpretations which have continued to dehumanise us and belittle us, and recast Asian women as active agents in the making of history. We have to begin to rescue the strands and threads of past and present experiences and future hopes into a tapestry whose hues and patterns will reflect us in our complexities and our contradictions, depicting us in our authenticity.

# Notes

1 See Kusoom Vadgama, *Indians in Britain*, Madison Press, 1982, and also M. Alexander and S. Anand, *Queen Victoria's Maharajah; Duleep Singh 1838-93*, Weidenfeld & Nicolson, 1980.
2 Folarin Shyllon, *Black People in Britain, 1555-1833*, Oxford University Press, 1977.
3 Ibid; p. 122.
4 Ibid; p. 125.
5 Patricia Holland, 'The New Cross Fire and the Popular Press', *Multi-racial Education*, Summer 1981, vol. 9, no. 3, pp. 61-80.
6 Stuart Hall, 'The Whites of their Eyes', in *Silver Linings*, Lawrence & Wishart, 1981, p. 32.
7 'Race and the Press' in *Race and Class*, vol. 18, 1976, Institute of Race Relations.
8 See Martin Baker, *The New Racism*, Junction Books, 1981.
9 See Errol Lawrence, 'Just Plain Common Sense: The "Roots" of Racism' in *The Empire Strikes Back*, Routledge & Kegan Paul, 1982.
10 See for an interesting discussion on this, David Green's article 'Photography and Anthropology: The Technology of Power' in *Ten.8*, no. 14.
11 Jo Spence, 'Feminism and Photography' in *Three Perspectives on Photography*, Arts Council of Great Britain, 1979.
12 Mary Ellen Mark, *Falkland Road: Prostitutes in Bombay*, Thames & Hudson, 1981.

Patricia Holland

# The Page Three girl speaks to women, too

**First: sizzling sauciness. . .**

Are you a flirt?
Try the **Sun**'s sizzling sauciness test.
Some people just can't help it. Every time they come face to face with a member of the opposite sex they start flirting like crazy.
It is all harmless good fun. There is nothing like a flirty encounter to brighten your day. (September 17)[1]

A vocabulary of emotional arousal summons laughter, thrills, shocks, desire, on every page of the *Sun*. But no sooner do they surge into being than these unmanageable forces find themselves tamed, re-expressed as fun, enjoyment, sparkle. 'It's all in your soaraway *Sun* today'; 'Your pow-packed *Sun*'; 'Life's more fun with your Number One *Sun*'. Fun organises and contains emotion.

The tone is exclamatory, celebratory, laced with a self-congratulation which verges on self-parody ('We're out of this world'). Everything in the *Sun* is subordinated to enjoyment presented with self-conscious relish – there is a continuous commentary in the *Sun* on the *Sun*.

Pleasure is organised across the pages of the paper through its photographs, layout, language, and beyond that two-dimensional surface there's an explicit address outwards to the reader, an address which is personal and direct. The reader is continuously invited to go beyond mere spectatorship and partake in the universal jollity. This is *your* pow-packed *Sun*, the flirty encounter brightened *your/my* day, *I* could be this week's Bingo winner . . . and indeed I could, for, as I read this paper, *I* and the reader addressed, I am the one invited, tempted to make myself a *Sun*lover.

A purveyor of pleasures, an organiser of your pleasures, my pleasures. . . But are they my pleasures? Am I not, rather, repelled by those pleasures called on by the *Sun*, by its appeal to a trivial sexuality, by its insults to the female body, by its jokes at the expense of women, its flippancy . . . 'Relatively few readers of the *Observer* can be close students of the *Sun*,' began an article by Charles Wintour on Sunday October 3. Locating myself an *Observer* reader, I, too, reject the appeal of the *Sun*, understand it is not for me, turn away from its address. To put it bluntly, I know the *Sun* does not want me.

From *Screen*, vol. 24, no. 3, 1983.

The *Sun* does not want spoilsports, killjoys, those who are not prepared to join in the high jinks, the sauciness, to allow a flirty encounter to brighten their day. Labour party critics are a 'dreary and embittered band' (leader, October 2). The *Sun*'s readers are different from those of the 'ageing *Daily Express*, the pompous *Daily Mail* and the boring *Guardian*.' It frankly warns us off, then celebrates its own rising circulation: 'Your super *Sun* has gone out of this world and set new circulation records for the galaxy. Last month we sold an amazing 4,249,000 copies every single day' (October 5).

So the *Sun* does not want people like me and I want nothing to do with the *Sun*. But, pause. . . Many things about the *Sun* repel me, but surely one of the things I find most unpleasant is its presentation of *women*. Yet when I read more closely I find that the *Sun* is not rejecting me *as a woman*. When it attempted to advertise in student newspapers with a 'Nudie-Varsity Challenge' it was, unsurprisingly, attacked by the National Union of Students: 'Page Three is grossly sexist, insulting to women and debasing.' But the *Sun* was sure of its ground. It called on a woman to speak to women. 'Luscious Linda Lusardi', the Page Three of the day, 'hopes that Britain's college cuties will ignore the spoilsports and try their luck on the nation's favourite glamour page' (October 15). The *Sun* rejects pomposity, boring analysis, criticial thought, and it can confidently invite women students to reject those things, too, to ignore the spoilsports and join in the saucy fun. The *Sun* speaks directly to women readers.

This article is an attempt to put aside my initial feeling of repulsion, and my social knowledge that the *Sun* is not for me. It is an attempt to make some sort of sense of that address.

## Next: drooling at breakfast time

The *Sun* has openly located its pleasure around sexuality – heterosexual sexuality. Its features and its presentation of 'news' are organised around forms of arousal ranging from shock and disgust to thrills or celebration, but sexual stimulus is a constant underlying theme, with the Page Three 'girls' – that particular, styled presentation of the female body as spectacle – 'those luscious ladies you drool over at breakfast' (September 20) as a central image.

Like all newspapers, the *Sun* constructs on the surface of its pages a series of narrative structures with similarities to the narratives we meet in feature films and novels: not the shaped and moulded narratives usual in those forms, but narratives nevertheless, organised in a temporal sequence with a range of characters who relate to each other in particular ways and whose stories develop in sequential episodes through both words and pictures. The narratives of a newspaper operate at different levels

of abstraction, ranging from major structuring threads to close particularities. The narrative threads involve the setting up of conflicts, moves to new alignments, aims, resolutions of conflict, surprise twists, key characters and so on.[2]

The narrative flow of a daily newspaper has its own particular form. Its forward movement is structured by its regular recurrence, but each morning there is a pause, as the mosaic presentation of that day's edition cuts across the forward flow. Each day the reader gains a certain freedom of reading, can organise the paper at will – begin at the back with the sport or in the middle with the TV or the feature – guided by certain principles. The main eye-catcher is on the front, Page Three is on page three, and the sports news – male bodies in action – is at the back, the only part of the paper in which the discourse of sex is not made explicit.

Within the pages of a newspaper multiple fractured narratives intertwine, interweave. Unlike the traditional narrative there is no final climax, no closure, for we never arrive at the last page. But the search for closure is there, both in the work of the newspaper itself and in the efforts of the reader. Thus, news and feature items are constructed into the flow of the narrative over time. New events and characters are brought in to fill the well-known roles. The different narratives influence each other and are cross-referenced. So, each day's edition is not a random collection of items: moreover, we readers work at it, make efforts to structure it and give it coherence. For we already know what Barthes has put into words – 'a narrative is never made up of anything other than functions: in differing degrees, everything in it signifies. This is not a matter of art (on the part of the narrator), but of structure; in the realm of discourse, what is noted is by definition notable.'[3] And the *Sun* itself directly calls on us to make sense of its stories, gives us indications and reminds us of what is notable. After all we know the plot so far and we have a good idea of the expected outcome.

In the *Sun* the news stories are dominated by sexual dramas, and features are dominated either by sex spectaculars or by invitations to sexual, or more precisely heterosexual, games. Characters who make front page headlines include football players like 'love tangle soccer star Andy Gray', who starred in 'secret baby for Andy Gray, soccer star shock' (September 28) which went through several daily episodes; entertainers like Liberace, sued by an ex-lover ('a liar and a junkie: Liberace blasts lover boy,' October 16); and, of course Royalty. Prince Andrew's holiday with 'sexy actress', 'soft porn starlet', 'sizzling actress' Koo Stark reverberated through its pages for several weeks. 'Is that courageous young man going to be corrupted and depraved – or is he just going to have a bit of fun under the palms?' asked a defence counsel at a pornography trial, reported as a '*Sun*

exclusive' under the heading 'Randy Andy's legal laugh-in' (October 12). Less well known performers are confined to the inner pages under headlines like 'Girls slam sexy sirs at school of scandal' (August 16); 'Love-in newly weds miss the jet' (March 22); 'Wonderbra! The mayoress strips off to a German band' (October 23). And this news, which is news of sex, is backed up by the sexualisation of public events. The *Sun* reported the return of the QE2 from the Falklands with 'Liner of love. Buxom blonde Jane Broomfield yesterday spilled the beans on the saucy antics that turned the QE2 into a floating love nest on the voyage home from the Falklands' (June 12).

The sexual activities on the news pages are paralleled by, and often indistinguishable from, the sexual games on the feature pages, which range from sex spectaculars featuring show-biz or other celebrities – 'How I saved my marriage by Bjorn Borg: inside the love nest of the world's top tennis star' (August 19); 'Romeo Julio: beauties are begging to get into his bed' (October 22) – to questionnaires and participation games played by *you* – 'Total loving: train your body to tell him I love you' (July 26); 'The mating game. Ten sexy steps to help you win a new love' (February 6); 'Sex and the newly single girl: the *Sun*'s special report on how to cope with a love crisis' (October 14). Sometimes they mix show-biz with everyday: under the headline 'Who are the naughtiest girls in Britain', *Sun* reporter Judy Wade asked various (male) touring performers to 'tell us which town served up the hottest receptions' (May 6 1977).

The features addressed to 'you' tread a delicate line between what is accepted and what is possible. A base line of heterosexual monogamy is assumed, but beyond that, hints at saucy antics range from: 'Are you a cheating lover? A questionnaire to discover if you are in danger, by Wendy Leigh, author of "What makes a man good in bed" ' (August 24), to 'Giggles galore at the naughty bring and buy' (an October 4 story about housewives' tea parties for selling sex aids).

> The function of narrative is not to 'represent', it is to constitute a spectacle still very enigmatic for us but in any case not of a mimetic order. The 'reality' of a sequence lies not in the 'natural' succession of the actions composing it but in the logic there exposed, risked, satisfied.[4]

Yes, yes. We know all about that: that was written sixteen years ago. But does it work for *newspapers*? I will argue that to read the *Sun* as a collection of narratives and to see the people constructed in its pages not as 'beings' but as 'participants', to use Barthes' terms again, is the only way to make sense of what it is up to.

The all-important question which then arises is: how is the reader . . . are the readers . . . are different groups of readers . . . included in, addressed by these narratives? The verbal address of

the features is often directed to both sexes simultaneously: you could say it was double-sexed:

> We all know lovers who cheat – and even some who get away with it. But are you sure it could never happen to you? How confident are you that you could never be tempted into a one-night stand? And that you would spot the signs immediately if your partner was having an affair?

'Partner' is a useful word. It assumes stability regardless of legal status and is not gender-specific. The questions in 'Are you a cheating lover?' also have a 'double-sexed' address, referring to 'the person you cheated with' and using 'they' and 'them' as singular pronouns. 'Have you ever suspected your partner of cheating? What did you do when you suspected them?' But despite the dual address of the words, the accompanying pictures show a high degree of differentiation between the sexes.

However, when verbal address does become gender specific, it is women who are spoken to directly. Almost all the features on sex are written under women's names, and in almost all of them when they speak to 'you', 'you' turns out to be a woman. Thus it is the newly single *girl* for whom sex is a problem: 'total loving' teaches women how to woo a man, and insists that we should 'never accept frigidity'.

Men by contrast are the implied, rather than the direct, addressees. They are almost never 'you'. Male attitudes to women are openly presented as predatory or contemptuous: Julio Iglesias says, 'Women are beautiful, I love them all and why shouldn't I?' (October 22); Kenny Everett says, 'People seem to like lots of nubile, scantily dressed girls on my shows . . . I said go and find some fresh talent, rub in a bit of body oil and throw 'em on the set' (August 12). So even when the tone shifts to 'the greatest moment in any woman's life is when sex and love blend perfectly', certain assumptions about the male reader lie behind the address to his female counterpart, and those are the assumptions which provoke the knowing wink and permit the salacious joke. Women are spoken to directly, but it is men who share the joke. It is men who drool at breakfast time, but meanwhile the invitation is out to women to come and join the fun.

## And then you too can be a Page Three Girl

* Aim for a look which is full of allure. A flirty smile in your eyes should not be difficult – especially with your favourite man behind the camera. And please, please relax.
* Try to avoid a toothy grin or a Bardot pout. This sort of expression can make you look self-conscious. It's best not to copy anyone – just be yourself. (October 27 1981)

Every morning millions of readers/viewers of the *Sun* newspaper turn from the front page bearing today's latest thrill, and instantly meet the gaze, exchange looks with, find their own gaze absorbed

by, that of the Page Three 'girl'. The daily turn of the page uncovers her flirty smile above the aggressive breasts that define her – a two dimensional strip-tease, performed on our behalf as often as we want. Her look of allure is always directed at us, her eyes always engage with ours, her favourite man behind the camera is, miraculously, replaced by ... every one of those millions – men, women, children and old people – who make the gesture of turning (Figure 33).

Page Three is a direct address by the newspaper to its audience. It organises that audience, sorts it into groups, addressing itself separately both to men and to women. It presents itself as a source of pleasure to both men and women. Page Three condenses within itself the newspaper's view of itself and its audience: it declares how the paper wants to be seen, how it should be appreciated, used and enjoyed. It is the pivotal point

33 'Do you want to be a Page Three girl?', *The Sun*, 27 October 1981, News Group Newspapers Ltd.

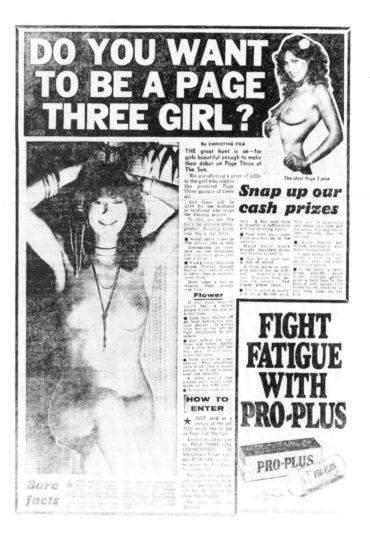

of the *Sun*'s address to its audience. It is central to its marketing and thus to its very existence.

But does Page Three really address *women*? Surely this pictured woman is no more than a fetishised image, designed for male gratification? Surely she tells us about the nature of male, not female, eroticism? Surely she is in the tradition of the pin-up, for male eyes only, to be overlooked or tactfully ignored by women viewers? Yet, although it does not exhaust it, Page Three dominates the meaning of 'woman' in the *Sun*, and women readers must cope with this meaning – a meaning which both does and does not refer to them, does and does not offer them back a sense of themselves. They look over it and through it when reading the newspaper in search of what is addressed to them *as women* . . . or do they?

In fact, as in the rest of the paper, there are important ways in which Page Three is addressed directly to women. It is part of the *Sun*'s discourse on female sexuality which invites sexual enjoyment, sexual freedom and active participation in heterosexual activity: 'Never accept frigidity'.

In order to understand Page Three's address to women, we need to look at its position within the newspaper's narratives: first at the narrative of Page Three itself, and then at the position of Page Three within the multiple narratives of the *Sun*. First, Page Three: its central character, the model girl, is only one of the roles in the drama. Other characters are the photographer (always a man), the male viewers, who appear both as a group and as named individuals, and the female viewers, including other potential Page Three girls. Various peripheral characters make an appearance from time to time: the model's mother, her boyfriend, her boss. Finally there is the Voice of the *Sun*, the authorial voice which speaks directly to us, endlessly jokes with its audience.

Like Saussure's famous 8.25 from Geneva to Paris, the Page Three girl is every day different yet every day the same. Regardless of who plays her part, she occupies the same central position in the plot, for this is her drama. Like a character in any narrative construction she is not a 'being' but a 'participant'. There is one action that defines her – she bares her breasts for the delight of male viewers.

Among the obvious differences between the narrative of newspapers and that of, say, most plays or feature films, is that the individuals who get to play the parts, to perform the roles, are plucked, so it seems, from 'real life'. This is so even when, as is often the case in the *Sun*, these individuals are in fact professional actors: or when the parts they are called on to play do not masquerade as 'news'. Because of the special relation of the newspaper narrative to real events, all of the characters bring into their roles something of this 'real life' quality. Thus a newspaper character like a Page Three girl is present in the narrative on a

double level, she has a double presence. She is there in her capacity as Page Three, but she is also there in her capacity as a 'real life woman'. Such a double presence is much stronger in newspapers than it is in, say, the film star/fictional character duality in a cinema because it participates in the ideology of truth which underpins all newspaper discourse including that of the *Sun* ('We shall go on reporting the truth, the whole truth' – leader, October 8). A newspaper is about what 'is'. The concept of 'fiction' which makes possible the construction of a novel or a feature film is alien to it. It makes its judgements by appealing to a clear opposition between 'truth' and 'falsehood'. So it is with the Page Three model: although she *becomes* Page Three, although she totally fills that role, that is not all there is to her. She has a 'real life' role in the newspaper, too, but, it is more fragmented, more difficult to grasp. It comes and goes, surfaces in different parts of the newspaper. Yet its very reality remains as a constant resource both for writers and readers.

A sense of *performance* is central to an understanding of Page Three, and the performance is there to be observed in the concurrent presence *in the narrative* of both performer and role. Alongside the visible construction of the role is a constant commentary on the act of construction itself, a constant self-reference. The newspaper 'contains' and visibly places its own particular narrative style in a way similar to that noted by Stephen Heath in regard to classic cinema: 'Classic cinema does not efface the signs of production, it contains them, according to the narrativisation described above.'[5]

Much of the *Sun* is written in terms of show business and many of those who people its pages are 'personalities'. And within the paper there is a continuous discourse on acting and on the meaning of performance. Dolly Parton, introduced as 'Hollywood's bustiest blonde', tells us: 'I'm not ashamed of the way I look. I have to live with it, so I might as well have fun. . . I look one way but I'm really another, and I look on the Dolly image just like a ventriloquist looks on his dummy.' Dolly clearly has the right attitude as far as the *Sun* is concerned. Writer Alex Harvey comments approvingly: 'What Dolly Parton has above all is a sense of good humour about herself and the way she looks' (October 1). Similarly many Page Three stories direct our attention simultaneously to the role (a bit of fun, a game, a joke at the lady's expense) and to the person who is playing the role ('I look one way but I'm really another'), in effect to a second simultaneous role. Thus the act of playing a part itself becomes part of the celebratory tone of Page Three, for this is no ordinary role, but a star role, coveted by many women. So the *Sun* invites all those aspirants to try their luck. 'The hunt is on for girls beautiful enough to make their debut on Page Three' (October 28 1981); 'Girls, do you do an unusual job and want to

appear on Page Three? Send a picture and details of yourself'
(September 21); 'College girls, ignore the spoilsports and try your
luck on the nation's favourite glamour page' (October 15). And it
offers advice on how to do it. From the lesson on how to be a
Page Three girl (October 27 1981) we learn that this involves at
least two people, the model herself and the photographer, her
favourite man behind the camera. Models are told how to pose
(body three-quarters on to the camera), what sort of look to adopt
(flirty smile in the eye) and what to avoid (heavy make up, fussy
jewellery, toothy grin). The photographer is told to look out for
his backgrounds (avoid heavily patterned wallpapers), how to
arrange the lighting (avoid ugly shadows) and generally how to
imitate 'the *Sun*'s glamour photographer Beverley Goodway'. He
constructs her picture and she takes a willing part in the
reconstruction of her self. An essential quality of the Page Three
role is the willing and eager participation of the pictured woman,
epitomising the *Sun*'s construction across its pages of a willing
and eager female sexuality. Page Three is 'the world's top
glamour spot' (October 4) and to reach it is an achievement – for
a woman – overshadowing other achievements, to be greeted with
pride.

So, to look more closely at some Page Threes. Introducing
'Lesley-Anne', 'Jacqui' and 'Merlita' (Figures 34-6)

First, Lesley-Anne. She's the one the 'fellas in British
Leyland's spares department' want to see, a regular on the pages
of the *Sun*. 'Their patience is exhausted' when she doesn't
appear, so the *Sun* offers her up to them, classily backlit by
photographer Goodway. She's positioned three-quarters on to

34-36 Page Three, *The Sun*,
'Jacqui', 8 February 1982; 'Lesley-
Anne', 22 March 1982; 'Merlita'
21 September 1982, News Group
Newspapers Ltd.

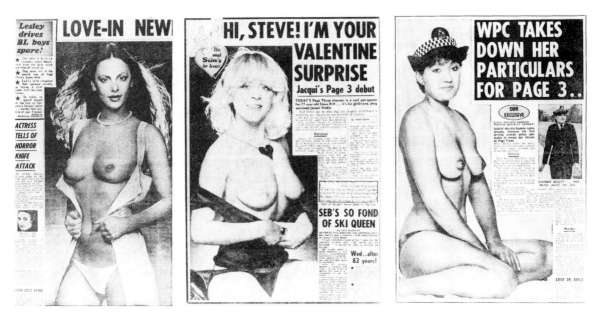

camera, her total nudity (which, we have been told, is often unsexy) relieved by a garment whose nature is difficult to identify, which she is perpetually either putting on or removing. 'Another Maxi picture of your Princess!' (Cue for guffaws.)

Jacqui is different. We're told that she wrote to the *Sun*, and to prove it part of her letter is reproduced. She asked to appear on Page Three as a surprise for her boyfriend Steve. 'This will knock his eyes out. It will amaze him when he actually sees me looking at him from Page Three'. For, 'the *Sun* is his favourite paper and he always looks at Page Three.'

Then, Merlita. She poses solidly, three-quarters on to the camera, no fancy lighting, no effects with bits of clothing. Her total nudity is only relieved by an almost invisible pair of briefs and ... a policewoman's hat. She 'knew she would make an arresting sight without her blue serge uniform – and here's the evidence.'

Lesley-Anne is a professional, Jacqui and Merlita are amateurs. Professional Page Threes are full-time models and have their following among the lads. The amateurs would *like* to be models: 'model girls seem to lead such an exciting life. I'd love to make it to the top – it's so different,' says Merlita, while Jacqui 'swims and jogs to keep her figure in trim'. But Merlita already has a job and Jacqui also wants to 'settle down'. She reckons that Steve will be so impressed that he will 'pop the question and ask her to marry him'. 'Over to you, Steve, for a happy ending.'

When Lesley-Anne plays Page Three the emphasis shifts from her to her audience, the lads at BL. For them the duality of her role is minimised. For them she is only Page Three, a picture, two-dimensional, to be cut out and pinned on a wall in the spares department. The *Sun* organises its male audience, and no doubt such groups of fellas do exist at BL and elsewhere, their expectations shaped partly by the daily appearance of Page Three as pin-up and by the mythology of Page Three as it has passed into public discourse beyond the pages of the newspaper. When such men are recuperated back into the narrative they become a male chorus, approving, appreciating, demanding more of the same.

These are the men addressed in a familiar way by another character who plays a part in all the Page Three dramas – the Voice of the *Sun*, the authorial voice who speaks the text of Page Three. It is the Voice of the *Sun* which grants the request of the British Leyland men, which entices women to come and take part, which offers cash prizes and, above all, joins the male chorus in its puns and corny jokes. Despite the fact that the credited writers are mostly women, this Voice is unmistakably masculine. It uses jokes to affirm male solidarity, nudges, winks and sniggers to assert male superiority: 'Pay as you yearn' (for the October 13 model who works in a tax office); 'Meter maid is just the ticket'; 'WPC takes down her particulars for Page Three'.

When Page Three is played by an amateur it is much more likely that the male audience will be particularised. Jacqui is looking at Steve from Page Three, Merlita thinks of the 'lads down the nick'. Individual members of the male chorus are here singled out for personal address and are amused when their two-dimensional pin-up turns out to be a flesh-and-blood girlfriend or colleague. 'The lads down the nick will get quite a shock when they see this!'

We think of their amazement compounded when her double presence on the page is complemented by her physical presence beside them as they gaze at the paper. The *Sun* glories in such shocks. It delights in constant changes of level and in the contradictions implied. So Steve is singled out to receive Jacqui's gaze, but he knows, and the Voice of the *Sun* reminds us, that she is also 'revealing her charms for millions of readers'. He may be a special individual, but at the same time he's just one of the droolers. The whole thing presented as an elaborate compliment, has set him up. The knowing complicity between the Voice of the *Sun* and the male chorus constructs a joke on him which is all the better because of Jacqui's assumed innocence. She seems to think she can be Page Three *and* Steve's girlfriend at the same time. She taunts Steve to claim possession, to pop the question, but at the same time she keeps her body in trim by swimming and jogging because she wants to be a model. In this presentation she's in control of her two roles; she can play them off against each other. She keeps her autonomy *and* her femininity. She constructs her autonomy *through* her femininity. No wonder she's pleased with herself.

It seems that despite the never-forgotten presence of the men in the story, the tension, the essential drama, is for women. It has to do with the aspiration to the status of model (autonomous femininity) and the jockeying for position between that aspiration and other modes of femininity – between the marriageable Jacqui and the 'delicious 36.24.36' Jacqui. For women like Jacqui the search for autonomy on these terms involves both an achievement and a defeat. The Voice of the *Sun*, while pressing its version of the achievement, is nevertheless constantly working to turn it into a defeat. It must present this 'excess of femininity' as its own creation and work to keep it under its control and that of the male audience. Once more, the work is done by means of jokes, and for the Voice of the *Sun* and its complicitous male chorus the joke is always on the woman.[6] Hence its search for the most extreme expressions of the tension, and its triumph in casting a policewoman in the role, turning her policewoman's hat from a symbol of authority into a provocative garment on a level with Lesley-Anne's underwear, something to relieve the unsexy nature of total nudity. After all, 'who would hesitate to be handcuffed by such a beautiful bobby?'

The crucial mediator in the transformation from working woman to model girl is, of course, the photographer. He literally stands in the position of the drooling millions and offers his view to them. But he has the privilege of creating the spectacle they merely yearn for. He witnesses the completion of Lesley-Anne's gesture, he organises the removal of Merlita's uniform and the redirection of her eyes. He awakens, brings out, the model girl latent in all women. It was Beverley Goodway who 'gave Merlita a taste of the model world'. Just as a certain sort of sex manual invites men to awaken the desire of their female partners, so we expect the expert Beverley, the prime ravisher, to advise male readers on how to draw out the Page Three girl concealed in their wives and girlfriends. Yet at the same time the feature on 'Do you want to be a Page Three girl' takes its place among the *Sun*'s frequent articles on sexual games, and, like them – though perhaps unlike sex manuals – addresses itself more to women than to men. In 'How to be a Page Three girl' women are not invited merely to respond to the photographer. No, it is up to them to prepare themselves, to work on themselves, to rehearse, to create their own autonomy. In this scenario the photographer is not the all-powerful creator, but the collaborator, adviser, technician. The Page Three girl must learn to ravish him.

So the Page Three role is clearly seen as a role, and is placed against the model's real life persona which is anchored in normality. Even the professional models have had fairly ordinary jobs: 'Carole-Ann worked as a sea front waitress in Weymouth before she became a tasty dish herself' (August 16). Peripheral characters are introduced from this world of normality, most often parents and other relations who express pride at their daughter's achievement: 'My mother's very excited and terribly proud of me' says Merlita (September 23); 'I'm very proud of her and her Dad's thrilled to bits' says Ellan's mother (October 4); Pepita's thirteen-year-old nephew will be 'pleased as punch' and her boss 'thinks it's great' (October 13).

This act, this double performance of Page Three, is close to what Mary Ann Doane, after Joan Riviere, has described as 'the masquerade': 'The masquerade doubles representation; it is constituted by the hyperbolisation of the accoutrements of femininity.'[7] It is not recuperable 'precisely because it constitutes an acknowledgement that it is femininity itself which is constructed as a mask – as the decorative layer which conceals a non-identity'.[8] In recognising the role *as* a role both the viewer and the actor have already distanced themselves from it and have put themselves into a position to manipulate it.

The action of Page Three takes place at a number of levels, and at each level there is a struggle going on, a struggle to define and contain, a struggle for autonomy and resistance:

| | |
|---|---|
| **1 The level of the pin-up: Page Three as a picture** | The three-dimensional flesh-and-blood men in the British Leyland spares department cut out a two-dimensional black-and-white picture from a newspaper for their own use. At this level the story is one of a relationship between real men and some meaningful marks on a flimsy sheet of paper. The woman is nothing but that picture, confined to the frame which surrounds it. The male spectators are the only actors. From time to time this real-life drama is re-enacted in the paper, reminding us that this is the paradigmatic relationship which justifies the very existence of Page Three. |
| **2 The narrative of Page Three: Page Three girl as double presence** | At this level, as we have seen, the characters work out their plots and sub-plots within the frame of Page Three itself. Male readers can follow the *Sun*'s attempts to win new recruits, can watch its attempts to overcome different sorts of resistance and can chortle at its jokes. Female readers can take part in the drama. Who will be Page Three tomorrow? It could be *you*. |
| **3 The other narratives of the newspaper: Page Three as a model, as real life persona, and the introduction of the Page Three principle** | At this level the model is not confined to her frame. She appears as a character in the sexual dramas which thread through the daily pages of the *Sun*. Professional Page Threes appear in the news and on the feature pages. One has a baby, another gets a part in a film; a feature on 'Page Three pioneers' (October 26) traces the lives of Page Three models from ten years ago; a news story on the sexual harassment of babysitters is illustrated by an account from a Page Three girl. Amateur Page Threes appear in their real-life personae. After all there's a story here, we want to know what happened to them. Take Merlita: two days after her first appearance we were shown Merlita in her jeans, eyes to the side once more, 'an arresting sight out of uniform', under the headline, 'Life is sweeter for sun-struck Merlita'. The news that 'she has now quit the police force' is casually mentioned. She's 'going to make a new career in modelling'. 'My mother is terribly proud of me' but 'I haven't seen the chief superintendent yet' (September 23). On September 27 she gets a smaller corner, 'Magnificent Merlita Buckler, who took down her particulars for Page Three, faces a showdown with her bosses today,' and the cause of the problem is finally spelled out. It's her 'barefaced cheek in appearing topless in Tuesday's *Sun* – while she wore her police hat'. |

Other amateur Page Threes force themselves into the role, confirming the *Sun*'s conviction that the Page Three principle is present in all women. 'Naughty Erica' runs topless on to a football pitch; the fleet comes home, and is greeted with the Page Three principle, the baring of breasts for male gaze. ('I wish I could meet her', said the man who sold me the paper.)

4 Life: Page Three girl as a real person

The women we were introduced to as 'Merlita' and 'Erica' also exist out of print, unspoken by newspapers. There too for all of us the struggle between femininity and autonomy must be worked out.

## Finally: playful Pauline's frolic or this is not the sort of behaviour one expects from civic leaders

Yes, but . . . Millions of women read the *Sun* and, what is more, they go on reading it. But all that analysis has not changed my own attitude. My rejection of the *Sun* remains as violent as ever, I have not argued it away. And of course I do not want to argue it away, for I believe it to be grounded in justifiable reasons. However, I cannot fail to note that my rejection, too, is constructed by the *Sun*. The paper calls down on its head uninhibited abuse from the rest of the press – abuse, it may be noted, often couched in sexual terms ('the harlot of Fleet Street', *Daily Mirror* May 8). But it has incorporated that abuse into its very image of itself. The *Sun* is what it is, its vast circulation is what it is, precisely because it is not like the rest. The *Daily Express* is ageing, the *Daily Mail* is pompous, the *Guardian* is boring. The *Mirror* is losing readers because it did not support Our Boys in the Falklands, Labour Party critics are a 'dreary and embittered crew'.

At the 1982 Labour Party conference MP Frank Allaun described the *Sun* as 'the most reactionary, jingoistic and anti-working class paper of them all'. But the *Sun* knows that it compels unswerving loyalty from many of its readers – 'There's no *Sun* today, and I don't bother with the other papers,' replied a station paper vendor when I asked about the news. 'Our readers will see right through this hysterical charge that the *Sun* is anti-working class. No newspaper has a better record in defending the real interests of working class men and women' (leader, October 2). And, when censured by the Press Council for its reporting of the black people's day of action,[9] the *Sun* answered, 'We have more coloured readers than any other newspaper' (October 8).

What the *Sun* is rejecting is moralism of any sort, bureaucratic power disguised as moral and cultural values, the whole range of attempts to put something over on you, to push you around, re-expressed in terms of elevation, education, propriety. The *Sun* rejects all that in the name of a working class whose rise to prosperity is still a living memory. Those who talk of a decline in that prosperity are the dreary and embittered who resent enjoyment, who attack the right to have fun, to be entertained. The *Sun* addresses a working class defined by its modes of consumption rather than its place in production. It unifies and organises its readers in terms of their forms of entertainment, by cultural attitudes rather than by class solidarity. The fact that

these forms of entertainment are actually provided by advanced capitalism disappears from view. Traditions of working-class discipline and organisation are rejected along with the middle-class bureaucrats, social workers, and cultural moralists. Rejected too are those who threaten this precarious position in a disorderly way: the immigrants, the muggers, the social security scroungers who snatch scarce resources and thus imperil the rest of the working class. The police are the allies of the working class in this scenario, defending them against attacks from below.

The *Sun*'s call for a particular kind of sexual liberation fits into this pattern. Sex is fun, a leisure activity, one of the rights of the consumer. Thus the organisation of gender roles takes place in terms of class identification. It is the moralists, the educators, the social workers who are the spoilsports, condemning Page Three as sexist and degrading. The *Sun*'s values are those which organise a working class – not the working class of labour histories, a class defined by self-help and hard work, but a working class which takes its pleasures when it can because they're only too fleeting. This is a working class that cannot be represented by the Labour Party. When Mayoress Pauline Duval demonstrated her acceptance of the Page Three principle, 'the attractive brunette stunningly shed the cares of office. Playful Pauline's frolic won roars of approval from her true-blue audience.' But her po-faced Labour opponents replied: 'It's not the sort of behaviour one expects from civic leaders.'

## Notes

1 Unless otherwise stated newspaper references are all to the *Sun*, 1982.
2 See Patricia Holland, 'The Invisible and the Obvious', *Lunatic Ideas*, London, Corner House Books, 1978, pp. 47-64, for a close look at the interweaving of narratives over a period of time in the *Daily Mirror*.
3 Roland Barthes, 'Introduction to the Structural Analysis of Narratives', *Image-Music-Text*, London, Fontana, 1977, p. 89.
4 Ibid., p. 123.
5 Stephen Heath, 'Narrative Space', *Screen*, Autumn 1976, vol. 17, no.3, p. 97.
6 See Mary Ann Doane, 'Film and the Masquerade: Theorising the Female Spectator', *Screen*, Sept/Oct 1982, vol. 23, nos 3/4, p. 85. In her analysis of a still photograph *'Un Regard Oblique'* she points out that, 'The woman is there as the butt of a joke – a "dirty joke" which, as Freud has demonstrated, is always constructed at the expense of a woman.'
7 Ibid., p. 82.
8 Ibid., p. 81.
9 For a look at the way the popular press treated the black people's Day of Action see Patricia Holland, 'The New Cross Fire and the Popular Press', *Multiracial Education*, Summer 1981, vol. 9, no. 3, pp. 61-80.

Susan Butler

# Revising femininity?
Review of *Lady*,
Photographs of Lisa
Lyon by Robert
Mapplethorpe

On May 2 1983, the *Sun* ran the following headline, in inch and a half letters across the width of a page: 'Miss Muscles!', while an overhead by-line announced, 'Sun spread on startling new shape in pin-ups'. This article celebrated the publication of *Lady*, a collection of photographs of body builder Lisa Lyon by Robert Mapplethorpe; only about a fortnight before, the *Sunday Times Magazine* had featured a pre-publication spread of several pictures along with Bruce Chatwin's introductory essay for the book. This suggests how quickly and how far *Lady* has made inroads on the popular consciousness at different levels, and specifically in terms of a new prototype of the body beautiful, a new possible symbol of the woman of the 1980s. The project of *Lady* grew out of a meeting between Mapplethorpe and Lyon in New York, about a year after she had created quite a stir by winning the First World Women's Bodybuilding Championship in Los Angeles in 1979. Lisa was apparently eager to discover someone to document the extraordinary but ephemeral sculpture of her anatomy, and Mapplethorpe seemed the right person to do it. The result is an encyclopaedia of roughly a hundred pages charting Lisa's physique in a series of pictures that range in type from fairly straightforward images of body building (often posed nude) through a varied selection of familiar and not so familiar cultural clichés of women.

The ambiguity of the effect as a whole is summed up in the title 'Lady'. Scrawled in a racy script across the provocative cover image, it suggests a camp take-off, a playful spoof of this traditional idea of femininity. Yet the concern of the book as it unfolds seems more an effort to justify the body builder as an authentic lady, totally feminine in all of the usual ways, so that this new way of femininity involves only perhaps an added ingredient, not a fundamental change (Figure 37). The notion of

From *Creative Camera*, September 1983.

120

37 Robert Mapplethorpe, photograph from *Lady: Lisa Lyon*, New York, Viking Press, 1983.

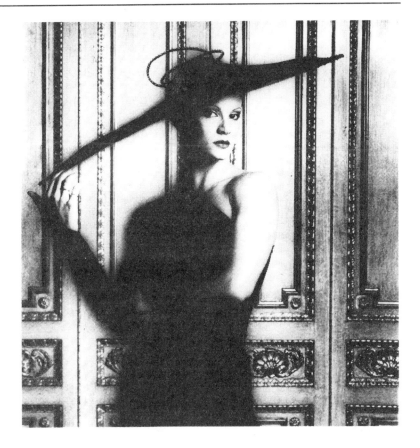

lady-like femininity may be as much a point of proof as a point of take-off, and this raises the question: does Lisa's 'new' image revise or get revised by a lurking presence in these pages of the habitual notion that what men think of women is the ultimate criterion of femininity? The *Sun* article broaches this possibility with undisguised directness by posing the terms in which, in our society, the judgement on Lisa's athleticism should be cast: 'But would YOU say that she is truly beautiful?'

To a limited extent, such issues have already been raised in our general consciousness by the recent recognition of the value of physical fitness. It is not so long ago that women were discouraged from developing their physical potential and often felt reluctant to be actively involved in sports in order to avoid seeming unfeminine or butch. The ideas of beauty and muscular strength in women were mutually exclusive, and doubtless some of this thinking remains despite the fitness craze, and also despite now-familiar imagery in the media which reflects it. For this image of women is carefully controlled, and usually remains within certain unspoken boundaries. Against this context, Lisa

Lyon's frank muscularity and the strength it implies seem to openly reject the dissociation of femininity and strength, to make a much more obvious attack on that dissociation than the images of fitness that now crowd the women's magazines. Indeed, the popular notion of fitness has little to do with the idea of actual strength. Rather, it is presented to women as the latest approved method for resisting the two cardinal feminine sins of ageing and being 'overweight'. In visual representations of this idea, the models used are often weedy and even anorexic-looking, and they seldom lift weights bigger than oversized cufflinks – Twiggy recycled with running shoes. Neither wispy nor wistful, Lyon's very solid physical presence, on the other hand, presents an image of greater actual strength; we are told in the introduction that she is able to lift Arnold Schwarzenegger over her head. At the same time, this physique in *Lady* is frequently combined with a more patently glamorous image of women than we have seen in some time, one largely derived from the movies of the 1930s and 1940s, as well as fashion photography of the 1950s.

At the most immediate level, the insistence on legitimising a connection between femininity and physical strength seems implicitly a victory, a liberation: women can now look and be both strong and glamorous. But a new imperative may arise from this, for the cataloguing of Lyon in an exhaustive variety of glamorous guises seems to add a corollary message to women, 'You can only have permission to be this strong if you can also look this beautiful.' Such an ideal may be even more impossible and intractable than the usual one which simply emphasises beauty and glamour *per se*. Certainly the new ideal elaborated by Lyon/Mapplethorpe is as dependent as ever on the phenomenon of God-given beauty which Lyon coincidentally happens to have a quite reasonable share of. Part of the impact of her looks has to do with the uncannily reminiscent quality of her face, which enables her to evoke the aura of a remarkable variety of well-known beauties, from Jane Russell and Connie Francis to, more recently, Paloma Picasso and Victoria Principal. In this advantage, the Lyon/Mapplethorpe venture plays it safe, since the appeal of Lisa's looks and Mapplethorpe's skill in photographing them effectively gives Lyon the freedom to get away with a kind of experimentation less conventionally attractive women would find more difficult to carry off. Yet a positive counter-argument is plausible here as well: that Lyon's attractiveness helps to create greater acceptability for the idea of physical strength in women generally, and therefore paves the way for women less obviously endowed with a conventional brand of good looks to feel freer to develop their bodies as they wish; the super-strength represented by women Olympic shotputters, for example, has perhaps been, if anything, a deterrent in this respect to many women. While Lyon's sport of bodybuilding (which in fact she considers to be a

ritual and an art form) is comparatively gratuitous in nature, her build is certainly much closer to the relatively more practical kinds of body development seen in women cyclists, swimmers and tennis players.

Nevertheless, in *Lady* the Lyon physique is presented not so much in practical terms as idealised ones, and one cannot avoid overhearing the revving of engines, the mechanics of hype behind this. Given Lyon's image to start with, its presentation is enhanced by Mapplethorpe's consummate mastery in posing and illuminating the figure as well as by the classical calm and precision of his composition within the square frame. Everything in these images is very strictly under control. Still more obvious as part of a process of idealisation is the considerable proportion of glamour or fashion images. Behind these images is a high-powered arsenal of no less than a dozen top-flight fashion designers, including the latest avant-garde/establishment types such as Claude Montana and Issey Miyake. These and similar pictures undoubtedly demonstrate Mapplethorpe's virtuosity as a kind of black-leather Beaton or Penn, and the total effect adds up to a formidable level of coffee-table credibility – but it also tends to compromise any other kind.

An idealising force can be felt as well in the strict absence of any very personal or individualised approach to the body as a nude image. There is very little tactile sense, for example, such as one finds in Weston's nudes. Occasionally, stretch marks are remotely visible on Lyon's body, but this kind of feature is never discovered or explored in a positive way. On the contrary, the use of graphite in several of the nude pictures, which produces a beautifully graduated modulation of light, additionally subordinates surface features of the body to a sculptural effect experienced as smoothly carved volume. While these pictures are amongst the most beautiful in the book in their way, they clearly present the body in monumental rather than personal terms; Lisa's physique is given to us mainly as product and effect, rather than as work. This is largely true even in the pictures which ostensibly show her working out: they are statically posed, often distanced, and, except for one picture of her hands, show little of the stress and strain, and none of the grimacing and sheer sweat that must be a fundamental and atmospheric part of her experience as a body builder. Thus the number and variety of images of Lyon in no way add up to an intimate portrait on a personal level; rather they comprise the elaboration of highly constructed image which can be further manipulated to coincide with and/or disrupt other highly constructed images of women. There is always a sense of distance and artifice – as Lisa remarks, 'The pictures are a little cold, like us.' And so, necessarily, is the ideal.

Ideals are, in any case, often potentially fascist by nature, since

they tend to celebrate a particular possibility not simply as one option amongst many, but as one implicitly superior to others. The flawlessness of Mapplethorpe's style brilliantly reinforces such an effect. For his elaboration of the image of Lisa Lyon the body builder as a glamorous 'lady' successfully assimilates the unfamiliarity of the body-building aspect to a familiar ideal convention, that of the *femme fatale*, represented here in images ranging from Harlow to *Maîtresse* kinds of evocation. The threat of feminine independence given specifically as physical strength and competence is thus converted into the traditional male projection of the dangerous lady, with her black widow beauty that lures only to destroy. In this way, feminine physical strength can all too easily be equated with, and thereby reduced to, the destructive psychological and sexual power often represented in the heroines of *film noir*. But not to take such sinister transmutations too seriously, they are meant partly as camp, if the mock-drama of props like tigers and motorcycles is anything to go by. Alas, however, the humorous possibilities of an underlying parody are at times compromised by heavy-handed attempts at something more resonantly Significant. This is the case with two images of Lisa nude, in profile and soft focus, first pointing a gun at some unshown person or object, then directing its cold shaft against her own bosom. Great reverberations of something phallic and fatal here, no doubt – but exactly how this version of a tired cliché should be interpreted is hard to tell. Or is the tiredness of the cliché the point, in which case these images too might be read as parody? Perhaps the difficulty is partly that Mapplethorpe's style is fundamentally a very serious one, and its sober beauty often eradicates the possibility of humour. It is far from a spontaneous style, and spontaneity is one of the few means by which a nuance of parodying cliché could be made to come alive; the problem is that simply too many images in *Lady* look like dead-pan rehearsals – and, consequently, reassertions – of familiar images rather than take-offs of them. And this is true across the soft-porn mock-ups, the glamour and black leather shots, and the series of photographic quotations: one simply does not know how to read them. An obvious level of contrivance in many of the images is of little help, since the conventions echoed are often already highly theatrical in themselves. Is the implicit self-consciousness at work in the imitation of various conventions, plus the fact of Lisa's physical strength, sufficient to overturn the conventions? Or do these would-be subversive elements simply provide the necessary alibi for pulling off the cliché, after all?

It becomes difficult to judge which possibility dominates, and perhaps that is part of the book's strategy; it can be read very differently by different readers – devotees of soft porn, fashion, feminism and, of course, photography. Hand in glove with this maximising of the potential audience through elaborating

different series of images is the need for patterns of elaboration simply as mechanisms for generating sufficient material to fill a book. One gets this feeling particularly from the photographic quotations. While such pictures testify to Mapplethorpe's knowledge especially of nude photography (he quotes Man Ray, Bravo, Weston and Leni Riefenstahl, amongst others), few of them have much relevance to the problem of exploring new images of feminine strength in relation to more conventional kinds of feminine imagery.

These difficulties notwithstanding, there are a handful of stunning images in *Lady*, some of them successful simply as beautiful pictures, while others succeed as genuine provocations. Two images effectively sum up, in very different ways, the problems at issue in the book: the cover photograph which shows Lisa in profile wearing a veiled picture hat, with her biceps flexed and wrists clenched, and the beautiful image in the graphite series showing a detail of shoulder and breast, with the arm raised and flexed to show its strength (Figures 38 and 39). Perhaps the most exhilarating images are the two full-length nudes of Lisa standing atop a rock embankment in classic body builder poses (Figure 40). These images have both humour and daring in their unabashed declaration of one woman's (and therefore every-woman's) right to develop her body as she is pleased to do so, for whatever reasons – and to display it in postures that make none of the usual concessions to a presumed male view.

38 & 39 Robert Mapplethorpe, photographs from *Lady: Lisa Lyon*, New York, Viking Press, 1983.

40 Robert Mapplethorpe, photograph from *Lady: Lisa Lyon*, New York, Viking Press, 1983.

One very important aspect of these and certain other photographs of Lisa is the way in which Mapplethorpe has used the still image of a female nude to portray a kind of held action, charged with energy, for in these pictures it is no longer possible to equate the stillness of the figure with passivity. This has partly to do with Lisa's body itself, of course, insofar as it reflects her ideal of a woman's body as 'neither masculine nor feminine but feline'. Certainly she does project that self-contained grace associated with cats, which even in repose suggests the ability to spring into sudden, spectacular action. Mapplethorpe's success in capturing this quality in the still image seems to me no small achievement in the tradition of nude photography, which has been overwhelmingly one of the female nude. To develop this kind of possibility in the nude image of a sense of capacity for active expression, can begin to give nude photography an important and needed scope beyond the straitjacket of aestheticism inherited from painting, with all the culturally limiting assumptions attendant in that. The only other photographer I can think of currently working in terms of using the still nude image to suggest a feeling of dynamism is David Buckland, who has recently used nude dancers (both male and female) to convey a sense of movement and torsion in posed images.

If *Lady* as a book is less than successful, it is because it fails to sustain the issues raised in its three or four most challenging images – women need options, not imperatives; enabling models, not ideals that cripple the psyche by their creation of a sense of inadequacy. What Sam Wagstaff (in his *Foreword*) has called Lisa's 'revised femininity' represents after all, only one of the kinds of options that women are thinking about now. In this respect, I find certain photographs of Lisa, some of them made, I believe, before the project of the book, more forceful and useful as single images – independent, free-floating radicals, as it were, undomesticated to any broader strategy which tries to make too much of them. As an extended series of photographs, *Lady* retreats both from redefinitions of the feminine and from an accompanying suggestion of possible gender displacement. But perhaps the new mythological superwoman presented here really does need all the strength she can muster: the burden of being beautiful has never been more heavy to bear.

Janice Winship

# 'A girl needs to get street-wise': magazines for the 1980s

## 'Undercoats' 1

One glance at *Etcetera*'s fashion spot 'Undercoats' (Figure 41) and any self-respecting feminist will sigh with exasperation, or worse. *Etcetera* claims to be 'The new magazine for the 80s girl', but what's new about pubescent young women in soft porn pics?

Not a lot of course. But arguably 'Undercoats' isn't that, not quite. Rather it plays on several levels, only one of which is the pornographic. I'm sure we *are* meant to read the spread as yet another version of the infamous bra ad whose caption runs 'Underneath they're all Lovable' and which Rosalind Coward suggests is to be deciphered as 'Underneath they all want it. An invitation to rape.'[1] But the invitation to women readers is also to register that meaning in order to draw it back along other paths.

The title 'Undercoats' humorously points to such a turn-around. The associations of 'undercoat' as the layer of dull paint priming the surface for a glossy finish is cut away by the 'undercoats' – the sexy underwear – in effect being the gloss. Similarly 'Undercoats' implicitly references the men-in-dark-raincoats brigade, flashing and getting off on women. Yet here that relation is reversed. It is young women who flash their bodies, and with their gaze and pose coolly confident, they express less the customary passive sexuality of women than an assertive strength. Their sexuality is constructed around a difference, between 'the masculine' – cropped hair and firm body, clumpy boots and dark mac – and 'the feminine' – shiny pink lips and lacy camisole. Maybe it isn't a sexuality which wholly breaks from the oppressive codes of women as sexual commodities, but neither does it straightforwardly reproduce them. The conventions of gender and sexuality are, it seems to me, being actively tampered with. If on the other hand as feminists we refuse that interpretation and reject the imagery of these pages, we need to be careful that we are not simply outlawing a *sexual* presentation of women. For is it possible to create new erotic codes – and I assume that is what feminism is striving for – without in some way re-using the old?

This is an edited version of an article which appeared in *Feminist Review*, no. 21, Winter 1985.

127

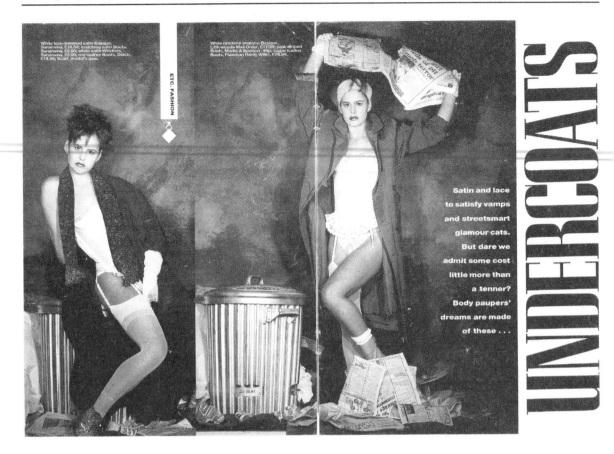

White lace-trimmed satin Basque,
Sunarama, £18.50; matching satin Briefs,
Sunarama, £2.50; white satin Wristlets,
Sunarama, £3.00; red leather Boots, Dolcis,
£19.99; Scarf, model's own.

ETC. FASHION

White broderie anglaise Basque,
Littlewoods Mail Order, £11.99; pink striped
Briefs, Marks & Spencer, 99p; taupe leather
Boots, Freeman Hardy Willis, £29.99.

UNDERCOATS

Satin and lace
to satisfy vamps
and streetsmart
glamour cats.
But dare we
admit some cost
little more than
a tenner?
Body paupers'
dreams are made
of these . . .

41 'Undercoats', *Etcetera*,
21 March 1985.

The spread isn't all about sex, however. Another thread picks up on 'the street'. In an urban environment the street is not simply a thoroughfare but one of the few spaces which is not private property and for which no one has to pay in order to have the privilege of being there. The street is therefore the place where those who are very poor and have no home, like the single homeless, may eke out a miserable living from what the well-off have nonchalantly discarded. In the 'Undercoats' feature, dust-bins and rubbish – sanitised as they are in the photos – symbolise that down-and-out existence, living in back-street alleys of the inner city.

The street is also the place which, again without much money, the young – and especially young males, who similarly have no personal space except that controlled by parents – can take over as their own by the forceful presence of their numbers, their looks, their music, their spray-gun graffiti and sometimes, their petty crime and violence. If that kind of street-wise culture has been most associated with young blacks in urban USA who have created their own means of survival in conditions of poverty, racism from whites and harassment from the police, in Britain it

is noteworthy that such a culture has been most vigorously created during the period of unemployment and recession in the 1980s. Learning the skills of the street has become a social requirement not just for young blacks (though certainly theirs *is* a strong contribution on the streets) but for young whites, and not just for young men but for young women too.

Thus the idea of 'streetsmart' in the 'Undercoats' feature hints not only at a certain fashion look; it also suggests the ability to look after oneself on the streets. And as a woman that means being able to deal with violence and sexual harassment from men. More generally, for young women as for young men, to be street-wise is to have the wits to get by, on the edges of society, and without that vital ingredient in a capitalistic society – money.

'Dare we admit some cost little more than a tenner? Body paupers' dreams are made of these. . .', declares the caption to 'Undercoats'. Satin and lace: rich and sensuous to the touch, expensive on the purse, 'naughty'. The stuff of (men's) sexual dreams but also the symbol for what a poor girl rashly desires and cannot have.

If this excessive reading of one fashion spread seems very doubtful, its proof lies in demonstrating that *Etcetera* magazine as a whole, and other young women's magazines, take up these themes. What I want to propose is that their editorial is premised, in a way that of other magazines is not, on an acknowledgement of the social effect of unemployment for young women. Their editorial dilemma is how to present dreams and desires, choices and possibilities when young women are, already, potentially defined as society's have-nots. An ad for Wella hair products in *Mizz* magazine advises, 'Get wise, street-wise' (26 April 1985). It is also the covert message of these magazines. But while the Wella ad urges only a professional hair cut and the use of its products, to be street-wise in the magazine involves both the acquisition of an eclectic mix of consumer goods and jumble sale buys, and 'street-wise knowledge'. And the latter includes some wisdoms and skills which draw on a feminist culture, if not on a feminist politics.

## Not a photo-story

*Etcetera* is one of three magazines for young women to have appeared on the news stands since 1983. The first launch was *Just Seventeen*, produced by the small publishers East Midland Allied Press (EMAP) who also publish the music magazine *Smash Hits*. It was intended mainly for the under-seventeens and to compete with *Jackie*. Starting life as a fortnightly publication in autumn 1983, eighteen months later its circulation and advertising revenue were sufficient to allow it to become a weekly, and as a sign of its success editorial director Dave Hepworth won the Periodical Publishers award of Editor of the Year.

D.C. Thomson, the Scottish family firm, are known (and hated by feminists?) for their stereotyped children's comics and *Jackie*, and for their old-fashioned women's weeklies like *People's Friend* and *My Weekly*. But with a reputation for a puritanical approach to all matters even vaguely sexual, D.C. Thomson had never deigned to compete in the market where magazines most bristle with sexual issues – magazines for the eighteen- to twenty-five-year-olds. Thus *Etcetera*, brought out in March 1985, was their first venture into the niche dominated by International Publishing Corporation (IPC) who own *Honey* and *19* as well as many others including the big women's weeklies, and by the National Magazine Company who publish *Cosmo* and *Company* as well as *She* and *Good Housekeeping*. In April 1985, and accompanied by expensive TV promotion, IPC opportunistically launched *Mizz*, this time a magazine aimed at sixteen- to nineteen-year-olds.

Despite their slightly different readerships, both *Etcetera* and *Mizz* owe their existence, and something of their editorial package and design, to *Just Seventeen*. *Mizz* in particular is what Brian Braithwaite and Joan Barrell call a 'me-too' publication.[2] That is, if one company comes up trumps with a magazine, rival companies rush in with their 'copy-cat' publications. *Etcetera*, on the other hand, with its glossy black and white rather than colourful look, is stylistically and editorially a bolder and, perhaps, more interesting magazine.

According to publishers the young women's market is highly volatile. By which they mean that young women's magazines can fall out of favour as quickly as they can also become publishers' gilded lilies; that in their constant striving for novelty – allegedly a prerequisite for a young audience – the magazines bloom and fade with changing styles of fashion and music. Against such a view Cynthia White has convincingly argued that publishers' expectations 'have become self-fulfilling prophecies'. Cheap paper, poor printing and flimsy editorial combine to produce 'superficial and ephemeral journalism'.[3] Certainly magazines for the younger end of the teenage market show the most frequent turn-around of titles, and compared to the sums IPC pump into *Woman* and *Woman's Own*, relatively little money has been invested in the 'young' sector.

The rationale for such differential investment is that magazines like *Woman's Own* make vast profits; the young teenage magazines do not. The latter are a post-Second World War phenomenon, whose birth was dependent on a capitalist market recognising the potential spending power of young women. Yet the market has also been acutely aware that the younger the girl the less ready cash she is likely to have and therefore the fewer commodities she is able to buy. As a result the magazines directed at young teenagers have always relied less on advertising than on sales for their revenue. Cover prices are comparatively expensive, sales on

the whole small, and profits low, so that in turn the editorial quality of the magazine is poor. A vicious circle, but one which the 1980s trio of magazines has finally broken.

The achievement of *Just Seventeen* was first to recognise the inadequacies of existing magazines for young women. As Dave Hepworth recounted, 'The greatest boon to *Just Seventeen* was photo-strip stories, the fact that everyone else did them. Because it immediately stamped them as corny photo-strip magazines and left them no room to change their character.'[4] Second, *Just Seventeen* was able to build on the success of *Smash Hits*, which had been produced by the same editorial team. The latter had reversed the usual 60:40 male/female ratio of music paper readers, so that EMAP judiciously opted to bring out the first issue of *Just Seventeen* banded to *Smash Hits*, thus securing both an initial readership and, as importantly, advertising. *Just Seventeen*'s strategy around advertising was to convince advertisers that even if young teenagers didn't have a lot of money to spend it was necessary to win their custom. Young women are, after all, the consumers of the future. As an IPC ad to advertisers once put it: 'You can persuade them to be yours for life. Build brand loyalties' (*Campaign*, 10 June 1983). To this end *Just Seventeen* arranged to give away small supplies of a wide range of new products to readers who wrote in, an arrangement mutually attractive to manufacturers and readers: who doesn't like receiving something for the mere cost of a postage stamp? It was a ploy *Mizz* and *Etcetera* also copied.

*Just Seventeen* chose wisely, too, to break a long-held convention of the women's magazine market and bring out the magazine neither weekly nor monthly but fortnightly. (*Etcetera* and *Mizz* have also followed suit in this respect.) In that way the magazine had less trouble than the weeklies in winning adequate advertising support and could sell a higher-quality magazine at a lower price than the monthlies.

Editorially Dave Hepworth wanted

> to create a proper magazine for girls who hadn't had a proper magazine before. . . . We wanted it to feel like a pop magazine, that felt as exciting and instant as that. We wanted it to be fashionable, not just about fashion. We also felt that you could communicate with girls of that age on a more mature level than was previously being done. . . . It's a pretty intelligent magazine. Certainly when you compare it with *Jackie*. It's not Hunk of the Month and all that sort of stuff.[5]

## 'Upstarts'

*Just Seventeen* is visually busy, with interesting colour combinations and fun pics like the face begun on the edge of one page

and completed overleaf. The paper is glossy and the print quality looks expensive. Its short lead time (the time between going to print and publication) gives it a vitality *Jackie* cannot manage. It is also irreverent and funny in tone. 'Our overall slant is not cloyingly female. You can have a certain amount of irony and you can have a certain amount of humour because girls respond to that, boys don't.'[6]

Nevertheless, it is the titles *Etcetera* and *Mizz* which indicate most clearly the differences between those three magazines and *Jackie* on one side and *Honey* on the other. *Mizz* isn't spelt Ms but it certainly sounds like it – as IPC must surely realise. It is a title which is meaningless and meaningful. A joke? A refusal to be quite pinned down? *Etcetera* conjures up, though whether intentionally is another matter, that it is moving to the sidelines, that it is not concerned with the mainstream, but with the edges, the trivia that mainstream doesn't bother to name and hardly deems worthy of attention. It is a quite different sort of emphasis from the focused gaze implied by the title *Look Now*. Women and women's issues as the etceteras of life has a neat irony, especially when set against the affirmation for women of such titles as *Woman's World* and *Woman's Own*. The cover of the first issue of *Mizz*, proclaiming 'Play it loud!', also distances itself from more traditional cover images. The model actively places her hand between herself and 'the world'. She controls who may gaze at her, and thus able to protect herself – she pushes that 'world' away – she may look out at what and whom she wishes relatively unmolested (Figure 42).

In contrast to these magazines *Jackie* looks and reads like a naive younger cousin from the rural backwoods, while *Honey* or *Look Now* seem overpolished, complacent, too caught up in conspicuous consumption and career success.

Maybe it is to give too political an inflection to suggest that the three new magazines speak to young women as the disaffected and dispossessed, as those who look on at a culture which is not theirs, and in which they have a peripheral place. But as in 'Undercoats', the magazines often upturn certain dominant cultural assumptions. They look on from a position 'outside' – from 'the streets'.

Such is the humour in the magazines. Thus for an English sensibility, *Just Seventeen*'s 'Gnome Sweet Gnome?' (3 April 1985). The article explains that with British Telecom replacing the famous red telephone boxes with 'draughty perspex bubbles' the old kiosks have come into their own:

> Introducing the latest, trendiest garden ornament of the eighties. Forget the barbecue set. Concrete over the goldfish pond. Sell the patio furniture and smash the sundial. Then go out and buy a telephone box. Absolutely everybody who is anybody has got one. . .

42 Cover photograph, *Mizz*, 12 April 1985.

Housewife entrepreneur Valerie Stafford . . . will deliver one to your door for a mere £450. Should you desire something a little more exotic, she will deck it out with gnomes, plants and fittings for a wee bit extra. But gnome homes are not the only use for such an obviously practical item. So far conversions include: greenhouses . . . showers, cocktail cabinets . . . outside loos, and kennels. The versatility of the phone box is endless. So go out and get yours now. Let's face it, no gnome should be without one! (*Just Seventeen*, 3 April 1985)

Nor, judging from the pic of Gnome Home, should he (*sic?*) be without a telephone.

In a similar vein 'Mizz workout' mocks aerobic classes:

The trouble with most workouts is they involve too much *work*. All that rushing to classes and doing your back in during the warm-up exercises. It's just no fun standing in a class full of Victoria Principal clones when your lycra-mix leotard makes you look like a non-singing version of Chaka Khan. (12 April 1985)

So *Mizz* offers its 'very own workout'. 'Walking from sofa to get cream cake' uses up fifteen calories; 'walking back to sofa to consume said cream cake', twenty-five calories; 'squeezing spots', fifteen calories – and so on. Having accounted for nine hundred and ten and a half calories on such everyday activities, the piece concludes: 'With a day like that, who has energy for an exercise class anyway?'

The repeated motif of 'the streets' in the magazines also echoes a vantage point beyond the centre (as well as beyond central London in all directions of the compass). 'Local Heroes' in *Mizz*, 'Spy in. . .' in *Just Seventeen* and 'On the streets' in *Etcetera* present street fashion: clothes young people wear, and showing them, literally, on the streets, somewhere in the (mainly urban) regions. Given the contribution of young blacks to street style, it might be thought that they would be well represented in these pages. But whereas *Etcetera* appears to make an effort in this respect (Figure 43) and includes black men as well as women, in *Mizz* and *Just Seventeen* the gesture is more likely to be a token one: just one young black person featuring in their street pages.

'On the streets', however, is also a metaphor for on the dole. And it is the magazines' attention to the views and interests of the unemployed which shifts their editorial into a potentially critical mould. 'Spy in Northampton' features Lee, aged nineteen, who 'had the choice of being a warehouse assistant or joining the army. So he opted for the dole queue. . .' (*Just Seventeen*, 17 February 1985). Magazines like *Company* and *Honey* do not much concern themselves with whether the low paid and unemployed are going to be able to afford the consumer delights they offer. After all, a lot of their readers clearly can. In contrast, for these three magazines the unemployed are the most important

43 'Irene Shelley', *Etcetera*,
30 May 1985.

reference group. As Brenda Polan reports in the *Guardian*, *Just Seventeen*'s ' "(wo)man on the Clapham Omnibus" is Sally from Grantham, an unemployed 16-year-old'. If Sally wouldn't like an article then out it goes.[7]

Likewise with the unemployed in mind, *Mizz* does a run-down on the facilities to which a UB 40 gives access across the country (12 April 1985). Shortly after the March budget *Just Seventeen* discussed the implications of the Chancellor's measures to pull down wage levels for young people (3 April 1985). The magazine concludes by asking readers 'What do you think?' while barely disguising its own criticisms, that, as Youthaid and the Youth Trade Union Rights Campaign (YTURC) put it, 'the budget had something very Dickensian about it'. It was 'a disaster for youth'.

If this article verges on encouraging a political response to unemployment, most articles tackle unemployment as an individual dilemma to be dealt with in a variety of personal ways. Two of the three girls in *Etcetera*'s feature 'Take Three Girls' (asking 'Will they live happily ever after?') are unemployed (21 March 1985). 'Linda, unmarried, is struggling to bring up her baby daughter alone'. Janet, unemployed since she left Newcastle Poly in July 1984, is 'a regular member of the audience at The Tube' and 'has big ideas about starting up her own dance classes'. Only Liz, 'an aspiring young accountant', has a job and the regular income and class aspirations that go with that: she 'loves going to cocktail parties and dinner dances'.

For the unemployed, hopes are for the future but desires can

be temporarily assuaged by sharing them with readers. Linda Hogarth:

> I've no qualifications but I'd really like to be a social worker. I'd go to college and get the qualifications if I thought I could do it. But it's Samantha. When she's two years old I'll put her in the local nursery, which costs two pounds a week, and I'll try to get a job in a shop. Just part-time to begin with until I know she's all right.

Meanwhile she persuades:

> I'm happy with my life at the moment because I've got Samantha, although sometimes when my friends call round and I hear where they're going and what they're doing, I get jealous. I've no regrets though... (21 March 1985)

Hopes and desires are also 'satisfied' by legitimating the hopes. *Etcetera* describes itself as '*Etcetera*, for the girl who wants everything. And more'. And why shouldn't she want, even though she may not have the means to have – except in the pages of *Etcetera*? But it is the veritable display of what *Etcetera* calls 'Upstarts' which promises that hopes just might be fulfilled beyond the pages of print.

'Upstarts' are young women, and men, who are emerging as Names in the artistic fields of fashion and music, art and design: 'Art Throbs: Making their way out of the masses are a group of young people who are changing the face of accepted style and setting the course for the shape of things to come...! (2 May 1985). Since relatively few readers are likely to move into such spheres of work, the appeal of this group may initially seem curious. Yet what they offer are not only the consumer goods – clothes, records and design goods – that young women want to buy, but also the model of a working life which seems possible and which, unlike the image of work as a daily anaesthetising grind, is palatable. Having themselves often been unemployed, 'Art Throbs' don't then lose their sense of purpose and originality in any boring nine-to-five routine. They retain both control over their work and a perception of the world which, at the cultural level at least, is challenging and positive. As P.P. Hartnett says of Trojan, 'Love him or hate him, Trojan is a fighter. He may not have the technique of the great masters, but his work is about living and living colourfully, which can't be bad' (*Etcetera*, 2 May 1985). Perhaps too the attraction of these 'Upstarts', and the lure of their culture, is that they most visibly transform gender codes.

It is only too easy for feminists to discount what appear to be cosmetic changes. But perhaps we shouldn't be too hasty. The gender bending of girls' 'boyish' haircuts and boys' 'girlish' make-up is the outward sign that underneath the cosmetic coating New Woman (New Man even) is struggling to find her (and his) identity.

## And a street-wise 'feminism'?

Nevertheless the New (Young) Woman who is emerging doesn't quite have the profile hitherto ascribed to her older counterpart. Penny Perrick, writing in *The Times*, for example, explained 'Why superwoman is out of style'. She maintained that after the noisy publication of *Options* and *Working Woman* – magazines allegedly for the New Woman of the 1980s – and after the mushrooming of Next and Principles shops selling the nicely co-ordinated separates of New Woman's uniform, the market has abandoned her, apparently shunting her 'onto the sidelines in favour of the Good Old Teenager'. The reason for such a move, Perrick continues, is that the New Woman, 'who may be a spinster, a wife, a divorcee, or all three within a few years', is 'complex and complicated'. No wonder then that

> magazine publishers have turned with a sigh of relief to the charming simplicity of the teenage girl, who can be guaranteed to be living with her mum, paying a token rent, and to have the wherewithal to buy herself a ghetto-blaster without heart searchings.[8]

Many teenage girls are living with mum (many aren't of course), but glibly to maintain that young women are a simpler readership to cater for is not only patronising but, on the evidence of these new magazines – let alone the evidence the girls themselves might provide – is plainly very wrong. The New Young Woman is every bit as complex; and so are her magazines.

The latter are finely poised between on the one hand acknowledging unemployment and on the other offering a good time. They also introduce (some) feminist ideas, but carefully don't use the label of feminism. Not overtly political around feminism, there is still a cultural level at which feminism *is* taken for granted. The magazines don't so much assume that the feminist case has been won as that it goes without saying that there is a case.

So, 'Quote of the week' in *Mizz* from a Conservative MP on the subject of juries: 'We need solid citizens with collar and tie and a good shave; clean, respectable chaps of substance and by that I mean men of property and education. Now *anyone* can be on a jury.' And *Mizz*'s comment: 'Says a lot for us women doesn't it?' (12 April 1985). *Just Seventeen* offers a sympathetic account of women's peace camps at Greenham; *Etcetera* discusses the illnesses feminists have brought to public visibility, like pelvic inflammatory disease and bulimia.

In 'Splitting Images' *Etcetera* takes issue with marriage as *the* privileged institution (not that the article puts it like that). It is one woman's account of the lack of support she and her live-in partner received from friends and family when their relationship began to crack, as compared to the all-round rallying which occurs when a marriage is under threat (21 March 1985). What is characteristic of this and other articles is that feminist ideas are

taken up pragmatically, translated into the practical and individual skills of the street-wise. Similarly, 'Enough is Enough' examines the increasing threat of male violence for women walking the streets and discusses the practical means, legal and illegal (it rejects the latter; for example, 'weapons' from sharpened combs to sprays), by which young women can 'fight back against street violence' and 'do something positive to make the streets safer' (*Mizz*, 12 April 1985). *Mizz*'s 'Personal safety plan' includes the advice to 'Walk with self-confidence and a sense of purpose', and to 'think seriously about a self-defence course'.

In a later issue *Mizz* explains 'How to become a virgin – a step by step guide to cleaning up your reputation' (26 April 1985). A tongue-in-cheek caption, but the article is informed by a feminist repudiation of a double standard of sexuality: 'It's not sleeping with someone that makes you a slag – and don't let anyone tell you otherwise.' The street-wise girl isn't so much urged to challenge the (masculine) double standard as individually to deal with its effects: 'It's a nasty feeling knowing that they (the blokes) are still sniggering about you and you've got more mud sticking to your name than to a cross country runner's gym shoe.' *Mizz*'s advice hinges on the idea that 'Celibacy is in, and if it doesn't *really* mean you mustn't have a sex life, it certainly means that you don't brag about it.' In addition:

> You've got to be choosy. Don't be flattered every time a bloke asks to walk you home. Don't be so grateful for his attention that you don't like to say no. . . . They want to talk to you and be with you because you're smart, sensitive, attractive and uniquely you. They're the ones who should be grateful. . . (ibid.)

Quite. The street-wise girl knows her own worth and strives to please herself. As *Etcetera*'s first editorial proposed: 'We won't devote ourselves to articles on how to please your man (or even how to grab your guy). Instead we'll devote ourselves to pleasing you' (21 March 1985). Which isn't to say that heterosexuality isn't a preoccupation. (Of course it is.) Or that lesbianism has more visibility than the occasional letter on the problem page. (Of course it doesn't.)

Short stories, for example, have been on such themes as bulimia and suicide (hardly 'pleasing' but certainly interesting on some young women's dislike of and lack of confidence in themselves). More generally they have been about relationships, that is, heterosexual relationships. Such stories, sometimes featuring 'strong' women and 'weak' men, upturn some of the conventions of older magazine fiction. One, 'The Diplomat's Daughter' by Jessica Daniels, had as the central character a strong and beautiful black woman who spurned the attentions of a white man. She maintained: 'The one thing you know and love about me is my body. I can't live with a love like that. . .' He,

meanwhile, 'never understood' what he had done to lose her (*Etcetera*, 4 April 1985).

Yet the centrality and privileging of heterosexuality is always assumed. Stories aren't about friendships between women, except as a secondary theme, and I doubt *Etcetera* could even entertain the idea of a short story about sexual love between women. Still, though heterosexism may not be challenged, the overall representation in *Mizz* and *Just Seventeen* as well as *Etcetera* isn't wholly organised around heterosexuality. Perhaps this is most noticeable in the regional 'on the streets' slots where young people are shown alone, or in all sorts of couple and other combinations: with sisters, brothers, same-sex friends, different-sex friends, groups of friends, work colleagues, in mixed age groups and mixed ethnic groups. In the context of such variety the occasional girl/boy sexual friendship has much less significance.

Interviews with male pop stars do have sexual overtones sometimes (there are also double-page pin-ups in *Just Seventeen*). But at the same time there are also interviews with successful and interesting women, usually from the media, like Annie Lennox and Toyah, Janice Long and Victoria Wood, who talk about their work as well as their personal lives, and who demonstrably offer role models not conventionally feminine. Victoria Wood: 'I don't know why so few women do comedy. I get loads of letters from girls who say they want to be like me – wearing a funny tie and being fat' (*Etcetera*, 16 May 1985). *Mizz* has a slot called 'Talking Heads' in which popular celebrities, men as well as women, are interviewed by readers. Included here have been Samantha Fox (favourite pin-up of male readers of the *Sun*) who is asked, among other things: 'How do you react to women who say that your type of modelling is obscene and encourages the exploitation of women?' (12 April 1985) and Barbara Cartland. The interest of such women for readers is that they enjoy success on the back of exploiting a traditional femininity; yet they do so in a social climate where that femininity is also being challenged.

To be street-wise isn't to be a feminist (although it could be) but to be alert to those contradictions. To be street-wise isn't to disapprove of Page 3 pin-ups or slushy romantic pulp writers but, if need be, to steer a deliberate path through the thick of those contradictions with street-wise outrageousness. *Vide* 'Undercoats'?

If there hadn't been fifteen years of the women's movement and organised feminism there wouldn't be this cultural space to play with gender and heterosexuality. If there hadn't been those years of pushing feminist ideals and high principles it wouldn't be possible in the 1980s for 'the street-wise' to engage more pragmatically (and realistically?) with the contradictions of femininity – as in 'How to be a Virgin' – or to laugh at 'Schmaltzy, chocolate box romance' whilst also enjoying it ('The

Rose of Romance', *Etcetera*, 14 April 1985). But pushing gender definitions and reshaping heterosexuality at the cultural level doesn't quite have the self-consciousness of a feminist politics.

Nevertheless, even if a 'street-wise' consciousness is unlikely to edge any further into a more overtly feminist politics in these magazines, we feminists would do well, I think, to read and take heed of what they are offering. We shouldn't just contemplate the many and inevitable ways they are *not* feminist, but also consider what they might say to feminism. What can we learn from these magazines to enrich a feminist politics?

What strikes me most about the magazines is their attention to gender rather than solely to girls and women. A cursory look at the magazines may give the impression of an awful lot of space devoted to the male sex. And the simple explanation would be to attribute that to the media's belief that adolescent girls are (or should be?) obsessed with boys. It's also feasible to suggest that the extensive presence of boys and men in the magazines is part of a project to take on questions of gender via masculinity. Gender is a shifting ground in these magazines, and femininity *and* masculinity are categories which are in flux.

Occasionally amongst the glossy dross is a humorous play on old ideas and old images of gender. While maybe not producing new imagery, these efforts stimulate reflection about that possibility. Like 'Go bust, young woman', introducing new Playtex bras called 'Thank Goodness It Fits': 'We put Playtex to the ultimate test with our Picasso-influenced model ... and as you can see – a perfect fit. Just think what it could do for you. . .' One of the best examples, and a recurring image in young women's magazines, is a Boots ad for their *17* range of cosmetics. Showing an attractive and made-up young man, the caption reads: 'Looks even better on a girl' (Figure 44).

Boys and men sometimes speak about the things girls and women either never hear, or hear only within the privacy of a heterosexual relationship. *Just Seventeen* offers: 'What do boys think . . . about love, sex and birth control?' (27 February 1985). *Etcetera* gives a first-person account of a young man's one experience of working for an escort agency and his nervousness about whether he was expected to sleep with his date, a fifty-year-old divorced woman. He wasn't:

> I suppose I was thrown off balance by the whole situation. It was a complete role reversal – she'd organised it all, paid for everything, all I'd done was trot around after her being a pretty(!) ornament. Most women don't stand for that sort of situation nowadays, so it was a lot for a macho (!) chap like me to handle. (13 June 1985)

In contrast with these magazines, *Spare Rib*, a self-consciously feminist publication, views the world and speaks from the position of women. Masculinity is looked at through the lens of feminism.

44 Boots No. 17 advertisement,
*Mizz*, 26 April 1985.

If that is *Spare Rib*'s strength – and indeed to allow women the voice they usually do not have is the point of the women's movement – it also tends to mean that men and masculinity feature as a fixed entity. Masculinity is reduced to its lowest and worst common denominator – domination over women. Lest I be misunderstood, I don't want to deny the necessity of women having that space or to ignore that masculinity as power is the political bedrock of feminism. But neither do I want to hold to that feminist protocol at the expense of allowing neither cultural nor political leeway for masculinity to change.

More relevantly for this discussion, these new magazines are in fact a sign that bits of masculinity, for some boys and men, are changing. To some degree, boys share with girls an interest in clothes, hair and makeup as well as music; and through these some of them have begun to express an emotional vulnerability that patriarchal culture traditionally permits only for women. Some of *Etcetera*'s stories trace young men's traumas as they stumble through unknown and tangled territory in pursuit of 'independent young women' (cf. 'Shelf Life' by Russell Hobbs, *Etcetera*, 12 June 1985). Ironically, too, perhaps the shared condition of (potential) unemployment for young people creates more 'equality' between them. In these magazines 'street-wise' is what both sexes need to be (though 'the street' can have very different and divisive meanings for each group).

Thus, without slipping into overstating how much gender has changed – there are only the merest glimmerings of a shuffling underfoot – I want to suggest that if feminism is to recruit young women, it needs to register these emerging shifts. Maybe too we

have to reflect on the politics we created in the 1970s and ask whether they appropriately address the needs and demands of a new generation of young women. I'm not sure feminism has registered the shifts around gender, nor that we have yet engaged in the kind of self-reflection and reforming of our politics which could attract them.

## 'Undercoats' 2

Turn back the pages: it is time that as feminists we thought carefully about the political implications of that 'Undercoats' image in *Etcetera* magazine. Such an image too easily produces a knee-jerk response in feminists: it's pornography, it shows women displayed for the male gaze and is necessarily oppressive to women. That response is one that at the outset of this article I tried to move beyond, suggesting that although superficially the image may resemble classic porn pics, the representation of gender is also being actively tampered with.

What we also need to bear in mind is that for the 1980s New Young Women (middle-class, educated young women) that image simply does not and cannot mean the same things as similar images did five to ten years ago for us 'older' feminists. That is partly because feminism *has* revealed pornography's abuse of women to women. And it is partly because, however indirectly, feminism has given these young women a knowledge and a strength to act in the world which also allows them to laugh at and enjoy those images in a way many of us could not, and cannot.

The question now is, are *we* strong enough to acknowledge that our politics have to shift in order to take account of these changes? Can we acknowledge that the stark confrontational style of feminism of the 1970s strikes no sympathetic chord with a group of young women whose relation to young men *is*, I suspect, a much more equal one than we could have ever envisaged a decade ago?

## Notes

1 Rosalind Coward, 'Underneath We're Angry', *Time Out*, no. 567, 27 February 1981, p. 7.
2 Brian Braithwaite and Joan Barrell, *The Business of Women's Magazines*, London, Associated Business Press, 1978.
3 Cynthia White, *Women's Magazines 1692 – 1968*, London, Michael Joseph, 1970, p. 39.
4 Ron McKay 'Just Seventeen: Glory without the Schmaltz', *Campaign*, 1 June 1984, p. 33.
5 Ibid., p. 32.
6 Ibid., p. 33.
7 Brenda Polan 'Sally Free and Easy', *Guardian*, 6 June 1985, p. 11.
8 Penny Perrick 'Why Superwoman is Out of Style', *The Times*, 13 May 1985, p. 8.

# Pornography: the politics of representation

In May 1983 the *Guardian* newspaper ran a full page advertisement for an exhibition of photography. The caption read: 'Don't miss Helmut Newton's "Big Nudes". (Unless, of course, you're tied up.)'[1] The image showed a woman from the waist up, naked, wearing long black leather gloves and bound tightly by cords around her neck, breasts and torso (Figure 45). The subsequent furore which raged in the letters page of the newspaper for the following two months said a lot about current debates over pornography and voiced almost every range of opinion within them. In the ensuing exchanges initial angry responses from women to the advertisement were attacked in turn by liberal men, as 'prudish hysteria' and 'attempts to impose censorship'. In this way feminist arguments were linked to right-wing campaigns against permissiveness. Although some feminists attempted to make their viewpoints clear, these were frequently misunderstood and did not gain overall support or 'win' the argument. The exchanges as a whole were marked by a sense of confusion. This stemmed from several sources: a failure to agree on what pornography actually is, a collapsing of distinctions between various positions opposed to pornography and disagreement over what, if anything, should be done about it. Both the confusions about pornography and the failure of a clear feminist voice to emerge, seem to me to be indicative of some of the problems in discussing this issue in the 1980s.

A great deal has been written on pornography by feminists in Britain and the United States over the last decade, and these articles represent only a very small selection of the material available.[2] The focus is again on the still image in photography and magazines, as the most widely consumed form of pornographic imagery. Any attempt to arrive at an overall definition of pornography from a feminist perspective is a project fraught with difficulty and one which I have not attempted here. This is because there is no agreement amongst feminists on what kind of response to make to pornography. It is an issue which concerns and angers many women, but one which has produced bitter divisions within the women's movement in Britain as well as in the United States. The contentiousness of these issues and the

143

# DON'T MISS HELMUT NEWTON'S 'BIG NUDES'.

## (UNLESS, OF COURSE, YOU'RE TIED UP.)

No one takes pictures like Newton.

Despite the blatant plagiarists, visual mimics, copycats and lookalikes the man's work remains inimitable. If you want to be startled, provoked, amused, surprised, come along to the Olympus Gallery and see his latest pictures.

The exhibition 'Big Nudes' is on now and runs 'til June 17, Monday to Friday, between 10.00 and 5.30. The work is also the subject of his new book '47 Nudes'. Copies will be on sale.

You'll find the gallery at 24 Princes Street London W.1. **OLYMPUS**

anger which they generate make it impossible to present a unified perspective without seriously distorting different viewpoints. What I have tried to do in this section therefore is to provide the means of working through some of the arguments within British feminist writing and to point out where these differ in general from various non-feminist approaches. The articles have to be seen as part of a continuing debate in the women's movement about how to understand, and how to fight, pornography. Mandy Merck's article usefully sets up the issues as well as serving as an introduction to a variety of feminist and non-feminist positions.

My reasons for focussing mainly on British material are twofold. The arguments of British feminist writers are probably

less well known in both Britain and in the United States. Books by Andrea Dworkin, Susan Griffin, the collection *Take Back the Night* edited by Laura Lederer and the film *Not a Love Story* have provoked widespread discussion and controversy, making the arguments of American radical feminists fairly familiar to a British audience.[3] More recently, the critical debates about pornography in the United States, attacks on the political and moral stance of anti-pornography campaigns, and the broader issues of the politics of sexuality have been opened up through published conference reports and articles.[4] In Britain the specific nature of debates about pornography has been somewhat different, and it seems important to represent what these are. A second reason then for choosing a British focus is that the ideological and legal context of pornography in Britain, as well as the politics of the women's movement, have framed the arguments rather differently from those of the United States. Some of these differences are brought out in the interview with Andrea Dworkin by Elizabeth Wilson, in which Wilson articulates criticisms socialist feminists in Britain have made of the American radical feminist view of pornography as a monolithic institution of male supremacy.

Feminist discussion of pornography in Britain has been largely framed by two opposing positions, that of the liberal consensus represented by the Committee on Obscenity and Film Censorship chaired by Professor Bernard Williams, and that of the right-wing, pro-censorship lobby led by Mary Whitehouse and the Nationwide Festival of Light. As several of the writers in this section suggest, neither of these positions offers much to feminists. The Williams Report, published in 1979, was intended to clear up the confusions surrounding the operation of the existing Obscene Publications Act.[5] It made a fundamental distinction between the public display of pornography and its private consumption, defending the latter on the grounds of the individual's right to freedom of choice. The report defined the pornographic as that which was 'offensive to reasonable people' and advised that its sale be restricted. As Rosalind Coward, Mary Bos and Jill Pack argue, however, pornography thrives precisely on its definition as illicit and hidden material. The concept of a 'reasonable person' further fails to acknowledge the particular objections which *women* have to pornography.

In general the kind of arguments made by liberals are unhelpful to women in formulating a strategy against pornography. But most feminists would also disagree with the critique of the moral right. Ruth Wallsgrove voices the mixed feelings of outrage, anger, disgust and fear which many women have when confronted by pornography. Her article usefully pinpoints why a feminist response has to be different from that of anti-pornography campaigners like Mary Whitehouse. Whereas

the latter object to *any* representation of sexuality, feminists have criticised pornography as an expression of male power. Wallsgrove suggests that both pornography *and* the right-wing campaigns to suppress it have produced an oppressive and limited view of women as defined by their sexuality.

Unlike the situation in the United States, women's groups in Britain have generally refused to form alliances with moral campaigners on the Right. But they have found little support from the Left, which has failed to engage with women's criticisms of pornography in any serious way. Whereas some women's issues have been taken up through campaigns in the Labour movement, pornography has not. This is perhaps because, unlike questions of women's equal rights to pay or work, feminist criticisms of pornography place a critique of male heterosexuality at their centre, a view which most men, and some women, still find unacceptable. Left-wing groups then, apart from occasional routine public denunciations, have tended to remain divided or silent on the question of pornography.

A second reason is that the issue has become hopelessly entangled with debates about legal censorship. This has made it particularly difficult for feminists or socialists to develop a distinct critique of pornography without appearing to ally themselves with a pro-censorship lobby. The problem arises over what is defined as pornographic. Under current legislation body images made by women and gay magazines and bookshops have been prosecuted along with commercially produced, mass pornography. As Wallsgrove argues, censorship laws often tend to be used against those who wish to change society's view of the sexual status quo. Yet, the law is one arena in which the definitions and meaning of sexuality are constructed, and therefore cannot be ignored as a sphere of action. One proposal, made here by Rosalind Coward, is that legal controls should be framed around the recognition that it is women who are exploited specifically in heterosexual pornography. She cites an attempt to introduce a law on these lines in France in 1983 which sought to make it illegal to publish images inciting hatred, violence, scorn or discrimination against women, but which was withdrawn after it met with violent opposition.[6] Similar legislation against racism in Britain offers a possible model, but its failure to deal with the rising current of racist abuse and attacks in the 1980s shows that the law cannot be effective without a real change in personal and public attitudes, and in institutions like the police and the courts.

One way in which some groups of women have challenged public attitudes and private behaviour is through direct action. From 1977 in Britain 'Reclaim the Night' marches have taken over the streets to claim women's rights to safe public space. Since 1980 Angry Women and Women Against Violence against Women groups have picketed and leafleted sex shops and

newsagents selling pornography, spray painted walls and windows, attacked offensive imagery in cinemas and sex shops, and demonstrated against pornography and all forms of sexual violence. Their actions have exposed the contradictions in the law and in the media which, while claiming to 'protect' women, sensationalise acts of sexual violence and prosecute the very women who publicly oppose them. And, perhaps as importantly, they have asserted women's strength and the potential for collective action against victimisation.

Yet some feminists, including myself, feel uneasy about the kind of analysis which underpins such actions. While admiring the courage and sharing the anger of those who act, it is possible to disagree with their arguments about the nature of pornography. I want to outline briefly some of these disagreements which are developed in detail in the articles by Rosalind Coward and WAVAW, by Mary Bos and Jill Pack and by Kathy Myers.[7] The differences exist at a number of levels: over the nature of pornographic representations; over the relationship between images of violence and violent acts; and, over the definition of sexuality itself.

In debates about pornography the issue of how representation works has become highly confused. Some feminists, represented in the comments by WAVAW here, treat pornography as though it were real, both in the sense that it records actual acts before the camera, and that it really represents what men think about women. They usually therefore condemn pornographic images on the basis of their content in which women's bodies are represented as sexual objects for men. But, as Rosalind Coward comments, the content of pornography is not fixed. What is seen as pornographic has been variously defined in historical terms. What we need to understand, she argues, is how certain images become pornographic according to their context or mode of consumption. All images objectify, so to use this as ground for opposing pornography is misguided. It might be more useful to examine how pornographic representations help to reinforce differences between what are defined as socially acceptable and what are defined as illicit forms of sexuality. Instead of a moral condemnation of *all* images of women's bodies, feminists could then begin to explore what kinds of representation of female sexuality *we* might want to see.

Perspectives differ even more sharply over the relationship between pornography and sexual violence against women. The evidence that pornography directly triggers violent and aggressive acts has not been proven. WAVAW and Reclaim the Night groups make this connection a central part of their analysis, arguing that pornography, in depicting women as passive, and often willing, victims of male sexual abuse, endorses and incites sexual violence. One criticism of this view is that it reproduces

the notion of women as perpetual victims, unable to act in their own right. Clearly, while there is a need to examine how pornography affects men as its main consumers in their attitudes to women, the connection between pornography and violence is not a simple one. Here the issue of the nature of fantasy is important. What is the relationship between pornographic fantasies and acts of violence? Is it a direct one of cause and effect as the slogan 'Pornography is the theory, rape is the practice' suggests? Or should we rather, as Kathy Myers argues, be examining why sexual fantasy is so often structured in violent and oppressive ways? If the latter, then 'violent' pornography has to be connected to other representations of masculinity in contemporary culture, for example in films like *Rambo*. The problem is complicated by the fact that WAVAW take their examples mainly from violent and sadistic 'hard-core' pornography while feminists like Coward and Myers address themselves to more 'everyday sexism'. This produces a disjunction between feminist analyses which makes it more difficult to develop a strategy in relation to more ordinary forms of sexism as well as to images of violence and sadism.

The relationship between violence and masculinity points to a further difference between feminists over the way in which they conceptualise sexual identity. As Mandy Merck puts it, is the problem in pornography men – or masculinity? The distinction is a crucial one. Radical feminists frequently depict male sexuality as inherently violent and aggressive, as the slogan 'All men are potential rapists' makes clear. Sexual violence in this view is not an isolated or aberrant act, but an extension of 'normal' heterosexual male behaviour. While many feminists would agree that violence and aggression are part of the way in which male sexuality is structured in our culture, not all would accept that these are innate or essential characteristics any more than passivity or receptiveness are 'natural' female qualities. In this view, pornography, along with other kinds of representation, forms part of a discourse which constructs and defines sexual behaviour for men *and* for women.

It is clear then that the issue of pornography has opened up areas of debate and disagreement within the women's movement, as well as between feminist and non-feminist positions. On the one hand, direct action offers a way of asserting women's opposition to pornography publicly and immediately, but it does not offer any means of exploring how sexuality might be differently constructed. On the other, a long-term aim of transforming heterosexuality does not offer much help in dealing with the kind of violent and misogynistic imagery which can be seen daily in films and magazines. We are still some way from an analysis that deals with pornography on a number of levels: as an industry, as a form of consumption and as a particular kind of

representation of women. Do we actually need this kind of analysis? I think that we do, both to better define the terms of what we are dealing with and, paradoxically, to debunk pornography's powerful aura. By examining its structure as an industry which adopts the characteristic forms of consumer capitalism, as a commodity which is marketed and consumed in specific ways, and as a system of representation whose visual codes and technologies interact with others, it may be possible to demystify pornography's power as the forbidden and illicit. At the same time, a feminist analysis has to focus on how pornography constructs sexuality and what precisely it is that *women* object to: the representation of the sexual itself, the particular forms in which female sexuality is represented or the ways in which these are consumed by men. Unless we do so, it will be difficult, if not impossible, to find new ways of representing sexuality for women. Pornography has colonised the sexual both in a material and a psychic sense. Women need to reclaim that space, not only to walk safely at night, but in order to represent their own sexual pleasures and desires.

## Notes

1 The *Guardian*, 20 May 1983.
2 A very useful and comprehensive annotated bibliography on women and pornography appeared in *Jump Cut*, no. 26, 1981. For more recent material see also the Bibliography.
3 Andrea Dworkin, *Pornography: Men Possessing Women*, London, The Women's Press, 1981; Laura Lederer (ed.), *Take Back the Night*, New York, Bantam Books, 1980; Susan Griffin, *Pornography and Silence*, London, The Women's Press, 1981; *Not A Love Story – A Motion Picture About Pornography*, produced by the National Film Board of Canada, 1981.
4 See Alice Echols, 'The New Feminism of Yin and Yang' and Ellen Willis, 'Feminism, Moralism and Pornography' in Ann Snitow, Christine Stansell and Sharon Thompson (eds), *Desire: The Politics of Sexuality*, London, Virago, 1984; Paula Webster, 'Pornography and Pleasure' in *Heresies* (Sex Issue), vol. 3, no. 4, Issue 12, 1981, and for a broader discussion of the sexuality debate in the United States, Carole S. Vance (ed.), *Pleasure and Danger: Exploring Female Sexuality*, London, Routledge & Kegan Paul, 1984. This book brings together papers and talks given at the conference 'Towards a Politics of Sexuality' held at Barnard College, New York in 1982. A useful report on the controversies aroused by this conference is given by Elizabeth Wilson, 'The context of "Between Pleasure and Danger": the Barnard Conference on Sexuality', *Feminist Review*, no. 113, Spring 1983.
5 Report of the Committee on Obscenity and Film Censorship, London, HMSO, Cmnd 7772, November 1979.
6 This law was intended to cover a whole range of public imagery including advertising. A similar, and more successful, attempt was made to amend the Conditions Governing the Acceptance of Advertisements on London Transport by the Greater London Council Women's Committee in 1984. Two new conditions were introduced: that advertising content should not depict, refer to or imply violence specifically against women, and that advertising should not depict women as sex objects.
7 I recognise that British radical feminist writing on pornography is under-

represented in this section. A collection of conference papers on pornography and sexual violence has been published which gives a broader view of WAVAW's arguments and the kind of issues they have taken up. See dusty rhodes and Sandra McNeill (eds), *Women Against Violence Against Women*, London, Onlywomen Press, 1985.

Mandy Merck

# Pornography

On a cold, forbidding night in late October, the main auditorium of Conway Hall overflows with more than 500 women. Elsewhere in the same building, another meeting is already underway, addressed by a Cambridge philosophy professor. Later that week, a new Act comes into effect – and immediately sells out at Her Majesty's Stationers. Mary Whitehouse tours Soho, closely followed by a feminist writer from America, and a muscular Village People type climbs out of his overalls on to the cover of *The Leveller* . . .

The Conway Hall women's meeting was addressed by the American feminist Andrea Dworkin, who like Mary Whitehouse recently explored the sex emporia of Soho. Dworkin was over for the launch of *Pornography: Men Possessing Women*, her new book published by The Women's Press. To complicate matters further, The Women's Press simultaneously published Susan Griffin's *Pornography and Silence*, another American study which reaches similar conclusions.

This is not to say that these works are identical – Dworkin's rationalist polemic is in clear counterpoint to Griffin's poetic mysticism – but both share an approach to the subject promulgated by American feminist groups like Women Against Pornography. But – even more complications – this approach does not amount to a feminist 'line' on porn. In fact, the matter has now become a major area of dispute – eliciting a 'Sex Issue' of the American feminist journal *Heresies*, criticising the Women Against Pornography position, and several sharp arguments at last summer's Communist University.

Dworkin and Griffin's books arrived on our shelves almost exactly two years after another work on the subject, the 267-page Home Office report of the Committee on Obscenity and Film Censorship. Chaired by Professor Bernard Williams, staffed by luminaries like *Guardian* writer Polly Toynbee, the Committee's impeccably liberal deliberations made rather more of a splash in academic circles than in the House. Meanwhile, Tory Tim Sainsbury's somewhat lowbrow Indecent Displays (Control) Bill passed into law.

While Toynbee railed in the *Guardian* against Sainsbury's 'puny, ineffectual and inadequate Bill', Mary Whitehouse was also complaining to the *Daily Mail*: 'clearly ineffectual . . . warning notices are useless . . . more serious than ever'. Meanwhile, bewildered vendors of movies, massages, magazines and Magi-Grip Portable Vaginas with Built-In Stimulator ('Take

From *City Limits*, November 13-19 1981.

151

It Anywhere') were buying copies of the Act by the gross – and discovering that although it rigorously translated 'public place', 'matter', and the 'statutory maximum' for fines – it offered no definition for the term 'indecent'!

## The body in question

The term 'pornography' always refers to a book, verse, painting, photograph, film – or some such thing – what in general may be called a representation ... We take it that, as almost everyone understands the term, a pornographic representation is one that combines two features: it has a certain function or intention, to arouse its audience sexually, and also a certain content, explicit representations of sexual material (organs, postures, activity, etc.).' – *Home Office Report of the Committee on Obscenity and Film Censorship.*

The word pornography does not mean 'writing about sex' or 'depictions of the erotic' or 'depictions of sexual acts' or 'depictions of nude bodies' or 'sexual representations' or any other such euphemism. It means the graphic depiction of women as vile whores ... or, in our language, sluts, cows (as in sexual cattle, sexual chattel), cunts. – Andrea Dworkin, *Pornography: Men Possessing Women.*

The stories are all the same, about mighty cocks and forceful fucks – completely phallic centred. This fits in with Andrea Dworkin's analysis of pornography as violence, as male sexuality being the drive to force and violate, not just women but 'feminine men', that is men who are blacker, weaker, younger, poorer. And some gay porn is, as she perceptively shows, made 'masculine' by the exclusion or denigration of women. – Chris Stretch, 'Men's Images of Men', *The Leveller.*

Pornography is an expression not of human erotic feeling and desire, and not of a love of the life of the body, but of a fear of bodily knowledge, and a desire to silence eros. – Susan Griffin, *Pornography and Silence.*

What is defined as pornography and what is defined as erotica no doubt depends on personal taste, moral boundaries, sexual preferences, cultural and class biases. These definitions have contracted and expanded over time; advocates of one or the other form of imagery have switched camps or staunchly defended their own. Just as normative attitudes about sexual behaviour, masculinity and femininity, and social relations between the sexes have shifted, so have attitudes about sexually explicit material. There are no universal, unchanging criteria for drawing the line between acceptable and unacceptable sexual images. – Paula Webster, 'Pornography and Pleasure', the *Heresies* Sex Issue.

Pornography, the Williams Committee argues, is a matter of representation. Actions (as in 'the true pornography is war/poverty/the cuts', etc.) or Jill Tweedie's recent formula ('Pornography is Violence Against Women') are exempted from their definition. Dworkin examines the Greek etymology of the word porne – 'the lowest class of whore' and graphos – 'writing, etching or drawing'. Although etymologies do not necessarily tell us how a word is understood now, she employs the ancient meaning to support her argument that pornography epitomises a systematic and trans-historical denigration of women by men.

But many feminists told the Williams Committee that they took similar exception to 'advertising, entertainment and other aspects of our social existence' which denigrated women. Are these also pornography? Furthermore, representations of men (notably in male gay porn, but also in certain 'hard-core' images, which emphasise erection and ejaculation) pose a problem for Dworkin's definition. As Chris Stretch observes in *The Leveller*, it may be necessary to extend the definition beyond the denigration of biological females to the cultural phenomenon of 'femininity' (here attributed to those who are weak, oppressed, 'other' than dominant white males).

In turn, this extension – and Christabel Pankhurst's reminder that men 'can alter their way of life', quoted at the beginning of Dworkin's book – produces further difficulties for her timelessly pornographic patriarchy. Do sexual representations change through history, as Paula Webster argues? Is the problem men – or masculinity?

## Seeing and doing

Porn is the theory, rape is the practice. – US feminist slogan.

It is not possible, in our view, to reach well-based conclusions about what in this country has been the influence of pornography on sexual crime. But we unhesitantly reject the suggestion that the available statistical information for England and Wales lends any support at all to the argument that pornography acts as a stimulus to the commission of sexual violence. – *Home Office Report of the Committee on Obscenity and Film Censorship.*

A journalist shall not originate material which encourages discrimination on grounds of race, colour, creed, gender or sexual orientation. – *NUJ Code of Conduct.*

Just because most men do not statutorily rape or assault women, and many live out relatively peaceful and caring lives, does not mean that pornographic sexist imagery has not taken an active part in shaping male perceptions. Indeed, all women feel afflicted by that imagery,

whether or not they choose to campaign against it, so it is unlikely that any man escapes its shaping influence. – Submission to the Committee on Obscenity and Film Censorship from the *Spare Rib* Collective.

Though we agree that much pornography denigrates and objectifies women, we reject the simplistic and demagogic equation of pornography with violence, and the confusion between fantasy and action that this equation implies. – US feminist protest against the National Organisation for Women's Resolution Condemning Pornography.

Pornography is intended to affect behaviour; it is expected to affect behaviour and it does affect behaviour. We read, for example, in the *Harper Dictionary of Modern Thought*, under the heading 'Pornography', that this is a medium 'designed primarily to arouse sexual excitement'. And indeed, the pornographer himself, just as he denies from the side of his mouth that pornography causes certain events, defends pornography as a necessary stimulus to another event. He tells us some men need pornography in order to be able to participate in any sexual act. – Susan Griffin, *Pornography and Silence*.

Unlike liberals, the British Left has traditionally argued that representations, 'ideology', produce effects. (So, similarly, have the Right.) This concern is reflected in recent campaigns to make journalists abide by their Code of Conduct and in legal prohibitions against 'inciting racial hatred'. However, the Race Relations Act refers to threatening or abusive publications or speeches in circumstances where racial hatred is likely to be stirred up. It is rarely implemented and never against fiction films, novels or phenomena like racist jokes.

Since certain representations are evidently acquired and used for the purpose of sexual stimulation, it is difficult to deny that they produce effects. Whether and how they denigrate, subordinate or incite attacks against women is more difficult to demonstrate. Campaigners of a variety of political persuasions have often attempted to show a relationship between sexual offences and pornography, but the Williams Committee argue that current statistics do not bear this out. There is no reliable information on the availability of pornography at given times, and – contrary to wide opinion – sexual offences do not seem to have risen nearly as fast as other forms of crime in the 'permissive' 1970s. Nonetheless, they note, some unexplained relation may be at work.

As *Spare Rib*'s submission to the Committee suggests, representations could produce effects which do not show up in the rape figures: female intimidation, for instance, or male presumptions that their reluctant dates don't really mean no when they say so.

On the other hand, the American feminists' distinction between fantasy and action reminds us of the complex way that representations produce meaning. Is every story of female subordination interpreted as a recommendation for it? Should we read fictional narratives literally? If porn causes rape, do Westerns cause duels in the streets?

## What is this thing called objectification?

If one views sex as only a means of expressing love, then loveless sex is meaningless. However, this is not the only view possible. – J. Lee Lehman, 'Lust Is Just A Four-Letter Word', the *Heresies* Sex Issue.

Pornography presents women as willing victims, as objects to be used, bodies created for the sole purpose of pleasing men. – Ruth Wallsgrove, 'Pornography: Between the Devil and the True Blue Whitehouse', *Spare Rib*.

Our memory of eros, of the feeling of wholeness, and our idea of love is clouded over by and surrounded with pornographic images. – Susan Griffin, *Pornography and Silence*.

This meeting and melting into one another, this becoming one instead of two, was the very expression of his ancient need. And the reason is that human nature was originally one and we were a whole, and the desire and pursuit of the whole is called love. – Plato, *The Symposium*.

A commodity is therefore a mysterious thing, simply because in it the social character of men's labour appears to them as an objective character stamped upon the product of that labour. – Karl Marx, 'The Fetishism of Commodities and the Secret Thereof', *Capital*.

Most people think of fetishism as the private taste of an odd minority, nurtured in secret. By revealing the way in which fetishistic images pervade, not just specialised publications, but the whole of the mass media, Allen Jones throws a new light on women as spectacle. The message of fetishism concerns not women, but the narcissistic wound she represents for man. – Laura Mulvey, 'You Don't Know What Is Happening Do You, Mr Jones?', *Spare Rib*.

To put it plainly: the fetish is a substitute for the woman's (mother's) phallus which the little boy once believed in and does not wish to forego – we know why . . . if a woman can be castrated then his own penis is in danger. – Sigmund Freud, *Fetishism*.

One of the strongest arguments against porn is the feminists' claim that it objectifies and therefore exploits women. It encourages men to

155

think of women only as bodies and not as whole individuals. The gay subculture also stands continually accused of encouraging sexual objectification by putting stress on physical appearance not on 'getting to know people'. Inherent in the argument when presented as above is, I believe, a moral implication about the way in which women and men should relate to each other; that is, as whole or complete individuals: their personalities, ambitions, thoughts, beliefs, etc. must be known before they can see each other as possible sex partners. – Greg Blanchford, 'Looking at Pornography', *Gay Left*.

Even those who would distinguish pornography from violence often agree that the problem is 'objectification'. The concept has a long history in our culture – from Plato's myth of some ancient human wholeness; to the Marxist idea of commodity fetishism (workers' alienation under capitalism from the very objects they produce); to Freud's use of the same term to describe the anxious over-valuation of an object or physical attribute as a replacement for the missing phallus. In each theory, a part stands in for some missing whole – a whole which is often defined as the totality of an individual human's attributes or potential.

Many representations stand accused of denying such wholeness to women: by continually characterising them as passive victims; by literally fragmenting the female figure ('Just holes asking to be humiliated and hurt', says Ruth Wallsgrove about soft-core vaginal imagery); or by obsessively inscribing upon it the fetishistic evidence of male anxieties. The latter, argues Laura Mulvey, says a lot about men, but 'bears little relation or relevance to (women's) own unconscious fantasies, their own hidden fears and desires'.

But is the appropriate response to all this an insistence that sex only be represented or conducted between old friends? And why do we so often defend intellectual or social characteristics as less 'objectifying' than physical ones? Is it wrong to fancy someone because of the colour of their eyes – and right if they agree with you about this article?

## The law of the father

If any indecent matter is publicly displayed the person making the display shall be guilty of an offence. – Indecent Displays (Control) Act 1981.

After a great deal of consideration, we decided in favour of the definition's referring to what is offensive to reasonable people. The notion of a reasonable person (usually in the unduly restricted form of 'the reasonable man') is already known to the law in connection with judgements of responsibility, negligence and reasonable foresight. . . . Conclusions that something is 'offensive to reasonable people' are

bound to be rather loose or rough, in the sense that it is not a matter of simple verifiable fact, and a magistrate will have to use his or her judgement. – *Home Office Report of the Committee on Obscenity and Film Censorship.*

If censorship becomes acceptable, it will not be too difficult for the State to move it into political areas as well. And when the State goes in for control of sexual behaviour, it does not centre on pornography. Birth control information, access to abortions, prostitution, male homosexuality and the hard-fought-for rights of women are attacked at the same time. – Greg Blanchford, 'Looking at Pornography', *Gay Left.*

We have strong feelings about being assaulted all the time by disgustingly sexist imagery in almost every shop, and on almost every billboard, and we would like relief from that. But we don't want a situation where people who are trying to work out theories of sexuality, ourselves included, have their work destroyed or inhibited by those people, and there are many, who cannot yet distinguish between what reinforces sexism and what questions it. Any new legislation, therefore, would have to encapsulate the concept of sexism, and at the current level of consciousness in our society on this matter, especially amongst those specifically appointed to watch out for it, such as the Advertising Standards Authority, we are naturally pessimistic about the effectiveness of such legislation even if it were properly framed. Perhaps instead of tightening up upon obscenity laws . . . we could suggest an extension of the laws which relate to incitement to hatred against particular groups in the population, in this case, the majority. – Submission to the Committee on Obscenity and Film Censorship from the *Spare Rib* Collective.

The new legislation is clearly ineffectual. It just reinforces my determination to do everything I can to get proper controls. – Mary Whitehouse interviewed by the *Daily Mail.*

Despite a history of literary licensing from the time of Henry VIII, no English prosecutions for obscenity occurred until 1708, when James Read, author of 'The Fifteen Plagues of a Maidenhead', was convicted of 'obscene libel'. This common law offence – described as one both of public corruption and breach of the peace – still survives today, along with a legal definition of obscenity based on Lord Chief Justice Cockburn's famous 1868 test of a 'tendency . . . to deprave and corrupt'. So does a vast body of legislation dealing with matters like indecency, public morals, importation of material and film censorship.

It was the purpose of the Williams Committee to survey and reform this enormous and often bewildering array of statute and common law. Their recommendations, including a learned

discussion of John Stuart Mill's 'On Liberty', continued the 'consenting adults in private' tradition of the Wolfenden Report, and were designed to maximise free expression and minimise harm to individuals by taking porn – like prostitutes – off the streets. People under eighteen and anyone likely to be injured in the production of pornography (viz. alleged 'snuff' movies) would be legally protected, but most representations would be available to adults in restricted areas or cinemas with chaste shop-fronts and clearly posted warnings. In line with this, legal terms like 'obscene', 'indecent' and 'deprave' would be scrapped for a test of public 'offensiveness'.

But merely restricting display or availability (which is, after all, what Sainsbury's law also does) ignores the concerns of anyone who regards the personal as political – and that includes Mary Whitehouse as well as feminists. Furthermore, replacing the undefined term of 'indecency' with some undefined offence to 'reasonable people' simply keeps the ball in the courts of the magistrates – whose class and gender interests aren't likely to vary from those of the traditional 'reasonable man'.

Circulating contentious representations of sex and sexuality has always been a major struggle for feminists and gay liberationists. *Spare Rib* has been banned in Eire, *Gay News* has been convicted of blasphemy, and institutions like the Film Censor and the Arts Council have restricted feminist films and artworks via certification and exclusion from exhibits. Professor Williams himself was surprised to learn in a public meeting about his Report that *Spare Rib* publishes polemical illustrations (a recent guide to self-examination for instance) which – under his recommendations – 'reasonable people' might be entitled to restrict to sex shops.

Until recently in the United States, post-war Supreme Courts upheld extremely liberal interpretations of free expression – which the American Civil Liberties Union (unlike the NCCL) has used both to defend 'hard' porn and Ku Klux Klan marches through black neighbourhoods. But with the rise of the New Right and a more conservative judiciary, the Moral Majority is currently employing regional law to remove feminist works like *Our Bodies Ourselves* from local libraries!

## Looking at pleasure

In a world ordered by sexual imbalance, pleasure in looking has been split between active/male and passive/female. The determining male gaze projects its fantasy on to the female figure which is styled accordingly. In their traditional exhibitionist role women are simultaneously looked at and displayed, with their appearance coded for strong visual and erotic impact so that they can be said to connote to-be-looked-at-ness. – Laura Mulvey, 'Visual Pleasure and Narrative Cinema', *Screen*.

MARCH ON THE CAMERA DISTRICT: Women against women against photography against women. Call Nilon for information. – *Impersonal ad in the* Heresies *Sex Issue.*

But the difference between us is that I want women to look at pornography. – Andrea Dworkin contrasting herself with Mary Whitehouse in the *Sunday Times.*

Are we ready to give up the eternal enemy and challenge our feminisation, which leaves us mute about our desires for pleasure, and so many other things? Once we take our eyes off them, and renounce our obsessive concern with their thoughts, feelings and actions, we can move from blaming to assessing our vision for change. – Paula Webster, 'Pornography and Pleasure', the *Heresies* Sex Issue.

Accusing anti-porn campaigners of repressed voyeurism is a tawdry commonplace. (Consider for a moment the popular image of a figure like Lord Longford.) But Paula Webster's arguments, like Andrea Dworkin's statement to the *Sunday Times*, remind us that our sallies into this area may involve the paradoxical combination of intense scrutiny and intense repulsion. (Imagine the pleasure of one. Imagine the pain – and pleasure? – of the other. Now, put them together. . .).

For women, looking is further complicated by the fact that we are both Spectator and Spectacle – a major conundrum within systems of meaning which tend to masculinise the former and feminise the latter. The tactics that arise out of this dilemma are equally contradictory: in order to criticise certain representations, it is necessary to call attention to them in the first place. . .

One suggestion by groups like Women Against Pornography is selective spectatorship: tour Times Square and Soho, insist on looking at representations traditionally consumed in private male enclaves, but boycott more 'respectable' mass-market products like *Dressed to Kill.*

Unfortunately, the boycott has sometimes been transmuted into shunning certain representations as absolute contaminants – unfit for consumption no matter what the purpose or the circumstances. At the Communist University, for instance, some feminists tried to prevent a showing of Michael Powell's *Peeping Tom* organised precisely to analyse that film's representation of voyeurism. Some of us happen to regard *Peeping Tom* as a devastating critique of that pleasure (which implicates both cinema and its audience). But even if the film endorsed voyeurism, would it never be appropriate to analyse?

How else will we come to understand the operations of colour, size, sound and editing in Hollywood movies – watched by the engrossed (engorged?) spectator? Or the obsessive concentration and mounting rhythms of certain literary narratives (where the

climax is the climax)? No 'vision of change' is simply out there, waiting to be discovered. To see it, we must construct it. But to construct it, mustn't we see?

Elizabeth Wilson

# Interview with Andrea Dworkin

Andrea Dworkin is a feminist writer who lives in New York. She is author of *Woman Hating*, *Pornography: Men Possessing Women* and a collection of stories, *The New Woman's Broken Heart*.

*EW*   How did you first become interested in pornography?

*AD*   Well, actually my interest in it goes back quite a long way, in that when I was in high school I thought that pornography had to do with sexual rebellion, and sexual revolution, and so it interested me in that way, and I knew that it was a deep influence on a lot of male writers whom I respected very much – Flaubert, Baudelaire – you know, writers of that magnitude, and also I knew that the work of writers I very much admired had been called pornographic and very often identified by some people as pornography. So, like many people, I approached it as something literary, something that had to do with intellectual rebellion and with literary life, and with a kind of literary outlawry – I was very moved by books like *The Story of O*[1] and other kinds of very high-class intellectual pornography. I responded to it absolutely. I thought that it was very profound and very full of ideas about sex, and very full of ideas about what love really was, and in fact I remember a male Marxist in college being absolutely outraged with me and saying: 'But that's the ultimate in alienated labour!' And I remember saying to him: 'Oh – but you know nothing about love.' And so – you know – because I had an interest in literature, and because I had an interest in sex, *therefore* I had an interest in pornography. And, as I moved more and more into the counter-culture in the sixties, and into various areas of bohemian life in New York City I encountered more and more pornography, and more and more intellectual writing about pornography. And when I began to really think about violence against women, and when I myself really experienced such violence in a way that I could not ignore, and I could no longer pretend that it had nothing to do with me, one of the first things that I did was that I went back, and re-read *The Story of O*, and I was absolutely mortified by what had in fact seemed to me a coherent definition of femininity.

Also I had thought that the sex the pornography portrayed was

From *Feminist Review*, no. 11, June 1982.

taboo and that pornography contained special, élite, pioneering knowledge – that it showed a sexuality that the whole conventional world had to keep from everyone, but *artists knew it*. I think that for a lot of people, even though they won't admit it, that's really the connection that they see between pornography and art. They know that historically artists have been very deeply influenced by pornography and therefore there is some relationship between pornography and art that they don't quite understand. And pornography seems to have had a very energising effect on male writers who were in fact very great writers, and therefore pornography in and of itself becomes something that appears to have a very special value, because it *had* a very special value to particular artists whom many people want to emulate. I think it's a very false idea of pornography. It's predicated on ignorance of the pornography itself; and ignorance of the reality of women's lives, and what forced sex really is in women's lives. Pornography only has that aura of taboo if one refuses to face what the content of pornography actually is and how the forced acts of sex in it correspond to women's lives. The whole male intellectual tradition that I was involved with in fact refused to face the relationship between pornography and women's real lives. Women's lives were worth nothing, and the pornography itself was very misrepresented whenever it was written or talked about. The reality is that men commit acts of forced sex against women systematically. That is precisely what the women's movement has been based upon – the women's movement has been based on that recognition.

*EW*  How did you become involved in the women's movement?

*AD*  Well – what happened to me was that I had lived a fairly honourable life as a leftwing radical, and I had married a very radical man, and – I was battered, I became a battered wife. And when I managed to escape, which was very difficult to do, the only person in the world who was willing to help me was a woman who called herself a feminist. And in addition to giving me refuge and shelter, she gave me books to read, all of which I argued with. I defended Norman Mailer longer than any living human being on the face of the earth! Henry Miller I was willing to give up. But it's beyond me now – I can barely recognise it. So it was a very long process of struggle for me.

The real origin of my work is that I decided I was going to try and understand what had happened to me, and you see the thing is that everyone told me what happened to me was personal, and that it happened to me because I wanted it, and that it was my fault. And I didn't know very much about what had happened to me, but I understood one thing about it that was so extraordinary, which was that it was completely impersonal. And it was the

impersonal quality of it, even in this relationship of complete intimacy and privacy, that was absolutely overwhelming to me. So when I left that marriage I said: I am going to try to understand why this happened. And what I did was I went back and re-read *The Story of O*. And I saw it from the perspective of a woman who had genuinely been regarded the way the woman in that book had been regarded. And as a woman who, despite all of her radical ideas, all of her radical politics, had in fact accepted those definitions of her own being. And so for me that was the beginning point and in my first book I explore the similarities in, for instance, pornography and fairy tales. But one of the reasons I now especially emphasise the reality of pornography is that I began to understand through talking with other women the extent, precisely, of that reality. It was only after my own book, *Woman Hating*, was published that I even learned that there were other battered women. I still thought that I was the only woman in the world to whom it had ever happened.

You see, I had a very well developed sense of myself in that I was well educated, I came from a family that treated me with great respect and great affection, I had a conscience in respect to other people, I acted on that conscience – and *yet* when this individual who hit me hit me, he hit me only because I was a woman – there is simply no other way to describe it. I mean the reason may have been that the laundry wasn't done right or that the refrigerator wasn't cleaned, and I may have been confused by trying to understand how my whole life and all my aspirations had somehow come down to trying to figure out how to clean the refrigerator the right way, but the fact of the matter was that I was hit because I was a woman. And every time I tried to get away, every time I tried to get help, people sent me back because I was a woman, people didn't believe me because I was a woman, so that my own individuality or my own personality or my own intelligence or my own sensitivity had absolutely no meaning in the real world in which I was living, which was defined completely by my sex-class and not by anything else. And that made me have to re-evaluate every thought, every idea and every experience that I had ever had in relation to sex.

*EW* You emphasise the reality – how pornography reflects a sadistic reality. But I think one difficulty – and I don't think I understand it, and I don't feel you've dealt with it – is the *difference* between fantasy and reality. What feminists who've become interested in psychoanalysis, say, in Britain, have been interested in is why people fantasise and why fantasy takes the form it does.

*AD* I think that if women want seriously to talk about what their fantasies are they have seriously to talk about their sexual

colonisation and their sexual possession and the ways in which scenarios of dominance and submission are internalised. I think we would be fools to think that we would have inner lives that are entirely disassociated from the actual system in which we live. And I feel that my responsibility in this area is to insist on what I know. And what I know is that pornography is reality. And what I want to see is a concentration on the condition of women's lives.

*EW*  You've been talking about pornography that has pretensions to being literature – books that are regarded as works of art. But porn today isn't like that – it's videos and photographs, and I should have thought that the porn industry around Hollywood or elsewhere was very much linked with other industrial development in California. In one sense you can't see it in isolation, it must be part of everything else that's happening in late capitalism.

*AD*  The first premise is that it can't be isolated from male supremacy, and I would insist that that is the first premise and that most of the discussions about pornography insist on isolating it from male supremacy and that is what is wrong with those discussions. But, in the United States the movement that analyses and confronts pornography does not see itself as being isolated or separate from movements against the exploitation of women in any area.

I agree with you that pornography is an odious expression of very basic capitalistic values and also must be addressed on that level, but that is insufficient in dealing with the reality of pornography because some of the solutions that are offered when that analysis is accepted as *the* analysis have to do with simply improving the working conditions of the people so that the women are not as exploited by the capitalist system, and yet still do the same sex-class determined labour.

*EW*  So it's suggested that it would be all right if women were paid more for being waitresses or prostitutes?

*AD*  That's right. Or, you know, on its most bizarre level what should we do, then, to solve the problem, should we nationalise the pornography industry.

*EW*  No-one's saying that over here!

*AD*  What *I'm* saying when the suggestion is made that the problem is capitalism is that sex-class labour is a very particular kind of labour that does not have an analogue – it's unique.

*EW*  Surely one can't take either 'capitalism' or 'male supremacy' as total or sufficient explanations. Surely you have to

say that in a capitalist society this form of exploitation, which antedates capitalism, the exploitation of women, takes on a very particular form.

*AD* Well, I think that what you have to say is that in a capitalist society, especially in a highly industrialised way, pornography becomes an institution of male supremacy. But I agree with you that pornography, at least in its current highly developed form, is an institution of woman hating that is particular to capitalist society.

*EW* What do you feel we can do about it? What should we do about it?

*AD* What, in terms of pornography specifically?

*EW* Yes, because you see I feel I know much more what we can do about battered women and I feel the women's movement has found something to do that's very practical but which is also – well, ideological. It challenges everything at once, it gives a woman a refuge, but it's also a statement to the world, *and* an analysis as well. But there's nothing in relation to pornography.

*AD* But what the movement has done in relation to battered women – which is extremely significant, in that it wasn't there when I needed it so I know what it means that it is there – is still on a level of such superficiality. We haven't dealt with the fact that battering continues systematically, that the laws support the battering ultimately, that the churches support the battering and the institutions of this society continue to support the battering. In helping the women, we're saving their lives but we're not changing the institutions that keep the women getting hurt.

*EW* I'm not sure, in fact, that I agree that the law does actually support beating women any more, although changes in the law on their own don't stop it happening.

*AD* That's right – they don't stop it happening.

*EW* But, nevertheless, isn't it important to change the law? Because the law is making an important statement about how society ought to be, right?

*AD* Absolutely so – so that, when you change the law with respect to battering, then you have to confront the laws with respect to marital rape, you see, because that's part of the same syndrome. Now that's a reform that from my point of view has essentially revolutionary implications. Changing the law with

respect to marital rape changes the position of women in society in a way that is irreversible and irrefutable. But we haven't done that! In the States we have just gotten our fourth state to end the statutory protection of rape in marriage. For me that's the priority, not only because of what it means to the women who are in marriages, but because of what it means ideologically and what its implications are in terms of the status of women in society in general.

Now, why pornography is important is that it completely perpetuates the sexual possession of women by men. It is propaganda for and a tool of sexual suppression of women that is unbelievably powerful in its effects. It is as if – I mean for us to sit here and talk about changes in the law, changes in this, changes in that, to me – and I do not make this analogy lightly, I make it with the utmost seriousness whether other people ultimately reject it or not – would be as if you and I were sitting as Jews in pre-Nazi Germany and the country was *saturated* with anti-Semitic literature and Jews were being beaten up on the streets and their shops were being broke into and you and I were sitting here talking about *some* improvements in *some* laws. And what I'm saying is that the character of the pornography and its relationship to actual violence against women, if it's analogous to anything, is analogous to the way anti-Semitic literature blanketed Germany and enabled what occurred to be justified, encouraged it, incited it, promoted it. And in my opinion ultimately was the link that made it all possible. And I think that pornography has that character.

I think that we have to recognise that when we're talking about pornography we are fighting for our lives, that we are dealing with a life and death situation. We have to confront the pornography by confronting what's in it. We have to confront the men who make it, confront the men who use it, we have to expose the values in it, we have to use the pornography to find the ways in which we ourselves are complicit in the system that oppresses us, for instance in the way I've described my own complicity in being involved with *The Story of O*, we have to use pornography as a tool to understand the system in which we live, and to change it. And, in terms of actual strategies there are a million strategies that range from picketing, leafleting, showing women the pornography so that they understand what it is.

Now I think that all of the incredibly upset and passionate and disturbed and angry responses to pornography when feminists address the issue have to do with the fact that we are finally getting down to the raw nerves, which is: what this sexual system really is; how male sexuality does in fact colonise us, set our limits; how in fact we are defined by this male sexuality. And we don't like it. We resent it and very often the way we express that resentment is by expressing resentment towards those who make

us aware of it. But it also raises very terrifying questions – about the nature of our own sexuality, about the ways in which we are complicit in our own degradation. None of this is pleasant. All of it is terrible, and yet without facing this, what are we to do? We have to face it.

*EW*  Yes, but – I think the problem I had with your book was that it seemed to me that you describe this absolutely monolithic system, which is ahistorical and it's always the same and it's always male supremacy and the prick is always a weapon and so on. And to me that makes me feel there is no way out of it, because men have always been like that and they'll always be like that and there's no sense of contradiction or moment of freedom. How can anything ever change? How can there be even a moment of freedom if this system is *so* monolithic, and so transhistorical and so all-pervasive? I think that at the end of your book you say that men think they've got it made:

> The boys are betting that their depiction of us as whores will beat us down and stop our hearts. The boys are betting that their penises and fists and knives and fucks and rapes will turn us into what they say we are – the compliant women of sex, the voracious cunts of pornography, the masochistic sluts who resist because we really want more. The boys are betting. The boys are wrong.

But I'm not sure that in terms of your own analysis they *can* be wrong. Do you see what I mean?

*AD*  Yes, I do. I think that the situation of women basically is ahistorical. And one of the failures of Marxism is that it is a gender-specific theory of change. I think that men's history has changed in a way that women's history has not because of the specific nature of sex-class labour. That's a reality as far as I'm concerned, I see it that way. What to do about it is another question, but the fact that we don't know what to do about it does not mean that we have to mistake what the reality is.

*EW*  But you see I don't think I'd agree that my situation or your situation is exactly the same as the situation of our great grandmothers. That actually isn't true. I do think women have more freedom than they had, say, 100, 150 years ago. And that does seem to me to say something about the possibilities of change. And I think that's what I don't see in what you've written. And you must *believe* there's a possibility for change or you wouldn't bother to go around talking about it, or writing about it.

*AD*  The kind of change that I'm interested in is not the kind of change that can be measured in the example that you just gave. The kind of change that I'm interested in is when women are no

longer defined in relation to and by contrast with men. And the kind of change that I'm interested in has to do with an end to a gender system that I think is specious, that I think is not a right or correct categorisation of human beings, that I regard as a fascistic system, in that a woman is born into this system and her destiny is predetermined from birth. And the coercive nature of that predetermination is what we're struggling against. And to the extent that I've made a contribution I think that it is in describing this system the way that it is. And I feel strongly that there is no way to begin to arrive at what must be revolutionary answers without in fact understanding the reality of the system, and I think that all the descriptions of it so far have essentially been apologies for it. They have been ways of saying, yes, it's painful in this way and it's painful in that way, but if we just move a little bit over here, we just do a little more there, we can get through. Now women have been remarkably resourceful in terms of individual survival, there's no doubt about that. But it's not what I'm talking about.

The fact is that women have not looked at pornography, that women have not seen it, and I think that the keys to our freedom may be there. It's only a possibility, it's an historical possibility.

*EW*  So why has change never been possible before, but now it is?

*AD*  The question is: is it possible? and I'm saying that I think so, because I *think* – I *think* that the men have made a very big mistake. I think that in displayng to us the true opinion that they have of us and the actual content of their sexuality they have made an irreversible error. And I'm telling you that I know I may be wrong. But if you have an historical possibility, then you must seize it, and you must try.

*EW*  But I still think that there is the question of power, because the tendency of your book is that women have no power and men have all the power. I don't believe we can change society without having and using some power, and how do we get it?

*AD*  Yes ... well, you see I've never been one to believe in one solution. What I believe is we have to do everything. I know that ends up sounding like no answer, but it is what we have to do, you know.

*EW*  I would say the first priority is for a very strong, autonomous women's movement.
One last question: I believe you've come under a lot of fire from the Moral Majority.[2] And yet it's also been said that feminists like you who've campaigned against pornography have

got all caught up in the Moral Majority, that the two movements are very close together. What has been your relationship to them, if any?

*AD* I have no relationship to them, or other similar groups, except that they have tried to get work of mine out of school libraries. But I refuse to abandon women to the Right. I mean, I cast my lot with women, which does not mean that I believe what they believe, but I am not going to define myself as part of the Left, meaning that my main enemy is the Right, meaning that most of those women are my enemies. This is the way I feel about it: women have a visceral aversion to pornography; the Right have been extremely successful in exploiting that aversion; and it is the responsibility of feminists to politicise the response of women in general to pornography so that women more deeply understand their situation and are in some sense radicalised by it. And what has happened in the United States has been a re-emergence of the most crass kind of sexual liberation philosophy, supposedly in response to the puritanism of the Right; and it has been a shoddy, manipulative and cynical attempt to stop feminists from confronting pornography.

The Right does not propose that pornography is a phenomenon that has to do with freedom. The intellectual defences of pornography have leftist origins. They are not quite accurately characterised as 'defences' either – because with rare exceptions the intellectual left has *advocated* pornography as crucial to liberation. Leftist writers from Abbie Hoffman to Gore Vidal to left-wing investigative journalists publish in pornography magazines and the actual producers of pornography are men, not exclusively but in shocking numbers, who were active in the anti-war movement, who are roughly my age, who were my political comrades.

But it is clear to me, from being in England, that the pornographers are more segregated from the Left here than is the case in the States, and that has helped me to see how pervasive their influence is there. My trip to England has been quite wonderful for me. I am working under many difficulties at home and in a very hostile political environment from all sides. So England has been an energising experience.

# Notes

1 Réage, P., *The Story of O*, London, The Olympia Press, 1970. It is known that Pauline Réage is a pseudonym, and there has been much speculation and disagreement as to whether it conceals a male or a female author. Because it is the sado-masochistic story of a woman's journey into complete sexual slavery it is obviously titillating to some and unacceptable to others that it should have been, or could have been, written by a woman.

2 The Moral Majority is the name given to a section of the organised Right in the United States.

Ruth Wallsgrove

# Between the devil and the true blue Whitehouse

I find pornography rather arousing at first, but a couple of hours later I feel disgusted and depressed by it, said one woman friend after looking through *High Society*. Some women do find porn – that is *Playboy* rather than *Playgirl* (which in my experience is read only by gay men) – turns them on, and many women have submissive, masochistic or rape fantasies, even though they are fighting in their lives against male domination and physical harassment. And even though they know rape is not a *sexual* experience, but a painful and terrifying experience of *force* for the victim. The only model of sexuality and eroticism in our society is the sexist model, and in our fantasies many of us see ourselves and our sexuality through men's eyes.

Only recently are we beginning to define our sexuality for ourselves. This is an incredibly lengthy struggle, because it is not just a question of changing our conscious attitudes, but also our unconscious ones. The fantasies persist however much we abhor them rationally.   *Roisin McDonough*

I believe that a feminist erotica is possible; that we can develop writing and photography and art and film that is sexually arousing, but is neither sadistic, nor depersonalised, nor stereotyped, which depicts equal and open sex, which does not depend on furtiveness and guilt and which puts sex into perspective. But first we must recognise that for many of us the unpleasant attributes of sexist sex are still an integral part of our sexuality. It's not going to be easy. And what is feminist sex, anyway? Do we want it to be spontaneous, whenever we feel like it with whoever we fancy?? Or should it be more than physical, in the context of relationships with people we care for? Should we just let ourselves go, or always be concerned with the consequences of sex?   *Source unknown*

90% of all pornographic material is geared to the male heterosexual market. Buyers of porn are predominantly white, middle-class, middle-aged married males.   *Susan Brownmiller*

From *Spare Rib*, no. 65, December 1977.

Nigel Thomas and Carol Slater in *The Leveller* (no. 4, March 1977)

170

estimate that almost 50 million pornographic magazines are sold every year in this country, and that over £30 million are spent on openly sold magazines alone.

Robbe-Grillet, author, provocateur and brilliant film maker, shocked many people with this, his second film in which Trintignant plays a drug peddler with sadistic obsessions. *Pariscope* wrote of it, 'The first intellectual film which is erotic, beautiful and funny all at once . . . the audience will appreciate Marie-France Pisier who is bound with ropes and chains, raped and then slowly strangled before the story ends with the longest nude scene ever shown on screen.' *France 1967/Dir. Alain Robbe-Grillet*, from September programme of the National Film Theatre.

I find pornography disturbing, chilling – even sometimes physically disgusting. Must I then be a killjoy, a frustrated prude, secretly longing to write articles on porn so that I can sneak a look while publicly tutting?

I have been, and am still, confused by the distance between my reaction to pornography and the debates carried out in the press about it. Mary Whitehouse and the Festival of Light seem as opposed to what I want for the world as do pornographers. And liberal men who proclaim that the Sexual Revolution has already occurred, and who contend that not only is porn a necessary expression of freedom of speech, but also that it is part of a new freedom of sex, certainly *live* in a different world to me. Freedom of speech? – almost anyone can speak in our society, but only those with money and power can make themselves heard. And sex – they all say pornography is to do with sex, but I feel immediately that it has more to do with power and violence. I like to be sexually aroused, but I don't like pictures of women handcuffed, submissive and inviting the reader to be brutal with them.

Pornography presents women as willing victims, as objects to be used, bodies created for the sole purpose of pleasing men. Even when the women in the stories are acting out lesbian or masturbation fantasies there is never any doubt that they are really performing for the reader – a man. And when they 'speak' they perpetuate all the old myths of female sexuality. The rough fuck is what they want, none of this boring foreplay or – worse – affection or communication. They are just holes asking to be humiliated and hurt. Magazines present rows and rows of exposed and disembodied vaginas. And this is just *soft* porn. Sado-masochism and child pornography are becoming ever more common, perhaps because men are becoming satiated with straight-forward Page Three of the *Sun* spreads at the family breakfast table.

Men must be pretty sick to enjoy fantasising about hurting

another human being. But perhaps porn is only fantasy; perhaps men do not act on it. Statistical studies do not show a direct link between pornography and rape. Rapists don't read significantly more porn than do other men, and the incidence of rape seems unaffected by trends in pornography. There is no evidence that porn causes rape directly, and there may be no *causal* link. But they are linked in spirit. Both are manifestations of the same attitudes towards women and sex, of a desire to avoid interaction with a woman as another human being, to have complete control over sex, at best. At worst, to feel and maintain power oneself by making women powerless. Both are elements of the ideology of the patriarchy.

So does porn matter? Does it have any effect on me, or other women, or girls, that my local newsagent stocks twenty varieties of pornographic magazines, set out in the doorway, with twenty varieties of simpering, undignified nudes in full colour on the covers? Does it make the men who buy them despise women . . . any more than anything else in our society that degrades women? Pornography can be seen as merely an extension of images of women in adverts, as shiny decorative objects.

But adverts themselves become more and more pornographic. Fashion photographers now take class porn photos, and the seedy, ludicrous publications in back-street shops are being superseded by glossies that hold press receptions to announce their first issue. Pornography becomes more intrusive and more threatening in its view of sexuality as it becomes respectable, and as the women in it become glamorous. Perhaps I am missing out on life not having such round breasts and such perfectly symmetrical labia, and not having a macho bloke around. . . . Even if porn were not harmful to women in the street, what of the women who are paid to appear in pornographic films and magazines? It is generally agreed that child – 'chicken' – porn exploits and abuses the child models, that children cannot be said to be choosing freely to appear in pornography, and that the experience could seriously mess up a child's sexuality. But the women in porn are freely consenting adults, aren't they? Do they believe in pornography and the view of women's sexuality portrayed in it – or do they just do it for the money? Are they sisters, forced through lack of positive alternatives as women in our society to find employment and importance in porn – or are they traitors, colluding in the degradation of all women for a few quick quid? And what does it do to them? Georgia Stark, an actress in blue movies, was quoted in *Newsweek*:

> The first film I made was really a downer. Afterwards I started to think about suicide. But after a while I got so I could do the Eleanor Rigby thing – you know, leave your mind in a jar by the door. Then I'd know I'm just an animal and they are taking pictures of an animal.

I don't like porn. How then do I differ from Mary Whitehouse? She like me finds porn degrading ... in her terms it is anti-love and anti-sex, much of which I disconcertingly find myself in agreement with. She claims to enjoy sex, in its proper place. The reason I believe she and I are fighting on different sides is that she focuses her attacks on things that are not to my mind pornography at all, but that are worthy, if not entirely successful, attempts to educate or explore. She is not solely concerned with images that distort, but also with those that try to describe sex as it actually happens. She vehemently attacks sex education in schools, but is quieter about hard porn in corner newsagents (although she is beginning to campaign against child porn). She became apoplectic over swear words on the Wednesday Play series on TV, some of which plays were remarkably sharp comments on our society. She finally managed to get *Gay News* prosecuted for 'blasphemy' because she could never prove it was obscene; there are many 'obscene' male homosexual magazines, but she concentrated on non-pornographic *Gay News* because it threatened to make homosexuals feel all right about being gay.

She, and others like her, indicate to us the dangers of legislating against pornography. It is not only the most degrading pictures of women that would be banned, but also things that are trying to question or change society's view of women and sex. Contraception information was illegal because it was considered obscene up until the 1930s in this country; and *Spare Rib* itself was banned in Eire this year as 'usually or frequently indecent or obscene' − for demonstrating to women how to examine our breasts for cancer. Censorship laws are always used against those who attempt to inform women about the basics of their reproductive organs, let alone their sexuality, while back street blue movies always find a way to survive.

Mary Whitehouse's reason for attacking pornography is precisely the opposite to mine. She wishes to maintain the sexual status quo, to preserve the stunted roles of women in our society. She is fighting to keep women divided into madonnas and whores, to keep sex disgusting and hidden, to keep women from self-knowledge. She claims to attack porn to protect women, but she does so in the name of the nuclear family and the sanctity of marriage institutions that oppress women.

I do not know if pornography and the Festival of Light are different sides of the same coin. Certainly both elements have co-existed as far back in society as one looks. It has often been argued − by liberal men − that wherever there is a restriction on acceptable sex, as in monogamous marriage, there will be a need for safe illicit outlets for men's free-ranging sexuality. A case of men having their cake and eating it. Women, of course, have always had to choose one or the other, between the two male-defined views of their sexuality − between having no sexuality and

putting up with sex as a wifely duty, and being defined totally by sex, as a 'good time girl'. I myself feel caught up in this dichotomy still in my head; between feeling sex is unimportant and unnecessary, and seeing sex as a Life Force, underpinning my every action.

But maybe Mary Whitehouse is losing, and pornography flourishes and grows. Maybe we should all now have the mentality of a golden-hearted whore, who loves like a man, within marriage, buying our husbands *The Joy Of Sex* for Christmas. Or perhaps porn has got too big for its boots, and is actually undermining marriage; porn is now big business, so perhaps sex itself is becoming capitalistic, moving out onto the market place – with women's bodies as commodities. What then will become of us?

> 'All the flacks make contracts. Contract sex. It means you agree to put out for so long for so much. You know? Like I have two-year contract. Some girls got only a one-nighter or a monthly, that's standard. You can be put out on your ear at the end of the month with only a day's notice. That's no life. Course once in a while some real bulger, she ends up with a ten-year contract. I never met one, but I heard of them.'
>
> 'What happens when your contract runs out?'
>
> Gildina shrugged nervously. 'Sometimes lower-level ground transport smasher. If you're dropped, sometimes you got a prospect. Sometimes you get by on one-nights or weekends till you turn up a prospect. But it drains you. Always worrying about maybe you'll end up in a knockshop. Sometimes you can't keep maintaining, and then your chances of getting even a lower-level flask run down.'

One possible future from Marge Piercy's *Woman On The Edge Of Time*.

I don't want to choose between Mary Whitehouse and the producers of *High Society*, between two equally unacceptable alternatives – between censoring all mention of sex through vaguely worded laws that will be applied by men, and allowing pornography to invade my life at an ever-increasing rate, on Radio One and in packets of bubblegum, and even in the radical press. I believe we should not agitate for more laws against pornography, but should rather stand up together and say what we feel about it, and what we feel about our own sexuality, and force men to re-examine their own attitudes to sex and women implicit in their consumption of porn. We should talk to our local newsagents – many of whom feel pressured into stocking porn – or picket porn movies, or walk down Oxford Street with our shirts off. We must make it clear that porn is a symptom of our sexist society, a reflection of its assumptions; that it is violent and misogynistic, and nothing to do with the free expression of 'healthy' sex, but rather the truly 'perverted' desire to trample on another human being. We must choose the third alternative – Women's Liberation.

# Rosalind Coward and WAVAW

# What is pornography? Two opposing feminist viewpoints

## Rosalind Coward

Contemporary pornography is a hugely profitable industry which thrives on being thought illicit. Even licensed sex shops have to maintain their identity as illicit or naughty, advertising their trade as 'adult fun', adult films, private shops. Pornography has been increasingly used by men in groups, at business lunches, stag parties, and so on, but even this usage and the fact that porn magazines are widely available does not contradict pornography's connotations of being risky. Pornography takes its definition from a commonsense notion of what is decent and what is indecent, a view so frequently and unquestioningly expressed that it becomes the adopted, 'right' one. What is decent is what is considered fit for mixed groups, and especially family groups. This notion of decency is constantly undergoing revisions: think of the ways in which television changes its ideas of what can be shown on 'family programmes'. Pornography exists at the edges of this definition of the decent; there is a constant revision of the pornographic, a constant incitement to yet more bizarre practices as the horizon of what is generally permissible widens. The recent Williams report on pornography re-iterated this idea of 'the decent'. Pornography, the report argued, should not be censored, but should not be displayed in places which might offend a 'reasonable person'.

The definition of what is pornographic changes over different historical periods. Ankles are no longer considered pornographic. But we can make some generalisations about it. Pornography is an industry of images aimed at sexual arousal. In our society, which is in many ways obsessed with sex, the description and detailing of sexual activity is almost exclusively confined to 'pornography' which is why any book, film or sex manual which details what happens in sex, runs the risk of being designated pornographic. (The recent attack on Sheba, the publishers of *For Ourselves*, by London's Tory Councillors is an example of this.)

Endless representations of sex are permissible as long as they remain at the broadly *metaphorical* level (we're happy to talk about 'doing it' but not about detailing precisely what we do).

This consensus notion of decency, used also by the Advertising

From *Spare Rib*, no. 119, June 1982.

Standards Authority, is a real problem for feminists. The ASA has been able to ignore feminist complaints on the grounds that we are being prudish, not moving with the times, and not accepting what 'reasonable people' would accept.

These notions of respectability, decency and reasonable display are connected with the form of sexual relations endorsed by our society, that is, the heterosexually dependent unit, usually the family. What would offend this unit will be considered indecent. *There is no understanding of how one group – women – might be degraded.*

However, I don't think that pornography is in and of itself violence against women, or incitement to sexual hatred. No representations have intrinsic meaning: a representation of a naked woman or a woman having sex doesn't have an intrinsic meaning. In a totally different culture, where nakedness and sex had different connotations, the meanings of such representations could be quite other. Meaning is given to a representation by its context, use and the arrangement of elements in it. The meanings of an image are decided by how it is lit, framed, the position of the subject, where her look is directed, and so on. Feminists, and women in general, tend to find offensive the *form* in which sexuality is shown in pornography.

At this stage though, there's been little detailing of how and why these codes are offensive. I think the main reason is that they are designed for male arousal, and *in our culture male arousal is a real social problem*, though rarely recognised as such. In law, it is men who commit sexual offences, but women are guaranteed protection only if they use their sexuality 'responsibly' – that is, within a heterosexually dependent unit. Women's sexuality is tightly policed. In the practices of the law, women's sexuality is seen as provocation to violence. Yet in porn, women are represented as voracious, eager and available for whatever men want. Porn is heavily characterised by showing women positively enjoying those practices which 'decent' society frowns on; these images are offered to arouse men. In our society, male sexual arousal is a source of potential violence from which we are not guaranteed protection unless we remain 'respectable', and porn predominantly deals in images designed to arouse this male response. This is not to say that porn causes violence in any straightforward way. Instead, I'm suggesting that porn puts into circulation images of sexuality that have definite meanings connected with them; sexual pleasure for men is initiation and dominance, and for women submission to men's depersonalised needs. The problem is that these meanings feed general definitions of sexual identity and sexual activity.

## Whose fault is it?
## What causes it?

Clearly, there's a hugely profitable industry that promotes porn and reaps the profit. But beyond that, I don't think it's useful to think about politics in terms of *who* is at fault as this doesn't rid us of the *practice* of porn, but only of individual practitioners. I'm more interested in the social structures that produce such a practice and who has the power within it.

Because of the way porn is preoccupied with male arousal, it does to some extent benefit men because it contributes to general beliefs about sexuality and also to definitions of sexual activity. These beliefs are the means by which women are subordinated. Pornography reinforces a split in the way women's sexuality is represented – between the wife and the goer. Pornography frequently promotes an ideology showing women as enjoying what men want. It reinforces ideologies of masculinity and femininity. Men are seen as initiators, the source of active desire. Women are seen as wanting what men want, but *responsive* to men (to their actions or looking), not as *responsible* in their own right. This is one reason for the commonness of rapes and the leniency of punishment; there is a thin dividing line between initiation (normal sex) and force (criminal sex). This is to say that pornography isn't a matter of men capturing the image market to sell women a representation of themselves as enjoying 'the sexuality of the slut house' as Andrea Dworkin put it. Unfortunately, it's a practice which has very close correspondence with the *whole* regime by which sexuality is organised and experienced in our culture. Because it is male sexuality which is considered active, indeed aggressive, it is male sexual arousal which is obsessively catered for; images are circulated which reinforce the ideology of men having compelling sexual needs, like any other active physical need. All women are deemed likely to provoke this need. Pornography promotes the image of women as the place where men's depersonalised needs can be met.

## What can we do?

The first thing we should do is stop setting up pornography as a separate problem, as self-contained rather than as a manifestation of sexuality in our society. We need to shift the focus away from porn and concentrate on sexual relations generally, on anti-sexism and anti-violence. Unless we do this we run the risk of failing to understand male and female sexual behaviour, and the working of power in it. Without this understanding, we can fall into an all too easy anti-porn position which the status quo is happy to accept as it largely leaves status quo notions of sexuality untouched.

I see three main reasons why we need to shift attention. One is that we need ways of linking up representations in adverts or in popular TV programmes, such as *Top of the Pops*, with pornography. We need to be able to specify what it is we object to

in all these representations. We need to understand how degrading meanings are constructed and reinforced generally and not just opt out by saying they are all pornography and that all pornography is offensive. Using terms such as 'offensive' without precision means that bodies like the Williams Committee and the ASA just impose their own meanings which have nothing to do with feminism.

Secondly, in the conventional political arena around pornography, the positions are too well defined and fixed. And neither side has anything to say for feminism. Liberalism asserts the right of one individual to do what (usually) *he* wants in a society where there is not equality between individuals. Thus sexism and racism get excused because liberalism will not recognise that one group has power over another and that individuals have power as representatives of those groups. I feel we need positive legislation which protects subordinate groups. However, legislative proposals put forward by the Mary Whitehouse position have nothing to do with feminism either. I don't think that Mary Whitehouse's anger is the proper anger of all women, unfortunately distorted. Hers is an ideology which is irretrievably reactionary and dangerous. It sees women as entitled only to protection within the safe confines of heterosexual, familial 'love'. Her views are anti-women, anti-democratic and pro-family; they are as problematic as pornography itself.

The inadequacy of traditional politics around pornography suggests that it might be productive to think about anti-sexist legislation like that proposed by the socialist government in France. Theirs contains clauses prohibiting the use of images or language considered degrading to women. Even if such legislation were never enforced (and the evidence from France is that it would be difficult to do so), it would be a propaganda victory for feminist ideas, rather than letting feminism be swamped with, or by, anti-porn, anti-sex moralism.

Thirdly, it would mean that feminists would have to refine our discussions of what is sexist, what is offensive and what is degrading: it would therefore advance the discussion of sexuality within the movement in general. If anything, recent controversies in the movement about sexuality have engendered a sense that we need more open, more explicit discussions of sexuality rather than any premature closing of the issue.

**WAVAW**

These chicks are our natural enemy . . . it is time we do battle with them. . . . What I want is a devastating piece that takes the militant feminists apart. They are unalterably opposed to the romantic boy-girl society that *Playboy* promotes. . . . Let's get it and make it a real winner. – Hugh Hefner memo

Pornography is about power – men's power over women. In it we are seen as vulnerable, helpless, open, submissive and longing to be violated. However the woman is portrayed in porn, whether as enjoying or resisting, the purpose is to give men pleasure and to increase their power over us.

We need to discuss what porn is. We would all agree that the display of girlie magazines in our local newsagents is pornography and we try to avoid seeing it. As porn is made by, aimed at and enjoyed by men, we thought it was necessary for us to look at it critically as a group of feminists. We found that the central themes are the domination, control, humiliation, mutilation and even murder of women. Porn is dangerous and deliberate propaganda for men,[1] legitimising and encouraging their view of us as mere objects for their use. Women are usually depicted in naked and submissive positions and contorted postures. For example, the man stands above the woman in a position of control while she lies on her back, or is draped upside down over some furniture, or even stands on her head exposing her vagina. The photo focuses on her exposed and vulnerable genitals: she is powerless. Often the sexual act is described as a power struggle in which the man is always dominant. The penis is described as a weapon and penetration is an act of mastery.

The images of women portrayed in pornography are a true representation of what men think female sexuality is. We like to be 'man-handled', raped, abused: we are shown to be maso-chistic, that is enjoying pleasure through pain, whilst men derive pleasure through inflicting pain. Pornography shows this very clearly.

## Whose fault is it? What causes it?

Pornography is more than mere pictures and images. Sexology, developed by men early this century, provides the 'scientific proof' that male sadism and female masochism are 'natural'. Havelock Ellis wrote 'While in men it is possible to trace a tendency to inflict pain . . . on the woman they love, it is still easier to trace in women a delight in experiencing physical pain when it is inflicted by a lover, and an eagerness to accept subjection to his will.'[2]

This then is the theory behind male sexuality and pornography depicts it. Our resistance to male 'passion' is, we are told, only a manifestation of our need to be conquered.

The Sexual Revolution of the 1960s changed the definition of female sexuality. No longer are we naturally passive, we are now to become active. At the beginning of this century women who resisted male sexuality were called frigid: now women who resist are accused of 'having difficulty achieving a high level of arousal'. These are the ways that men have invalidated any challenge to their dominant sexual values.

Pornography is not a harmless fantasy indulged in by a few limp perverts. It is a multi-billion dollar industry in America, larger than the record and film industry together and in Britain the pattern seems the same. Films, magazines, video and bondage gear are the products of pornography, but it must not be forgotten that real women are used within it.

Linda Lovelace exposes the horrors of her life as a sex symbol in her book *Ordeal*. She had no choice – she was forced to perform at gun point. Significantly the male media in the 1970s hailed her as a 'liberated lady'. Her exposé of her gruesome experiences was ignored, as her reality was silenced. And hers is not an isolated example.

This rapidly expanding sector of the economy relies on the degradation and humiliation of women to provide 'entertainment' for men – our fathers, brothers, sons, husbands, friends, lovers and bosses, all of whom may buy and enjoy pornography.

Real women are used, sometimes tortured or even murdered (Snuff Movies) to make the pictures that are pornography. These images justify and condone the violence against women which occurs outside the industry. It is the same woman-hatred which motivates men to rape, murder and mutilate women in our homes and on the streets.

Knowing that men enjoy this form of 'entertainment', we must question male sexuality. What is going on in their heads when they derive pleasure from seeing a woman bound, gagged, hung up on a meat hook and raped? Even the men who don't get off on hard-core porn are implicated by their failure to challenge the men who do.

Not only does pornography reinforce male sexuality, it also perpetuates the myth that women are willing and eager to be dominated, often violently.

Linda Lovelace provides her answer to 'women want it' – she didn't and we don't. We are the women in pornography – our genitals exposed for men's glances and contempt. Many women may look away from the daily images of our bodies displayed for men's pleasure and profit. The reason is not that we are 'repressed' but that our gut reaction is correct. We see ourselves being degraded and we reject it. We feel embarrassed, dismayed or upset. This is the effect that porn has on us.[3]

## What can we do?

Only with collective strength can we fight pornography. Individually we may be undermined by it, but together in groups we can explore our feelings. It became clear to us that the objectification of our bodies is not confined to pornography. We looked at porn and developed an analysis to understand what it's about and what it does. This has inevitably led us to question all

institutions of male supremacy. The male/female relationship depicted in pornography is an extreme example of the power imbalance within the institutions of heterosexuality. Because pornography has directly influenced all the images of women, it is the clearest and most obvious target for feminist action against violence against women.

Picketing sex shops which sell not only magazines and films but also whips, chains and bondage gear, is a way of expressing our anger. It inconveniences the shops' managers but also gives us a chance to talk to more women. On every picket held by this group, women of all races, classes and ages have either joined us on the picket or signed petitions. By organising pickets outside sex shops, cinemas and newsagents we are validating women's anger. And anger is our response to an industry which exploits, humiliates and degrades us.

## Notes

1 By deliberate we do not mean that there is a conscious conspiracy to create pornography in order to put women down, rather we mean that porn is not an accidental or isolated phenomenon.
2 Havelock Ellis, *Studies in the Psychology of Sex*, vol. 3, ch. 1, Love and Pain, 1926 ed., p. 89, F.A. Davies and Co., Philadelphia.
3 We do not suggest that we are speaking for every woman, but our own responses within the group, the responses of women we talk to, and women who sign petitions and join pickets against porn indicates that most of us oppose it.

Written collectively by Gloria, Jill, Linda, Katrina, Julie, Sheila, Kate, Anne, Lyn, Megan, Imelda, Jayne, Tina after discussion at Central London Women Against Violence Against Women.

# Porn, law, politics

Mary Bos and Jill Pack

Growing public concern about pornography prompted the last government to set up a committee to examine the operation of the legislation governing the distribution and content of pornography. However, the confusion surrounding the operation of the current Obscene Publication Acts, which has affected both those selling pornography and those opposed to it, was the principal reason behind the establishment of the Williams Committee which reported in November 1979 on Obscenity and Film Censorship. The report reads very much like a liberal philosophical essay, concerning itself with questions of the 'public good', 'harms', freedom of expression and general questions of the notion of 'art'. The findings challenge a few myths, such as those surrounding the posited correlation between the quantity of pornography and the number of sexual offences, and recommend that the term 'obscenity' be abolished as a legal definition and instead that the 'matter to be restricted should be "offensive to reasonable people"'. It is anticipated in the report that this definition will widen the material currently legally available, though of course the operation of any law introduced along these lines will determine whether this is so. However, the report came out in favour of 'restricting without suppressing pornography' and recommended that pornographic films and picture magazines (including material currently available in newsagents such as *Mayfair* and *Men Only*) should be sold from behind closed doors so that public displays do not offend 'reasonable people'. It is proposed that the written word should no longer be subject to any law surrounding obscenity or 'offensive material'.

Although the report recommends the prohibition of photographic images only in very limited cases (where the actors in the production of the photographs are either minors or suffered actual bodily harm), there is throughout the report a different attitude to photographic images than to the written word. The basic recommendation of the report is that photographic pornography should be hidden from public view, and only be available in specialist shops, which are clearly labelled and which restrict entry to those over 18 years of age. This stems partly from one of the basic premises of the report that the innocent, those not wishing to consume pornography, should be protected while at the same time the freedom of those who wish to indulge should not be impinged upon. For, although one might inadvertently see a picture, and be offended, one cannot inadvertently read a book or article.

From *Camerawork*, no. 18, March 1980.

182

However, we think there is another, more deep-seated reason for this discrepancy in the report's attitude to written and visual pornography, which lies in the nature of photography itself. Photography is imbued with an ideology of realism – it seems to represent reality in a direct and unmediated way. It is perhaps for this reason that it is seen as more dangerous, more offensive and therefore in more need of censorship than other modes of representation. It is interesting to note that at the present time in soft-porn magazines such as *Men Only*, the non-photographic images (e.g. cartoons and sketches) and the written text are much more explicit and 'stronger' than the photographs are allowed to be. The stories and the letters page will discuss sexual activity in great detail whereas the photographic images would never go this far, and in fact usually show women on their own. The written word is seen in the report as the medium of self-expression and of opinions, and therefore in need of protection from censorship. To censor the written word is to threaten freedom of expression and therefore the report avoids recommending any restrictions on the written word. Also, the report notes that the written word tends to be regarded as less offensive 'than pictorial matter, and that there are basic psychological reasons for this fact'.

The different attitudes and responses to written and visual advertisement are signalled both by the general public's different responses to the two media, as well as by the present application of the law. Since the *Lady Chatterley* trial in 1960 few publications have been prosecuted on the basis of their written text alone, and even less have been found guilty of 'attempting to deprave and corrupt'. It is the *photographic* representation of explicit pornographic sex which causes the most concern.

Although we may feel sympathetic to the general liberal intentions of the Williams Report, it seems to us that its views are based on a false premise. It assumes that one can distinguish between 'reasonable people' and the 'others'. More particularly it assumes that people who consume pornography don't themselves find the material 'offensive'. We think that it is precisely because pornography is illicit and offensive that it is sexually stimulating. 'Reasonable people', to use the report's terms, may also find it sexually stimulating, and consumers of pornography may themselves find it offensive; the division between 'society' and 'outsider' is much more difficult to draw than the report suggests.

The Williams Committee was instituted to examine the workings of the present laws and make recommendations rather than to examine the specific position that pornography has in our society today and the social forces that determine that. Here we would like to take a broader view of the reactions to pornography and why we believe it is an important area of our culture to study.

Many people regard pornography as a symptom of a rotten society, reflecting its implicit values and providing a privileged

understanding of the workings of sexuality.

We disagree with this view, for it assumes that representations are autonomous and separate from the 'real'. Images and representations are part of the social; they produce and reproduce society rather than merely 'reflecting' it. Pornography, along with other cultural products such as short stories in women's magazines, forms part of a discourse of sexuality which seeks to define and construct sexuality.

The growth in pornography is popularly considered to be the effect of the growing permissiveness of our age from the 1960s and the liberalisation of many laws surrounding sexuality that took place in the latter part of the decade. Permissiveness is a term that takes its definition from a particular relationiship to 'normal' heterosexuality, with the family primarily representing the unit for the organisation of sexuality in our society. The liberalisation of laws restricting various forms of sexual activity in the late 1960s was largely motivated by a caring concern to liberalise certain inhumane laws. However, the permissiveness of the 1960s defined its limits – that sexuality should be expressed in a loving, preferably heterosexual relationship. Deviant forms of sexuality would be allowable provided, like sexuality for pro-creation, they took place behind closed doors and between consenting adults. Homosexuality and prostitution were, in most circumstances, no longer crimes provided they were not conducted in a public place. The Williams Report echoed the sentiments expressed in the Wolfenden Report whose recommendations became law in the 1959 Street Offences Act. The Wolfenden Report wrote that '. . . we feel that the right of the normal decent citizen to go about the streets without affront to his or her sense of decency should be the prime consideration and should take preference over the interest of the prostitute and her customers. . .' The tendency of the laws passed, and their operation, has thus been to maintain the definition of sexuality in relationship to the norm of the family. Sexuality is seen to be for procreation inside the family, so that sexuality outside the family should be non-reproductive and hidden.

Pornography has not necessarily become more available but more publicly available. The permissiveness of the 1960s enabled sex to be more freely discussed and sexuality to be more freely represented. We would argue that rather than pornography influencing advertising images, as some feminists would say, in fact advertisements for, say, underwear have meant that porno-graphic magazines and film stills have been able to find public access. Formerly, hedonistic sexual fantasies, epitomised by pornography, were private; now they are gaining a public place. With a public space a market for pornography was created which, having established itself, gathered its own momentum. It is this movement into the realm of the public, this confrontation of

formerly private fantasies, that provokes public concern.

It would thus appear that when the cry goes up to ban pornography or clear it from the streets more is at stake than a desire not to see pictures on news-stands of women being flagellated by men in rubber. The 'public concern' surrounding pornography says as much about the sexual attitudes of our time as the actual content of the magazines and films themselves. Why is it a campaigning issue both of a certain group of feminists as well as of tub-thumping puritans, particularly given that feminists supporting the Reclaim the Night Campaign represent that part of the women's movement that is most clearly anti-family, whereas the supporters of Mary Whitehouse are concerned with decency and a desire to preserve the 'holy family' from decay?

The issue that is a stake here is of differing images of women. Both sides would seem to embody a notion of an essential (though differing) female sexuality. The Williams Report acknow-ledged the distinction between attitudes to sexuality within the women's movement and those attitudes held by a right-wing anti-pornography lobby. The Mary Whitehouse lobby would distin-guish the representation of women's sexuality as having its base in the home and the family – an essentially 'natural' state of affairs. Sections of the women's movement, however, see representations of women at work as somehow being 'more real' than those of women naked and provocative and hence place an economistic view on the nature of women's sexuality. What is being made is a political point that these images are more exemplary, less exploitative, and consequently do not objectify women. The Reclaim the Night Campaign represents one current of opinion among feminists, an opinion which sees a continuum from hard-core porn through soft-core porn to advertising images. The Williams Committee reported that evidence from feminists 'tended to see pornography as but one form of sexism, perhaps a particularly blatant and vicious form but essentially reflecting the same view of women commonly encountered in advertising, entertainment and other aspects of our social existence.' 'This exploits women' stickers are indiscriminately applied to adverts in public places. This is a consequence of the belief held by some feminists that all images of women are exploitative – very much a seventeenth-century puritan or Islamic 'anti-image' notion. Nude or sexually provocative images of women are seen as objectifying women – the object of the man's gaze – in a way that images of women at work do not. Yet these latter images do not objectify women any less than, say, pornography does – they are still representations of women, albeit ones that we more easily endorse. They are no more 'real' than a pornographic image of a woman. All images objectify.

However, many other feminists find images of women attractive and in addition would argue that sexuality should be brought out

into the open, with the proviso that it should not degrade and exploit women in the process. The emphasis is placed on the ownership of one's own body and the consequent belief in the ownership of one's image, and hence they confuse the representation and the real. It has been suggested that the development of a 'feminist aesthetic', and a non-exploitative erotica, would be a way forward in controlling the production of an image. What this ignores, though, is that the production of an image does not just take place in the shooting of a film or picture but also at the place of viewing. The codes that operate in the reading of an image and the construction of its meaning cannot be so easily changed – for example the connotations of 'woman as exchange object' and 'woman to be looked at/consumed' are codes that must be tackled in the process, if not before, of developing an 'alternative erotica'. What we are saying essentially is that we do not believe in a feminist language (langue) or different codified system in terms of the spoken word or images, but we do not rule out the possibility of a feminist speech (parole), in other words a different use of the language (langue), maybe through subverting the meanings but using them nevertheless. Maybe the written word, rather than the image, is the current site for the development of a new erotica. Interestingly, the Williams Report proposes no censorship whatsoever in the written word.

Pornography is currently illegal if it is considered by a court to be 'obscene', and the test of obscenity is the highly subjective one of whether the material has a tendency to 'deprave or corrupt'. The Williams Committee pointed out 'that it is the circumstances of publication, particularly in relation to the likely audience, that governs the finding of obscenity, not the content of the material alone'. In other words images do not have implicit intrinsic meanings, but gain specific meanings through their institutional contextualisation, which endows them with a particular significance. Consequently the image of a woman is not inherently sexist, but is only so by the context in which it appears. 'A picture of a girl in underwear is perceived differently if it is on the cover of a woman's fashion magazine from the way it is seen if it is on the cover of a "man's magazine" ' (Williams Report). An image is inherently 'notoriously unstable' and thus open to interpretation. However, the interpretation is not freely negotiated but is anchored, or held down, by various factors and in particular the context in which it appears.

Various codes – social conventions, textual codes – determine the reading of a particular image and operate as a constraint, a necessary constraint, on the interpretation of an image. To understand an image, and the message it conveys, the viewer must have access to the codes which structure the meaning, or else produce a very different meaning to the one which is

culturally prevalent. So, for example, pornographic/erotic images from a different cultural and historical period to our own, such as eighteenth-century feudal Japan, may not be seen in our culture as erotic or pornographic. In our culture the image of a naked woman has very different connotations to the image of a naked man. A naked man does not connote availability in the same way as a naked woman. Consequently it is no accident that women are used to sell commodities such as cars – a man in the same position would not have the same connotations.

One of the problems in the development of a possible feminist erotica is that of the nature of sexual difference and the way this is structured symbolically and hence informs the way in which images of men and women are constructed. Sexuality should not be narrowly defined, it is not about sexual fantasies. Pornography, and the enjoyment gained from looking at it, is generally considered to be an aberration from the norm; the norm, as pointed out by Juliet Mitchell, in *Psychoanalysis and Feminism*, is that for sexuality 'to be decent (it) must have an object'. Pornography provides a fantasy, not an object. Pornography clearly has no reproductive function and its use as a means of sexual satisfaction through fantasies is considered a deviation. The 'object' that makes sexuality 'decent' is thus a member of the opposite sex. The enjoyment gained from pornography is essentially scopophilic, pleasure from looking. Women are simultaneously looked at and displayed and become the object of male fantasy, the man becomes the bearer of the look. The meaning of the woman is ultimately that of sexual difference, the visual absence of a penis, and hence the threat of castration, which is constantly disavowed by the male spectator. Stephen Heath in *Screen*, vol. 19, no. 3, argues that the function of pornographic images of women is to continually and repetitiously pose them as 'the other'. The hidden discourse of the pornographic image is 'a ceaseless verification, the truth of the image – my sex exists and the woman is different and is her sex, the difference, my representation.' It is this continual repetition of looking, of seemingly boring images that provides the basis for a profitable industry, which is not to say, however, that these particular representations of female sexuality are just a result of capitalism.

We have tried to argue that pornography is a site for the struggle over the representations of women. Women are represented in many different ways. We have tried to make the point that no one single type of representation has an ontological superiority over another. There are a variety of discourses which seek to define female sexuality at any one time. We do not regard any of these as being any more real or truthful than another. They are all 'merely' representations; this is not, however, to deny their importance or their power. Nor is it to suggest that all

discourses are equally influential or powerful. Pornography seems to be particularly impelling because it locks into the sexual structure in our culture. Pornography brings fantasies to 'life' – or at least into the realm of the visible. These fantasies only gain their significance because they reflect the structuring of sexuality in our culture.

Hence, other discourses on sexuality, such as a medical one, do not have an erotic effect. Although this may seem self-evident it does impel us to ask the question: 'What lends pornography its power?' As we have suggested, it is not something implicit to pornography which makes it so powerful, but rather its relation to the nature of sexuality in our culture.

We think that in order to investigate pornography further we need to investigate the structuring of sexuality, particularly such notions as voyeurism and fetishism; Freud would seem to be indispensable to any such investigation.

So, although we are very sympathetic to feminist antipathy to pornography, we feel we need to understand it, rather than simply reject it as the product of male oppression. Pornography is a product of the sexuality of our society, and men alone did not create this – we are all implicated.

By banning certain images the ideology which informs them will not fade away. However, this is not to say that one has to accept pornography as inevitable, but it does force one to recognise that wishful thinking and good intentions will not change the nature of sexuality in our society.

Kathy Myers

# Towards a feminist erotica

This paper is a response to the ideas which came out of the Camerawork one-day discussion for women on the subject of pornography. This discussion aimed to set the problematic area of pornography within the wider issue of the politics of sexual representation. It was also hoped that discussion would deal with the controversial subject of 'feminist erotica': this did not take place, a resistance which speaks of a fundamental dilemma in sexual politics. Many feminist critiques of the representation of women hinge on the assumption that it is the act of representation or objectification itself which degrades women, reducing them to the status of objects to be 'visually' or 'literally' consumed.

I want to argue that this assumption can lead feminism into deep water. On the one hand, it works to deny women the right to represent their own sexuality, and on the other it side-steps the whole issue of female sexual pleasure. I want to suggest that questions of representation and of pleasure cannot be separated, and that a feminist erotica could examine the nature of this relationship. This in turn demands examination of the forces which produce dominant ideas of sexuality and pleasure. Rather than seeing power as a force which 'represses' or 'holds down' our sense of pleasure and sexuality, I want to suggest the opposite: that power actually produces forms of pleasure and sexuality. The forms of sexuality and pleasure produced through pornographic representations are not acceptable for a variety of reasons. However, I want to argue that through a relocation, a respecification of the nature of power, new, potentially progressive images may be produced: the perception of power as a positive force provides the groundwork for a feminist erotica.

Finally, this article holds that images themselves cannot be characterised as either pornographic or erotic. The pornographic/erotic distinction can only be applied by looking at how the image is contextualised through its mode of address and the conditions of its production and consumption.

From *Camerawork*, no. 24, March 1982.

## The workshop

Feminists working on the politics of female sexuality have all but ignored the issue of female sexual pleasure: caught on the defensive, most have devoted their energies to a counter-offensive against the dead weight of patriarchy, fighting images which are deemed sexist or exploitative. One of the most organised and coherent groups in this sexual defence lobby is WAVAW (Women Against Violence Against Women). As this group was dominant both in force and number at the Camerawork day event, it would be useful to outline their analysis.

WAVAW's objection to pornography, unlike that of groups on the right, is not premised on the moral or health grounds, but is rooted in their understanding of the role which pornography plays in the antagonism between the sexes. Pornography is objectionable because it 'humiliates', 'denigrates' and 'exploits' women.

Exploitation operates on several levels. Firstly, through the process of representation, women are 'objectified'. Women's gender and social status is reduced to the level of a commodity which may be possessed and exchanged by men. Secondly, pornography restricts female sexuality by reducing it to specific anatomical characteristics: e.g., the repetitive fetishisation of breasts, legs, vagina, etc. Through this fetishisation, sexuality is fragmented, the part is left to stand for the whole. Thirdly, WAVAW suggest that the proliferation of pornography has actually led to an increase in sex crimes against women. These three processes of objectification, fetishisation and violation are central to the WAVAW critique of pornography.

What is missing from the WAVAW analysis is an understanding of how and why these processes occur: all their analyses are simply traced back to a monolithic notion of patriarchy. All imagery, all practices within the 'dominant ideology' are interpreted as further evidence of 'patriarchal oppression'. This defensive tactic continually reduces women to victim status and leaves very little space within which an alternative female sexual practice may be negotiated. The only alternative which is presented as viable is a total withdrawal from heterosexual relations not as a matter of sexual preference but of political necessity.

WAVAW's concept of power is premised on a fundamental contradiction. On the one hand, power as synonymous with patriarchal oppression works to victimise women. Its force is monolithic and cohesive, and from the point of view of women, politically negative. On the other hand, WAVAW's intentional withdrawal from men, and endorsement of separatism, suggests that women can establish new ways of organising their sexuality, relationships and experiences: that women have the power to positively establish a separate identity. Whilst women may positively organise their 'real' experiences, this sense of positive

organisation is not extended to the construction of 'positive' representations of women. The domain of representation is perceived as essentially colonised by patriarchy and leaving little room for manoeuvre.

As an alternative, I want to draw on some of the ideas of Foucault as a way of exploring the power-pleasure-representation nexus, and look at how these relations are produced by, as opposed to held down by, power.

Foucault, in his book *The History of Sexuality* aims to investigate 'The regime of power-knowledge-pleasure that sustains the discourse on human sexuality'. For Foucault, sexuality has become a means of controlling and administering social relations. The idea that control over sexuality provides a way of controlling a society is not new. What makes Foucault's approach novel is his rejection of the idea that control is exercised through systems of repression. On the contrary, Foucault suggests that the history of sexuality has been characterised by an 'explosion' of 'polymorphous discourses on sexuality'.

One of the characteristics of this 'explosion' is the making verbal, the putting into words, of sexuality. Foucault traces this back to the model of the church confessional. The model of the production of truth through the process of confessing can for example be found in modern practices of psychoanalysis. Our society's obsession with sexuality also permeates many 'unspoken' practices. For example, Foucault argues that the architecture of the eighteenth- and nineteenth-century poorhouses, schools, factories, homes, etc. were all 'saturated' with sexual knowledge. This knowledge informed the layout of bedrooms, toilets, school doors, cloakrooms, etc. In addition, discourses on sexuality spread through the institutions of welfare, jurisprudence, psychiatry, medicine, exercising complex and often contradictory influences on the development of personal and sexual relationships within society.

Foucault refrains from combining these constituent elements into a monolithic theory of the relations between power and sexuality. Power, like sexuality, is perceived as multifaceted, emanating from many institutional 'power-bases'. It is this polymorphous quality of power which gives it its strength and flexibility, but which also denies the possibility of any simple causal or deterministic analysis of power relations.

For Foucault, power works to produce a multiplicity of female sexualities which work to insidiously maintain the social order: e.g. the production of the ideology of 'romance', of 'hysteria', the 'nervous woman', 'frigid wife' or insatiable 'nymphomaniac'. Certain forms of female sexuality support the family structure, others are outlawed from it: e.g. pornography, prostitution and lesbianism. For Foucault, this public/private dichotomy, far from challenging the social order, works to secure and legitimate the

parameters of acceptable and unacceptable behaviour.

This analysis also challenges the idea of an 'essential sexual instinct' waiting to be uncovered, or freed from repression. The concept of power as positive and productive both gives us the tools to analyse the patriarchal order (not as a monolithic system of oppression, but as a specific socio-historic articulation of power relations) and also provides the ammunition for change (a re-organisation of power relations). It shifts feminism from the site of oppositional practice (a defence against the bastions of patriarchal power) to that of a positive practice working to deploy power.

But to say that power produces sexuality and pleasure is itself inadequate: we have to understand how this process specifically occurs. The experience of pleasure is both a social and emotional activity. The two are inextricably linked: we need to ask how the powers of the imagination and fantasy can actually produce and sustain dominant notions of sexual practice. One of the biggest problems with WAVAW's empiricist analysis of pornography, is their inability to explain this connection.

## The real and the representational

One of the central characteristics of WAVAW's argument is the distinction they make between the material world of 'real' relationships and the imaginary world of representation and fantasy. This separation of the imaginary and the material seems too simplistic an account of the way we live our lives, ignoring the crucial position of systems of representation, whether images or language, in our 'real' relationships.

This separation points to a central contradiction in their argument. On the one hand, they see 'real' relationships and representations as totally separate; on the other hand, they point to the ways in which pornographic imagery not only reinforces but actively instigates the sexual abuse of women. They continually invoke imagination and fantasy as agents of sexual oppression with no possible positive role.

For WAVAW, the sin of pornography is its ability to structure and organise fantasy in ways which are thought to be oppressive. Fantasy, the guilty party, becomes the breeding ground for violent actions. But there is a difference between criticising the social discourses which structure the form and content of the imagination and blaming fantasy and imagination themselves. This is a distinction which WAVAW seem unprepared to make. Yet fantasy, and all the associated mechanisms of daydreaming, the imagination, inspiration and creativity are a fundamental part of experience.

Rather than dismissing the power of the imagination and fantasy as politically undesirable, what is required is a greater

understanding of their determination and structure under a phallo-centric order. Such an analysis may bring women closer to understanding the nature of their oppression. Of course it also presents the ultimate challenge: how to re-structure the systems of language, association and meaning which organise our consciousness.

## Pornography and sex

As I've already suggested, the sexual isn't already given, but is produced through a variety of social practices which extend across the fabric of daily life. Some of these practices are socially condoned (e.g. heterosexual relations with marriage) and others condemned (e.g. hard-core pornography). Even heterosexual relations within the family are not simply legitimated but governed by social mores about the kind of sex act allowed, the age of participants, etc.: there is a complex web of regulation, channelling and development which is not fixed or innate but directly related to the social and historical attitudes of the social formation.

Whilst WAVAW interpret pornography as evidence of the continuing conflict between the sexes, the libertarian tradition, equally starting from the premise of an essential sexuality which is socially repressed, has tended to defend pornography on the grounds that its outlaw status directly challenges the status quo.

The 'sexual radicals' such as Reich and Marcuse played a central role in the development of the libertarian tradition. Following Freud's analysis, they proposed that sexuality was subject to social censorship when it threatened to disrupt the social order. This invested sexual practices with a potentially revolutionary power. However, their idea of a rebel sexuality is continually undermined by the notions of sexuality with which they worked: that is that an 'essential' sex could be uncovered if layers of repression and social oppression were stripped away. Obviously this idea of an essential sex is not a particularly fruitful avenue of enquiry for feminists who wish to challenge dominant notions of the essentially feminine which in the end are found to rest on biologistic or universal criteria.

The heritage of the libertarian tradition has continued to inform many popular notions of sexuality, for example the so-called 'permissiveness' of the 1960s as well as many aspects of the male gay liberation front. Libertarianism also informs Angela Carter's influential book: *The Sadeian Woman*. She suggests that the Marquis De Sade's documentation of nightmarish sexual exploits are fundamentally concerned with the nexus of power, sex and class under bourgeois relations. By caricaturing these relations in their most oppressive and violent forms pornographic literature, Carter argues, is capable of offering a critique of

'accepted' social relations, where oppressive power relations are continually disguised and denied by reference to the natural order, romance, desire, etc.

However, while pornography is apparently invested with the power to subvert accepted gender relations, it may have the opposite effect. Because it lies outside the accepted, it implicitly acknowledges and accepts social privileging of the family, reproduction and heterosexual union. It basks in its role as deviant. Caught in this binary model of acceptability/ unacceptability, pornography works to restrict the expression of sexuality.

For example, soft-core pornography reduces female sexuality to genital sexuality: a woman's sexuality is defined in terms of her orifices. The sexual no longer refers to the potential of the erotic body as a whole, but to fragmented, fetishised aspects of a woman's anatomy. The sexual is reduced to a series of well-worn scenarios which have their ultimate resolution in the promise of penetration (by the imagined reader, or more explicitly by a male actor). The images are dulled by sameness, a constant repetition of the imagined fuck. The pornographic colludes with what the libertarians purport it to disrupt. The sexual is located in the organs of reproduction. Pornography works to celebrate the union of sexuality and alliance, of pleasure and reproduction; sex is genital sex, and nothing more.

Libertarianism also falsely assumes that everything which is socially unacceptable (and hence subject to censorship) is inherently subversive and liberating. This is because they focus only on pornography's claim to be erotic. It is the eroticism in pornography which is thought to be liberating, symbolising the life-giving forces of love, pleasure, desire, etc.

Thus, libertarianism leaves unexplored the implicit power relations with which pornography is invested. Power is exercised through pornography on many levels which speak of an implicit gender fascism: e.g. that the magazines are produced for the consumption of men, the recurrent portrayal of women as victims, the fact that their sexual pleasure is produced for an imagined male audience, etc.

These power relations within pornography challenge the libertarian claim to its liberating potential. It is this continual overdetermination of the sexual by power relations which renders the pornographic image unacceptable.

Libertarianism also positions freedom as the antithesis of power relations. It is power which keeps freedom down. But to accept this is to see power as repressive, as hindering the development of sexual expression. Foucault's analysis of power, in contradiction to this, sees power as actually producing sexual discourses. It seems to me that if we are to understand the role of pornography in our society and understand the ways in which our

conception of female sexuality is produced, we have to see power as a productive as opposed to a simply oppressive force. Our conception of freedom, of sexual pleasure, needs on the one hand to negotiate the existing power forces, and on the other move towards the construction of new sexual experiences. What is required is a shift in the location of power, not a denial of its existence. It is through this reworking of power relations that a sense of freedom may be established.

This idea of power producing pornography cannot be confined to an examination of the image. An analysis of pornography which focuses purely on its content is in danger of falling into a kind of 'reductive essentialism', e.g. the notion that exploitation resides in the representation of female sexuality *per se*, rather than in its contextualisation: the conditions of its production and consumption; the ways in which meanings are created, etc. Unless we can shift the debate on representation away from the image, there is very little 'positive' work which can be done.

Whilst it is true that we designate certain images as pornographic, pornography also refers to a particular mode of productive relations which market and sell sexuality: e.g. the choice of model/subject matter, the photographer-model relationship and the conditions under which they work, the choice of medium and distribution, all affect our reception and interpretation of what constitutes pornography. This economy of pornography works to structure not only to whom the material is made available, but also the kinds of pleasures and responses which are elicited.

The false claim of libertarianism is to suggest that eroticism lies outside the nexus of existing power relations. But this is not the same as saying that the erotic is powerless, and that work cannot be done to explore its full potential. This is the ultimate meaning of a feminist erotica; to reappraise the ways in which versions of female sexuality have been produced, and to use this as a springboard to develop new dimensions and meanings for female sexuality. We have to understand the ways in which images work to construct our own experience of our sexuality. Rather than running away from the powers of the imagination and fantasy, we have to reappraise the role of representations in structuring our needs and desires as a step towards constructing new meanings for the experience and representation of our sexuality.

I want to illustrate this point with one image taken from a soft-core porn magazine and one from a woman's journal (Figures 46 and 47). By comparing them, I want to suggest that woman's sexuality is deployed in a variety of ways. This deployment is dependent upon the context in which the image appears, its mode of production as well as consumption.

On first impression, the two images seem remarkably similar:

46 Slix New Waves
advertisement, source unknown.

47 Pornographic photograph,
source unknown.

the model's pose and attitude, the seaside setting, etc. The main difference appears to be that the Slix model sports a bikini whilst the porn model is naked. It could be argued that women's exploitation is only a matter of degree along a scantily clad continuum. However, the surface similarities belie fundamental differences in the representation of female sexuality and in the kinds of pleasures offered to audiences.

Many of these differences are hidden from the viewer. For example, the production of pornography differs in most respects from the production of a fashion advert. This affects their economic foundation, the choice of studio, photographer, model, etc. They are specialist discourses which retain their autonomy. For example, the 'photographic life' of models is extremely limited. Few nude models ever make the transition to become fashion models, partly because of the stigma which certain forms of nude modelling carry, and partly due to the fact that different selection criterion operate. Fashion models have become increasingly slender, younger and taller. Most nude models are considered too 'curvy' for fashion work: different 'aesthetics' operate. In turn this visual aesthetic cannot be divorced from the respective audiences for fashion and pornographic imagery. To put it simply, there is an overall tendency to market 'fleshier' women to men and thinner, sometimes sexually androgynous, images of women to female audiences. This micro-politics of body style speaks of the aesthetic and pleasurable segregation of sexuality across a range of visual discourses, which cannot be simply explained away in terms of 'taste' nor patriarchal oppression but require further examination.

Selling female sexuality to a woman is not the same as selling it

to a man. The anticipated gender of the audience is crucial in structuring the image. For example, look at the angle of the women's heads in the two images. The pornographic model's face is angled towards the viewer. Her mouth is open, a classic signifier of sexual receptiveness and anticipation. In the small inset photo the same model faces and acknowledges the camera. Behind the camera, we, the audience, are located.

By comparison the Slix model, sweeping back her hair, looks across the scope of the camera. She does not face us, her mouth is closed. Not so much a sulky pout as an expression of relaxed langour. Like the pornographic image, she is aware of being on display. But the tenor of her demeanour is proud and inaccessible. She sweeps back her hair from the heat of the sun, not from passion.

By comparison, her legs are together. The Slix model's mouth and legs offer no point of entrance. The body of the Slix model is a matt sandy tone, she is relaxed. The skin of the nude model is oiled to give the effect of a sheen of perspiration which can signify sexual activity and tension.

The girls in the background of the Slix image look at each other not at the camera. Self-absorbed, they reiterate the confident, self-engrossed narcissism of the foregrounded model. She takes pleasure in her sunbathing, not in the presence of her audience. Only the small inset model in the beach jacket to the right of the image pays the camera a cursory glance.

What differentiates the pornographic image from the fashion shot is the mode of address. The Slix mode of address is characterised by the tension which it establishes between the model's desirability in conventional terms, and her inaccessibility. The advert works to secure a distancing effect between image and audience.

By comparison, the nude model's sexuality is posed as invitational. The pleasure of looking at her merges with the pleasure of being with her. Her sexuality stretches out to embrace the viewer. The nude model 'asks' the audience to possess her. It is a form of sexual consumption which implicitly genders the audience as male. The model's apparent expression of pleasure is not for herself. She is not autonomous, her pleasure is always for the consumption of another, and herein lies one of the fundamental alienations of pornographic imagery.

By comparison, the Slix advert positions the audience as spectator, to keep a safe distance and to observe, not to touch. Sexual inaccessibility is conveyed through the structure of the image. For example, the self-absorbed pose of the model, the cropping, editing and retouching of the photograph, work together to reinforce the displayedness of the model, and in doing so, distance the audience.

The impact of the Slix advert is based on the strength of the

photograph. Its scale and use of full colour works to dominate the page. The seaside location, the pattern on the bikini, the sense of displayed style are all anchored in the copy line 'New Waves'. These associations are cemented by reference to the brand name of Slix which is in bold type. Image and copy line work together. 'New Waves' links the image to the body of the text.

Whilst the image celebrates the tension between desirability and inaccessibility, the body of the text suggests sexual provocation. Unlike the provocative pose of the pornographic image, the Slix advert suggests sexual power as opposed to sexual availability and perhaps vulnerability. The wearer of the Slix bikini is promised power over others, the power of sexual display: 'Slip into Slix and make a few ripples.'

The target audience for this advert is women. The advert is designed to appeal to women. One of the pleasures which the advertising system offers women is the promise of a kind of power and self-determination. Images of women marketed to women rarely present female sexuality purely in terms of vulnerability, accessibility or availability. But the power which the advertising of beauty and personal products offers women is always of a limited kind, located in terms of sexual display, appearance, and attractiveness. What the advert may offer for consumption is an ideal version of self. It also plays on women's pleasure in looking at attractive women. This kind of visual pleasure is inscribed in the image.

We may find many images of women unacceptable, glamourised, exploitative or whatever; but we cannot simply interpret women's pleasure in reading them as evidence for the extent to which the female consciousness has been colonised by patriarchy. We have to account for women's pleasure in looking at images of women.

The advertising image and the pornographic image offer different kinds of pleasure to their respective audiences. If audiences did not find them in some way pleasurable they wouldn't work; magazines and products wouldn't sell. It is their pleasurable associations which perpetuate them. But pleasure as a concept cannot be tackled in isolation, we need to understand how pleasure is produced through the structuring of power and sexuality.

## Towards a feminist erotica

One of the central objections put forward by feminists in their critique of pornography and other modes of representation is that it 'objectifies' women. Objectification has become a much abused term. There is a sense in which the process of sight and perception necessarily entail objectification in order to conceptualise and give meaning to the object of our gaze. Within

feminism, objectification has a quite specific meaning: through the process of representation, women are reduced to the status of objects. This is partly derived from a commonsense use of the marxist idea of commodity fetishism; images of women have become commodities from which women are alienated. Their status as commodity works to deny their individuality and humanity. The second sense of objectification which has informed its current usage is derived from Freud's concept of sexual fetishism: the idea that objects or parts of the anatomy are used as symbols for and replacements of the socially valued phallus. Hence, the argument goes, men have difficulty in coping with women's sexuality because of its castrating potential, and because of its lack of a phallus. In order to cope with this anxiety, men fetishise aspects of female sexuality – for example, the legs or breasts – as symbols of acceptable sexual power.

The use of the term 'objectification' is coupled with a tendency to interpret all forms of sexual symbolisation as evidence of sexual fetishisation. In the analysis of female imagery two processes of symbolisation are brought under closer scrutiny: that of sexual fragmentation and sexual substitution. Frequently these processes of metonym (where the part stands for the whole) and metaphor (where one object or aspect of the anatomy stands for another) operate together. For example, the depiction of female sexuality through the representation of a stiletto-shod foot isolates and fragments the sexual by focusing on a part of the anatomy and fetishises the foot by over-valuing it as a phallic symbol. Psychoanalytic interpretations of this kind of imagery have suggested that the stiletto as phallic symbol serves to 'give' the woman her missing phallus, thus circumnavigating the castration threat which she poses for male sexuality and rendering her safe.

Whilst this kind of analysis may provide an adequate interpretation of the dominant associations of stilettos in our culture, can we say that all forms of sexualised imagery can be interpreted in terms of phallic substitution? There exists a repertoire of conventionalised symbols which have become imbued with fetishistic associations of which the stiletto is only one example; but symbolisation is not a closed system of limited or fixed meaning. Symbolism is polysemic (has no one, fixed meaning); there always exists the possibility of powerful symbolism which works to activate forms of sexual expression which are not recognised by phallocentric interpretation.

Because fetishisation usually employs a fragmented image, there is a danger of assuming that all fragmentary images are necessarily fetishistic. The process of sexual fetishisation (specific phallic associations) is always complicated by that of commodity fetishisation, whereby the image of a woman's legs, for example, becomes isolated and estranged. They become a commodity, an object of display to be visually consumed by an audience.

What is at issue is not so much the perceptual processes of objectification and fragmentation which are a necessary part of rendering a complex world meaningful but rather the specific forms of objectification entailed in commodity and sexual fetishism. It therefore seems important to create a working distinction between the process of fragmentation, which implies a breaking up or disabling of the physical form, and what could be termed 'a pleasure in the part' – the pleasure derived from looking at a picture which depicts the curve of an arm or the sweep of the neckline. Such images could be interpreted not as a butchering of the female form but as a celebration of its constituent elements, giving a sense of the scope and complexity of sensual pleasure which breaks with specific genital sexual associations and with the necessity of overdetermining phallic substitution in the representation of the female form.

It seems that we have to clarify whether it is the process of necessary objectification entailed in perception which we object to (used, for example, whenever we look at the world, at art, at a book, etc.) or the meaning which it carries for women under specific patriarchal formations. These are two separate issues which tend to be collapsed into each other when feminists talk about the representation of women in art, photography, etc. To refuse to differentiate between the two modes of objectification is to endorse a kind of perceptual essentialism – that objectification is inherently exploitative and demeaning.

To see objectification in essentialist terms is to deny the possibility of any alternative practice within the representation of women. Feminists would be denied the possibility of visual communication and new forms of perception.

What is crucial is that existing theories of male power based on phallocentrism cannot provide a basis for the development of a progressive female sexual politics. One of the oppressions of patriarchy is to constrain female sexuality through a system of binary oppositions: e.g. masculine as opposed to feminine, passive versus active, emotional and sexual, sexual receptiveness as opposed to sexual drive, etc. This binary system works to perpetuate unacceptable ideologies about the nature of sexual relations. This means that feminist sexual practice cannot simply position itself in opposition to the dominant ideology. The kind of questions which it must ask have implications not only for what is meant by a representational system (and the part which it plays in structuring fantasy and the imagination) but also what is meant by power, sexuality and pleasure.

It is in terms of the pleasure derived from representational systems that we need to reintroduce a notion of the erotic. Within sexual politics we have to find a way of accounting for women's sexual attraction to each other; the visual pleasure of leafing through a glossy women's magazine; the appeal of the heroine

star systems, etc. Such pleasure cannot be simply dismissed as more evidence of patriarchal oppression, that women are continually gulled into a search for the ideal type simply to appeal to 'their man'. We cannot dismiss sexual attraction as further evidence of patriarchal mystification.

What we need to do is explore the ways in which female sexuality is marketed and represented. As I've tried to show with the help of two images, this representation is far from homogeneous. Nor can we assume a fixed meaning for an image with which we are familiar. Meaning is produced through the process of representation, the context in which an image appears, its mode of production and consumption.

I haven't attempted to problematise definitions of the pornographic and erotic which are historically and socially defined. At any one moment there will exist competing definitions: for example, those which exist within the feminist movement, as opposed to the liberal Williams lobby or the Whitehouse brigade. Rather than looking for any simple causal analysis we need to further our understanding of how the exercising of power produces forms of sexuality which work to structure the process of pleasure, fantasy and the imagination. Ultimately the distinction between pornography and other modes of sexual representation cannot rest on the characteristics of the image. The differences between pornographic vaginal imagery and medical vaginal imagery are learned through contextualisation: they are not innate.

In the reappraisal of our sexuality, there may appear to be an overlap between the kind of images designated as pornographic as opposed to erotic. This means that the exploration of female sexual pleasure through imagery will remain politically controversial.

*Some suggestions for the kind of questions which need to be asked when producing or appraising potentially progressive images of women:*
How is the image produced?
Whose fantasy is being recorded?
What power relationship exists in the photographer-model relationship?
How are models selected, what is their relationship to the overall production process?

*How will the image be distributed and where will it be circulated?*
The politics of distribution cannot be separated from those of production, nor of consumption. Where an image is distributed will affect who will see it, in what context, etc. It is obviously important to sort out whether an image is for private or public consumption, whether it will be seen in a gallery or a magazine, etc. It needs to be asked whether an image's validity or

'usefulness' depends on how an audience will use or interpret an image. For example, does the risk of appropriation by men invalidate producing erotic imagery for women? This risk could be countered by showing these images in, for example, *Camerawork*.

### Visual conventions of the image

How do we classify an image as erotic? What conventions and genres of representation does an image trade on?

To what extent does an oppositional system need to reuse and question familiar styles in order to go forward and create new meanings?

What are the signifiers of sexuality?

How do we recognise the gender of the subject?

In fact how important is the thwarting of easy gender assignment for erotic pleasure?

### The audience and pleasure

What kind of pleasures does an image offer its audience?

How is the sexuality and subject position of the audience constructed – are they sexed as male or female?

What kind of emotional responses does the image demand?

Does it demand any kind of audience interaction to interpret the meaning of the image? To what extent does the image challenge assumptions already held?

# SECTION FOUR

# New images for old: the iconography of the body

I am quite sure that the vitality of many female students derives from frustrated maternity, and most of these, on finding the opportunity to settle down and produce children, will no longer experience a degree of passionate discontent sufficient to drive them constantly towards the labours of creation in other ways. Can a woman become a vital creative artist without ceasing to be a woman except for the purposes of a census?[1]

Women have always been visible as objects within culture, but only rarely have they been acknowledged as subjects of cultural production in their own right. Thus while images of the female body abound in western art, the representation of female subjectivity, knowledge and experience is largely excluded from the same creative traditions. This makes any attempt by women to represent themselves doubly difficult. It demands a continuing movement between the criticism of existing imagery and the creation of new kinds of representation for women. Nowhere is this more important than when women intervene to change the conventions by which femininity is circumscribed and mapped out on the female body. The identification of the feminine with the biological nature of the body has always been a powerful argument for assigning women a negative role in the production of culture.[2] According to this view, women fulfil their creative role 'naturally' by having children, as the quotation above suggests, while men create art. It is against this context that feminist artists have claimed the right to speak about, and to see, women's experience differently. Using a variety of strategies, including celebration through symbol and myth, deconstruction of dominant visual codes, parody and role reversal, feminist artists have literally taken apart traditional ways of viewing the female body and tried to find new images and language with which to explore feminine identities.

The articles in this section include a mixture of writings by both artists and critics which illustrate various ways in which the problem of re-presenting the female image has been approached. They are not in any sense representative of all the issues and

critical debates, let alone the practices, within feminist art over the last fifteen years.[3] In recognising the range and diversity of feminist cultural production, my problem was one of deciding what to leave out. The final choice is intended to reflect a diversity of possible answers to a set of specific questions. Given the history of the female nude as erotic spectacle, can women find a new imagery for the female body which escapes oppressive codes of representation? If, as Lisa Tickner puts it in her article, the female body is 'colonised territory', can it be reclaimed as a site of different meanings and values for women? And is it ever possible for women to construct new identities for themselves without first destroying the old ones?

Claiming the right to see the past differently has been crucial to all oppressed groups, not only in order to recover traditions which have been misrepresented and rendered invisible, but to search for meanings and images which prefigure current concerns, albeit in fractured and contradictory forms. One important aspect of feminist cultural politics has been the renewed interest in work by women artists of earlier periods who, while usually working within the styles and conventions of their own time, can be seen to stand in a different relationship to contemporary discourses on femininity. I have chosen the pieces on Frida Kahlo, Tina Modotti and Suzanne Valadon to represent some of the possibilities which 're-viewing' women's art from a feminist perspective can bring. In various ways the work of these three artists represents the female body as a site of different meanings from those embodied in masculine iconographic traditions. In the 'classic' image of the nude the address to a male spectator is made explicit through the way in which the body is displayed, posed and formed for his aesthetic and erotic enjoyment. But when a woman artist paints or photographs the female body the potential for a different kind of looking is opened up. In my article on Valadon I have explored how women's pleasure in looking might be differently constructed from that of the male spectator. Laura Mulvey and Peter Wollen point to the ways in which the work of Kahlo and Modotti also changes how we are invited to look at the female body. But the traditional image of the female nude in fine art not only reinforces a view of women as erotic objects, it also helps to maintain an ideological fiction in which men are always seen as creative artists and women as their passive models. When women artists represent the female body they are thus challenging fundamental assumptions about the gendered nature of creativity.

For contemporary women practitioners, inheritors of feminism, the issues are more consciously posed and the answers even more diverse. Within a heterogeneity of cultural work, however, it is possible to identify particular themes and particular strategies which have characterised feminist representation. Women artists

in the 1970s began to explore those areas of female experience, such as menstruation and maternity, child care and domestic work, which have been denied autonomous expression traditionally within cultural forms controlled by men. While stress on the personal and subjective has been a central element of the ideology of art since Romanticism, women have specifically used their self-images to explore the relationship between personal experience and the *social* construction of femininity. What distinguishes feminist art is the attempt to find new ways of representing women's experience which challenge or subvert the cultural forms in which women are defined as subordinate. But just how this can be done has been a matter of some debate within feminist art practice and critical writing since the mid-1970s. These debates focus very directly on the problem of finding a visual language to represent femininity and female sexuality in new ways.

As Lisa Tickner outlines in her article, one strategy for women artists in the early 1970s was to develop a specific iconography of the feminine in order to celebrate female identity in positive ways. If the feminine is repressed and unrecognised in patriarchal culture, then could it be found in areas which lie outside the structures of male art and language? Some French feminist theorists have invoked metaphors of the female body: fluidity, closeness, diffuseness and touch, which they argue have the power to disrupt the rigid, distant, focussed and scopic order of masculine discourse.[4] Similarly the feminine body has been celebrated in women's art practices through an exploration of bodily processes such as menstruation, pregnancy and childbirth, and in visual metaphors for female sexuality. Most notably, imagery based on the vagina began to be used in order to challenge male representations of female sexuality and simultaneously to assert a specifically female centred subject matter. This was seen as the first step to a genuine female self-expression. Judy Chicago and Miriam Schapiro wrote in 1973:

> [To] be a woman is to be an object of contempt and the vagina, stamp of femaleness, is despised. The woman artist, seeing herself as loathed, takes that very mark of her otherness and by asserting it as the hallmark of her iconography, establishes a vehicle by which to state the beauty and truth of her identity.[5]

As Rozsika Parker shows, the attempt by artists like Suzanne Santoro to demystify and claim new meanings for the female genitals has met with outright hostility and censorship from the male art establishment, but it has posed problems for feminists too. This kind of imagery represents what has traditionally been denigrated or hidden as pleasurable and meaningful for women. It can thus speak directly to women's experience, but defines that experience as biologically rather than socially formed. By

focussing on the women's genitals, some have argued, vaginal imagery identifies women with their bodily functions, in a way which reaffirms reactionary and essentialist definitions.[6]

The idea of a feminine aesthetic which is based on female experience poses the concept of an authentic, uncolonised space outside of existing representations. Some feminists, like Lucy Lippard, argued in the 1970s that there were general aesthetic qualities which differentiated women's art from that made by men. These included certain formal characteristics such as a preference for centrally focussed and 'body-identified' images.[7] But while the art which is produced by women may be different from contemporary male art in particular respects, differences cannot be assumed automatically, they must be historically specified. While the vagina was hidden or tabooed its representation could be a powerful gesture of liberation and affirmation for women. But, with the circulation of increasingly explicit pornographic representations of the vagina, the meaning of vaginal imagery has been radically changed. It can no longer represent an authentic or uncolonised expression of female sexuality. Feminist artists who seek to transform the iconography of the body must do so therefore in recognition of the changing context in which their work will be read. As Gisela Ecker argues in *Feminist Aesthetics* it may be more useful to talk about a feminist, rather than a feminine, aesthetic, that is one which is developed consciously in the context of particular cultural politics and not simply 'given' by virtue of being a woman.[8]

From this position, many women artists working in the latter half of the 1970s in Britain and America explicitly rejected direct or symbolic representation of the female body, arguing that its meanings were already over-determined by multiple imaging in mass media and artistic tradition. As Mary Kelly put it:

> [It] seemed crucial, not in the sense of a moral imperative, but as a historical strategy, to avoid the literal figuration of mother and child, to avoid any means of representation which risked recuperation as 'a slice of life.' To use the body of the woman, her image or person is not impossible but problematic for feminism.[9]

If visual language inscribes women's image in certain fixed ways but always as spectacle for the (male) viewer, then the problem is not one of finding new ways to say 'woman', but of questioning language itself. Thus, the issues of language and meaning were central to the work of those artists who began to break down and expose the ideological workings of visual representation and its effects on the spectator. In Britain, Mary Kelly's own work perhaps represents this strategy most clearly.

In *Post Partum Document* she documented and analysed her relationship with her infant son over a period of four and a half years. Using multiple levels of text and imagery, the work

combined fragments of personal documentation: soiled nappy liners, the child's first letters, and diary entries, with an extended theoretical analysis based on Lacanian psychoanalysis, which together are intended to deconstruct the cultural, social and psychological meaning of motherhood. Instead of presenting a single female identity Kelly poses femininity as a complex production of social and cultural meanings which it is the task of the artist to deconstruct. The explicit purpose of such work is to disrupt the expected pleasures offered by the subject matter and its usual treatment in visual art, in order to engage the viewer in an active process of critically considering how such conventional meanings are made. Thus, rather than being offered a view of the artist's personal experience of motherhood, the viewer is forced to read this as part of an analysis of social and cultural discourses which define motherhood as a particular kind of experience for women. Any simple or easy access of the 'image' is refused, which has to be seen in the context of a dense and often difficult textual analysis.[10]

This strategy was characteristic of various kinds of feminist cultural work in the late 1970s. As Laura Mulvey put it with reference to film, the destruction of the spectator's pleasure was to be a radical weapon, and new visual forms would offer a different kind of engagement with the image. These ideas were developed from a modernist art practice which rejected illusionism, narrative and figuration in favour of an emphasis on materiality, process and the deconstruction of the image. By exploring the process of representation itself, it was argued, feminists could develop a strategy which challenged the ways in which mainstream media represented women. The viewer of the work would experience

> the thrill that comes from leaving the past behind without rejecting it, transcending outworn or oppressive forms, or daring to break with normal pleasurable expectations in order to conceive a new language of desire.[11]

These ideas have been extremely formative and influential in feminist cultural production and criticism. They do, however, present certain problems, not least because the thrill which Mulvey powerfully evokes was experienced more often by the artist or film-maker than by her audience. Audiences unfamiliar with modernist art practice were sometimes mystified, alienated or simply bored by it. This does not, I think, negate the validity of the work itself but does raise real questions about the relationship of feminist culture to a woman's audience, which have to be further explored. Very often, the starting point for this kind of practice was a critique of the notion that 'positive' images of women in feminist art simply could replace the 'negative' images of women in mainstream culture. This, it was argued, did not

207

take account of the way in which meanings are produced, nor of how women are formed and placed as subjects within culture. While agreeing with this general criticism, I would suggest that we need to look again at the value of positive and celebratory imagery. What kind of political meaning does such imagery have for women? And how can pleasure be used strategically to develop different forms of representation? What lies behind these questions is the sense of a cultural politics which, while recognising the need to challenge existing representations, also pays attention to women as audiences for, and consumers of, culture.

Greater attention to the way in which images produce meanings and address their audiences, as well as to the power of mainstream culture to recuperate radical content, has been recognised as crucial in recent feminist art practice. Work in the 1980s has also opened up wider possibilities of re-imagining feminine identity, for example through use of masquerade, myth and parody. While it is still difficult to see feminist art at all in Britain, some of these potential strategies could be seen in exhibitions such as 'Sense and Sensibility' at the Midland Group Gallery in Nottingham in 1982, in 'Pandora's Box' which toured the regions in 1984 and in 'The Thin Black Line' at the Institute of Contemporary Arts in London in 1985. This last exhibition of black women's art, one of several organised by Lubaina Himid, shows the importance of recognising a diversity of interests in feminist art work. Struggles by black women to be recognised as artists have been even greater than those of white women. Black women are subject to racist *and* sexist stereotyping which, as Himid suggests, can lead to their complete rejection by the white, male art establishment or else to a limited tokenism. Their work challenges those stereotypes and engages directly with the experiences and knowledge of black women. The issue of audience is a crucial one since work addressed to a black viewer's experience can be totally misread by white critics and audiences. This acknowledgement of differences amongst women, as well as shared meanings, raises important questions about whom feminist art speaks to, and in whose language.

These questions have also been addressed in part by those feminists who have chosen to work outside the institutions of fine art production and exhibition in areas of popular culture. The use of photography, of cartoons and of graphics has been seen as one way of communicating feminist ideas and imagery in forms which are more accessible to a wide range of women. For example, the explosion of cartoons with a distinctly feminist viewpoint and humour shows how visual images can be used to comment directly on women's oppression in popular ways (Figure 48). This feminist humour is never just a joke, since it subverts and disrupts male comic traditions based on the humiliation of

48 Angela Martin, Cartoon from *A Good Bitch*, The Women's Press, 1984.

women. Feminist cartoons can thus be seen as fulfilling the function of disrupting and transforming male culture, and at the same time speaking directly to women's knowledge and experience.

The strategy of disrupting and transforming visual discourse through parody and reversal has also been important for feminist photographers. The camera lens has been a central mechanism for controlling feminine appearance and defining women's bodies in terms of the erotic. It is therefore particularly difficult for feminists working in photography to 'speak' across the predominant representation of women as erotic spectacle. At the same time, photography's dual status both as commercial product and individually controlled practice means that it is an area where feminists can challenge dominant stereotypes, while using a familiar visual language. The work of photographers like Cindy Sherman in the USA and Jo Spence in Britain re-uses and disrupts the meanings of very familiar imagery from high art, cinema, glamour photography and the family album in order to parody and subvert media stereotypes. Jo Spence has used her own image to explore the way in which women are encouraged to see themselves in terms of 'ideal' types of girl-next-door, *femme-fatale* or dumb blonde. By 'playing' with self-images, it is possible both to overcome the split between the photographer/voyeur and model/sexual spectacle, and to suggest that femininity is a product of multiple and contradictory images. Rosy Martin's and Jo Spence's use of photography to explore and to imagine other possible identities for themselves shows one way of breaking down the barriers between 'fine art' and 'therapy' to develop a new kind of photographic practice. Their work is part of a broader photographic project which includes *A Picture of Health*, an investigation of the taboos, fears and silences which surround the treatment of breast cancer. Here the female body is represented as a site of struggle over definition within medical discourses on health and illness.

These few examples clearly do not exhaust the possibilities of feminist visual practice, but they do indicate some important ways in which feminists have attempted to change not only the visual codes of art, but the context in which representations of women are seen and used. After fifteen years in which many possible strategies have been explored, it seems particularly important that we maintain an openness to different kinds and levels of work. The development of popular cultural forms as well as fine art practices is essential if feminist representation is to challenge the dominant stereotypes of femininity *and* to mobilise new kinds of meanings and pleasures for women.

# Notes

1 Reg Butler, from a lecture given at the Slade School of Art in London, 1962. Reprinted in *New Society*, 31 August 1978, p. 443.

2 For a useful discussion of women's position in culture, see Sherry Ortner, 'Is Female to Male as Nature is to Culture?', in M. Rosaldo and Louise Lamphere (eds), *Women, Culture and Society*, Stanford, Stanford University Press, 1974, pp. 67-68.

3 For a comprehensive documentation of feminist art in Britain see Rozsika Parker and Griselda Pollock (eds), *Framing Feminism: Art and the Women's Movement 1971 – 1984*, London, Routledge & Kegan Paul, 1987.

4 These ideas are expressed in Luce Irigaray, 'This Sex Which Is Not One', and Hélène Cixous, 'The Laugh of the Medusa', both in Elaine Marks and Isabelle de Courtrivon (eds), *New French Feminisms*, Brighton, Harvester Press, 1981. The implications for developing a female aesthetic are discussed in the Introduction by Gisela Ecker (ed.), to *Feminist Aesthetics*, London, The Women's Press, 1985, pp. 15-22.

5 Judy Chicago and Miriam Schapiro, 'Female Imagery', *Womanspace Journal*, vol. 1, no. 3, Summer 1973, quoted in J. Chicago, *Through the Flower*, New York, Doubleday, 1977, pp. 143-4.

6 See Michèle Barratt in Rosalind Brunt and Caroline Rowan (eds), *Feminism and Cultural Politics*, London, Lawrence & Wishart, 1982, pp. 37-58.

7 J. Chicago, op. cit., pp. 141-2.

8 G. Ecker, op. cit., p. 21.

9 Mary Kelly, *Post-Partum Document*, London, Routledge & Kegan Paul, 1983, p. xvii.

10 The full documentation for the work is reproduced in Mary Kelly, *Post-Partum Document*, op. cit. Some critical responses to the work and its use of psychoanalytic theory are included in Rozsika Parker and Griselda Pollock, *Framing Feminism*, op. cit.

11 Laura Mulvey, 'Visual Pleasure and Narrative Cinema', *Screen*, vol. 16, no. 3, Autumn 1975, p. 8.

# The discourse of the body

Laura Mulvey
and Peter
Wollen

The art of both Kahlo and Modotti had a basis in their bodies: through injury, pain and disability in Frida Kahlo's case, through an accident of beauty in Tina Modotti's. Frida Kahlo sought an iconic vocabulary which could both express and mask the reality of the body. Tina Modotti, whose career began as a film-actress and a model, re-directed the look which had focussed on her outwards when she herself became a photographer. Kahlo's art became predominantly one of self-portraiture; Modotti's one of depictions of others – predominantly women, but seen with an eye quite different from the one that had looked at her.

Frida Kahlo had about thirty operations in the years between her accident in 1925 and her death in 1954. In the accident her spine was fractured, her pelvis shattered and her foot broken. For long periods she was bedridden, in pain and incapacitated. She was unable to have the child she desired and suffered miscarriages and medical abortions. In some respects her painting was a form of therapy, a way of coping with pain, warding off despair and regaining control over the image of her crushed and broken body (Figure 49). Painting brought pleasure, hope and power over herself. It made possible both a triumphant reassertion of narcissism and a symbolisation of her pain and suffering. She painted originally for herself and it was not really till Breton recognised the value and fascination of her work for others that she conceived the possibility of holding exhibitions and marketing the paintings.

The vocabulary which Frida Kahlo found and used was primarily that of traditional Mexican Catholic art, especially depictions of martyrdom and of the Passion. There is an explicit use of the imagery of the Passion: the wounds of the scourging and the crucifixion, the knotted cord, the ring of thorns, the simultaneous shining of sun and moon during the tenebrae. The style and iconography is that of popular baroque, in which intensity of expression is given precedence over beauty or dignity, and like most popular forms there is an archaic, almost mediaeval aspect to the representation, a love of minute detail, a disparity between foreground figure and background setting, a disregard for proportion and perspective. The graphic is systematically favoured rather than the perceptually realistic.

In particular, Kahlo uses the device of the 'emblem'. In *Henry*

From *Frida Kahlo and Tina Modotti*,
Whitechapel Art Gallery, 1982.

211

*Ford Hospital* her body on the bed is surrounded by a set of emblematic objects, like those surrounding the crucified Christ in an allegory of redemption. Emblems and attributes are graphic signs which carry a conventional meaning, often in reference to a narrative subtext (attributes) or a common set of beliefs (emblems). At times, Frida Kahlo used complex allegorical schemes, as in *Moses* (1945) with an idiosyncratic personal iconography. Through the resources of emblems, she was able to transcribe her physical pain and suffering into a form of graphic language, which could be read by the spectator. The appeal is not to an imaginary identification with herself as subject of pain but as a symbolic reading of herself as vehicle for suffering as in *The*

*Little Deer* (1946).[1] Hence the common reaction of horror rather than pity, itself associated more with 'low' than 'high' art.

Another mode of representing the body which she used was to draw detailed imagery from anatomical textbooks. Before her accident she had intended to study medicine and her injuries gave her a further reason for studying anatomy. Anatomical organs are often used as emblems – the bleeding heart of Catholic tradition, or the pelvis in *Henry Ford Hospital*. The accuracy of anatomical depiction contrasts with other stylistic aspects of her painting, drawn from an epoch and a *milieu* without precise anatomical knowledge. The effect produced is not only one of physical fragmentation and dislocation but also a kind of anachronism.

Beauty is another form of accident, one that is prized rather than feared. Yet it is one which can bring with it its own burdens. After her expulsion from Mexico, the ship on which Tina Modotti was deported docked in New Orleans and she was detained for eight days in the Immigration Station there. She wrote to Weston,

> the newspapers have followed me, and at times preceded me, with wolf-like greediness – here in the U.S. everything is seen from the 'beauty' angle – a daily here spoke of my trip and referred to me 'as a woman of striking beauty' – other reporters to whom I refused an interview tried to convince me by saying they would not speak of 'how pretty I was' – to which I answered that I could not possibly see what 'prettiness' had to do with the revolutionary movement nor with the expulsion of Communists – evidently women here are measured by a motion picture standard.[2]

Ironic, in a way, that this letter should have gone to Weston who did more than anyone else to promote and perpetuate the legend of Tina Modotti's beauty, both through his daybooks and through the photographs for which she was model, culminating with the famous series of her lying nude on the *azotea* in 1924. Tina Modotti also acted as a model for Diego Rivera when he was painting murals in the Agricultural College at Chapingo in 1926. Earlier she had been an actress – playing the fiery Latin vamp in early Hollywood westerns. When Tina Modotti herself became a photographer she photographed primarily women, but the contrast with Weston's approach could not be greater.

Weston became famous as a photographer of the female nude. He claimed that it was the formal quality of the shape of the female body which interested him and that any erotic motive (and there certainly was one, because he had affairs with the great majority of his models) was suspended in the photographic work. His particular form of voyeurism, of taking women as an object of gaze, was justified in the terms of pure aesthetic form. About the comments of others on the erotic quality of his work he wrote: 'Others must get from them what they bring to them: evidently

they do!'[3] implying also that an erotic interpretation might follow from the 'sexual suppression' he himself did not suffer from. The fact remains, however, that his nude photographs of Tina Modotti are often taken from above, looking down on her as she lies passively, sun-bathing or asleep, on the ground, in a conventional pose.

Tina Modotti's photographs were not of 'beauties' but of peasant and proletarian women, marked by the conditions of their life. Often they are mothers with small children, their bodies framed to emphasise not their own form but that of the interaction with the children (Figure 50). That is to say, they are represented in the process of activity and work, rather than isolated in a pose for the camera. The camera position is often below head height (it is only men who are photographed from above, partly to bring out the circular shape of their hat-brims). In her photographs of women especially the careful organisation

50 Tina Modotti, *Woman with Child*, n.d., Trieste, Comitato Tina Modotti.

of the composition is not allowed to over-ride the directness of the look.

For Frida Kahlo beauty was inextricably bound up with masquerade. In her self-portraits, whatever the degree of pain implied, by tears or even wounds, her face remains severe and expressionless with an unflinching gaze. At the same time the mask-like face is surrounded by luxuriant growth, accoutrements, ornaments and familiars – a monkey, a doll, a hairless dog. The ornament borders on fetishism, as does all masquerade, but the imaginary look is that of self-regard, therefore a feminine, non-male and narcissistic look. There is neither coyness nor cruelty, none of the nuance necessary to the male eroticisation of the female look. The masquerade serves the purpose of displacement from a traumatic childhood of the subject herself, ever-remembered, ever-repeated.

Throughout Kahlo's work there is a particular fetishisation of nature, an imagery of fecundity and luxuriant generation which is clearly a defence against her knowledge of her own barrenness, one of the products of her childhood accident. Veins, fronds and vines often merge with the body itself. There are three modes of self-portraiture: the body damaged, the body masked and ornamented, the body twined and enmeshed with plants. In some paintings even the rays of the sun are incorporated in the web. Fruit in still lives become parts of the body, flesh-like, or like skulls with vacant eyes. It is as though compensation for her barrenness, and a defence against trauma are condensed in pullulating images of cosmic and natural vitality sometimes counter-posed with images of barrenness itself, of lava rock and broken ligneous forms.

In a sense, nature is being turned into a complex of signs. Similarly the body itself becomes a bearer of signs, some legible, some esoteric. Masquerade becomes a mode of inscription, by which the trauma of injury and its effects are written negatively in metaphor. It is as if the intensity of the trauma brings with it a need to transfer the body from the register of image to that of pictography. Thus faces are read as masks, and ornaments as emblems and attributes. The discourse of the body is itself inscribed within a kind of codes of nature and cosmos, in which sun and moon, plant and animal, are pictograms. At the same time this pictographic effect de-eroticises the imagery.

Hayden Herrera, writing about Frida Kahlo, writes of 'her nearly beautiful face in the mirror'.[4] The aptness of 'nearly' carried with it a covert recognition of the overt ruin seen in *The Broken Column* against which beauty has been constructed as a defence. It is the artifice, the masquerade, which produces the uneasy feeling of slight mismatch between ostensible features and ostensible subject.

Tina Modotti, on the other hand, suffered from the inscription

of beauty on her body by others. It is somehow appropriate that while Frida Kahlo is remembered for her jewellery and her extravagant costumes, Tina Modotti is remembered as one of the first women in Mexico to wear jeans.

It is the discourse of the body, together with its political and psychoanalytical implications, which provides a continuity for us with Mexico between the wars. The history of art, as Viktor Shklovsky observed, proceeds by knight's moves, through the oblique and unexpected rather than the linear and predictable. If the art of Frida Kahlo and Tina Modotti has appeared to be detached from the mainstream this by no means entails any loss of value. In many ways, their work may be more relevant than the central traditions of modernism, at a time when, in the light of feminism, the history of art is being revalued and remade.

## Notes

1 The metaphor of the 'stricken deer' has a tradition in Mexican poetry. See, for instance, 'Verses expressing the feelings of a lover' by Sor Juana Inex de La Cruz (Juana de Ashaje 1651-1695):

> If thou seests the wounded stag
> that hastens down the mountain-side,
> seeking, stricken, in icy stream
> ease for its hurt,
> and thirsting plunges in the crystal waters,
> not in ease, in pain it mirrors me.

translated by Samuel Beckett, in *Anthology of Mexican Poetry*, ed. Octavio Paz, London, 1959. On the theory of the emblem, and Sor Juana's practice of it, see Robert J. Clements: *Picta Poesis*, Rome, 1960.

2 Letter from Tina Modotti to Edward Weston, quoted in M. Constantine, *Tina Modotti: A Fragile Life*, New York and London, 1975, p. 175.

3 *The Daybooks of Edward Weston*, Millerton, New York, 1961, vol. 2, p. 32.

4 Hayden Herrera, *Frida Kahlo*, Chicago, 1982.

Rosemary
Betterton

# How do women look?
# The female nude in the work of Suzanne Valadon

The representation of women in the visual media has become a crucial area of concern for the women's movement over the last few years. Most energies have been put, quite rightly, into countering the stereotyping and sexism of media images. Evidence of how wide such concerns have become is shown by the very useful booklet published by the Trades Union Congress, *Images of Inequality: The Portrayal of Women in the Media and Advertising*.

At a more theoretical level, a body of feminist work has been developed which analyses the position of the male spectator in relation to the female image as being one of power and control. This work has developed a powerful feminist critique of the ways in which women are represented in the visual media. It has constituted an important challenge to the notion that there can be a common experience of images across gender (and also race and class) divisions. However, an analysis of images which focuses exclusively on their relationship to a male spectator leaves certain problems unexplained and difficult to resolve. Centrally, it offers no explanation of how *women* look at images of women. It is this question which I want to develop here in two main ways. Firstly, what does it mean to look from a woman's point of view? And, secondly, how do women appear in images made by women?

The focus of the first part of the article will be on the question of spectatorship, both male and female, in relationship to representation of women's bodies. I want to argue that women can and do respond to images of themselves in ways which are different from, and cannot be reduced to, masculine 'ways of seeing'. The work of Suzanne Valadon (1865-1938) shows how a woman artist working within a male tradition of representation *could* produce images which disrupt the conventions of a genre. My starting point for looking at Valadon was a general interest in women artists working at the beginning of the century many of whom are perhaps known by name, but whose work is difficult to see either in reproduction or in exhibition.

This is a shortened version of an article which appeared in *Feminist Review*, no. 19, March 1985.

217

It was the discovery that she worked extensively on the female nude, a subject linked almost exclusively to male artists, which seemed to connect up with wider questions about the relationship of women to images of themselves. In particular it raised the issue of what kinds of pleasures are offered to women as spectators within forms of representation which, like the nude, have been made mainly by men, for men. If 'pleasure in looking is split between active/male and passive/female'[1] then how do I, as a woman, explain my enjoyment of certain images, especially within a category such as the nude? On what basis would it be possible to make critical distinctions between images which work for women and those which work against them?

In a culture where images of female sexuality are multiplied endlessly as a spectacle for male pleasure, there is a crucial political point in feminist arguments that *all* representations of the female body draw upon the same visual codes, and reinstate the same relationships of sexual power and subordination. No images can ever entirely escape the circle of voyeurism and exploitation which constitutes male power in representation. Even Valadon's nudes, whether flicked through in a book or hung on a gallery wall, are defined within a regime of looking which is oppressive to women. Such a view, however, although powerful and persuasive, seems unnecessarily pessimistic politically, and for reasons I indicate below, theoretically dubious. It is necessary to argue that some forms of representation *are* better than others, on the basis that they offer women images of themselves which are not humiliating or oppressive.

It also seems important from the point of view of feminist cultural production and criticism to begin to map out the shifts and changes within representations of the female body which might offer a basis for developing new kinds of imagery. It is a political project to search for and construct more positive images for women, as well as to denounce and deconstruct those which are limiting and oppressive. Feminists working in different areas of cultural production are developing strategies of intervention which have a critical function towards dominant stereotypes and also try to find and to develop new kinds of representation for women.

Female sexuality is clearly a problematic area of representation for women artists to work on, given the bias of western culture towards fetishizing the female body. The nude in art has been enshrined as an icon of culture since the Renaissance, and epitomizes the objectification of female sexuality. For both these reasons it is peculiarly resistant to change by women artists. Suzanne Valadon is unusual as a woman artist in taking the nude as a central theme of her work. Her work therefore poses some interesting questions about the relationship of women to a 'masculine' genre. Does a woman artist necessarily produce a

different kind of imagery from her male counterparts? Can a woman who is not a feminist produce work which is feminist? If the nude is embedded in a structure of gendered looking, based on male power and female passivity, is it possible for a woman artist to 'see' it differently?

I want to try to answer these questions by looking at those aspects of Valadon's experience as a woman and as an artist which made her relationship to the nude distinctly different from that of her male contemporaries. In her work, I will argue, we can see a consciousness of women's experience which challenges the conventions of the nude.

## Looking as a woman . . .

I want first to review briefly some arguments which have been put forward to explain the position of women as spectators and to account for women's pleasure in images of women. In most analyses, the position offered is a profoundly contradictory one for women. On the one hand, woman as spectator is offered the dubious satisfaction of identification with the heterosexual masculine gaze, voyeuristic, penetrating and powerful. This may offer the pleasure of power and control, but at the expense of negating women's own experience and identity. The problem with this is that it cannot offer any positive explanation of women's pleasure as *different* from male pleasure. On the other hand, it is argued, women's pleasure is bound up with a narcissistic identification with the image of female body, usually shown to be desirable but passive. This second explanation seeks to account for the frequency with which the female image appears, often semi-nude, in women's magazines and in advertising which is addressed specifically to a female audience.

The first explanation suggests that images of women are attractive because, as women, we are subject to socialization. We inhabit a patriarchal culture in which we, no less than men, are socialized into the acceptance of women's bodies as desirable and accessible. We are bombarded with images of style, glamour and seduction through magazines, adverts, cinema and television. No wonder these images become objects of fantasy and desire for us, too. No wonder they seep into our consciousness as models of what we really want to be. Recourse to the concept of socialization alone, however, can only provide a partial explanation. It cannot fully explain the different ways in which certain images affect us (Page Three Girl, no; Marilyn Monroe, perhaps . . .), nor on what basis we might make critical distinctions between different images. It also does not explain why women might respond to the same image in different ways. For example, while I am quite clear that my pleasure in a female nude by Valadon is greater than in one by Renoir, I certainly cannot

assume this to be true for all women. What makes the difference? Not socialization, but certain kinds of knowledge and experience, of which for me the most important is an awareness of feminist ideas.

Socialization can also suggest a particular notion of 'false consciousness' in which women, and men, are duped into a passive absorption of current ideologies of femininity, an acceptance of the status quo as given. This does not seem to accord with the reality of most women's experience of being confronted, at some moment in their lives, with a gap between the ideal image of femininity presented to them and their own less than ideal selves. Such awareness may lead to depression or to consciousness raising, but either way it suggests that the 'fit' between experience and ideology is never complete.

The other kind of explanation of women's pleasure draws upon the concept of narcissism. If the male look is characterized by voyeurism, observing and taking pleasure at a distance, the female look, it is claimed, is narcissistic, finding pleasure in closeness, in reflection and in identification with an image. Narcissism as a concept has a dangerous ambivalence for women, however. In popular usage, the myth of Narcissus who fell for his own reflection and pined away for love of it stands for unhealthy obsession with self-image. When transferred to women, it has traditionally been cited as a confirmation of innate frivolity and self-indulgence. (In medieval and Renaissance iconography women holding a mirror signified Vanity.) It therefore points to a kind of essentialism which has reactionary implications for women. But as Rosalind Coward has argued, women are in love with their own desirability for very real reasons:

> because desirability has been elevated to being the crucial reason for sexual relations, it sometimes appears to women that the whole possibility of being loved and comforted hangs on how their appearance will be received.[2]

It follows then that women will anxiously scrutinize images held up as ideals of femininity for signs that they can appropriate to themselves. But since there is usually a mismatch between ourselves and the images held up to us, the response cannot be one simply of pleasurable narcissism. The relation of women to their images is profoundly uncomfortable, a relation which, describing the negative sense women have of their own self image matched against the ideal, Coward terms 'narcissistic damage'.

The concept of narcissism has been deployed by some feminists, however, in an argument for a specifically feminine erotic experience. Luce Irigaray in 'This Sex Which is Not One' claims that the kind of look which separates the subject from the object of the gaze and projects desire on to that object is essentially masculine.[3] Female eroticism is bound up with touch

much more than with sight, women's pleasure being autoerotic. This, she argues, means that women have a problematic relationship with the whole process of looking in western culture. Women are bound within visual discourse to become objects and never subjects of their own desire. Since distance is an absolute condition of viewing and women's pleasure is autoerotic, any pleasure women have in the visual image is vicarious and even masochistic.

Irigaray, then, takes the idea of narcissism a stage further in suggesting women's pleasure in self cannot be mediated through the experience of other images. Her argument is problematic in that it posits an essential feminine erotic experience apparently outside cultural and social definitions. But what she does do is to offer an account of women's pleasure which is not bound within the parameters of male experience, and which is seen as distinctly different. This is important for any positive analysis of women's pleasure, though it needs to be explained as a *social* process rather than assumed as an essentially feminine characteristic.

So far I have written about a 'masculine' and a 'feminine' viewpoint as if these were unproblematically assumed by 'real' men and women whenever they look at an image. Both 'masculine' and 'feminine' are not essences, but social categories formed through changing social experiences. They are not only imposed from outside us, they are also experienced subjectively as part of our understanding of who we are. But in a patriarchal culture it is clearly the case that women are forced to adopt a masculine viewpoint in the production and consumption of images far more often than men are required to adopt a feminine one. Since gender relations are not equal, women, in looking at paintings or watching films, may indeed be placed in the position of adopting a voyeuristic gaze: but that position involves discomfort, a constant process of readjustment. For example, a woman looking at a nude could quite easily adopt a position of aesthetic detachment, since that is the way we are all taught to look at art in this culture. However, if she began to refer the image to her own experience of being treated as a sexual object (for example, of walking down a street past a group of staring men), the way she looked at the image could change her point of view.

In Mulvey's re-examination of the structures of spectatorship in cinema she develops the idea of the 'mobile' position of the female spectator. The woman watching the film is caught up in the pleasures offered by 'masculinization' but is unable completely to adopt a masculine viewpoint. Mulvey explains this mobility in Freudian terms. The woman is torn between the memory of her 'phallic phase' before the development of femininity, and her assumption of 'correct femininity' which demands that the active phallic phase be repressed: 'the female

spectator's phantasy of masculinization is always to some extent at cross purposes with itself, restless in its transvestite clothes.'[4] But I want to argue that this ability to switch points of view may be seen in a more positive way as opening up a critical space between a masculine or a feminine position and the actual experience of a woman watching a film or looking at a painting. We need to make a distinction between looking 'as a woman' and the fact of being one, between a feminine position and female experience.

In looking at a glamour photo or a nude it is possible to be both fascinated and attracted by the image, and *at the same time*, well aware of the difference between the image and our own experience: just as in reading a romance or in watching a melodrama one can be swept up by, and yet recognize, the seductive pull of fantasy. This suggests a certain ability to move between and to acknowledge different viewpoints at once, to look critically 'against the grain' while still enjoying the process itself. I am not arguing that this ability is innate to women by virtue of biological sex, but that it *is* a condition of women's viewing under patriarchy. Men too can look critically, but within forms of culture made for and by men they are less likely to be forced constantly to negotiate a viewpoint. Nor do I want to suggest that women automatically look in a detached and critical way. Looking (or producing) as a woman is dependent on a certain consciousness that such looking is, or could be, different from a masculine viewpoint. Such consciousness in turn depends on a recognition that women's social and cultural experience is itself differently arrived at. It also requires a consciousness that women's experience could be positive and productive, capable of giving voice and vision.

This enables us to ask what kind of imagery might be produced which *would* address women's experience. In the case of the nude, what kind of struggle over discourses of representation would signal an attempt to break with male iconography? In Suzanne Valadon's work precisely this critical space is opened up between the iconographic tradition of the nude and the representation of female experience. Her work is characterized by a certain tension between expectations set up by the genre and the way she actually represents the female body. This tension within the generic codes of the nude marks a point of resistance to dominant representations of female sexuality in early twentieth-century art. It may also account for some of the confusion of critics, who have described her work as both 'masculine' and 'feminine' (Figure 51).

A woman artist cannot be assumed to have 'seen' differently from her male contemporaries, but it can be argued that the particular force of her experience produced work which was differently placed within the dominant forms of representation of

51 Suzanne Valadon, *The Blue Chamber*, 1923, Paris, Musée Nationale d'Art Moderne.

her period. It is necessary therefore to look at how Valadon's background and position as a woman artist affected her representation of the nude.

## Artist as model

Suzanne Valadon worked for about ten years as a professional artist's model. This is significant for her own work as an artist and for the ways in which her subsequent identity has been established. Modelling in the late nineteenth and early twentieth centuries signified a particular relationship of artistic practice to sexuality. The period of Valadon's working life from the 1880s to 1938 saw the popularity of Bohemia as a central myth of artistic life. At its core was the relationship between the male creator and his female model. Alfred Murger's *Vie de Bohème*, published first as short stories and then in book form in 1851, set a pattern for fictional accounts of young artists and doomed models. Clearly part of the success of Bohemia lay in its mobilization of existing

ideologies of masculinity and femininity. In the artist-model relationship there seemed to be a 'natural' elision of the sexual with the artistic: the male artist was both lover and creator, the female model both his mistress and his muse. Some male painters explicitly connected their artistic powers with sexual potency. Auguste Renoir, for whom Valadon modelled in the 1880s, was alleged to have said: 'I paint with my prick.'

The connexions between phallic and creative power became a well-worn theme in the discourses of artists and critics of the period. This ideology is clearly restated in a book published in 1930 by C.J. Bulliet called *The Courtezan Olympia, an Intimate Survey of Artists and their Mistress Models*. The title neatly conveys the book's qualities of titillation and sexism:

> Genius is creative, and our guardians of morals, professional and amateur, rightly (even if ignorantly) sense a connection between the lusts of the body and this creative energy of the mind and emotions.[5]

The essential complement of the lusty artist was the female model, who was never seen as a contributor in the production of an image, but only as passive material to be posed and manipulated, subject to the transforming power of the artist. In popular myth, and sometimes in fact, the model's exploitation as the object of the artist's gaze led directly to her exploitation as his sexual object. In paintings of the nude by some modernist artists of the 1900s this connexion is represented explicitly, as for example in the various versions of *Artist and Model* by the German painter, Kirchner.

The fusion of the sexual and the artistic in ideologies of art production clearly created problems for a woman artist. Painting from the female model formed part of the definition of what it meant to be an artist, but at the same time it had come to signify a sexualized relationship. For a woman to become a 'serious' artist then, a transgression of contemporary ideals of femininity was implied: yet if she kept to the 'safer' subjects of domestic scenes, flower paintings or landscapes, she risked relegation to the secondary status of 'woman artist'. In Frances Borzello's study of the artist's model it is suggested that the normative value of the male artist/female model relationship was such that it rendered all other relations between artist and model deviant.[6]

But what of the ultimate 'deviation' – when both artist and model were female? The social relations of artistic production in the late nineteenth century still made such a relationship unlikely, however, despite the growing numbers of women entering the artistic profession in the 1880s and 1890s. In France the 'Union des Femmes Peintres et Sculpteurs' was founded in 1881 to promote the interest of women artists and support their demands for access to education and exhibition. Over a twenty-year period the Union fought for, and gradually won, rights to academic

training at the Ecole des Beaux Arts and finally in 1903, the right for women to enter the competition for the Prix de Rome, the height of an academic artist's aspirations.[7]

Such an entry into the art establishment and the right to be treated on an equal basis with male art students was important for the professional recognition of women as artists, even though academic honours were by then scorned by the avant-garde. Sources such as the painter Marie Bashkirtseff's diaries, first published in 1887, emphasize the conflict between middle-class femininity and the paradigm of artistic life. The respectability afforded by academic training did enable women to study the nude without loss of social position.

Although the classes for women were available in Paris, for instance at the Académie Julien where nude male models were used, painting from the nude must still have been a relatively rare experience for women before 1900. It has been taken for granted by most writers on women in art that institutional exclusion from study of the nude was damaging to women artists. But it is not clear what drawing from the naked body would have meant to a middle-class woman. What relationship could she have to the male iconography of the nude? Even viewed through the distancing veil of aesthetic values, the nude in painting was uncomfortably close to the sexually explicit discourses of pornography. The fact that both shared the same regime of representations meant that at any moment the image could become dangerously ambivalent, as did Manet's painting of *Olympia* in 1865. For a woman brought up within definitions of bourgeois femininity which tabooed the sight of her own body, let alone anyone else's, painting the nude must have been fraught with difficulty. Intervention in a genre bound up with the fundamental premises of male creativity involved problems far beyond institutional exclusion. It questioned the definition of femininity itself. It is therefore not surprising that few women artists working at the end of the nineteenth century made the nude a central theme in their work, despite increased access to life classes.

Yet Suzanne Valadon did just that. From her first drawings in the 1880s throughout her working life she produced images of the nude. What made this possible? The answer seems to lie in her background as a model which made her experience of art markedly different from the majority of both male and female artists. Her sexual identity was constructed outside bourgeois femininity and, by selling her body as a model, she entered the art world by an 'underground' route. Furthermore, her class background barred her from access to professional or academic training. As the illegitimate daughter of a part-time seamstress and cleaning woman, she occupied an extremely marginal position even within the working-class milieu of Montmartre.[8]

In the 1880s, the suburb of Montmartre was becoming a favoured area for artists looking for cheap studio space and picturesque views. Women in search of work stood in the Place Pigalle waiting to be viewed and picked out by artists in search of models. The parallels with prostitution are clear: a model also offered her body for sale, she was usually of lower-class origin and dependent upon her middle-class 'client', her rates of pay were low and established by individual negotiation. Even if a model led a blameless life, she was clearly defined outside the codes of respectable femininity.

By her own account Valadon was a very good model and extremely successful at it, and there is nothing to suggest that she felt exploited. But modelling placed her both outside the respectability which was still accepted by most women artists and at the opposite pole from their aspirations. She was situated between the harsh world of the exploitation of women's work in low-paid jobs, with prostitution as an alternative, and the Bohemian world of the artist. What made Valadon almost unique was her successful transition from one to another. This transition of Valadon's from model to artist was a hard process, both in terms of acquisition of technical ability and in the struggle to form a new identity as a professional artist.

In becoming an artist Valadon took on, and lived out, the characteristics of the male Bohemian stereotype: a succession of lovers, a scorn for money and a wild lifestyle. Yet it was not a role which, as a woman, she could inhabit without contradictions. This is evident in the complicated and difficult relationships she had with her mother and with her son, Maurice Utrillo, which created enormous tensions throughout her life. It is also evident in her work. While her early drawings used nude subjects, these were often based on her own body or that of her child. Her relationship to the nude therefore could not be the same as that of a male artist using female models, although she learnt to draw using conventions of representation common to artists of her period.

Her work was based on direct experience of the way her own body was used as a model, and it is clear from the self-portraits that she saw herself in an uncompromising and independent way. She is both subject and object, viewer and viewed, in her nude studies, in a way which begins to redefine and reconstruct the relationship of artist and model and, in turn, of spectator and image. Valadon's interest lies partly, then, in the way she combined roles of model and artist and by doing so disrupted the normative relationships of masculine creativity and feminine passivity. But she is interesting also because as a model she did not conform to the respectable image of the 'woman artist' and thus was able to work within the male-defined iconography of the nude. Valadon's disruption of those codes comes neither from a

conscious feminist perspective nor from mere circumstance, but from the consciousness which she developed as a woman who experienced different but overlapping definitions of femininity and masculinity, creativity and class.

## Model as artist

When Valadon began to produce her first drawings during the 1880s the academic tradition of the nude was already fragmenting. During her working life as an artist the formal conventions of art were radically transformed by the modernist aesthetics of the Parisian avant-garde. But as Carol Duncan has pointed out, the modernist 'break' did not challenge the ideological assumptions embedded in the representation of the nude.[9] The social and aesthetic radicalism of avant-garde artists did not necessarily imply a critique of existing gender relations. In the work of Picasso or Kirchner the theme of male sexual dominance and female passivity is reproduced in an even more explicit and violent way. Valadon's work has to be situated in a complex set of discourses of modernist aesthetics and more traditional ideologies of gender relations.

I want to draw out one strand which is relevant to Valadon's choice of a particular mode of representing the nude. This was the desire in the second half of the nineteenth century to represent the 'modern' nude, no longer veiled in history or mythology, but the woman 'as she is', seen on the modelling couch, in the studio and in a landscape. The notion of woman 'as she is' in itself signifies an ideological construction at work. In the bathers of Renoir, Degas and Cézanne and in Gauguin's women of Tahiti, for instance, can be seen the reworking of the powerful myth of woman as nature. The nude in landscape in particular came to signify an identification of women's bodies with the forces of nature. Women could be seen as 'naturally' representing fertility and unthreatening eroticism.

How do Valadon's drawings of the nude relate to this theme of the natural woman? Clearly she too was concerned to represent the modern nude, stripped of historical and mythologizing trappings. But her work departs significantly from the repressive connotations of the work of her male precursors and contemporaries. Her choice of theme – woman seen naked in the studio, in domestic interiors and in landscape – suggests that she should be placed with painters who sought to demystify the nude and develop new forms of realism. Yet in her treatment of the theme women are not shown to be instinctual and natural beings, but individuals engaged in social relationships and activities.

What Valadon tried to capture in her drawing was the intensity of a particular moment of action rather than a static and timeless vision. This suggests a conscious and deliberate attempt to

change existing codes of representation which, in the case of the female nude, emphasized beauty of form, harmony and timelessness. She chose in her portraits and nudes to show women caught in moments of action and engaged in relationships with each other. This choice was not governed by an uncontrollable emotional urge, as some of her biographers have suggested, but by a thorough familiarity with the work of contemporary artists, in particular Degas and Toulouse Lautrec. It was these two artists who recognized her drawing ability while she was still a model, and who encouraged her to exhibit her work in the Salon de la Nationale for the first time in 1894. Her work was shown alongside that of Degas and Lautrec in private galleries in the 1890s and 1900s, and after 1909 she exhibited regularly at the most important venues for modern art in Paris, the Salon d'Automne and the Salon des Indépendants. The social milieu she frequented included most of the leading members of the Parisian avant-garde. Such a position suggests that Valadon was quite familiar with current discourses on art and was capable of consciously transforming them.

A comparison between her early drawings and the work of Degas shows very clearly how she drew on his conception of the nude but fundamentally changed its character. Degas produced a set of ten pastels for the Eighth Impressionist Exhibition in 1886 on the theme of nudes at their toilet. According to Degas his intention was to show:

> a human creature preoccupied with herself – a cat who licks herself; hitherto the nude has always been represented in poses which presuppose an audience, but these women of mine are honest and simple folk, unconcerned by any other interests than those involved in their physical condition. . . It is as if you looked through a keyhole.[10]

His statement is interesting in two ways. Firstly, in the contradiction between his stated desire to represent the nude in a way which denies its traditional voyeurism and yet which reinstates voyeuristic looking in an even more intense way as if 'through a keyhole'. The body on display is to be replaced by peeping into the intimate and hidden world of women. Secondly, he reproduces precisely the ideology of women as nature, absorbed in their physical beings – like cats they perform purely instinctual and reflexive rites of cleanliness. In these images, then, the viewer is given a privileged access to a private, narcissistic moment: seeing a woman alone and caught unawares, intimately framed. Compared with the sensuous and intimate voyeurism of Degas, Valadon's drawings and pastels on the same theme look curiously awkward. Her women are seen usually in middle distance, isolated in space and uncomfortably posed. Rather than attributing this to lack of facility, it may point to a rather different treatment of the theme (Figure 52).

52 Suzanne Valadon, *Nude getting into the bath beside seated grandmother*, c. 1908, Paris, Collection Paul Pétridès.

In Valadon's drawings of women getting in and out of baths, drying themselves and getting dressed, the viewpoint is more distant and placed artificially high in the picture plane. The effect is to flatten and to distort space so that the spectator is offered no ideal viewing position from which to look at the nude figure of the woman. This distortion of form and flattening of space was part of modernist aesthetics, but as used by Valadon here, it disrupts the continuity between the viewer and the viewed, the illusion of a continuous space. But more than this, Valadon's use of the drawing medium alters the seductive quality of Degas' nudes. Where his pastel is soft and sensuous, suggestive of the softness of flesh or the blurring half-tones of shadow, Valadon's lines are abrupt, edgy and harsh, denying any erotic sensation. Degas himself acknowledged the difference in letters to his 'terrible Maria', written around 1900, when he refers to her 'wicked and supple drawings' which are 'drawn like a saw'.[11]

These differences in composition and technique are crucial to the very different experience which the viewer has in relation to Valadon's drawings as opposed to Degas' nudes. But the employment of modernist distortions and stress on the constructed nature of the image do not in themselves imply a radical change in the representation of the nude. Picasso, Matisse and others pushed those formal distortions much further in their versions of the nude, but could not be said to challenge its

voyeuristic premises. It is the combination of the visual style with the innovations Valadon makes in the iconography of the nude which makes her work specifically different. The naked woman is very frequently shown in a social relationship with another woman, often clothed and older, a servant or mother figure. Valadon used her own mother, as well as her son, friends and servants, as models for her drawings in the 1900s. Both figures are shown engaged in some activity which implies a moment in a series of relationships and activities, and also a kind of communication between the women. The experiences represented are familiar and banal ones, not mystified through representation into a timeless moment.

By doing this Valadon is not simply offering us another version of the nude, she is challenging a central truth which it embodies. This myth is of Woman who, changeless and unchangeable, is identified with her biological essence, identified with her naked body. One of the peculiar features of the nude in art from 1500 to 1900 is that it offers us a woman who remains essentially unchanged through a kaleidoscopic variety of sets and costumes, landscape or harem, Venus or prostitute:

> Thus against the dispersed contingent and multiple existence of actual women, mythical thought opposes the Eternal Feminine, unique and changeless.[12]

Valadon's nudes, in showing women's nakedness as an effect of particular circumstances and as differentiated by age and work, therefore challenge the idea that nakedness is essence, an irreducible quality of the 'Eternal Feminine'.

Taken as a sequence, Valadon's drawings from the 1890s and 1900s show a series of interactions between women and children. This theme of women's relationships is continued in her paintings, though more frequently here the naked woman is seen in isolation. Many show two women of different ages – as in the works on the theme of mother and daughter, *Little Girl at the Mirror*, 1909, and *The Abandoned Doll*, 1921 (Figure 53). In both paintings a naked adolescent girl looks at herself in a hand mirror, while in the second her mother gently dries her back with a towel, the abandoned doll lying at her feet. The two pictures together suggest a narrative of the onset of puberty and the girl's awareness of her own sexual being. In the earlier work the older woman shows the girl her reflection in an almost violent gesture. In the later picture the girl herself twists away from the mother, and while their poses echo each other, the physical contact between them is broken by their separate glances. In such works Valadon is questioning the dominant tradition of the nude as spectacle for the male viewer by focusing upon women's sense of the relationship between their state of mind and their experience of their bodies in processes of changing and ageing.

53 Suzanne Valadon, *The Abandoned Doll*, 1921.

In a series of paintings from the 1920s and 1930s she draws, in common with her contemporaries, on existing iconographic codes of the reclining nude, but her versions differ from theirs in the attention given to the individuality of the sitter. In some, women look discomforted by their nakedness, while in others they seem unaware of their bodies: but in either case, the viewer is made aware of the woman's face which is as strongly and individually delineated as her body. Some critics have noted that Valadon brings together the two separate genres of the nude and portraiture:

Everything is portraiture as far as she is concerned, and a breast, thigh, wrinkle are interrogated with no less attention than a facial expression. The models, often chosen for their ugliness, their commonplace nature – heavy breasts, sagging stomachs, wide hips, prominent buttocks, thick wrists and ankles – are depicted with a gift for individual characterization which we find in both individual and collective portraits.[13]

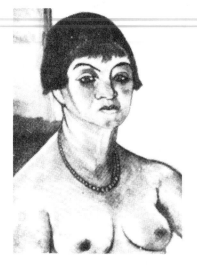

54 Suzanne Valadon, *Self Portrait*, 1932, Paris, Collection Paul Pétridès.

Dorival's comments are descriptively accurate while at the same time revealing his well-bred disgust for women who do not conform to the idealized, classless stereotype of the nude. Other male critics have found the stress on individual identities marked by class and age similarly difficult to take. One critic even accused Valadon of misogyny, of taking her revenge on women through a refusal to idealize their bodies.[14] Embedded within such critical confusions is the clear assumption that the aesthetic value of the nude is bound up with the sexual desirability of the model. Valadon's insistence on the individuality of her models, their differences in body size and shape, in age and in class, suggests relative indifference to conventional ideals of sexual attractiveness. Two of her own *Self Portraits*, painted when she was fifty-nine and sixty-seven respectively, show herself naked from the waist up, confronting the viewer with made-up face, jewellery and cropped hair (Figure 54). The painting shown in Figure 54 is disconcerting in its combination of self-image and nude form, and in Valadon's refusal to compromise with old age. Even more now than when it was painted, the image asserts the recognition of women's own view of their bodies against the tyranny of images of youth, beauty and attractiveness endlessly reflected in contemporary culture.

I am not arguing that more 'realistic' representations of women's bodies are necessarily better *per se*, but that Valadon ruptures the particular discourse of the fine art nude in which nudity = sexual availability = male pleasure. In doing so, she offers us a way of looking at the female body which is not entirely bound in the implicit assumption that all such images are addressed only to a male spectator.

## Conclusion

Valadon's representation of the nude can be differentiated in a number of ways from the dominant imagery of female sexuality current in fine art in the early twentieth century. Although she worked within the category of the 'modern nude', and at times reproduced elements of its essentialist ideology of woman as nature, her work taken as a whole significantly departs from the norm. In showing naked women as diverse individuals engaged in daily social activities, the nude's primary signification as a sexual

object for men is reworked as a site of different kinds of experience: of pleasure and embarrassment; of intimacy and sociability; of change and of ageing. In another way the formal characteristics of her drawing and painting deny the sensuous illusionism of the painted pin-up and render the woman's body less available to a voyeuristic gaze. If a male spectator's presence is always clearly signified in the traditional discourse of the nude, Valadon's work at least makes it more difficult for a male viewer to assume such a position unconsciously, as the comments of the male critics quoted above would indicate.

I do not want to suggest that Valadon's work should be retrieved uncritically, to be dusted off for feminist consumption. Her acceptance of male definitions of art is undeniable, and so too is her success as an artist within those definitions during her own lifetime. But what she did do was to open up different possibilities within the painting of the nude to allow for the expression of women's experience of their own bodies. Although she worked within the given forms of her own period, she redrew their boundaries in order to represent and engage with a woman's viewpoint. Her work shows that it is possible for women to intervene even within a genre which has such a powerful tradition of male voyeurism as the nude in painting.

Such attempts to re-present and re-imagine dominant iconographic codes are important for feminists now engaged in visual culture as producers and as critics. The transformation of existing codes and symbols is necessary because there is no alternative visual language readily available to express women's experience. But it is also important to recognize that such a transformation at the level of representation cannot be achieved without taking on problems of institutional change. So long as the practices of history, criticism, reproduction and publishing continue to marginalize, negate and isolate women's role in the production of culture, then we will continue to see their work in terms defined by a male critical tradition. In 'recovering' the work of a woman artist we can begin to challenge and oppose the sexist assumptions of dominant cultural discourses from a feminist critical perspective. In that sense, 'looking as women' not only means bringing different kinds of experience to the making and reading of images, it demands a conscious attempt to transform the conditions under which such images are produced, seen and understood.

## Notes

1 L. Mulvey 'Visual Pleasure and Narrative Cinema', *Screen*, vol. 16, no. 3, 1975, p. 11.
2 R. Coward, *Female Desire: Women's Sexuality Today*, London, Paladin, 1984, p. 78.

3 L. Irigaray, 'This Sex Which Is Not One' in E. Marks and I. de Courtivron (eds), *New French Feminisms*, Brighton, Harvester Press, 1981.

4 L. Mulvey, 'Afterthoughts. . . Inspired by Duel in the Sun', *Framework*, vol. 6, nos 15/16/17, 1981. The psychoanalytic implications of Mulvey's ideas of transvestism and the female spectator in cinema are taken up by Mary Ann Doane in 'Film and Masquerade – Theorising the Female Spectator', *Screen*, vol. 23, nos 3-4, 1982.

5 C.J. Bulliet, *The Courtezan Olympia, an Intimate Study of Artists and their Mistress Models*, New York, Covici Friede, 1930, p. 2.

6 F. Borzello, *The Artist's Model*, London, Junction Books, 1982.

7 J. Diane-Radycki, 'The Life of Lady Art Students: Changing Art Education at the Turn of the Century', *Art Journal*, Spring 1982.

8 In references to Valadon's life her mother, Madeleine, is frequently described as a laundress. A reason for this mistake possibly lies in the popularity of the laundress as a stereotype of female working-class sexuality in late nineteenth-century French culture. For further details see Eunice Lipton, 'The Laundress in Late Nineteenth Century French Culture: Imagery, Ideology and Edgar Degas', *Art History*, vol. 3, no. 3, 1980. Valadon herself becomes a stereotype of sexual promiscuity in many biographical accounts.

9 Carol Duncan, 'Virility and Domination in Early 20th Century Vanguard Painting', in Norma Broude and Mary D. Garrard (eds), *Feminism and Art History*, New York, Harper & Row, 1982. Modernist art movements in the 1900s were characterized by a rejection of the spatial illusionism, narrative and figuration of the European art tradition in favour of forms of art which used distortion of space and form and a greater degree of abstraction, and stressed the expression of subjective experience.

10 Royal Academy, *Post Impressionism*, London, Royal Academy, 1979, p. 64.

11 Robert Rey, *Suzanne Valadon*, Paris, Editions de la Nouvelle Revue Française, 1922, pp. 9-10.

12 Simone de Beauvoir, *The Second Sex*, Harmondsworth, Penguin Books, 1983, p. 283.

13 Bernard Dorival, *Twentieth Century Painters*, New York, Universe Books, 1958, pp. 34-5.

14 Jean Vertex cited in Jeanine Warnod, *Suzanne Valadon*, Switzerland, Bonfini Press, 1981, p. 73. No source given. An analysis of critical responses to Valadon's work requires a separate study in itself. Such comments reveal very clearly the patriarchal discourses of art history, which are incapable of dealing with women artists in other than stereotypical ways.

Lisa Tickner

# The body politic:
## female sexuality and women artists since 1970

The recent work of a number of women artists has taken as its starting point the human body. This paper is concerned to pursue some of the implications that arise from this; to suggest some categories for the material; and to investigate its significance in the light of Linda Nochlin's observation that 'The growing power of woman in the politics of both sex and art is bound to revolutionize the realm of erotic representation.'[1]

It does not appear to me possible, at the moment, to discuss the work of women in this field *without* sketching an outline of the many pressures and contradictions bearing upon it. These need to be discussed, firstly in relation to the tradition of western erotic art and the nude (man the maker and spectator, woman the passive object of desire);[2] and secondly in relation to the last phase of the feminist movement, beginning in the 1960s, with which women's body art has been largely co-incident.[3]

It is possible to divide the western tradition of erotic imagery, if not into two exclusive categories, at least into two polarities which might loosely be labelled the 'fantasist' and the 'realist'. In discussing the superior merits of Rops over Rowlandson, Huysmans also, by implication, defined the difference.

> It must be admitted, however desirable she may be, Rowlandson's woman is altogether animal, without any interesting complications of the senses. In short he has given us a fornicating machine, a substantial sanitary beast, rather than the terrible she-faun of Lust.[4]

The expression of erotic fantasy is characteristic of Romanticism and Decadence, but it is not to be exclusively identified with them. The images are frequently of woman alone (thereby isolating her into a more effective symbol); woman dominant over man or submissive to him; or woman masturbating or engaged in lesbian love-play. The images are usually in some way fragmented, distorted, or otherwise fetishized, and the range runs from the spied-on innocent (*Susannah and the Elders, Diana and Actaeon*), to the sexually conscious Fatal Woman who, as

From *Art History*, vol. 1, no. 2, June 1978.

Circe, Medusa, Delilah, Judith or Salomé, is perhaps the typical embodiment of the *genre*. Huysmans' 'interesting complications of the senses' have operated in different ways and on different levels in the work of artists like Fuseli, Burne-Jones, Moreau, Klimt, Munch, Beardsley, Lindner and Allen Jones, but the associations are generally those of violence, fear and death.

It is not difficult to see both the sadistic and the masochistic elements in this imagery as projections of male fantasies and fears, compounded by guilt or an exaggerated awe, and, in Freudian terms, these can be recognized as dependent on displaced castration anxieties and a repressed homosexuality. This aspect of the tradition emphasizes above all the *mystery* of woman (appropriately, in so far as she is the receptacle for those psychic forces and contradictions the artist does not understand): an enigma to be approached with fascination or with fear.[5]

The 'realist' aspect of the tradition, on the other hand, appears to pay more attention to Woman as sexual partner. Romano's *Aretino* prints, Rowlandson, Picasso, much pornography and otherwise 'underground' imagery depicting copulating couples seems to accommodate woman as an equal and even active partner in mutual sexual enjoyment.[6]

Such *apparent* openness about female sexuality should not, however, be mistaken for its direct expression. Such an image is also produced by a male artist for a masculine audience, and here too, as Berger had indicated, 'the spectator-owner will in fantasy oust the other man, or else identify with him'.[7] In coitus, the male is Everyman. Not so the woman, whose chastity has been prescribed by a patriarchal and Christian society, and who is at one and the same time the embodiment of virtue and the instigator and repository of sin. Erotic art is centred upon the depiction of Eve rather than Mary – the courtesan and not the wife – and this is emotionally the case even when the painting is nominally concerned with Venus, Diana, or the toilets of Bathsheba and Susannah. The wife and mother is erotic only in the context of an implied rape of domestic virtue (such as provides the *frisson* to all those Victorian caucasians in the barbarian slave markets).

Once we have questioned the *nature* of the woman who is a sexual partner, we can see that the 'realist' tradition, too, is often concerned in a subtler way with fantasy: with the dream of the unthreatening and sexually available woman. Female lust is insatiable and provocative, only in so far as that is arousing to masculine desire, and often only as a prelude to her submission before the phallus. Huysmans' 'fornicating machine, a substantial sanitary beast' is here no more attractive, or to women recognizable, a stereotype than the 'terrible she-faun of Lust'.

The conventions of the erotic tradition range from the plausible to the absurd, from the flattering to the misogynist, and

so, in a sense, inevitably cancel each other out. Surveying the images of women in Surrealist art, Xavier Gauthier concluded that she was both a symbol of purity and transgression, one and multiple, the embodiment of repose and movement, victim and executioner, the nourisher and the destroyer of man, his protector and his protégée, his mother and his child, sky and earth, vice and virtue, hope and despair, death and Satan.[8] What can we possibly deduce from this fact that she can be everything, but the knowledge that she is nothing? She seems everywhere present in art, but she is in fact absent. She is not the expression of female experience, she is a mediating sign for the male.

## Introduction to the work

It is clear that women's sexual roles and expectations have changed dramatically in the last 70 years, and that Freud, Kinsey and Masters and Johnson have all marked stages in the re-evaluation of female sexuality.[9] The greater social freedom for women which we have witnessed in the last 20 years or so is often attributed to the 'permissive society', which has been in fact as much effect as cause, and as much a curse as a blessing. It has sanctioned the increasingly public exploitation of female sexuality, especially in the areas of advertising and 'soft' pornography. Women's bodies are used to sell to men *and* women, who are thereby encouraged to collude in their own reification, and to identify with the characteristics of exhibitionism and narcissism. Through advertising and newspaper photographs the glamorized nude becomes accepted by both sexes as part of the natural language of the media.

It is now widely assumed that in the wake of these changes, women will find a cultural voice to express their own sexuality, and that in doing so they will add without modification to the existing tradition of erotic art and literature, thereby rendering it 'complete'. The fallacy here exists in the implication that there is a clearly defined male sexuality that can simply find expression and an already existent female sexuality that simply lacks it. Women's social and sexual relations have been located within patriarchal culture, and their identities have been moulded in accordance with the roles and images which that ideology has sanctioned. It will be necessary to differentiate between true and alienated desire. For the moment we should not be surprised to find that the much-vaunted collections of women's erotic fantasies are hauntingly familiar, and inclined to reflect traditional images of sexual relations between men and women. The most famous female erotic novel is, after all, the *Histoire d' 'O'*, Pauline Réage's account of masochism and submission, which ends with the heroine's masked entry to the ball, naked, and on a leash slipped around a ring through her genitals. Similarly, Nancy

Friday's *My Secret Garden* sets out to reveal 'a whole new realm of sexual experience', and yet the majority of the fantasies belong under the headings of exhibitionism, rape, masochism and domination, and lesbianism. We have, as Mary Ellmann wrote, accommodated our alienation; we are saddled with men's view of us and cannot find our true selves – in art, in literature or often in life. 'Those who have no country have no language. Women have no imagery available – no accepted public language to hand – with which to express their particular viewpoint,'[10] and so the problem is firstly to manufacture one out of the materials to hand, and secondly to decide on what is to be said.

Women artists *do* live in a culture still dominated by patriarchal values, but within this their experience of life – and eroticism – *is* differentiated from that of men. The double standard has distinguished their sexual roles on both the psychic and the social levels.

There *could* be no role-reversed equivalent to Degas' and Lautrec's brothel scenes, no 'keyhole' art recording the intimate and perhaps homosexual moments of the off-duty *male* prostitutes. It is at this moment impossible to imagine a woman artist in the situation of Picasso's late prints: 89-90 years old, recalling with affection and nostalgia both creative and coital moments from her youth. And what of the male muse, doubling as cook, housekeeper and emotional support system? What would be the iconography of Man where women made the imagery, what parallels or alternatives to the virgins and venuses, mothers and whores, *femmes fatales*, vampires and Lolitas with which we are familiar? Nor is there any parallel to the masculine preoccupation with the pubescent girl, which runs from Lewis Carroll to Balthus, Bellmer and Ovenden. Fantasies of seduction by other females are almost always written by men, where they are to be interpreted as thinly veiled allusions to the incestuous desire for the mother. Voyeurism, and even more fetishism, which have both provided the impetus for large quantities of erotic art and literature, are both rare amongst women.[11] The question is how, against this inherited framework, women are to construct new meanings which can also be understood.

Women's body art is currently to a large extent reactive, basically against the glamorous reification of the Old Master/ Playboy tradition, but also against the anti-academic convention in so far as that, too, continued to see the female body as a special category of motif.

Living *in* a female body is different from looking *at* it, as a man. Even the Venus of Urbino menstruated, as women know and men forget. Breasts, the womb, ovarian secretions, menstruation, pregnancy and labour, as de Beauvoir has reminded us, are for the benefit of others and not ourselves.[12] Woman is the natural prey of the species in a way which man is not, and these

experiences are perhaps closer to their re-expression in the work of Martha Wilson and Judy Clark, than to an eighteenth-century nude.

Given, as it were, this double alienation – the body as occupied territory in both culture and nature – women artists have only two consistent courses of action. One is to ignore the whole area as too muddled or dangerous for the production of clear statements; the other is to take the heritage and work with it – attack it, reverse it, expose and *use* it for their own purpose. The colonized territory must be reclaimed from masculine fantasy, the 'lost' aspects of female body experience authenticated and reintegrated in opposition to its more familiar and seductive artistic role as raw material for the men.

Paradoxically, then, the most significant area of women and erotic art today is that of the *de*-colonizing of the female body; the challenging of its taboos; and the celebration of its rhythms and pains, of fertility and childbirth. Narcissism and passivity must be replaced by an active and authentic sexuality, and we must cease to accommodate, in Ellmann's terms, the 'canopied bed' of our alienation.[13]

I have divided the work into the following categories, which are not of course mutually exclusive. Each could be substantiated by a quantity of material, but I have had to be highly selective in my examples.

1 the male as motif;
2 'vaginal iconology';
3 transformations and processes;
4 parody: self as object.

## 1 The male as motif

There was until the twentieth century no tradition, because no opportunity, for *women* to paint the male nude. The Surrealist artist Léonor Fini has done so, in ways that begin to prefigure more recent attempts, but her iconography remains largely dependent on that of the fatal sphinx-woman, and her power over the unconscious male. She is 'in favour of a world where there is little or no sex distinction',[14] but her view of woman is ultimately reactionary, since the femininity which she celebrates is an archetypal image of the Romantic movement: she accepts the definition of woman as 'other' and elevates it, without questioning the meaning of the sign.

Although she paints women and group portraits as well, Sylvia Sleigh is best known for her pictures of nude men, many of which invert famous examples of the female nude – such as Botticelli's *Venus and Mars (October)*; Ingres' *Turkish Bath*; and Velazquez' *Rokeby Venus (Philip Golub Reclining)*. The traditional references provide a degree of continuity with the past, but at the same time

they provide a witty and ultimately subversive reminder of the extent to which the values of that tradition are non-transferable, and of the modifications that she has chosen to make. One key distinction is that she combines the portrait genre with the nude, and her sitters are therefore highly individualized male friends rather than anonymous women.

*Philip Golub Reclining* depicts a dreamy adolescent boy in a typically 'feminine' recumbent pose on a satiny draped sofa (Figure 55). Behind him is the mirror in which the artist is reflected: a small but briskly energetic figure of indeterminate age, in contrast to his relaxed and expressionless, youthful passivity. Similarly, the *Double Image: Paul Rosano* accommodates the 'violence' that Berger suggests results from the substitution of a male for a female nude. The male/female clues are ambiguous, and the resulting sensuality of the body is therefore partly androgynous – graceful but with plenty of 'virile' body-hair; delicate features and a mass of carefully arranged hair but well developed genitals – in fact the back pose with its concentration on the configuration of bone and muscle and the potential energy in their tension is itself a contrast to the more languid passivity of the front.

Women generally like Sleigh's paintings, finding them both sensual and affectionate, and appreciating their solution to the 'problem of gentling the male without destroying his – at least potential – potency'.[15] Male reaction has been less favourable, and *Double Image* brought in hundreds of complaints when exhibited in 1975. 'Woman gets even by painting nude men'[16] ran a headline on another occasion; and yet Sleigh's paintings are chiefly remarkable for *transcending* such crude reversals, and since

55 Sylvia Sleigh, *Philip Golub Reclining*, 1971, New York, Lerner Misrachi Gallery.

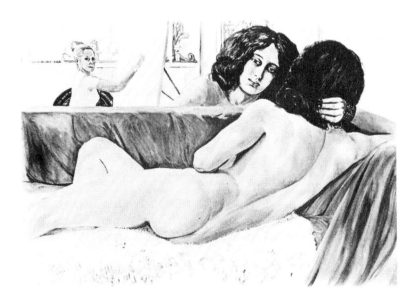

the subject is so uniquely 'present' in his portrait, the body, though celebrated, is not objectified.

Colette Whiten is a young Canadian artist who also uses men as part of her subject matter, but in a less traditional figurative fashion. She makes casts of men, but in a process which entails the construction of elaborate machines to hold them in place, the assistance of helpers at the casting itself is almost a 'performance' (certainly a rite), and the eliciting of 'testimonies' from the subjects.[17] Since the process demands an enforced passivity, and since the men have to be depilated and vaselined for it, and since once locked in the stocks they are dependent on female ministrations for sympathy, water and cigarettes, the overtones of erotic domination are extremely strong, and startlingly explicit. At the same time Whiten denies any conscious 'feminist revenge', the men are usually her friends and unpaid volunteers to the painful eroticism of the process (Figure 56).

Perhaps what these unlikely images of Sleigh's and Whiten's have in common is best summed up by the phrase which Joan Semmel used to describe her own paintings, 'sensuality with the power factor eliminated'[18] (or perhaps in Whiten's case, reversed). The same thing is true of Betty Dodson's copulating couples – the significance lies in giving back the woman her sexuality, her potency and her desires – and freeing those from the power relations of a patriarchal society.

Judith Bernstein's interest in phallic imagery grows out of a pre-occupation, first with calligraphy, and then with graffiti, which she pursued into the men's lavatories of the Yale Graduate

56 Colette Whiten, *Untitled I*, 1971-2.

art school. Her current work consists of huge and hairy charcoal drawings of punningly phallic, mechanical screws – monumental in scale but sensual to touch. What she seems to intend is the celebration but also the reappropriation for *women* of a heroic image, and its re-sensualizing for their pleasure. They are metaphors for women ready to acknowledge the masculine elements in themselves, and who are 'ready to admit things hidden for a long time – that they have the same drive, the same aggressions, the same feelings as men'.[19] This would seem to suggest an echo of Freud's concept of the libido as 'masculine' in men *or* women; and its reclamation – incorporating the masculine into our female creativity in the way in which male artists have popularly drawn on their 'feminine' sensibilities.

## 2 'Vaginal iconology'

Greer: 'Women's sexual organs are shrouded in mystery. . . . When little girls begin to ask questions their mothers provide them, if they are lucky, with crude diagrams of the sexual apparatus, in which the organs of pleasure feature much less prominently than the intricacies of tubes and ovaries. . . . The little girl is not encouraged to explore her own genitals or to identify the tissues of which they are composed, or to understand the mechanism of lubrication and erection. The very idea is distasteful.'[20]

The acceptance and re-integration of the female genitals into art has thus been a political, rather than a directly erotic, gesture. Like the associated violation of the menstrual taboo, it celebrates the mark of our 'otherness' and replaces the connotations of inferiority with those of pride. It is a category that promotes self-knowledge (like the self-examination health groups by which it has probably been influenced), and as Barbara Rose has pointed out, it refutes at least rhetorically both the Freudian concept of penis envy and the notion of women as 'The Dangerous Sex'.[21]

Judy Chicago and Miriam Schapiro have suggested an *unconscious* use of the 'centralized void' in female imagery, and have drawn on the work of O'Keefe, Hepworth and Bontecou amongst others in support of their case.[22] This has caused considerable controversy, and it is not altogether clear whether Chicago was insisting on such imagery as biologically innate (though often disguised to accommodate itself to the demands of masculine culture), or politically appropriate as a way of asserting femaleness in an area where it has conventionally been denied. East-coast feminists reacted strongly to the idea of womb-centred imagery as just the old-style biological determinism in a new guise (Figures 57 and 58).

But the point in either case is not only to 'express' femaleness in some nebulous fashion, but to redefine it, and this is where familiar symbols can be useful in the construction of new

57 Judy Chicago, *The Rejection Quintet: Female Rejection Drawing*, 1974, collection of the author.

58 Judy Chicago, place setting from *The Dinner Party: Virginia Woolf*, 1979, *photo* Beth Thelen.

meanings, particularly where they are used in association with less familiar attributes. In *Let it all Hang Out*, for example, Chicago aimed to express the ability to be feminine and powerful simultaneously;[23] but the problem here is to maintain the challenge, and not just rework an existing set of associations.

Shelley Lowell's *Rediscovery*, an apple with a vagina as its core, is a powerful image which celebrates a subject that is still largely taboo, and suggests through its title the feminist connotations of exploration, understanding and re-integration so important to Chicago. At the same time it evokes the old connections between women and delicious passive consumable, between female sexuality and the theme of temptation and sin, and arouses a very similar set of responses to those provoked by a Sam Haskins photograph of an apple/breast. It may have *intended* a reference to such visual puns, but the irony is double-edged, because the clichés are not challenged but indulged.

Betty Dodson is an erotic artist who has developed a positively missionary attitude towards masturbation as 'a meditation on self-love',[24] seeing it as the 'sexual base' from which women can achieve sexual and hence political liberation. Deciding that there was no contemporary aesthetic for the female genitals, she decided to help create one, and at the 1973 N.O.W. Sexuality Conference in New York she presented a series of slides: firstly of her earlier work; secondly of anatomical diagrams from medical and educational sources, frequently as ugly as they were incorrect; and finally pictures of the individuals in her own body workshops, their genitalia affectionately categorized as 'Baroque',

'Danish Modern', 'Gothic', 'Classical', 'Valentine'.[25] A thousand women, many of whom had never seen their own vaginas, let alone anybody else's, gave her a standing ovation.

Suzanne Santoro, an American living in Rome, has been similarly moved to comment on, and rectify the absence of, female genitals in masculine culture: 'When I saw how this subject had been treated in the past, I realized that even in diverse historical representations it had been omitted, smoothed down, and in the end, idealized'.[26] Santoro's intention in her book *Towards New Expression* is to find a way of 'understanding the structure of the female genitals' (when she had taken a cast of her own in 1970 she had been amazed by the very precise construction and form), and to produce 'an invitation for the sexual self-expression that has been denied to women till now, and . . . not . . . to attribute specific qualities to one sex or the other'[27] (Figure 60).

The Arts Council withdrew this book from their 1976 exhibition of 'Artist's Books' (for which they had originally requested five copies), 'on the grounds that obscenity might be alleged'.[28] They *did*, however, include Allen Jones' *Projects*, thereby inadvertently endorsing the views of Laura Mulvey[29] and Suzanne Santoro, that whilst the image of woman as fetishized object, repository for male sexual fantasies and fears, is 'acceptable' in our society, the image of the vulva itself which the fetish seeks to displace is 'obscene'.

Only in western culture, however, can the point be made and the image reinstated in this way. Nowhere has the vagina been depicted in *more* graphic detail than in the Vaginal Albums of the Japanese Ukiyo-e tradition. Many of these belong to the genre of the 'courtesan-critique' – guides to the famous courtesans of the day giving details of their beauties and faults, their location and price, and sometimes complementing a facial portrait with a genital one. If the vagina has been anaesthetized or omitted as part of the de-sexualizing of women and the fetishization of their image, then an emphasis on genital imagery as a parallel to women's reclamation of their sexual identity is fine. The implications are fairly clear. But if vaginal imagery, however beautiful, exists in this way within a male-dominated society – in association with the courtesan critique which identifies the woman with her genitals in a relationship of bought possession – that is another matter, and the symbol is not open to 'reclamation' as in the west.

## 3 Transformations and processes

Women are arguably closer to bodily processes and transformations than men: their physical cycles are more insistent, and they are used to treating their bodies as raw material for manipulation and display. Women are never acceptable as they *are*; as de Beauvoir has suggested, they are either the raw material for

their own cosmetic transformations, in which nature is present but fetchingly 'culturized', or for the artist's.[30] Alternatively, and at a deeper level, they (we) are somehow inherently disgusting, and have to be deodorized, depilated, polished and painted into the delicacy appropriate to our sex.

Investigating the make-up process is a way of re-investigating one's identity. Cosmetics pieces were fairly common in the early 1970s, and one of the first was *Lea's Room*, inspired by the bedroom in Colette's *Chéri* as 'the boundary of female life', which was part of the Cal. Arts Womanhouse programme. A woman dressed in pink silk and antique lace sat at a mirrored dressing table in an opulent, satiny and perfumed room, repeatedly putting on make-up, wiping it off in discontent, making up again. . . .[31]

The English artist Sue Madden, in planning a 'cleansing ritual', took as her texts Berger's comment on women as both the surveyor and the surveyed, and Robin Morgan's reference to 'Each sister wearing masks of revlon, clairol, playtex, to survive.' She intended to film 'removing rituals', plucking eyebrows, shaving armpits and legs, applying face packs and astringents – which she sees as activities 'which wipe away women's identity' – and by thus working through them to bring together the surveyor and the surveyed within herself.[32]

These examples, eccentric as they may at first seem, question the cost and the meaning of woman as sexual object in the world, in the same way as Sleigh's more artistically conventional paintings of male nudes foreground the issue of woman as object in art. They attempt the investigation of an identity which is assumed to be separate from, and hidden by, external appearance: Adrian Piper speaks of an 'awareness of the boundaries of my personality', and Antin of 'moving out to, into, up to, and down to the frontiers of myself'.[33]

Women who work directly *on* their bodies, not just to emphasize the transforming process but to make of that material 'art', are concerned with both issues – i.e. women are object in life *and* art – at the same time; and also with a conflation of the roles of the artist, the model and the work. Take for example Eleanor Antin's *Carving: a Traditional Sculpture*, which consists of 144 photographs of her naked body, front, back and both profiles, documenting a weight loss of 10 pounds over 36 days.

> This piece was actually done when the Whitney Museum asked me to tell them what I intended to have for one of the Annuals . . . since I figured the Whitney was academically oriented, I decided to make an academic sculpture. I got out a book on Greek sculpture, which is the most academic of all. (How could they refuse a Greek sculpture?)
> This piece was done in the method of the Greek sculptors . . . carving around and around the figure and whole layers would come off at a time until finally the aesthetic ideal had been reached.[34]

The other transformations are those of bodily processes, including ageing and decay (e.g. Athena Tacha's ongoing catalogue of the effects of time on her body);[35] and of a calculated disgust that is cultivated in defiance, and as an exorcism of the prescribed female role.

Betty Dodson feels that women will not live easily in their bodies until they have learnt not to suppress its less 'feminine' physical processes. It would be difficult to find a fuller expression of that, or a more extreme/satirical rejection of all veneer and polish than the *Catalysis* series of performances by Adrian Piper. In *Catalysis I*, for example, she 'saturated a set of clothing in a mixture of vinegar, eggs, milk, and cod-liver oil for a week, then wore them on the D train during evening rush hour, then while browsing in the Marboro bookstore on Saturday night'; and in *Catalysis V* replayed tape-recorded belches at full volume while researching in the Donnell Library.[36]

Menstruation has been so concealed as to *invite* the violation of the taboo[37] ('The blood jet is poetry/There is no stopping it' as Plath wrote) – partly for the sake of public recognition and re-assessment; partly as an emblem of celebrated femininity, the embracing of our inferiority; partly as the hinted at resurrection of ancient matriarchal powers;[38] and partly in reaction against what Ellmann has called 'the insistent blandness of modern femininity'.[39]

Menstruation images have been even rarer in art than in literature: in that form they can scarcely be discreetly alluded to, or veiled in metaphor. Judy Chicago's notorious *Red Flag* photo-lithograph, a self-portrait from the waist down showing the removal of a bloody Tampax, was made deliberately 'to introduce a new level of permission for women artists' and 'to validate female subject matter by using a "high art" process'.[40] (Cf. also the *Menstruation Bathroom* in Womanhouse, which set out to explore the dichotomy between the secrecy, the discomfort and the mess, on the one hand, and its gauzy packaged denial on the other.)

Gina Pane is a rare example of a woman body-artist who actually damages her own body. She talks a lot about 'reaching' people in an anaesthetized society, and she is prepared to suffer to do that, although she insists that she does not enjoy pain and is really an optimist. In a performance in May 1972 she had been cutting her back with a razor blade whilst turned away from the audience, when

> suddenly I turned to face my public and approached the razor blade to my face. The tension was explosive and broke when I cut my face on either cheek. They yelled 'no, no, not the face, no!' . . . The face is taboo, it's the core of human aesthetics, the only place which retains a narcissistic power.[41]

Except perhaps in the specific instance of what Barbara Rose first termed 'vaginal iconology',[42] it is impossible for women to assert their identity directly through their appearance. They already *have* a reputation for narcissism. Since women are not *expected* to be disgusting, the violation of certain established taboos, like that on public reference to menstruation, symbolizes a disrespect for the social order, and a rejection of the normal patterns of domination and submission which are enshrined within it. Vulgarity can be a means of enhancing dignity 'when the obscenities are merely signals conveying a message which is not obscene'.[43]

## 4 Parody: self as object

The following quotation from John Berger has already been mentioned by several of the artists discussed, and it is central to a consideration of the subject/object contradictions which face women working with the female body. This seems the moment to quote it in full:

> A woman must continually watch herself. . . . From earliest childhood she has been taught and persuaded to survey herself continually. And so she comes to consider the surveyed and the surveyor within her as the two constituent yet always distinct elements of her identity as a woman.[44]

Carolee Schneemann is an artist who has used her own body in her work, and appeared nude in performances of her own, Oldenburg's and others since the early 1960s. Personal, sexual and artistic freedoms are mingled in 'a determination to incorporate the nude body in all my work' – i.e. performance, film, paintings and collages.

> In some sense I made a gift of my body to other women: *giving our bodies back to ourselves*. The haunting images of the Cretan bull dancers – joyful, free, bare-breasted, skilled women leaping precisely from danger to ascendancy, guided my imagination. . . .[45]

a timely reminder that in rejecting men's view of us, we cannot afford to lose also an authentic joy in the very *real* pleasures of the body, particularly if by some such exorcism we can heal within ourselves the split between the surveyor and the surveyed.

Hannah Wilke's *Starification Object Series* includes a performance in which she provides the audience with bubble gum to chew, and then flirtatiously takes it back, forming it into tiny vaginal-like loops and sticking them in patterns over her naked torso. In the 1974 video *Gestures* she manipulates her flesh and features and converts her mouth into a vaginal metaphor by exposing its inner labial structure.[46] For Lil Picard's *Life Sculpture* she enacted the roles of sex kitten and Venus and ended her own *Soup and Tart* performance in a crucifixion gesture which, like the vagina/mouth metaphor, Penny Slinger has also used.

247

59 Lynda Benglis, Photograph of the artist, *Artforum*, November 1974.

Lynda Benglis is an established artist who has for some time divided her work between abstract, of sensual, poured-foam sculpture and more directly autobiographical and auto-erotic video pieces. In 1974 she deliberately parodied the still-bohemian image of the West Coast sculptor in four consecutive published photographs which appeared as exhibition notices and/or advertisements. The last, and most controversial, was a full-page colour advertisement in *Artforum*[47] showing an aggressively sexual image of a greased nude body with just a pair of sunglasses and a huge latex dildo as accessories (Figure 59). Benglis apparently intended it as a 'media statement . . . to end all statements, the ultimate mockery of the pinup and the macho'[48] (and the dildo image is a bizarre blend of the two). Reactions were mixed. A group of the editors condemned the advertisement as 'an object of extreme vulgarity . . . brutalizing ourselves and . . . our readers',[49] thereby playing into her hands by proving, according to the critic Lucy Lippard, 'that there are still some things women may not do. . .'[50]

At the same time those who claim an art form out of being 'intentionally' exploited like Cosey Fanni Tutti of the COUM group, or supplement their activities with the odd nude pose in *Knave* (Penny Slinger), shift the meaning of the work, however serious its original or possible intentions, from parody to titillation.

The depiction of women *by* women (sometimes themselves) in this quasi-sexist manner as a political statement grows potentially more powerful as it approaches actual exploitation but then, within an ace of it, collapses into ambiguity and confusion. The more attractive the women, the higher the risk, since the more closely they approach conventional stereotypes in the first place.[51]

It is difficult to see what the most useful conclusions might be, especially when we are so clearly in the *middle* of a process of change (and one which could yet be reversed). There are, however, a number of points to be made.

The female image in all its variations is the mythical consequence of women's exclusion from the *making* of art. It is arguable that, despite her ubiquitous presence, woman as such is largely absent from art. We are dealing with the sign 'woman', emptied of its original content and refilled with masculine anxieties and desires. Nowhere is this more evident than in the area of eroticism, and women see themselves reflected in culture as through a glass darkly.

Yet paradoxically the tool for objectifying their experience *is* culture, *is* the process which already distorts it and which is not itself value-free.

The only solution is to grasp and reconstruct it, through the exposure and contradiction of the meanings it conveys. We cannot pull out of thin air a new and utopian art – or a new and

utopian sexuality: both must be arrived at through struggle with the situation in which we find ourselves. Art does not just make ideology explicit but can be used, at a particular historical juncture, to rework it. There seems to me every reason to believe that feminism, and ultimately the overthrow of patriarchal values, will transform art in just as dramatic a fashion as the bourgeois revolutions.

In one way, women do not need to be 'sexually' liberated in order to produce erotic art, they need to be liberated into the art-making process itself – many of the reasons why they have not produced an erotic imagery being the same as those which have prevented them from making art at all. Desirable as the free expression of human sexuality may be, it is not *per se* a precondition for the making of art, or we might have had precious little of it; but the making of art *is* a precondition for the expression of even a confused or repressed sexuality such as Moreau's or Beardsley's. Both these questions have arisen simultaneously for women because broadly speaking they only entered art in large numbers at the same time as they sought to redefine their sexual relations, and for much the same reasons. They are able to express their sexuality only at the point of changing it, and it is from a restructuring of their sexual situation (bearing in mind that this is quite a different thing from generalized 'permissiveness'), that we may expect that revolution in the realm of erotic representation of which Linda Nochlin has spoken.

The process, here as elsewhere, is perhaps best seen as a dialectical one. The thesis is represented by the erotic art of a male-dominated culture, and the antithesis by women's current response to that – an attack on the patterns of dominance and submission within it, a rejection or parody of the standards by which women are judged sexually desirable, a repossession for our own use of the 'colonized' and alienated female body, and tentative steps towards the expression of a sensual appreciation of the male. The synthesis is yet to come, and apart from the fact that one obviously hopes for a truly androgynous human culture, and the kind of authentic erotic expression that would be its corollary; to discuss it at this stage would clearly be premature.

## Notes

1 Linda Nochlin, 'Eroticism and Female Imagery in Nineteenth-Century Art' in Thomas B. Hess and Linda Nochlin (eds), *Woman as Sex Object, Studies in Erotic Art 1720-1970*, Allen Lane, 1973, p. 15.
2 Basically, I am arguing from the premises of writers like John Berger and Linda Nochlin: that in the European nude, ownership is primary and the sexuality of the subject is not her own but that of the owner/spectator; and that the very term 'erotic' implies 'erotic-for-men', even (especially!) where the subject is lesbianism or female masturbation, in reflection of social and

hence cultural relations between the sexes. See, for example, Berger *et al.*, *Ways of Seeing*, BBC and Penguin Books, 1972, and Nochlin, op. cit.

3 Two aspects of this are particularly relevant here. Firstly a renewed interest in, and valuation of, female sexuality, with concomitant attempts to experience it as 'authentically' as possible; and secondly the emergence of a women artists' movement, emphasizing and encouraging the use of specifically female experience, especially the domestic and sexual, conventionally considered too trivial or inappropriate as creative material. It is perhaps worth emphasizing that these two aspects are linked not only in the feminist theory from which they derive, but also in the practice of many women making erotic art (for example in the expressive and therapeutic activities of Betty Dodson); and that such work is therefore at least as political as it is sensual in effect, and usually quite intentionally so.

Useful information on the genesis of the American women artists' movement is contained in Jacqueline Skiles and Janet McDevitt (eds), *A Documentary Herstory of Women Artists in Revolution*, revised 2nd ed., KNOW Inc., Pittsburgh, 1973. See also Lawrence Alloway, 'Women's Art in the '70s', *Art in America*, May/June 1976, pp. 64ff.

4 Huysmans, 'L'œuvre érotique de Felicien Rops', *La Plume*, no. 172, 15 June 1896, pp. 390-1.

5 Cf. Fellini's remark that women are 'the darkest part of ourselves, the undeveloped part, the true mystery within'. Quoted in Mary Ellmann, *Thinking About Women*, Harcourt Brace Jovanovich, New York, 1968, p. 22 (where she suggests that there is something 'digestive, even bilious, about this remark. . . .').

6 I regret not having space to do more than mention in passing Carol Duncan's stimulating essay on 'Virility and Domination in Early 20th Century Vanguard Painting', *Artforum*, December 1973, pp. 30-9. She suggests that the painting of the decade before World War I 'was obsessed with such confrontation between female nudity and the sexual-artistic will of the male artist'. Meanwhile the (female) nude remained the primal aesthetic 'object', partly out of habit and long tradition, and partly because it had become such a useful basic theme by which to practise a formal language or to authenticate a new and major statement. It permitted the display of dazzling variations precisely *because* it was otherwise such a conservative motif. Not wanting to invent his abstract shapes subjectively De Kooning used instead the substructure of a woman's body: 'I thought I might as well stick to the idea that it's got two eyes, a mouth and a neck'. (From an interview with David Sylvester, 30 December 1960, quoted in Thomas B. Hess, 'Pin Up and Icon' from Hess and Nochlin (eds), *Woman as Sex Object*, pp. 228-9.)

7 John Berger *et al.*, op. cit., p. 56.

8 Xavièr Gauthier, *Surréalisme et sexualité*, Editions Gallimard, Paris, 1971, p. 194.

9 At the same time that it has been deemed necessary to protect women from exposure to erotic material, they have paradoxically been assumed indifferent to it. Kinsey concluded (*Sexual Behaviour in the Human Female*, Saunders, 1953) that very few women had produced what might be called erotic figure drawing; that few were interested in graffiti at all, let alone explicitly sexual graffiti in the male vernacular tradition; that very little erotic literature had actually been written by them, although a large proportion purports to be; that they do not often use sexual material for masturbatory stimulation; and that female fetishism was extremely rare. He was, however, puzzled by curious inconsistencies – for example, women claimed to find erotic films *more* stimulating than men did – and these may well have been due to the breaking down of established taboos. More recent experiments have suggested that his results reflected in part what women felt they were *expected*

to experience, and also what they were prepared to reveal to interviewers. *The Report of the U.S. Commission on Obscenity and Pornography* (Bantam, 1970, p. 28) concluded that

> Recent research casts doubt on the common belief that women are vastly less aroused by erotic stimuli than are men. The supposed lack of female response may well be due to social and cultural inhibitions against reporting such arousal and to the fact that erotic material is generally oriented to a male audience.

One might also point out that there is no visual equivalent to the subtradition of explicit female eroticism in the Blues; e.g. Bessie Smith's 'I'm wild about that thing', 'You've Got to Give Me Some', and 'Empty Bed Blues'.

10 Linda Nochlin, op. cit., p. 11.

11 Since in strictly Freudian terms the male, fearing castration, sets up a fetish that will substitute for the 'missing' phallus of the woman, it is not surprising that, because women are already 'castrated', fetishism among women is extremely rare. However, although schematically we would therefore *not* expect to find it in quite the same way, it does seem possible that – perhaps through male identification – some women might at unconscious levels hallucinate the phallus and embody it in a fetish. It remains unlikely that a woman artist would produce any real equivalent to the fetishistic imagery of Allen Jones, except for purely political purposes. Nancy Grossman has perhaps come the nearest; see Cindy Nemser, *Art Talk: Conversations with 12 Women Artists*, Charles Scribner, New York, 1975, pp. 327-46, for a useful interview.

12 Simone de Beauvoir, *The Second Sex*, Penguin, 1972, p. 64.

13 Mary Ellmann, op. cit., p. 199.

14 Leonor Fini, quoted in Constantine Jelenski, *Leonor Fini*, La Guilde du Livre et Clairefontaine, Lausanne, 1968, p. 15.

15 Linda Nochlin, 'Some Women Realists. Painters of the Figure', *Arts Magazine*, May 1974, p. 32.

16 *Feminist Art Journal*, Spring 1975, p. 36, and headline from an unidentified Washington newspaper cutting, in the collection of Ms Sleigh (1974).

17 John Noel Chandler, 'Colette Whiten: her working and work', *Artscanada*, Spring 1972, pp. 42ff. and Connie Hitzeroth, 'Colette Whiten', *Artscanada*, May 1973, pp. 45-9.

18 Joan Semmel, quoted in Dorothy Seiberling, 'The Female View of Erotica', *New York Magazine*, February 1974, p. 55.

19 Cindy Nemser, 'Four Artists of Sensuality', *Arts Magazine*, March 1975, pp. 73-5, and also *Feminist Art Journal*, Spring 1975, p. 49 – brief notes by Rose Hartman, referring to the Philadelphia Civic Centre's refusal to show Bernstein's work in the Focus exhibition. The director John Pierron excluded and dismissed her work as 'simply a penis without redeeming social value'.

20 Germaine Greer, *The Female Eunuch*, Paladin, 1971, p. 39.

21 Barbara Rose, 'Vaginal Iconology', *New York Magazine*, February 1974, p. 59. Perhaps by implication this category also rejects the idea that phallic energy is required in Mailer's assertion that 'a good novelist can do without everything but the remnant of his balls', and the claim variously attributed to Van Gogh, Gauguin or Renoir: 'I paint with my prick'.

I have kept Rose's rather loose and general application of 'vagina'; the proper distinction between internal vagina and external vulva is increasingly blurred in non-medical writings.

22 See Judy Chicago and Miriam Schapiro, 'Female Imagery', *Womanspace Journal*, vol. I, no. 3 (Summer 1973), pp. 11-14; and Judy Chicago, *Through the Flower*, Doubleday, 1975, pp. 142-4.

23 Judy Chicago, *Through the Flower*, pp. 181-2:

I had never seen those two attributes wedded together in an image. I felt ashamed – like there was something wrong with being feminine and powerful simultaneously. Yet I felt relieved to have finally expressed my power. I could never have shown it comfortably if it were not for the growing support of the female art community.

24 Betty Dodson, *Liberating Masturbation: A Meditation on Self Love*, Bodysex Designs, New York, 1974.

25 Ibid., pp. 25-7.

26 Suzanne Santoro, *Per Una Expressione Nuova/Towards New Expression*, Rivolta Femminile, Rome, 1974 (Italian and English text), un-numbered pages.

27 Ibid.

28 Robin Campbell quoted by Roszika Parker in 'Censored', *Spare Rib*, January 1977, no. 54, p. 44.

29 See Laura Mulvey, 'You don't know what is happening do you, Mr Jones?', *Spare Rib*, February 1973, no. 8, pp. 13-16.

30 Simone de Beauvoir, *The Second Sex*, Penguin Books, 1972, pp. 190f.

31 Lucy Lippard, *From the Center. Feminist Essays on Women's Art*, E.P. Dutton, New York, 1976, p. 129; and Judy Chicago, *Through the Flower*, p. 162.

32 Rosie Parker, 'Housework', *Spare Rib*, no. 26, p. 38.

33 Quoted in Lippard, op. cit., p. 105. One might add to her examples of 'expanding identity', Carolee Schneemann's *Up to and including her limits* – an 8-hour performance work with film and video presented at the Berkeley Art Museum in April 1974, and subsequently self-published as a book, 1975.

34 Cindy Nemser, *Art Talk: Conversations with 12 Women Artists*, p. 281.

35 Lucy Lippard, op. cit., p. 130.

36 Adrian Piper, quoted in Lippard, op. cit., p. 167.

37 The aspects of shame and pollution survive in a rich variety of menstrual euphemism (those used by women tend to be coy, those used by men tend to be sexual and derogatory); in varying degrees of commitment to the traditional taboos on swimming, bathing and intercourse; and in the advertisements for sanitary aids which perpetuate the embarrassment in order to reassure women that their products will minimize the humiliation. It is interesting to note that amongst a wealth of public sexual imagery, advertisements for sanitary protection are prohibited by the IBA, in part because of the public outcry that greeted a discreet experiment several years ago. The only exceptions are a few pilot advertisements on selected radio stations, carefully vetted for 'tastefulness' and subject to timing restrictions. A similar American ban was lifted towards the end of 1972.

38 E.g. Mary Beth Edelson's *Blood Mysteries*, which invited the direct participation of women in the sharing and reworking of menstrual experience. The figure of a powerfully built nude woman with a circle around her abdomen and flowing hair around her head, was drawn on the wall above a real wooden box with four compartments: *Menstruation Stories*, *Blood Power Stories*, *Menopause Stories*, and *Birth Stories*.

39 Mary Ellmann, op. cit., p. 142.

40 Judy Chicago, op. cit., pp. 135-7.

41 Gina Pane, interviewed by Effie Stephano, *Art and Artists*, April 1973, p. 23. See also Lucy Lippard, 'The Pains and Pleasures of Rebirth: Women's Body Art', *Art in America*, May/June 1976, pp. 73-81. Reprinted in *From the Centre*, op. cit.

42 Barbara Rose, op. cit., p. 59.

43 Shirley Ardener, *Perceiving Women*, Malaby Press, 1975, p. 47.

44 John Berger *et al.*, op. cit., p. 46.

45 Carolee Schneemann, *Cézanne she was a great painter*, The Second Book, January 1975, Tresspuss Press, p. 24; 'unbroken words to women – sexuality creativity language art istory' (*sic*).

46 Lucy Lippard, op. cit., p. 135. See also Cindy Nemser, 'Four Artists of Sensuality', *Arts Magazine*, March 1975, *passim*.
47 *Artforum*, November 1974, p. 5.
48 Lynda Benglis quoted in Lucy Lippard, op. cit., p. 105.
49 Ibid., p. 104.
50 Ibid., p. 127.
51 There are still very few ways in which a woman is as *unequivocally* appreciated as she is for her physical and sexual beauty – or can earn as much as the £60,000 for an advertisement claimed by Farrah Fawcett-Majors. There is very little self-parody to be found in that.

Rozsika Parker

# Censored:
## feminist art that the Arts Council is trying to hide

There is increasing media uproar over whom the Arts Council chooses to support, but not surprisingly we hear few complaints about the Arts Council's censorship.

Press attack on public patronage began in London in summer 1976 with Carl Andre's bricks at the Tate Gallery, continued with Mary Kelly's *Post-Partum Document* at the Institute of Contemporary Arts in October and reached a crescendo the following month with Coum's exhibition *Prostitution*, also at the ICA. Taxpayers' money, we are told, was being spent on dirty nappies, Tampax and pornography. Attention was briefly diverted from the cuts and the falling pound by self-righteous articles trivialising the artist's intentions instead of trying to explore the relationship between art and audience. But at least we were able to look at the artists' work and draw our own conclusions. Not so with Suzanne Santoro's art. The Arts Council decided to suppress her book *Towards New Expression* (Figure 60). Selection is sometimes necessary but on what grounds?

The story began in February, when the organisers of an Arts Council touring exhibition of books made by artists rang *Spare Rib*. They had been impressed by feminist artist Suzanne Santoro's book and wanted to include it in 'Artists' Books'. Could we supply her address?

Soon afterwards Suzanne, an American living in Rome, received a letter saying that her book was wanted for the show and the organisers 'must have five copies by mid-February'.

Suzanne was in England when 'Artists' Books' opened at the ICA in August. Arriving at the exhibition, she noted that her book was entered in the catalogue as Number 103. She browsed through the show – out of the 119 books by individual artists, only ten were by women – but she couldn't find her book. There was no Number 103. Her work had been excluded though it had originally been selected and entered in the catalogue.

Suzanne's sparse, carefully produced, black and white volume was published by the Italian women's liberation group Rivolta

From *Spare Rib*, no. 54, January 1977.

60 Suzanne Santoro, *Towards New Expression*, Rome, Rivolta Femminile, 1974.

Feminile. Suzanne is one of a number of women artists whose work is based on images of women's genitals. For example, there's Ann Severson's film *Near The Big Chakra*, and Judy Chicago's work in paint and porcelain.

For most feminists vaginal imagery signifies a rejection of images by men of women, and an exploration and affirmation of their own identity. It attacks the idea of women's genitals as mysterious, hidden and threatening, and attempts to throw off a resulting shame and secrecy. Suzanne begins by demonstrating

the way women's genitals have been portrayed in the history of art – 'annulled, smoothed down and in the end idealized'.

Suzanne established herself as an artist in the 1960s. Her art was taken seriously, she was professionally successful. 'I built huge things out of rope. I did a lot of heavy, difficult sculpture. I worked with sheet metal and things like that,' she says, 'then I got involved with feminism – with a group called Rivolta Feminile. For three years we talked about sex.'

It was in 1970. In Italy the debate over vaginal and clitoral orgasm was well underway. Suzanne reacted as a person working with shape and form: 'I had never really looked at myself, so I decided to take a cast of myself. We were learning how important it was for women to know how they were made. I took a cast and I was amazed by the structural solidity of it – the very precise construction and form.'

She went on to photograph genitals and in *Towards New Expression* she juxtaposes the photographs with illustrations of flowers and shells. The photos are a refined examination of structure, desexualised and isolated in the centre of a blank page.

She carefully points out that the juxtaposition of flowers, shells and genitals is not intended to confirm the old identification of women with nature as against culture. She writes: 'The placing of the Greek figures, the flowers and the conch shell near the clitoris is a means of understanding the structure of the female genitals.' And she adds: 'I just wanted to make the point that I had found structural identities, not symbolic identities.'

In *The Second Sex* Simone de Beauvoir underlines the importance of knowing the structure: 'The feminine sex organ is mysterious even to the woman herself ... Woman does not recognise herself in it and this explains in large part why she does not recognise its desires as hers.'

Similarly, Suzanne sees demystification as a pre-requisite for sexual self-expression: 'The placing of the flowers and the conch shell near the clitoris ... is also an invitation for the sexual self expression that has been denied women till now,' and which, she believes, leads to greater self knowledge in other areas of our lives. 'Expression begins with self assertion and the awareness of the difference between ourselves and others.'

By 'expression' she means creative or artistic self-expression. The whole book condemns the image of women in art which damages our ability to see ourselves as creative people. The female nude – passive, available, devoid of individual desires, her body a blank canvas for men's creativity – is a major subject of art in our culture. And it's easy to take the image at face value and believe we're destined to be always the model and never the maker. Suzanne concludes: 'We can no longer see ourselves as if we live in a dream or an imitation of something that just does not reflect the reality of our lives.'

In Italy Suzanne's work has been widely exhibited and discussed. Some women feel that isolating a woman's genitals confirms the split between sexuality and other social relations. Others feel that we have been identified for too long by our biology, and even though Suzanne is using a biological/natural imagery to criticise the way we've been perceived in the past, it's dangerously open to misunderstanding.

She has received criticism but never censorship. *Spare Rib* asked the Arts Council why they'd suppressed *Towards New Expression*. 'On the grounds that obscenity might be alleged,' replied Director of Art Robin Campbell. 'We are willing to defend obscenity on the grounds of artistic excellence but considered that in this case the avowed intention of the book was primarily a plea for sexual self expression.'

But if it was not considered artistically excellent, why, we wonder, was it selected for the show in the first place? And what sort of 'obscenity' is the Arts Council prepared to defend? The answer is women used, women subjugated, women on display – in other words, Allen Jones' *Projects*, which did appear in 'Artists' Books'.

*Projects*, his second book, records sketches and concepts for stage, film and TV shows, including *Oh Calcutta!* and Kubrick's *Clockwork Orange*. It's all there – the shiny cat suits, bare buttocks and leather. But something is missing, as Laura Mulvey showed in her psychoanalytic interpretation of the book: 'Although every single image is a female form, not one shows the straight female genitals. Not one is naked. The cunt (yoni) is always concealed, disguised or supplemented in ways which distract attention from it.'[1]

Laura maintains that Allen Jones' work expressed the castration fears that women arouse in men. 'It is man's narcissistic fear of losing his own phallus, his most precious possession, which causes shock at the sight of the female genitals and the fetishistic attempt to disguise or divert attention from them.'[2]

'Fetishism,' she explains, 'involves displacing the sight of women's imaginary castration onto a variety of reassuring but often surprising objects, shoes, corsets, rubber goods, belts, etc., which serve as a sign for the lost penis.'[3]

Hence Allen Jones equips his women with phallic substitutes such as whips, high heels, or actually turns them into phalluses: 'The body unified to a maximum, rigid whole in shiny rubber.' Laura concludes: 'Women are simply scenery onto which men project their narcissistic fantasies. The time has come for us to take over the show and exhibit our own fears and desires.'[4]

Suzanne is trying to do just that. But the establishment isn't giving in easily. She's left talking to herself and we are provided with another example of the way women vanish from culture. Some years ago Suzanne said, 'As a child I used to go to bed and

pinch myself to feel if I was alive. Am I real? That feeling of not being, not living a full enough life is still with me. I think it's a female thing.' Her recent experience at the hands of the Arts Council must have increased her feeling of 'not being' but it's certainly shown the subversive quality of works like hers.

## Notes

1 Laura Mulvey, 'You don't know what is happening do you, Mr Jones?', *Spare Rib*, no. 8, February 1973, p. 14.
2 Ibid., p. 15.
3 Ibid., p. 15.
4 Ibid., p. 30.

Lubaina Himid    # We will be

Being an artist, being black and a woman has its difficulties. These are that teaching in art schools is hardly ever possible, that our writing and criticism are rarely ever published, and that getting grants from ever-decreasing resources is miraculous. In Britain today there is not the will in art schools, in art publishing or from arts funding bodies, either to acknowledge the existence of the black woman artist or to treat her as an equal and her contribution as valid. Day-to-day economics play a major role in the lack of options and choices. Many black women live in inner city areas of the country and do not have the space for a separate studio or a studio within living accommodation. This does not make us lesser artists, but it does make us resourceful in adapting kitchens and bedrooms.

At the moment, black women artists are striking out in different directions. We have rarely thought, worked or shown as a group, but often we show in exhibitions together, for example, in *Five Black Women* at the Africa Centre and *Black Women Time Now* at the Battersea Arts Centre in 1983, in *Celebration and Demonstration* at St Mathews Meeting Place, *The Mirror Reflecting Darkly* and *The Thin Black Line* at the Institute of Contemporary Arts in 1985. We do not expect to agree with each other on form or function, and these exhibitions have proved that this is where the daring and the richness lies. We do expect a loyalty and a commitment to showing together and especially a commitment to encouraging younger women. The abolition of the metropolitan counties and all that they have done for Black Arts may sweep away some of the rungs upon which we have climbed thus far. The rungs were made from guilt and tokenism, but they have helped us to find each other and to make ourselves less invisible, at least to each other.

The best places for seeing black women's work regularly are the Brixton Gallery and the Black Art Gallery in London, while other places have made token and occasional gestures in our direction. These gestures were linked to funding and, while they were good opportunities for the artists, may never occur again without some hard arguing. In the years since 1981 there have been a fair number of exhibitions which, though not showing exclusively the work of black women, have featured them to some degree. The *Race Today* collective's *Creation for Liberation* open exhibitions, one a year since 1983, funded by either the Greater London Council or Greater London Arts or both, is one example

which takes place each summer in Brixton. Black women also showed at the Black Art Gallery in Finsbury Park in the *Heroes and Heroines* exhibition and in *Heart in Exile*, its opening show. This gallery, while totally committed to showing the work of black artists, has been rather slow in accepting that women have a valid and equal contribution to make. In January 1985 a huge exhibition took place at the Festival Hall which combined the work of black crafts people and so-called 'fine' artists. It was called *New Horizons* and women featured in both sections. This was funded directly by the Greater London Council. *Into the Open* at the Mappin Art Gallery in Sheffield in 1984 showed the work of only five women, as compared to fifteen men, but each artist had the opportunity to show a good body of work – a rare thing in a mixed show.

So far the most obvious places in which to show work up and down the country have been hopelessly silent. I assume that they are waiting for black women artists to go away or give up, or to prove themselves. If so, they are out of luck. How can galleries like the Tate, the Serpentine or the Whitechapel in London, the Museum of Modern Art in Oxford, the Arnolfini in Bristol or the Third Eye Centre in Glasgow, justify their total boycott of our work? Doubtless, they can claim to have shown, in some corner of some downstairs room, the work of one black artist who happened to be a woman. But I have never noticed any work by black women artists in major survey exhibitions like the *Hayward Annual* or the *British Art Show* in 1985. Black women are committed to showing work in local and community venues, but we have every right to be seen in the so-called places of excellence too.

In art schools black women are usually separated from each other, one for every two or three years' worth of fine art students. There are then three main methods of teaching: an insistence that, as a black woman, the artist has something to be angry about and should express it; an insistence that angry or political statements are not art; a complete lack of any tuition at all. The instructions are always opposite to the artist's own mode of working. She therefore has little idea whether she is a victim of racism, of boredom, or is just a lousy artist.

In the last few years, largely through women's exhibitions and occasional forays into art schools as visiting lecturers, black women have begun to counteract this teaching and to learn from each other. Veronica Ryan, who has shown quite widely at major galleries in London as well as around the country, has been very instrumental in encouraging and teaching students while being respected as an artist by the establishment. Maud Sulter has done a great deal of research into black women's creativity in Britain, while Marlene Smith and Sutapa Biswas are coming forward as strong political artists, challenging myths and stereotypes fearlessly.

The themes in the work of black women artists cover a wide spectrum. We are making ourselves more visible by making positive images of black women, we are reclaiming history, linking national economics with colonialism and racism, with slavery, starvation and lynchings. There are some women whose work revolves around home, childhood and family, all of which are inextricably linked with racism in education, the challenging of racial stereotypes, and breaking through tokenism and sexism. These, and the broader themes of black heroes and heroines of the struggle for equality and freedom, international politics and the theft of our culture over hundreds of years show a personal/general, general/political, political/personal spiral in our work.

Sonia Boyce said of herself in 1983:

> I am British born of West Indian parents. I live a schizophrenic life, between an anglicised background and a West Indian foreground; to put it another way, between 'but look at my trials nah', and 'gaw blimey'. My work tries to reconcile both of these. Most of the work has evolved from memories of 'trivial' events or milestones in my life. The pictures attempt to be funny/ironic/sarcastic/symbolic – public and private images.[1]

She is a storyteller. Her pieces are figurative and decorative epics about what life has been like for Sonia Boyce, as she says, a mixture of Gonga peas and rice and bangers and mash. She does not protest, predict or dictate, she remembers. She creates to remember her childhood and to remind us of ours (Figure 61). She uses pastels, layer upon layer of deep soft colour: rich purples, lilacs, browns, blues and oranges. The scenes are often interiors, fabulously wall-papered beyond the imagination of the Sanderson's catalogue. The women seem to be dreaming and thinking, far off into the distance, both backwards and forwards, taking in gossip, remembering times, the odd rueful smile reflects the irony of life in Britain; the British, the schools and the rules. This work draws the black viewer into a conspiracy of knowing and recognition. Many of the pieces recall incidents which have occurred often in her life and that have also happened to other black women. There were Sundays spent in delicate and pretty clothes unable to play, beribboned and bored. There was the drag of being in love with the 'wrong' man. 'It was one of the unwritten laws at school that black girls never became too familiar with white boys. After two years with Nigel I still find it difficult to walk down the street holding his hand.' She recalls the joy of listening to women gossip, about abortion, separation, adultery, travel. She has drawn the terror of dreaming about King Kong, the film, the creature, the 'natives'. One large drawing, of a young woman in the kitchen washing up, recalls the pandemonium that can be caused by colours, head dress, and patterned cloth when worn by black school students in Britain. Recently Sonia has

61 Sonia Boyce, *Big Woman Talk*, 1984, *photo* Anne Cardale.

turned her attention to the church and its influence on her family and on other black people worldwide. In this work she uses text, images and titles 'Missionary position I' and 'Missionary position II'. During a residency in a London school she focussed on the theme of the portrait and of daughters and mothers. She drew her mother, surrounded by her favourite things, standing looking far from complacent and yet quite complete. Sonia's work is simple storytelling and honest revelation: rare gifts.

In two years she has provided dealers, curators and critics with much fodder. She has exhibited widely and in addition to those exhibitions mentioned above, has shown work in the Bluecoat Gallery in Liverpool, in the Riverside Studios, the Gimpel Fils gallery and the Nicola Jacobs gallery in London, the last being in a show chosen by the art critic of the *Guardian* newspaper, Waldemar Januszczak. She has shown that she can and will exhibit with anyone, anywhere, no matter who selects her work. Waldemar Januszczak, while loathing black art, has tried relentlessly to single out her work for critical praise using terms like 'sensation of intimacy', 'insight into the strain', and 'unsettled dreams'. He believes that she is wasted in showing with other black artists. He is wrong. With his help she could fall headlong

into the trap of producing work for sale to and for the eyes of a privileged white minority who completely misunderstand her work, but grab it anyway. She could be in danger of becoming a much sought-after curio: the acceptable face of black art.

Claudette Johnson is more committed to sharing skills with black women than she is to producing goods, a gain for black women, a loss for dealers and buyers. She has produced some of the most dynamic images of black women over the last few years which are daring, challenging and moving. They urge the black woman viewer onwards and upwards. Their 'mistake' was that they did not intentionally communicate with the white viewer in the same way – they were not meant to. White men longed to adorn the walls of their houses with them while white women tried to prevent her from being given a grant to produce more work on the grounds that her work was not meant for them and was therefore exclusive.

In the exhibition catalogue for *The Thin Black Line* she says:

> The black women in my drawings are monoliths. Larger than life versions of women, invisible to white eyes and naked to our own. They are women who have been close to me all my life with different stories. They are not objects. Every black woman who survives art college, fairy tales and a repressive society to make images of her reality – deserves the name artist.[2]

For me Claudette's drawings explore what strength means, what beauty means and what that power can do. They invite us to participate in the battle for equality, dignity and freedom of expression. They explore our sexuality and its myths and legends. In some drawings the women dare to say and do what we should all be doing every day, challenging male superiority, laughing at it, ignoring it. Some works have a stern, silent calm before the storm's fury. In another drawing in strong, dark reds and greens, there is a unity between mother and daughter; the older woman giving through experience, the younger woman giving with daring and energy (Figure 62). There are no words to help you with these works, there is a low humming intensity of colour, a richness of browns, sweeping arches, swirling shapes and merging meanings. There is a correct interpretation, but it is personal to the viewer and at the same time widely and loudly politically relevant.

In my own work, which ranges from wooden cut-outs to collages and paintings, I am trying to do several things, probably too many. I make images of black women because there are not enough of them. I expose the lies of the printed media because they have got away with too much for too long. And I am interested in smashing the notion that creative genius is solely in the hands of the white male. I want to change the order of things and take back the art which has been stolen. My work is satirical

62 Claudette Johnson, *Untitled*, 1982, *photo* Anne Cardale.

and sometimes vicious, uplifting and funny, depending upon your health, your wealth, your colour or gender. I use found materials, cloth, cardboard, paper and drawing pins, but have been seduced recently by acrylics while painting a mobile mural on wooden panels for Notting Hill. I am interested in the colour possibilities of paint but am repelled by its pretensions to magic.

In the past I made some wooden cut-out pieces of white male nudes with three foot long penises. I was trying to laugh at them, to sneer, and to jibe, to expose them as liars and cheats, but I have since decided that they are best left well alone, ignored. There are too few visual images of black women – we are not all

nurses or Tina Turner. I want to destroy the stereotypes that television, the newspapers and advertisements are constantly feeding us – when they acknowledge that we exist at all. I am only interested in painting black women as independent, strong-thinking people (Figure 63). I try not to be naive and over-optimistic, we are not going to be able to run off into the sunset together, not without a bit of a fight.

I believe we should not be fooled by fashionable funding and token gestures, but we must take advantage of them. I have spent much time in organising exhibitions as well as showing in them: *Five Black Women* at the Africa Centre, *Black Women Time Now* at the Battersea Arts Centre, and most recently *The Thin Black Line* at the Institute of Contemporary Arts in London. I also co-selected *Into the Open*, an exhibition at the Mappin Art Gallery in Sheffield. Showing work in these and other exhibitions has given me the courage to go on making things. For this I have had to rely on other black artists and curators. White dealers, critics and curators, whether male or female, are not in the least interested in my work, with one or two exceptions.[3] I am not either sad or exotic enough for funding bodies and galleries: frankly, this pleases me.

The artists I have mentioned here are all concerned with the politics and realities of being Black Women. We can debate about how and why we differ in our creative expression of these

63 Lubaina Himid, *Freedom and Change*, 1984, *photo* Anne Cardale.

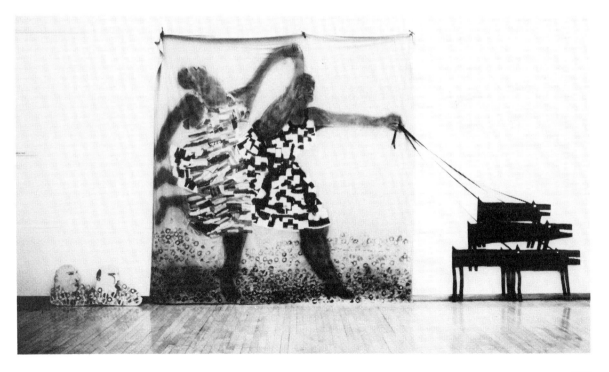

realities. Our methods vary individually from satire to storytelling, from timely vengeance to careful analysis, from calls to arms to the smashing of stereotypes. We are claiming what is ours and making ourselves visible. We are a few of the hundreds of creative black women in Britain. We are here to stay.

## Notes

1 Sonia Boyce, statement in *Five Black Women* exhibition, The Africa Centre, London, September 1983.
2 Claudette Johnson, statement in *The Thin Black Line* exhibition catalogue, Institute of Contemporary Arts, London, November 1985.
3 The critic and writer Sarah Kent has been consistently supportive of my work for some years.

Rosy Martin and
Jo Spence

# New portraits for old:
## the use of the camera in therapy

The images and text reproduced here have had several functions for us. They were produced by us both in the course of work we were doing together as co-counsellors, but they are also part of large individual projects, and part of work we are doing in a women's photograph group on Identity Crisis.[1] Co-counselling is a non-hierarchical, inexpensive way of training to discharge past hurts and griefs as well as being a two-way non-evaluative talking and listening contract between people.[2] We met at an ILEA evening class run in North London by Peter Clark. As unemployed people it cost us £1 each to join. In this instance we were working on childhood memories, taking as our starting point a photograph which was significant for Jo as the site of trauma, and for Rosy as a site of pleasure.

In the session from which these photographs were drawn we worked to produce a series of different images of ourselves. We started with a preconceived idea of what we wanted to disrupt, replace and rework, and worked within this framework. Integral to this work is a shared politics both of feminism and of a demystification of photographic practice. As feminists we take it for granted that current dominant images of women should be continually questioned and, if necessary, challenged, but we find the notion of 'positive' images a limited one in that it ignores how meaning is constructed, or how subjectivity is produced. Since it is rather a fixed way to discuss photography, we prefer to explore the construction of images, to understand the cross-over between what feels personal and what is public, and given wide circulation. Playing with ways of presenting ourselves to camera was a way of doing this. Our individual explanations of how we did it and to what effect follow later.

We are not trying to give a definitive explanation of what we did, or what we hoped to achieve. Rather we are offering it as an example of a new photographic practice which could be taken up in therapy, in play, or as a way of asking ourselves new, perhaps awkward, questions, or discovering new ways of having dialogues with ourselves or each other. The traditional portrait in photography is enshrined in a complexity of professional practices

From *Feminist Review*, no. 19, March 1985.

and philosophies, typified by the notion that people can be represented by showing aspects of their character. This relates to the idea that photographs can reveal something that is ordinarily not visible, but that the gifted photographer brings it out through artistic and professional skills. We understand the portrait differently. It presents a range of possibilities, or subject positions, which are not forever fixed in silver, electronics or paint. These can be examined, played with, questioned, accepted, changed or discarded. We think the term 'keyword' used by Raymond Williams is helpful. He sees crucial words as knots of cultural, economic and political meaning, that derive from their evolution and use. If we translate this term into 'key images' and apply it to personal photographic portraits, it offers a way of thinking about the possibilities of this approach for individuals using their own cameras.

We believe that each of us has sets of personalized archetypal images 'in memory', images which have been produced through various photo practices – the 'school photo' used by Jo as her starting point is one example, the family album snapshot used by Rosy is another. Such photos are surrounded by vast chains of connotations and buried memories. We need to dredge them up, reconstruct them, even reinvent them, so that they work in *our* interests, rather than remaining the mythologies of others as photographic archetypes. By this we mean, for instance, people who told us about that 'self' which appears to be visible in our various photographs. This work related to a theory of narcissism in as much as it is about the contemplation of our self-image, but is about a divided self, sliding across between the everyday concept of a social self, and the concept of a self as experienced in our psychic lives. And rather than as women living in happy contemplation of their own self-images, as Ros Coward points out, we are 'much more likely to be dominated by discontent'.[3] Certainly our work has confirmed this discontent, and this exploration, with the rapid accumulation of a *wide range* of possible 'selves', covering a whole spectrum, has enabled us now to step more confidently over the threshold and ask ourselves new questions about this discontent.

## Photo therapy?

Within a framework of co-counselling we have been using a technique known as 'reframing'. We take a specific piece of behaviour, history, or in this case an image, examine what we think it represents to us and how we would like to change it – that is, change our impression of what we think it is about. Put crudely, reframing is a kind of internal permission-giving: permission to change, to re-view, to let go, to move on. It is not a way of discussing the 'real' in order to see if it is 'biased', but of

finding new ways of perceiving the past so that we can change our *activities* now.[4] Through the medium of visual reframing we can begin to see that images we hold of ourselves are often the embodiment of particular traumas, fears, losses, hopes and desires. Once on the psychic 'operating table', out in the open as a piece of personal 'theatre', we can begin to work on them. We are talking initially about changing the images in our heads, not social or economic change, but we both passionately believe that a first step towards such broader change can be this facing up to certain limiting defence mechanisms and 'blocks' which we inhabit and which pattern us. We are locked into past histories of which we are largely unaware, but by using reframing as a technique everything can potentially be turned on its axis, words and images can take on new or different meanings and old ideas can be transformed.

We would emphasize here that we are only adapting some of the techniques of co-counselling and reframing and do not in any way subscribe to a philosophy of individual growth removed from broader social and economic change. Nor do we assume that people have much money to expend on such activities. But photo therapy is a way of using our cameras so that they can be given a personal, social and political use.

Our approach came from counselling each other over a period of time about how we presented ourselves in the everyday world through our personal styles: make-up, fashion, body gesture, facial expression. We were working on the problems for us as a heterosexual and a lesbian woman in wishing to be non-conformist within our own peer group, or in working towards a better understanding of conflicting authority figures from whom we required approval. In the process of uncovering these fears we began to see how as feminists, from working-class backgrounds, who had entered higher education with the potential to take up positions of power as teachers, we were often unable to negotiate the conflict between different groups/figures we were trying to 'please' – parents, peer group, the labour movement in a generalized sense, fragments of the women's movement, our tutors in higher education, academics, lovers, friends, ourselves. Each of these 'approval' figures would be inflected slightly or radically different from the other. (What on earth would be the bedrock of pleasing ourselves? And how bourgeois and individualistic!) This work on approval is one of the underlying themes of the Identity Crisis project in which we are involved. However, for this piece of work, we concentrated on what we were able to give ourselves permission to 'try out', in the special world we created for ourselves in front of the camera, a world of social interchange, and in our psychic view of ourselves.

This kind of working together is not like looking in the mirror and pulling faces at yourself, trying out new poses, playing about

with fashion accessories; it is much more than just dressing up. There are several stages.

(a) This comprised discussions where we gave ourselves time to speak for an hour. The other listened and encouraged, perhaps asked a few provocative questions, but never intervened, disapproved or approved. Working as psychic 'midwives' rather than as parent or authority figures, teachers or social workers – and never taking up the indulgent privileges that come with being lovers – we eventually came to understand each other very well, and to love and respect each other's feelings without wishing to take over, be in control, or feel anxious or vexed because nobody was listening to what we said. It became clear over several sessions of this talking and listening that, although we had never intervened in each other's material (a term from co-counselling) we each remembered and built upon what the other had said, respected it and ultimately integrated it into the broader framework of working together so that we were able to take more and more risks without first seeking approval from each other.

(b) This involved choosing which photograph to use as a starting point, and we tried various possibilities. The series shown here is the result of the fourth session we did together. In the early sessions we each brought minimal props as a starting point. Our ideas often bounced off each other: for example Jo brought a bridal veil purchased from a jumble sale and a bunch of plastic lilies to the first session, while in the second session Rosy brought a black lace cape and diamanté earrings.

(c) Setting up the pictures: once the camera and lighting had been set up, we took turns to take centre stage, presenting what we wanted to camera, seeking suggestions for possible 'improvement' or heightening of effect, then waiting to be photographed.

(d) The final interaction between photographer and sitter: here the choice of which 'moment' to photograph was the issue. It involved trying to interpret the needs of the other, but also trying to add in some essential extra on top of what the sitter was trying to construct for the camera; for example, in the images of Jo as her father, the hunching of the shoulders and the sinking down of the head was a suggestion from Rosy. Once we had gleaned what was being constructed for the camera, it was the photographer who added the last element, for she was always in a position of being a friendly helper. As such she could encourage that last ounce of 'permission giving' that could be blocking the sitter from presenting something traumatic or upsetting. For instance, it often took a lot of encouragement for Jo to try to present herself in any glamorous or 'feminine' way. In this sense the sessions

were vastly different from any ordinary portrait session in a high street photographer's studio where we go with a pre-conceived idea about what we want, or what we hope for, and then collude with the photographer to reproduce it. These sessions were helped by the fact that Jo had been a portrait photographer for many years and was well aware of what was *not* needed in the sessions. Essentially we were always working towards the inter-penetration and the re-presentation of psychic states as well as physical stages. We were seeking not to be dignified, beautified, respectable or safe. Instead, we tried to use the space for playing and for doing what we felt we needed to do.

(e) At the end of the time we discussed how we felt about the session and any particular things that had emerged.

(f) A further stage of understanding how images of ourselves came to 'mean' certain things occurred when the prints were returned through the post from the processors. We were never together when this happened, it was always an individual process.

(g) Then there were discussions about what we felt had been achieved, in the light of the fact that we had the prints. After our discussions we circulated each set of images within our peer groups. This 'trying out' stage was often difficult because our own expectations were not always met by the ways others read the pictures. We found people surprised that we would '*want* to look like that'. Initially we found it difficult to explain what we had done, or to make it clear that we were not intent on producing new, fixed images, but rather constructing a range of other possible images as available to us.

(h) The final stage came when we discussed the photographs for mounting and laminating as part of an exhibition. We started to structure it as a piece of work, and added a written text to point to what we were trying to do. At the same time we wanted to leave room for viewers to interpret it for themselves and to see it as an amateur practice they could try for themselves.

## Technical details

We used the highest technology we could afford, which was a Pentax camera with mini zoom lens and electronic flash. We sent the films to a colour-processing company who provide a cheap and efficient mechanized service, free film, and prints with consistently good image-resolution and colour balance. We shot all pictures in 35mm colour negative film, and we used colour prints for exhibition purposes. These were recopied and printed in black and white for this article. Throughout we used one

diffused light source which was placed to the right of the camera. We never changed the position of the camera though we did zoom in closer on occasion. In this way we hoped to simulate simple institutional lighting, like early school or police or medical photos, as well as hoping for some similarity to automatic photo machines. We made no effort to hide the main shadow, always working close to a white background.

Most people engage in some sort of amateur photographic practice and most households have a camera. We would like to encourage the use of cameras in ways other than for holiday shots or family snaps. If your equipment is less than ours, it hardly matters initially; if you lack electronic light, work near a good natural light source. All you need is privacy and the time and space to build up trust with another person or in a group, to carry out this type of practice.

Each session took two to three hours and cost roughly £10.00 for a set of seventy-two pictures. All processing was done through Truprint, who always supply a further 'free' film when prints and negatives are returned. It is also possible to order an extra set of prints when the film is initially processed, at very little extra cost. This way both sitter and photographer can have a complete record of everything done in the sessions.

## Rosy's story

Jo and I had been co-counselling for some time, and in one session I was examining which clothes I was 'permitted' to wear as a lesbian-feminist. I felt that there was an acceptable uniform, but I had always rejected uniforms and tried to use clothes as an aspect of self-expression and pleasure.

I am a tailor's daughter, and both my parents had loved to dress me up and create me as their 'delightful' little girl. My father made me beautiful clothes, party dresses of satin and net, with full skirts and bows, and exquisitely detailed coats and jackets from the 'cabbage' left after he'd made clothes for himself or my mother. A fascination with clothes and dressing-up was a rewarded activity for me. As the child of my parents' middle-age (they had already brought up a family of two sons), my mother also created me as her 'pretty little girl'. My hair, light auburn and frizzy-curly, was encouraged to grow and carefully directed into ringlets and curls. I always received lots of positive attention from adults as a child, through having beautiful hair – gained at the cost of hours of brushing and untangling – and of teasing from my peers. My mother has still not forgiven me for having cut my hair short.

64 Rosy Martin, four photographs
from *Photo Therapy: Transforming
the Portrait*, 1985.

'Who constructed this child?
Mum. Dad. Hollywood?  .
The photographer?

Transformations.
The child in me.
Me as child.
The child I contact for my work.
The child others find unacceptable.
The child no-one else should see.
The child that no-one chose to
    photograph.'

Later I designed and made my own clothes. I dressed for myself and created my own style – loosely based on Hollywood references to strong women – Bette Davis, Joan Crawford, Mae West. I also enjoyed setting up contradictory sign systems, for example, returning to ringleted hair and sometimes choosing feminine evening clothes when my work involved using heavy industrial machinery and designing and making large objects. I enjoyed playing with my appearance, wearing 'theatrical' clothes, avoiding being fixed, being over the top, even in my everyday image.

It was feminism that limited my pleasure in dressing up. Yet even within feminist dress codes I played with my image – by wearing my father's trousers for instance. But I was entering an identity crisis over how I presented myself. It was highlighted by my theoretical awareness of myself as the object of 'the look'. As I shifted my position from heterosexual to women-identified to lesbian, I found myself within a series of dress codes that I found quite limiting. I felt a peer-group pressure, a 'thou shalt not' dogma, the safest solution to which would be a couple of pairs of jeans, lumberjack checked shirts and short, short hair. But what of my own delight in style, and playing with visual contradictions? Where is the freedom of this set of restrictions? Anonymity? Perhaps belonging to a group? Yes, of course. But I retained my need for a personal style and I continued to express it. The part of my personality that was given space through photo therapy was my delight in creating a visual image and my delight in performance. In the earlier photo therapy sessions, I examined transitions and transformations, for instance in reframing female into feminist archetypes. These images included the spiritual/ powerful: the goddess; the sorceress; gender-benders; the principal boy; Isherwood's Berlin; transforming the man's suit; tragedy/fragility: the poor waif; the virgin; the bride; the madonna; age change; the rich middle-aged woman; the school girl; the pre-school child. Some of these were carefully planned and constructed, others arose spontaneously and their full meanings only emerged in the photographing stage, or later in looking at and talking about the prints. As our work progressed I stopped using make-up to help me to create an image, since I felt it had acted as a barrier and a caricature.

In the session illustrated here my starting image was a family album photo, taken by my father on holiday. Interrupted in my thoughts, I've turned my face to the camera. 'You look like Shirley Temple'; 'How cute', people say. (We discovered that Jo too had her own version of the Shirley Temple look among her family photos.) The second childhood image was taken by a professional portrait photographer and was much more stylized; it represented my capacity to collude to produce an idealized image – to perform, to be lovable as the good little girl, wide-eyed and

flirtatious, in need of protection by my father? I wanted to examine these images of myself as a child, images I now see as constructions, produced primarily by my parents, but also by the current stereotypes of the 'good little girl' who for my parents was Shirley Temple, and by decisions made by the photographer over which *I had no real control*. I wanted to examine, recreate and transform this construction to reclaim myself as a child, in all her aspects, to take back the power I/she so obviously had – the capacity to be creative, autonomous, independent – as well as vulnerable. She existed as a mirror of an idealized image for 1/60th of a second.

The props for this session were a handful of coloured ribbons, and a newly acquired outfit which I had jokingly called my romper suit, since it reminded me of the clothes of very early childhood. I started by re-creating the photos from childhood. Then I challenged the pose by laughing and undermining its idealized aspects. As a designer of toys, play equipment and play space I also contact the child in me for my work. It is important to be able to empathize with a child state, to play and feel as possibly I did as a child. The child that others found/find unacceptable is the child in me that shows feelings, especially those of despair or anger. She was never photographed. She has been transformed by these new photographs into someone who must be taken into account, not edited out of memory. She is still here. These aspects are still present, but in the adult are called 'irrational' and not acknowledged as valid. In co-counselling, space is given for exploring these feelings, they are not silenced. The final transformation is to an autonomous adult, who owns the various aspects of herself and who takes care of herself, no longer caring that she is the object of 'the look'.

Although I enjoy changing costumes and finding props, it became clear that a feeling for the work was most important, letting go in front of the camera, taking risks, working together. In this sharing, accepting and mutually extending way the work grew, it is a true collaboration, and yet we were each responsible for our own section.

A few years ago I felt very comfortable with my own strength and independence, but when my life changed abruptly, and I was confronted with feelings of loss and powerlessness, I became aware of how brittle that strength had been, and of a need to examine and acknowledge my own vulnerability. Here I chose to show images of myself as a child, dependent and vulnerable, showing emotions of delight, trust, self-absorption, depression, anger and grief. This is part of my move to reach a balanced state that recognizes and integrates strength and vulnerability, independence and dependence, and to accept that both aspects co-exist.

65 Jo Spence, four photographs from *Photo Therapy: Transforming the Portrait*, 1985.

'Who constructed this child? Family, State, Media?

Transformations.
Obedient. Fixed?
The adult forced upon me.
The child denied.
The adult infantilized.

I am child, mother, father,
    grandparent.
Split between past, present
    and possible futures.'

## Jo's story

These images are part of a health project – 'The body as the site of struggle – the sign as the site of struggle', where I am trying to make available visually what is usually unknown, unseen or feared by most people: a struggle for health during the mind/body crisis around having breast cancer. For me this includes my rejection of orthodox medical treatment. It is a continuation of earlier work about absences and silences, most particularly in relation to photographs from family archives – what are usually termed

family albums. This piece of work on health has involved me with different photographers so that we could explore photographic style and genre in relation to images of illness/health, in order to describe and problematize a particularly neglected form of struggle in debates on visual representation. It is to try to form a bridge between work on health struggles, and work on the image which seem to me to be totally related. Just as the body is fragmented through representation, so it is fragmented, parcelled up as specialities, within a discourse of health. The entire body of work, including these images, is a way of having a strengthening and informative dialogue with myself about my own ability to survive such an ordeal, and to challenge the apparently all-powerful medical orthodoxy, by embracing a holistic approach to health (traditional Chinese medicine).

Throughout my photo therapy sessions I was always aware of the limited ways in which I perceived myself visually both in images and on a day-to-day basis. In retrospect I appear to have worked through a whole series of bourgeois icons of womanhood. For example, the blushing bride, transformed by me into an Edvard Munch-type 'shriek' about what lies in front of the bride; the sorrowing widow; the ballerina (the nearest I could allow myself to be romantic or feminine); the Joan Collins glamour type (totally impossible to give myself permission to do seriously); various Terence Rattigan type spinsters; the tragic heroine of an opera, but encoded through a Goya-like type of positioning of the face and body, and use of lighting. Often because of Rosy's presence and the clothes and props she had brought I could widen my threshold of allowing myself to appear 'out of character' by donning diamanté earrings, evening dresses, lacy and frilly clothes, really 'pretty' garments – things I'd never dare to buy and which Rosy herself only kept in her props cupboard for dressing up or play, or which had been more appropriate to her previous peer groups or lifestyle. In the first two sessions I applied make-up, being more involved with heavy theatrical daubings, often totally painting the face out with white grease paint. In the later sessions I lost all interest in make-up. I felt it had been a way of masking myself from the camera, hiding away and so playing safely.

The session reproduced here came about because I had been doing work on my fragmented memories of childhood, particularly around health patterns in my family and my attitude to my parents' health, in particular my mother's, and how it affected my childhood. I realized from what I said about this school photograph that I still felt massive anger and resentment about being the eldest child and always, or so it seemed, having to stand in for my mother on these occasions, as little housewife and mother. The photograph had been used in a co-counselling session with a professional counsellor and our conversation tape

recorded and then transcribed by me. These sessions enabled me to see why this particular photograph seemed rooted in so much pain, without it being attached to any specific memories of the past. I was also able to grasp why I had spent so much time as a mature student in a study of the ideological working of the story of Cinderella. Once this unravelling process had begun I could proceed into a photo therapy session with Rosy. The photograph in question is a school photograph taken when I was roughly eleven years old, just after the end of World War Two, a particularly difficult time for most children as we readjusted to peacetime. In my family, however, it meant no actual changes around working patterns, but it was the beginning of my realization of my failure as a school-girl. Both my parents went on working full-time in factories and I continued to be a 'latch key' child in charge of a younger brother. It was a period of great resentment, one that was never resolved in spite of my later political understanding of why those events took place and of how powerless both parents had been to create the ideal world I had expected from my socialization as a very young and only child, safe in the bosom of a lower middle-class family.

This apparently ordinary school photo turned out to be the sight/site of real traumas about rejection, unlovedness, responsibility, and the desire to perform and please as a child to obtain the missing love. What I wanted to come to terms with in this session was the powerlessness I felt around that period. This was also relevant to the powerlessness I was experiencing as a person who was potentially chronically or terminally ill with breast cancer, who had recently been totally traumatized in hospital, and who felt hostility and fear towards the medical profession. I felt it was all going to follow a certain path fairly quickly, as I found myself as a feminist in the contradictory position of reclaiming my mother's life and experience, whilst perhaps following in her footsteps (she died of breast cancer).

When I was in hospital, watching women of my age coping with illness, I began to remember how ill both my parents had been, how they *looked* when they were ill, how my father aged in that process, and how I had not wanted to identify with or accept the fear aroused by detecting in myself certain visible likenesses to both of them during my extended illness. I realized too when I was in hospital that, despite this, I still felt alienated from both my parents (now dead). Although this was counteracted by my sense that politically I understood how and why things had been the way they were, I still could neither internalize them peacefully nor accept them as an integral and positive part of my history. The process of reconstructing these family fragments through co-counselling and work with Rosy, so long denied, had a reconciliatory effect on me, and I felt I could now begin to be my own positive internalized parent. In wanting to push away bad

memories, and to deny them as part of me or my history, I was in fact robbing myself of essential strengths and resources which were present in my family.

The starting point was the school photograph, which immediately evoked memories of my hair being pulled tightly back and tied and controlled. What I wanted was to change my visual image, to transform the inner image of myself from that time, and to explore my potential for changing this 'personal archetype' to something with which I felt happier. If this all sounds rather mystical, it wasn't. It was a very straightforward reframe of a partially perceived view of self which was transformed into something I was happier with, through a series of stages. During the session I used no visible reference material but through my visual memories of self and parents tried to get in touch with parts of myself that had never been allowed to speak, either visually or verbally, parts that had been silenced, buried, glossed over. Each pair of images was the result of very slight adjustment of clothing and facial and body expression, helped by Rosy. We both found it rather traumatic for me to present myself in some of these ways, but hurried through them to the more joyful transformation I was unable to effect for myself because I still can't bring myself to tie a pretty ribbon in my hair. I relied totally on Rosy braiding my hair in a way I would not have dared, and then encouraging me to stand more erect. In retrospect I was aware that the final image created came out of a mixture of my distant perception of the hippy era, and of a romanticized school-girl image, although of course this could and has been read differently by others.

## Notes

1 'Photo Therapy: transforming the portrait' is a laminated touring exhibition. It is available for hire from Photography Workshop, 152 Upper Street, London N1 1RA. Rosy or Jo are also available to lecture or run workshops.
2 For a description of this see H. Jackins *et al.*, *Fundamentals of Co-Counselling Manual*, USA, National Island Publishing, 1962.
3 Rosalind Coward, *Female Desire*, London, Paladin, 1984, p. 79.
4 Practical experience of reframing came from attending a one-day workshop led by Ian Grove-Stephenson. See also *Re-framing: Neuro-Linguistic Programming and the Transformation of Meaning*, USA, Real People Press, 1982.

# Bibliography

Advertising Standards Authority, *Herself Appraised*, London, Advertising Standards Authority, 1982.

The Arts Council of Great Britain, *Three Perspectives on Photography*, London, The Arts Council of Great Britain, 1979.

Baker, E.C. and Hess, T.B. (eds), *Art and Sexual Politics*, New York, Macmillan, 1973.

Barrett, M., 'Feminism and the definition of cultural politics', in Brunt, R. and Rowan, C. (eds, *Feminism, Culture and Politics*, London, Lawrence & Wishart 1982, pp. 37-58.

Barrett, M. *et al.* (eds), *Ideology and Cultural Production*, London, Croom Helm, 1979.

Barthes, R., *Mythologies*, London, Paladin, 1973.

Barthes, R., *Image – Music – Text*, London, Fontana, 1977.

Berger, J., *Ways of Seeing*, Harmondsworth, Penguin, 1972.

Blanchford, G., 'Looking at Pornography', *Screen Education*, no. 29, Winter 1978-79, pp. 21-8.

Borzello, F., *The Artist's Model*, London, Junction Books, 1982.

Bowlby, R., *Just Looking*, London and New York, Methuen, 1985.

Brooks, R., 'Woman Visible: Women Invisible', *Studio International*, vol. 193, no. 987, March 1977, pp. 208-12.

Brooks, R., 'Fashion: Double Page Spread', *Camerawork*, no. 17, Jan.-Feb. 1980, pp. 1-3.

Broude, N. and Garrard, M.D., *Feminism and Art History*, New York, Harper & Row, 1982.

Brown, B., 'A feminist interest in pornography – some modest proposals', *m/f*, nos 5 and 6, 1981, pp. 5-18.

Brown, B. and Adams, P., 'The feminine body and feminist politics', *m/f*, no. 3, 1979, pp. 35-70.

Brownmiller, S., *Against Our Will: Men, Women and Rape*, New York, Secker & Warburg, 1975.

Brunsdon, C., 'A subject for the seventies', *Screen*, vol. 23, nos 3-4, Sept.-Oct. 1982, pp. 20-30.

Brunsdon, C., *Films for Women*, London, British Film Institute, 1986.

Butcher, H. *et al.*, *Images of Women in the Media*, Birmingham, Centre for Contemporary Cultural Studies, University of Birmingham, 1974.

Carter, A., *The Sadeian Woman*, London, Virago, 1979.

Carter, A., *Nothing Sacred*, London, Virago, 1982.

Cherry, D. and Pollock, G., 'Woman as sign in Pre-Raphaelite Literature: a study of the representation of Elizabeth Siddall', *Art History*, vol. 7, no. 2, June 1984, pp. 206-27.

Chicago, J., *Through the Flower*, New York, Anchor Books, 1973.

Chicago, J., *The Dinner Party*, New York, Anchor Books, 1979.

Cixous, H., 'The Laugh of the Medusa' in de Courtrivon, I. and Marks, E. (eds), *New French Feminisms*, Brighton, Harvester Press, 1981, pp. 245-64.

Clark, K., *The Nude*, London, John Murray, 1956.

Coward, R., 'Re-reading Freud: the making of the feminine', *Spare Rib*, no. 70, May 1978, pp. 43-6.

Coward, R., 'Underneath we're angry', *Time Out*, no. 567, Feb. 12th-March 1st, 1981, pp. 5-7.

Coward, R., 'Sexual violence and sexuality', *Feminist Review*, no. 11, Summer 1982, pp. 9-22.

Coward, R., *Female Desire: Women's Sexuality Today*, London, Paladin, 1984.

Coward, R. and Ellis, J., *Language and Materialism*, London, Routledge & Kegan Paul, 1977.

Coward, R., Lomax, Y. and Myers, K., 'Behind the fragments', *Camerawork*, no. 24, November 1982, pp. 2-3.

Cowie, E., 'Women, representation and the image', *Screen Education*, no. 23, 1977, pp. 15-23.

Cowie, E., 'Woman as sign', *m/f*, no. 1, 1978, pp. 49-63.

Cowie, E. *et al.*, 'Representation vs. communication', paper from the Socialist Feminist National Conference, London, March 1979.

Culler, J., *On Deconstruction: Theory and Criticism after Structuralism*, London, Routledge & Kegan Paul, 1982.

Doane, M.A., Mellencamp, P. and Williams, L. (eds), *Re-vision: Essays in Feminist Film Criticism*, Los Angeles, American Film Institute, 1984.

Duncan, C., 'Virility and domination in early 20th century vanguard painting', in Broude, N. and Garrard, M.D., *Feminism and Art History*, New York, Harper & Row, pp. 293-313.

Dworkin, A., *Pornography: Men Possessing Women*, London, The Women's Press, 1981.

Dyer, R. (ed.), *Gays and Film*, London, British Film Institute, 1977.

Dyer, R., 'Don't look now: the male pin-up', *Screen*, vol. 23, nos 3-4, Sept.-Oct. 1982, pp. 61-73.

Earnshaw, S., 'Advertising and the media: the case of women's magazines', *Media, Culture and Society*, vol. 6, no. 4, Oct. 1984, pp. 411-21.

Echols, A., 'The new feminism of yin and yang', in Snitow, A. *et al.* (eds), *Desire: the Politics of Sexuality*, London, Virago, 1984.

Ecker, G. (ed.), *Feminist Aesthetics*, London, The Women's Press, 1985.

Ellis, J., 'Photography/pornography/art/pornography', *Screen*, vol. 21, no. 1, Spring 1980, pp. 81-108.

Equal Opportunities Commission, *Adman and Eve*, Manchester, Equal Opportunities Commission, 1982.

Ferguson, M., *Forever Feminine: Women's Magazines and the Cult of Femininity*, London, Heinemann, 1983.

Foucault, M., *Discipline and Punish: the Birth of the Prison*, Harmondsworth, Penguin, 1977.

Foucault, M., *The History of Sexuality*, Volume One: *An Introduction*, Harmondsworth, Penguin, 1981.

Freud, S., *On Sexuality*, Harmondsworth, Penguin, 1977.

Goffman, E., *Gender Advertisements*, London, Macmillan Press, 1979.

Green, N. and Mort, F. 'Visual Representation and Cultural Politics', *Block*, no. 7, 1982, pp. 54-68.

Griffin, S., *Pornography and Silence*, London, The Women's Press, 1981.

Hall, S., 'The Whites of Their Eyes: Racist Ideologies and the Media' in Brunt, R. and Bridges, G., *Silver Linings*, London, Lawrence & Wishart, 1981, pp. 28-52.

Harrison, M., 'Notes on feminist art in Britain 1970-1977', *Studio International*, vol. 193, no. 987, March 1977, pp. 212-20.

Heath, S., *The Sexual Fix*, London, Macmillan Press, 1982.

Henley, N.M., *Body Politics*, New Jersey, Prentice-Hall, 1977.

Heresies Collective, *Heresies: the Sex Issue*, no. 12, 1981.

Institute of Contemporary Arts, *Women's Images of Men*, London, ICA, 1980.

Institute of Contemporary Arts, *About Time*, London, ICA, 1980.

Institute of Contemporary Arts, *Issue*, London, ICA, 1980.

Institute of Contemporary Arts, *Desire*, London, ICA, 1984.

Institute of Contemporary Arts, *The Thin Black Line*, London, ICA, 1985.

Irigaray, L., 'This sex which is not one' in de Courtrivon, I. and Marks, E. (eds), *New French Feminisms*, Brighton, Harvester Press, 1981.

Jamdagmi, L. and Patel, A., 'Black lives: white careers', *Feminist Art News*, no. 6, 1982, pp. 16-17.

Johnston, C. (ed.), *Notes on Women's Cinema*, London, Society for Education in Film and Television, 1973.

Jones, A.R., 'Julia Kristeva on femininity: the limits of a semiotic politics', *Feminist Review*, no. 18, Winter 1984, pp. 56-73.

Kaplan, E.A., *Women in Film Noir*, London, British Film Institute, 1978.

Kaplan, E.A., *Women and Film: Both Sides of the Camera*, New York and London, Methuen, 1983.

Kay, K. and Peary, G. (eds), *Women and the Cinema: A Critical Anthology*, New York, Dutton, 1977.

Kelly, M., *Post Partum Document*, London, Routledge & Kegan Paul, 1983.

Kent, S. and Morreau, J. (eds), *Women's Images of Men*, London, Writers and Readers, 1985.

King, J. and Stott, M. (eds), *Is This Your Life? Images of Women in the Media*, London, Virago, 1977.

Kingsley, A. and Semmel, J., 'Sexual imagery in women's art', *Women's Art Journal*, vol. 1, no. 1, 1980, pp. 1-6.

Kuhn, A., *Women's Pictures: Feminism and the Cinema*, London, Routledge & Kegan Paul, 1982.

Kuhn, A., 'Women's genres', *Screen*, vol. 25, no. 1, Jan.-Feb. 1984, pp. 18-28.

Kuhn, A., *The Power of the Image: Essays on Representation and Sexuality*, London, Routledge & Kegan Paul, 1985.

de Lauretis, T., *Alice Doesn't: Feminism, Semiotics, Cinema*, Bloomington, Indiana University Press, 1984.

de Lauretis, T., 'Aesthetic and feminist theory: rethinking women's cinema', *New German Critique*, no. 34, Winter 1985, pp. 154-75.

Lederer, L. (ed.), *Take Back the Night*, New York, Bantam Books, 1980.

Lesage, J., 'Women and pornography', *Jumpcut*, no. 26, 1981, pp. 46-7, 60.

Lippard, L., *From the Centre: Feminist Essays on Women's Art*, New York, Dutton, 1976.

Lippard, L., 'Sweeping Exchanges: the contribution of feminism to the art of the 1970's', *Art Journal*, Fall-Winter 1980, pp. 362-5.

Lipton, E., 'The laundress in late nineteenth century French culture: imagery, ideology and Edgar Degas', in Frascina, F. and Harrison, C. (eds), *Modern Art and Modernism*, Harper & Row, London, 1982, pp. 175-83.

Longford, F. *et al.*, *Pornography: the Longford Report*, London, Coronet Books, 1972.

Lovell, T., *Pictures of Reality*, London, British Film Institute, 1980.

Marchetti, G., 'Readings on women and pornography: an annotated working bibliography', *Jumpcut*, no. 26, 1981, pp. 56-60.

Mathews, J., 'Through the lens: fantasy', *Camerawork*, no. 15, Sept. 1979, pp. 2-3.

Midland Group Nottingham, *Sense and Sensibility in Feminist Art Practice*, Nottingham, Midland Group, 1982.

Millum, T., *Images of Women: Advertising in Women's Magazines*, London, Chatto & Windus, 1975.

Miner, V., 'Fantasies and nightmares: the red-blooded media', *Jumpcut*, no. 26, 1981, pp. 48-50.

Mitchell, J., *Psychoanalysis and Feminism*, London, Penguin, 1975.

Mulvey, L., 'You don't know what is happening do you, Mr Jones?' *Spare Rib*, no. 8, 1973, pp. 13-16, 30.

Mulvey, L., 'Visual pleasure and narrative cinema', *Screen*, vol. 16, no. 3, Autumn 1975, pp. 6-18.

Mulvey, L., 'On *Duel in the Sun*: afterthoughts on visual pleasure and narrative

cinema', *Framework*, nos 15-17, 1981, pp. 12-15.

Myers, K., 'Tu: a cosmetic case study', *Block*, no. 7, 1982, pp. 48-58.

Nead, L., 'Representation, sexuality and the female nude', *Art History*, vol. 6, no. 2, June 1983, pp. 227-36.

Nead, L., 'A definition of deviancy: prostitution and high art in England c. 1860', *Block*, no. 11, Winter 1985-86, pp. 40-7.

Neale, S., 'The same old story, stereotypes and difference', *Screen Education*, nos 32-3, Autumn-Winter 1979-80, pp. 33-7.

New Museum of Contemporary Art, *Difference: On Representation and Sexuality*, New York, New Museum of Contemporary Art, 1984.

Nochlin, L. and Hess, T.B. (eds), *Woman as Sex Object: Studies in Erotic Art 1730-1970*, New York, Art News Annual, 1972.

Onwurah, C., 'Sexist, racist and above all, capitalist', *Guardian*, 3 Sept. 1985, p. 10.

Ortner, S., 'Is female to male as nature is to culture?' in Lamphere, L. and Rosaldo, M. (eds), *Women, Culture and Society*, Stanford, Stanford University Press, 1974.

Parker, R. and Pollock, G., *Old Mistresses: Women, Art and Ideology*, London, Routledge & Kegan Paul, 1981.

Parker, R. and Pollock, G. (eds), *Framing Feminism: Art and the Women's Movement 1971-84*, London, Routledge & Kegan Paul, 1987.

Patel, A., 'Images of Asian women in the (white) media', *Artrage*, nos 3-4, Summer 1983, pp. 40-1.

Perkins, T.E., 'Rethinking stereotypes', in Barrett, M. *et al.*, *Ideology and Cultural Production*, London, Croom Helm, 1979, pp. 135-59.

Phillips, A., 'Fast operators: women at the work station', *Camerawork*, no. 32, Summer 1985, pp. 12-14.

Pollock, G., 'The politics of art or an aesthetic for women?' *Feminist Art News*, no. 5, pp. 15-19.

Posener, J., *Spray It Loud*, London, Routledge & Kegan Paul, 1982.

Rhodes, D. and McNeill, S. (eds), *Women against Violence against Women*, London, Onlywomen Press, 1985.

Root, J., *Pictures of Women: Sexuality*, Routledge & Kegan Paul, 1984.

Said, E., 'Opponents, audiences, constituencies and community', in Foster, H. (ed.), *Postmodern Culture*, London and Sydney, Pluto Press, 1985.

Seaton, J., 'Private Lives, Public Display', *New Socialist*, no. 8, Nov.-Dec. 1982, pp. 24-61.

Snitow, A., Stansell, C. and Thompson, S. (eds), *Desire: the Politics of Sexuality*, London, Virago, 1984.

Sontag, S., 'The pornographic imagination' in *Styles of Radical Will*, London, Secker & Warburg, 1969, pp. 35-73.

Spence, J., 'What do people do all day? Class and gender in images of women', *Screen Education*, no. 29, Winter 1978-79, pp. 29-45.

Spence, J. and Dennett, T. (eds), *Photography/Politics: One*, London, Photography Workshop, 1979.

Spence, J. and Dennett, T., 'Beyond the family album', *Ten.8*, no. 4, 1980, pp. 8-10.

Stern, L., 'The body as evidence', *Screen*, vol. 23, no. 5, Nov.-Dec. 1982, pp. 38-59.

Tickner, L., 'Allen Jones in retrospect: a Serpentine review', *Block*, no. 1, 1979, pp. 39-45.

Trades Union Congress, *Images of Inequality*, London, Trades Union Congress, 1984.

Tuchman, G. *et al.*, *Hearth and Home: Images of Women in the Mass Media*, Oxford, Oxford University Press, 1978.

Vance, C.S. (ed.), *Pleasure and Danger: Exploring Female Sexuality*, London, Routledge & Kegan Paul, 1984.

Warner, M., *Monuments and Maidens: the Allegory of the Female Form*, London, Weidenfeld & Nicolson, 1985.

Webster, P., 'Pornography and pleasure', *Heresies*, issue 12, 1981, pp. 48-51.

Weeks, J., *Sex, Politics and Society*, Harlow, Essex and New York, Longman, 1981.

White, C., *Women's Magazines 1693-1968*, London, Michael Joseph, 1970.

Williams, B., *Report of the Committee on Obscenity and Film Censorship*, London, HMSO, Cmnd 7772, 1979.

Williamson, J., *Decoding Advertisements: Ideology and Meaning in Advertising*, London, Marion Boyars, 1978.

Williamson, J., *Consuming Passions*, London, Marion Boyars, 1986.

Willis, E., 'Feminism, moralism and pornography' in Snitow, A. *et al.*, *Desire: the Politics of Sexuality*, London, Virago, 1984.

Wilson, E., *What is to be Done about Violence against Women?*, Harmondsworth, Penguin, 1983.

Wilson, E., *Adorned in Dreams: Fashion and Modernity*, London, Virago, 1985.

Winship, J., 'Sexuality for sale' in Hall, S., Hobson, D., Low, A. and Willis, P. (eds), *Culture, Media, Language*, London, Hutchinson, 1980, pp. 217-23.

Winship, J., *Inside Women's Magazines*, London, Routledge & Kegan Paul, forthcoming.

Wolff, J., *The Social Production of Art*, London, Macmillan Press, 1981.

Women in Media, *Packaging of Women*, London, Women in Media, 1976.

Women's Images, *Pandora's Box*, London, Trefoil Books, 1984.

Women's Media Action, *Women's Monitoring Network Reports*, nos 1-6, 1980-85.

Women's Studies Group, Centre for Contemporary Cultural Studies, University of Birmingham, *Women Take Issue*, London, Hutchinson, 1978.

# Index